b 13335248

709·5

DUBLIN INSTITUTE OF TECHNOLOGY

DUBLIN

Donated to

**Visual Art Degree
Sherkin Island**

D1349205

DIT Library Mountjoy Sq

POINT / EAST E

EXPLORE STUNNING TALENTS IN ASIA

Edited & Published by
Viction:ary

DIT Library Mountjoy Sq

CONTENT

PREFACE

"I ALWAYS WANT TO PRODUCE WORKS THAT MAKE PEOPLE WHO DISLIKE MY WORK TO FROWN AND SAY, 'WHAT'S THAT?' AND ALSO TO DISAPPOINT THOSE WHO LIKE MY WORK."

Japanese painter Taro Okamoto once said, "I always want to produce works that make people who dislike my work to frown and say, 'What's that?' and also to disappoint those who like my work."

Perhaps this could sum up what the Asian design scene is like now. Eastern designers are blazing new trails with work that defies conventions. Their design is not like anything we have seen before because the word 'imitation' is not in their dictionary. They have found their voice, a voice we will be hearing more and more of in the years to come.

Asian designers are now celebrating the local, digging up the unique heritage and treasures from their country / city, and injecting new energy into them. The international design scene is eager to commemorate their rise too. Take 'China Design Now' (2008), the very first exhibition of contemporary Chinese design in the UK, held by the world's largest museum of decorative arts and design – Victoria and Albert Museum (V&A), it marked the significance of the barely-known yet spectacular creative energy in modern China. No doubt, many more Asian countries would be on the show 'up-next.'

Oriental elements are omnipresent, from Tom Ford's last collection for Yves Saint Laurent to Manish Arora's whimsical designs and Kylie Minogue's geisha look. Not to mention Chinese artworks with Cultural Revolution motifs taking the auction world by storm.

The Japanese design industry was the first to blossom in Asia and the legendary graphic designer Keiichi Tanaami has been there since. His work in the 60s, predominantly a cocktail of sexual graphics, neon colours and pop culture, was way ahead of his times. (If you pit it against graphic work nowadays, you'll probably think it's a recent piece!) His latest collaboration with Indian fashion designer Manish Arora is a proof that the psychedelic master has the eternal power to turn anything he touches into gold, whether it is graphic design, animation, films or paintings. Although 60s flower power is history, Tanaami's works never fail to make the era look modern.

Born in 1973, Japanese creative Nagi Noda is one of the pioneers of the Kawaii culture which is spreading its joy across the globe. Her work, which is often dubbed 'Alice in Wonderland meets Emily the Strange,' is about turning your wildest dreams into reality. Her photography for b+ab's campaign is unapologetically cute, knocking on the door of your childlike subconscious. Her campaign for Laforet Spring 07, which features New York dance group Scissor Sisters clad in roses at various stages of undress, epitomises her knack for finding beauty in craziness.

Thanks to the Singaporean government investing more into the arts, the design industry there is happening. Asia's leading art and design collective :phunk studio's style is inimitable since it makes its inspirations, from Japanese Otaku subculture to Hong Kong pulp fiction to traditional Chinese folklore,

its own. It is no surprise that :phunk studio has joined forces with heavy weights like Nokia, MTV, Daimler Chrysler, Comme des Garçons, and Levis and represented Singapore at the Gwangju Design Biennale 2005 and the London Design Festival 2006.

Me and Mister Jones, comprising husband and wife designer duo Fanny Khoo and Tom Merckx, is another notable creative in Singapore. Their most impressive works include Absolut Vodka and the Useagain exhibition. The former is an exclusive Absolut cocktail menu card for the hottest bar while the later involved Me and Mister Jones breathing new life into unused or rejected artwork. "It was very challenging to put thousand of pieces together like a gigantic puzzle, merging very different illustration styles into something completely new," Merckx said.

Born in the 60s, Hong Kong creative Stanley Wong witnessed the city's design industry heightening the awareness of its cultural roots over the years. He has been developing his Redwhiteblue series since 2000, in which the nylon bag takes centre stage in his photography, installations, posters, etc. His creative presentation of the bags has made his series precedent setting and many culturally conscious works by youths have followed suit. However, belying the glamorous colours of red, white and blue (the same shades the late Polish director Krzysztof Kieslowski used for his three colours trilogy) is Hong Kong people's transcending poverty with sweat and tears in the 60s and 70s.

Hong Kong-based international graphic design magazine IdN, who is celebrating its 15th anniversary this year, has been living up to its name International designers' Network over the years. In addition to featuring top-notch designers from around the world, its conferences, exhibitions and competitions act as the glue to the design community. "IdN is still like a kid that refuses to grow up, constantly looking for that next toy. Volume12 Number6 'It's Playtime' best fits this analogy," Art Director Jonathan Ng said.

MEWE Design Alliance, the internationally renowned Chinese design studio comprising Guang Yu, He Jun and Liu Zhi-zhi, is famed for its book design. Their works were exhibited in 'China Design Now' held by the V&A. Even though they have achieved critical acclaim in their early career, they remain modest. "We don't have a specific style, but we may have a unique approach to pondering problems," Liu said.

Other Chinese designers are donning their prophet hat and are foretelling what their country will be like in the future. The work of photographer Chenman, who counts her hometown Beijing as one of her inspirations, frequently depicts Chinese women as futuristic glamazons 3/4 full-figured yet sultry, strong yet vulnerable, masculine yet feminine. In other words, a stark contrast to the popular pencil-thin frame.

In Korea, more and more young people are joining the creative industry, thanks to its government pouring money

into the business. Leading designer Zinoo Park, who is famed for his critique of globalisation, is not satisfied with making work which is just style. For instance, his 'The Perfect Fake Bag' series, part of the project 'Truth & Irony' exposes the fact that people prefer fake goods to genuine ones. And of course the irony is that the bag becomes an original once the word 'FAKE' graces it. "It also sends a message that it is ourselves that is to be valued, not by what we wear or carry," Park said.

The Thai design scene is gearing up as well. OSISU, the face of eco-design for the country, channels manufacturing and construction waste into stunning designs. Besides using recycled materials in its products, OSISU draws inspirations from nature, namely animals and plant forms. OSISU is living proof that environmental awareness and financial success can co-exist.

The East, which is famed for its business saviness and get-go attitude, is now seizing the international media's attention for its burgeoning creative scene. From design to art, fashion to architecture to film, Asia's creatives are scooping awards and earning critical acclaim. Their style is distinctive, a celebration of traditions, an indulgence in the present and a wink at the future. The tiger is wide awake and ready to take the world by storm.

/ POORONI RHEE

/ SEOUL, KOREA

Title: Red Mummies **Type:** Paintings, Window graphics **Year:** 2006 **Client:** -

Description: Works created for Rhee's solo exhibition. She likes to create a story behind her works. She also likes to create fonts made with red ribbons that would wrap around and transform and vanish. Animal shapes and number shapes were created and named as the Red Mummies.

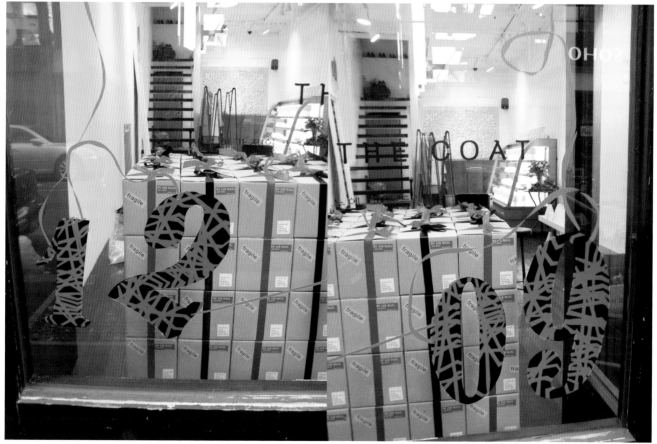

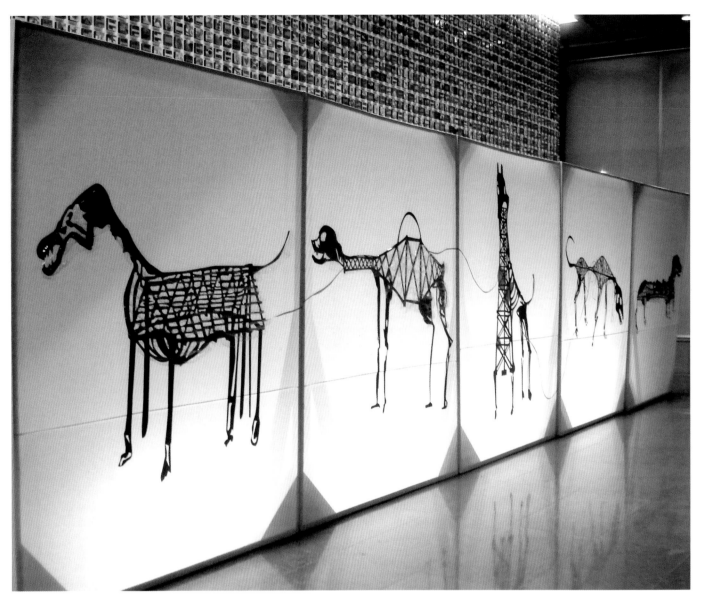

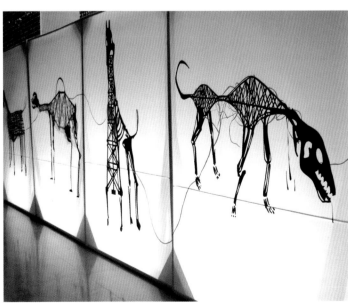

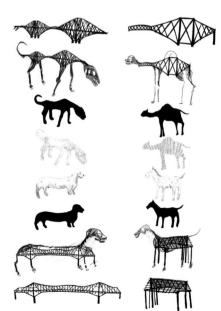

Title: Sketches For An Animal City
Type: Illustration, Artwork **Year:** 2007
Client: -

Description: Illustrations created for the Korean design magazine / journal D.T. called 'Sketches For An Animal City' and the exhibition 'Fantastic Artistic Seoul Team' at Ilju Art Center, Seoul.

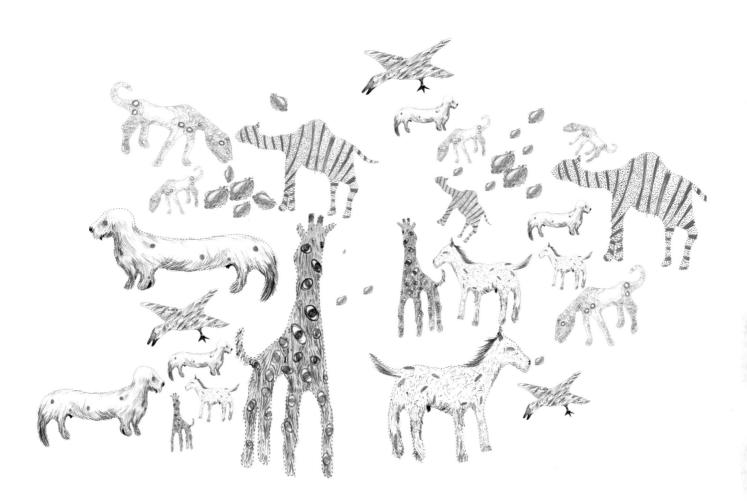

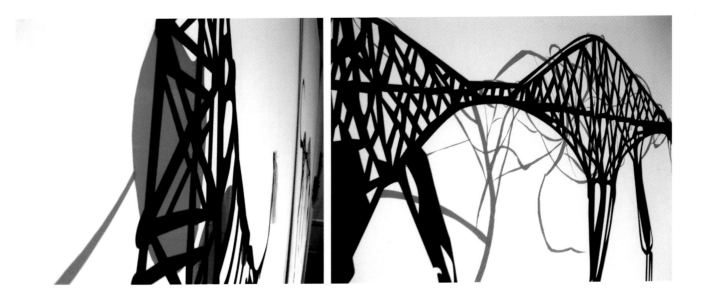

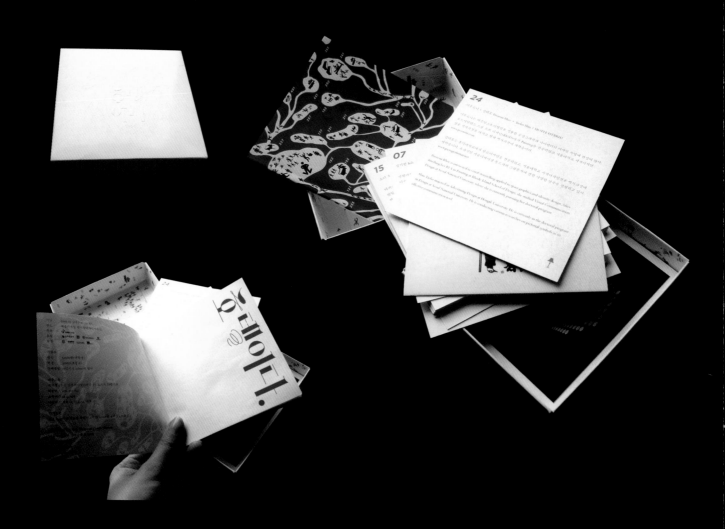

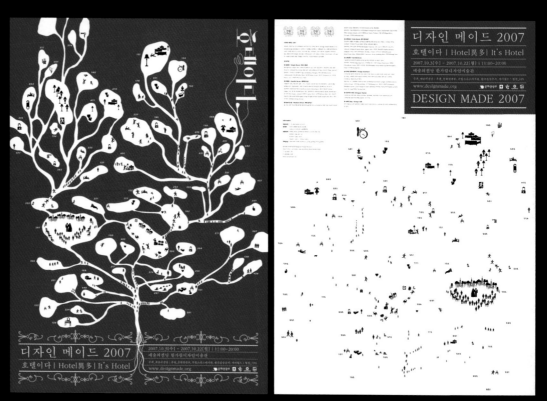

Title: It's Hotel **Type:** Exhibition Identity, Poster, Brochure, Leaflet, Exhibition
Year: 2007 **Client:** Design Museum, Seoul Arts Center

Description: Rhee was invited to exhibit her works at the Design Museum, Seoul Arts Center as well as to create the exhibition promotional materials. The theme of the exhibition was 'It's Hotel' showing different rooms and aspects of design objects in different situations. She made a pattern of an ant house where different activities could take place. With the help from Jeon Woochan and Shin Taeho, both typo and pictogram experts, Rhee created posters, leaflets, books and invitations. For the exhibition, she made a wall-graphics with lighting, using hybrid animals mentioned in the classic Chinese book '山海經' (The Classic of Mountains and Seas / Shanhaijing) with the help from Shin.

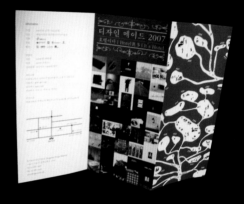

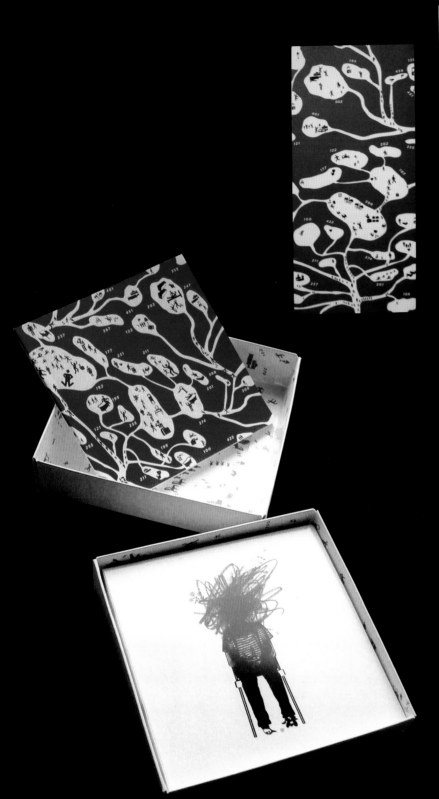

Title: Kingdom Hybrid **Type:** Character designs, Prints, Calendars, Pins, Hangers **Year:** 2006 **Client:** -

Description: A collection of hybrid animal characters for a solo exhibition. The characters were made with a story about a mad scientist trying to draw and categorise a new species of animal-plant hybrids. Personal works were exhibited and the characters were used for the limited edition calendars and pins for the exhibition visitors.

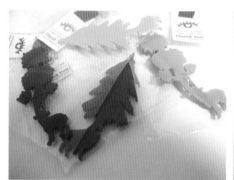
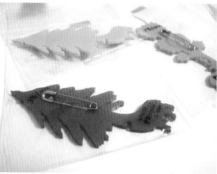
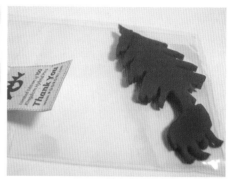
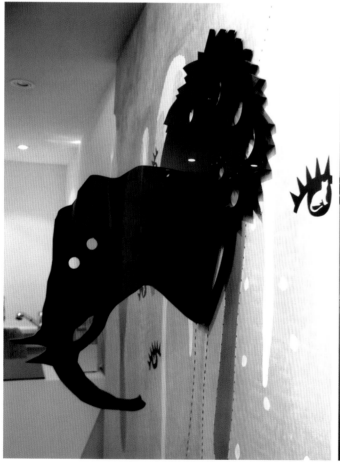
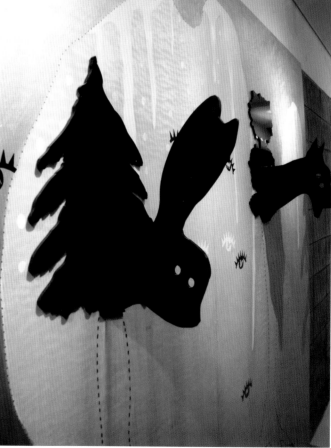

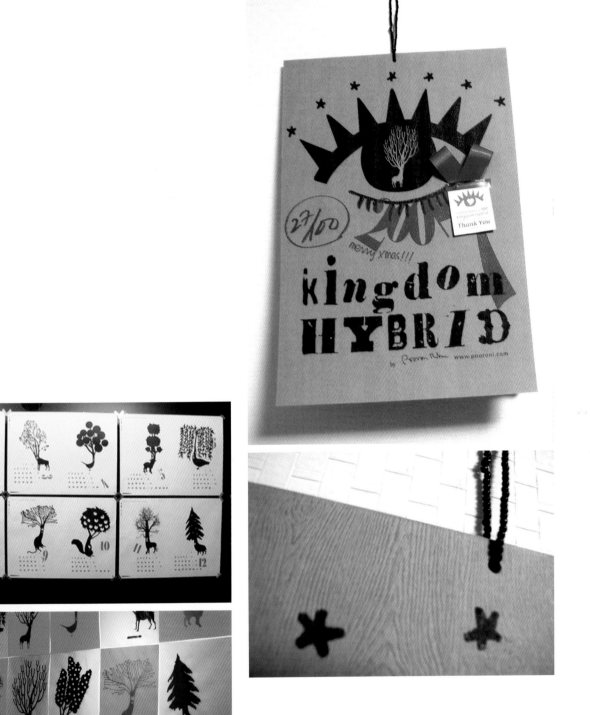

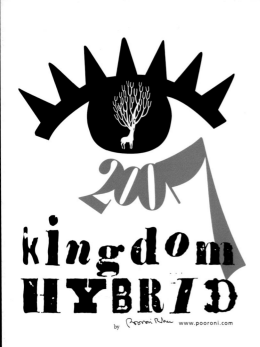

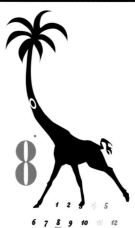

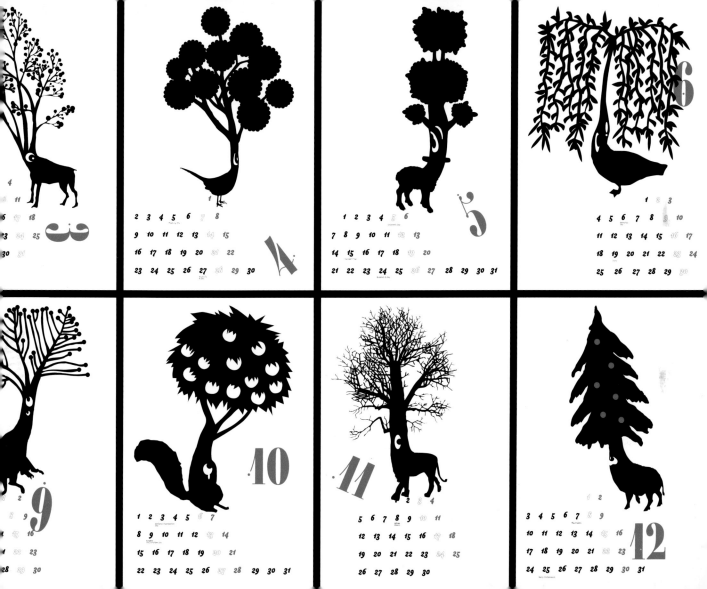

Title: Kingdom Hybrid **Type:** Window display
Year: 2006 **Client:** Shinsegae International

Description: A Christmas window display for a Korean fashion collect-shop, Boon the Shop, for men. They wanted to use the Kingdom Hybrid characters with unusual colours for Christmas, and characters were silk screened on wood cubes, with patterns on the background. The cubes were versatile and could be stacked into a tree shape at one time and later into different forms for different display purposes.

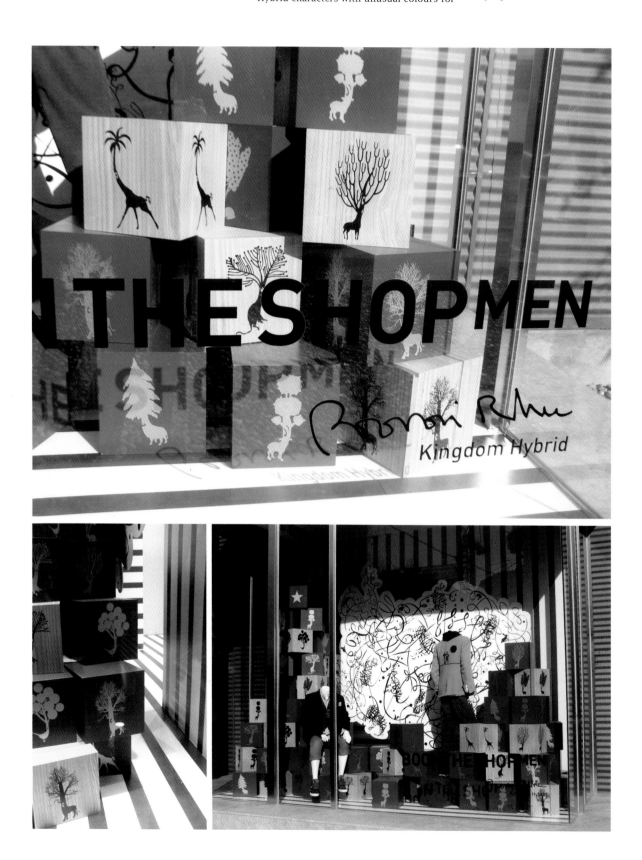

Title: From Wheat To Bread **Type:** Space graphics **Year:** 2006 **Client:** Woosong University, ZNP Creative

Description: Space Graphics created with ZNP creative for a bakery in Woosong University – The graphics were applied to the huge columns in the bakery space with the red spaghetti chandeliers Zinoo Park created, so graphics were created to go with the lighting and to depict the young and fun atmosphere in the university. The graphics show the white tree with dairy, and flour mixing with hands and a red tree with baked eateries hanging instead of fruits.

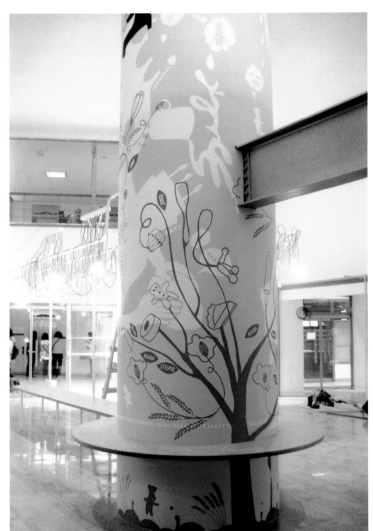

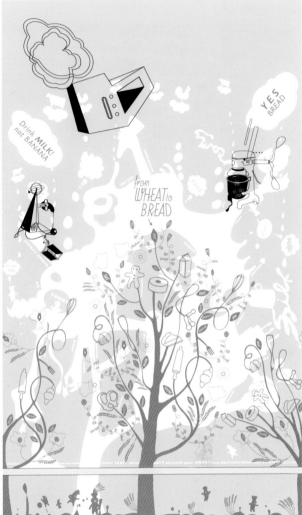

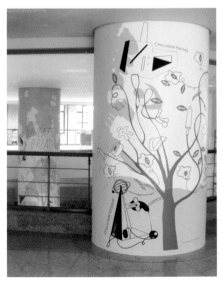

Title: Make-up Bag **Type:** Brochure
Year: 2007 **Client:** Stuffandthings

Description: 'Make-up Bag' is an artist col-
laboration project, initiated by Stuffandthings
and Milkxhake, aims to explore the creativity
of the new generation of non-woven materials
which are invented by Stuffandthings.

Five artists from different fields were invited
to participate in this project to create their
own make-up in by given non-woven fabrics.
The project witnesses the ultimate creativity
across the material boundary and celebrates
the new era of non-woven materials.

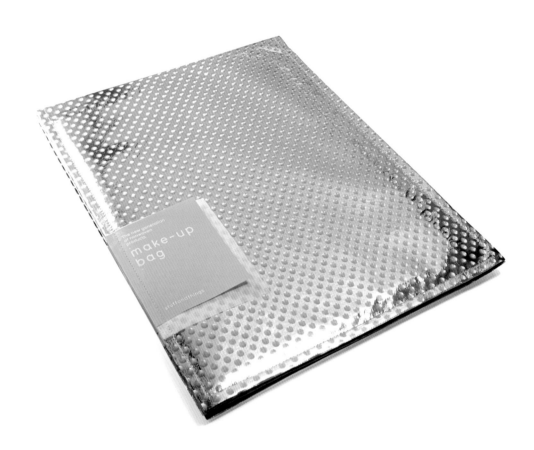

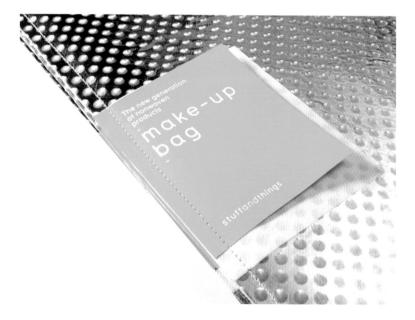

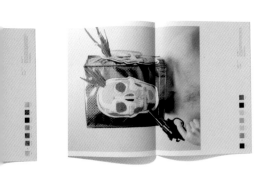

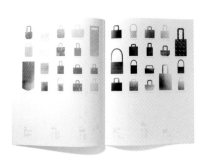

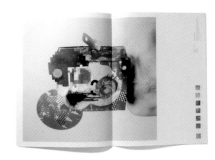

artist_02/
Rob
McGuire
&
Will
Lees

Title: JMW Summer Arts & Dance Program 2006 **Type:** Promotional campaign
Year: 2006 **Client:** JMW School of Ballet

Description: JMW is recognized as one of the most prestigious ballet schools in Hong Kong. They launch the children summer art & dance programs to encourage creativity each year. Based on the theme of 'colouring game,' Milkxhake designed the event logotype, pro-

motional posters and the website for the kids to play around in 2006.

The colours Milkxhake chose were inspired by kids' pastel colours. 3 pastel colours were used to produce different versions of posters. The kids can fill the colours directly onto the poster like a colouring game. The concept was also extended from printed items to their promotional website.

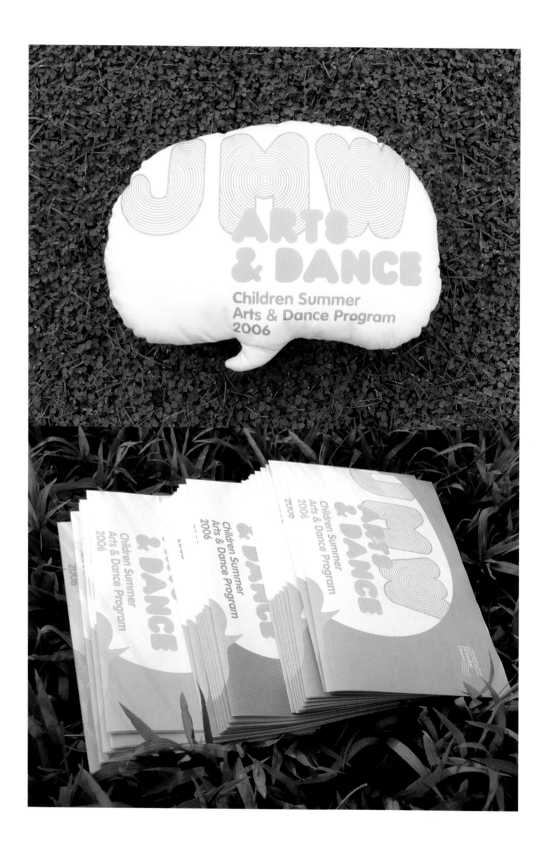

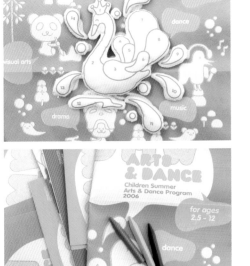

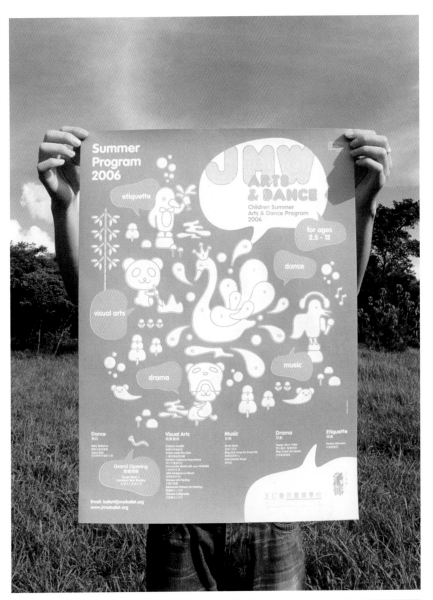

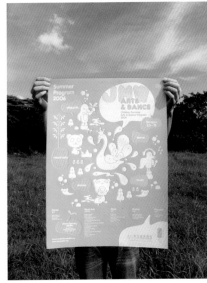

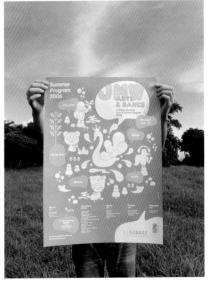

1/ Title: The Very First Magazine 2006
Type: Calendar design **Year:** 2006
Client: Antalis (HK) Ltd.

Description: The Very First Magazine 2006 is a creative collaboration of 12 young designers from the Asia Pacific Region. Antalis (HK) invited Milkxhake to design a New Year calendar for 2006. They came up with an interesting idea of publishing a new year 'Calendar Magazine' by mixing the concept of 'calendar,' 'magazine' and 'visual diary' in an unconventional approach.

2/ Title: Outside Fabrica **Type:** Notebook
Year: 2004 **Client:** Moleskine Hong Kong

Description: This was an exhibition project invited by Working Unit Ltd and Moleskine Hong Kong in 2004, aimed to collaborate with different artists and designers to create their own Moleskine note book. Milkxhake's contribution 'Outside Fabrica' was a photo notebook documentation of all the interesting images taken outside Fabrica when Mo was in Italy.

1/

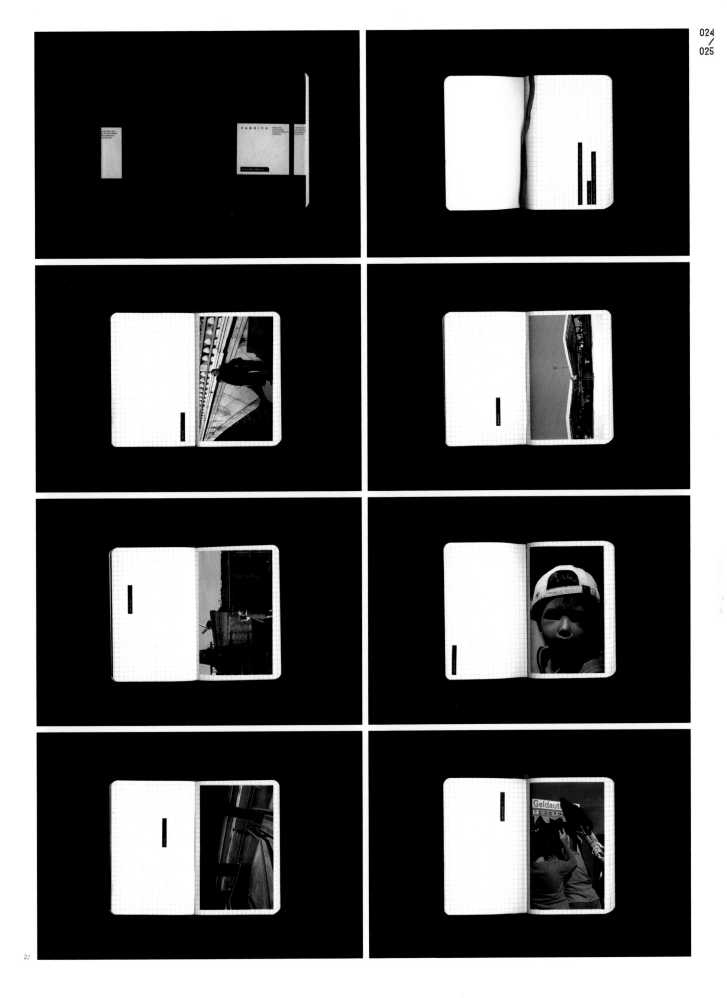

Title: HKDA Awards 07 Creative Campaign – 'Design. No Junkfood' **Type:** Promotional campaign **Year:** 2007 **Client:** Hong Kong Designers Association

Description: This is a creative campaign designed for Hong Kong Designers Association (HKDA) Awards 07, an Asia-Pacific Design Biennale. Milkxhake did the whole promotional campaign, from Call-for-Entries and Judges Seminars to Awards Presentation based on the theme 'Design. No Junkfood,' a statement on the value of design. The poster is a wrapper for designers to wrap their 'fresh-stuff' entries.

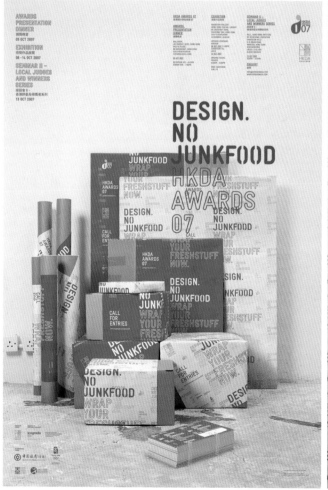

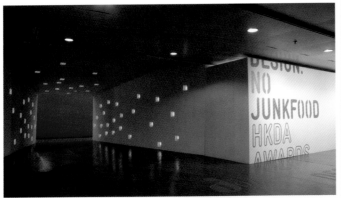

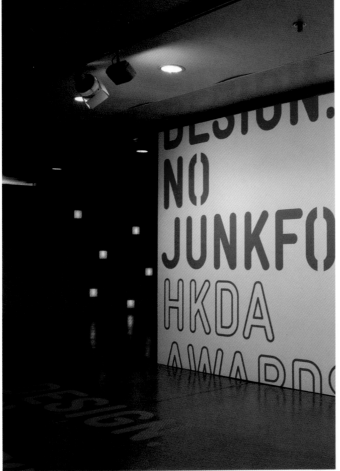

/ HIDEKI INABA

/ TOKYO, JAPAN

1/ Title: Relax Magazine No.101 **Type:** Graphic Art **Year:** 2005 **Client:** Magazine House
Description: -

2 - 3/ Title: Shu Uemura BTB24-Graphic Design By Hideki Inaba **Type:** Graphic Art
Year: 2007 **Client:** Shu Uemura
Description: ©2007 Shu Uemura, Hideki Inaba.

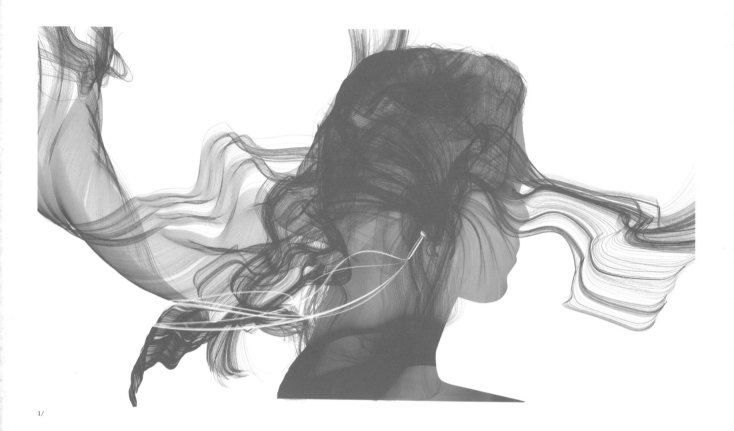

1/

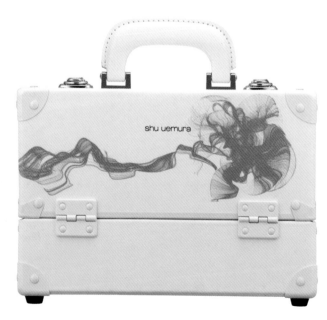

2/

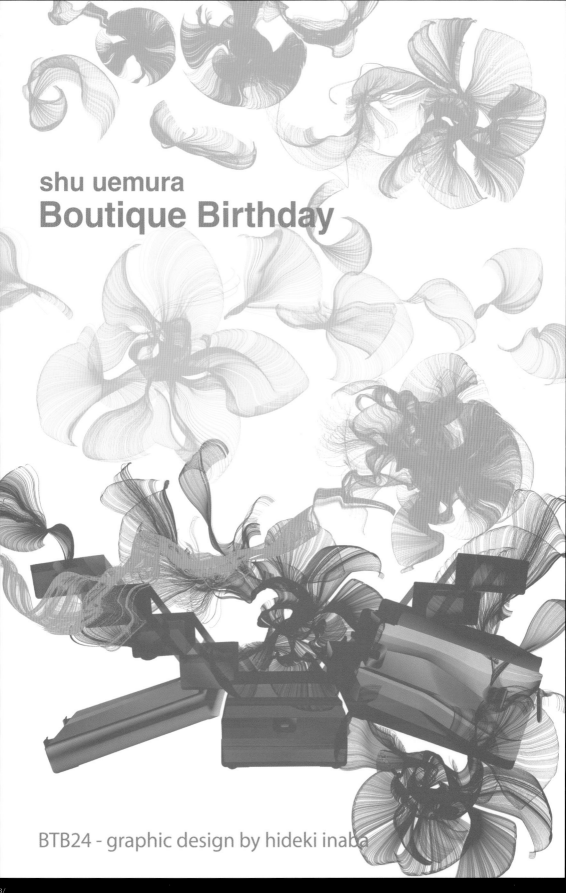

shu uemura
Boutique Birthday

Title: NEWLINE 1 **Type:** Graphic Art
Year: 2004 **Client:** -

Description: For Hideki Inaba's exhibition
'NEWLINE' in Tokyo, Sapporo 2004.

1/ **Title:** GRAPHIC LINE **Type:** Graphic Art
Year: 2007 **Client:** -

Description: For Hideki Inaba's exhibition
'GRAPHIC LINE,' Shu Uemura Tokyo 2007.

2/ **Title:** Untitled **Type:** Artwork **Year:** 2001
Client: +81

Description: -

1/

2/

1/

1/ Title: NEWLINE 2 **Type:** Graphic Art
Year: 2005 **Client:** -

Description: For Hideki Inaba's exhibition
'NEWLINE 2' in Tokyo, Sapporo 2005.

2/ Title: NEWLINE 1 **Type:** Graphic Art
Year: 2004 **Client:** -

Description: For Hideki Inaba's exhibition
'NEWLINE' in Tokyo, Sapporo 2004.

2/

1/ **Title:** E2-E4_Album Art **Type:** Graphic Art
Year: 2001 **Client:** CD E2-E4 2001

Description: -

2/ **Title:** NEWLINE1 Burst-Helvetica
Type: Graphic Art **Year:** 2004 **Client:** -

Description: For Hideki Inaba's exhibition
'NEWLINE' in Tokyo, Sapporo 2004.

1/

Puttin' the lin fine.
Throwin' records
out the window.
out the floor.
ause we don't
want em no more.
Burst-Helvetica

JOYN:VISCOM

BEIJING, CHINA

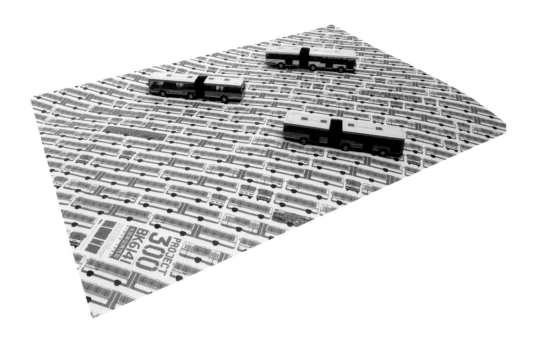

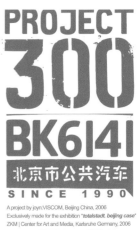

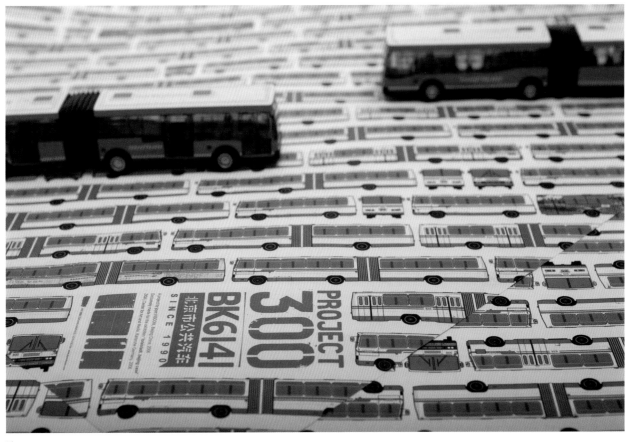

1/ Title: Project300 **Type:** Graphic, Video
Year: 2006 **Client:** ZKM (Germany)

Description: Invited by ZKM (Germany), JOYN:VISCOM created for its exhibition 'Beijing Case' which focused on the cutthroat speed of urbanisation. With the outdated and poor bus No.300 which should be retiring soon and the creature Sunspot from the outer space shooting around the third ring road of Beijing, it showed the high speed urbanisation process of Beijing.

2/ Title: Unmask's 2002-2006
Type: Catalogue **Year:** 2006
Client: Dimensions Art Center

Description: Unmask art group consists of three members, who work and live in Beijing taking sculpture as intermedium. They held their first exhibition which showcased their works done in the past 4 years (around 2002) at Dimensions Art Center in 2006. To make it more interesting and mysterious, the team took the meaning of the word 'unmask' as the concept of the catalogue and hide the info with their design method. Besides, for the team echoed the theme of the poster by making 3D sculptural font.

2/

UNMASK'S
2002~2006

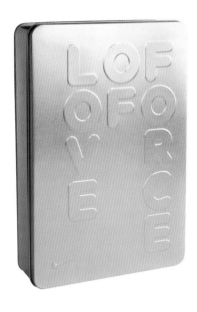

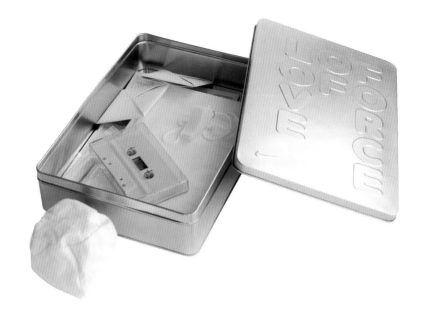

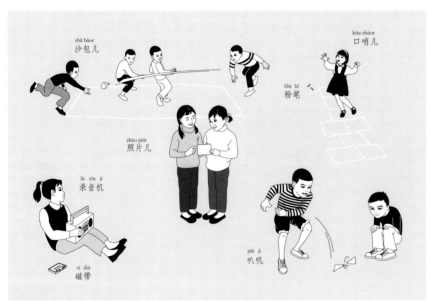

sha baor
沙包儿

kǒu shàor
口哨儿

fěn bǐ
粉笔

zhào piàr
照片儿

lù yīn jī
录音机

cí dài
磁带

pià jī
叭叽

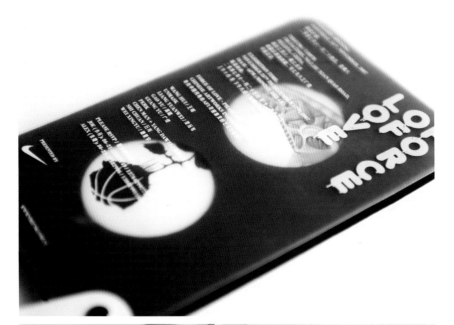

Description: It was designed for Nike Air Force One 25th Anniversary Celebration 'Force of Love' at the Beijing Stop, which had invited numberous artists and designers from different fields to create for Air Force One 'Force of Love.' The design took kinds of things about life and game in 1980's to evoke old memories on the passed times.

Title: Plugzine No.2 **Type:** Publication
Year: 2006-07 **Client:** JOYN:VISCOM

Description: Plugzine is an independent and periodic publication launched in 2002, specialised in visual communication. 'Addicted to Drawing' is the name of Plugzine No.2, which includes two magazines, a sketch book and four covers in 4 colours.

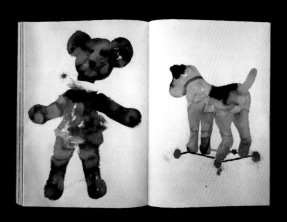

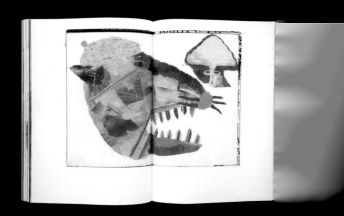

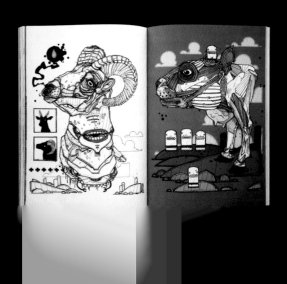

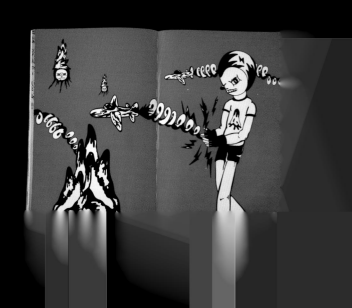

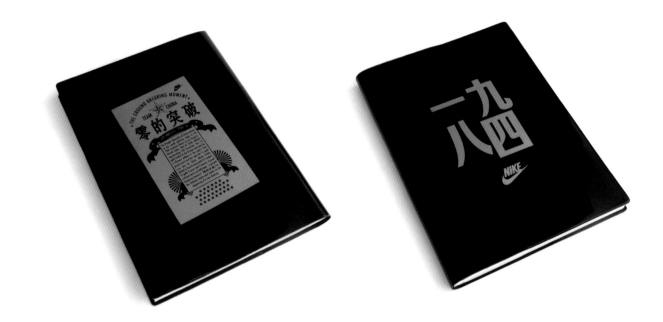

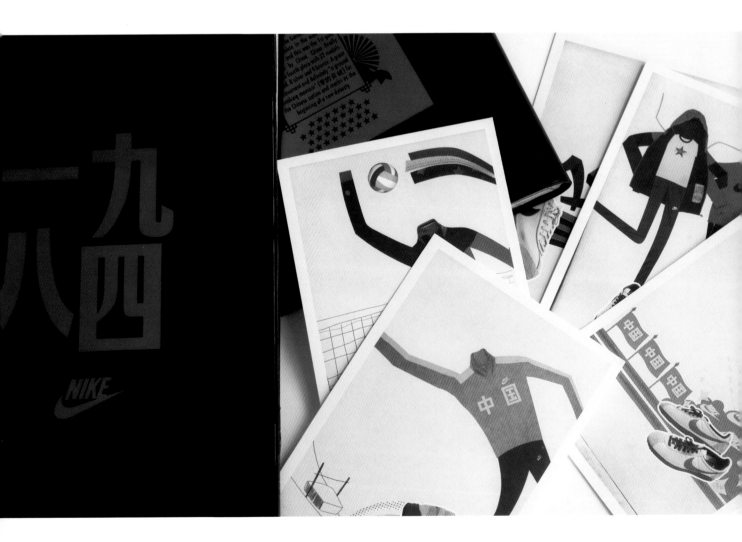

Description: Tracking memories when the China Olympic team got the first gold medal at the Los Angeles Olympics in 1984... As the sponsor of the Beijing Olympics, Nike released an original collection based on the year 1984, which includes clothing, bags, shoes and accessories.

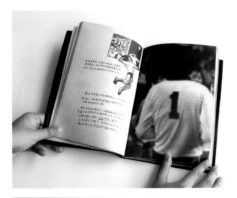
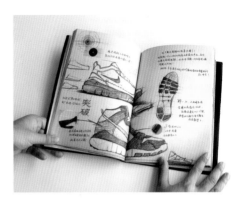

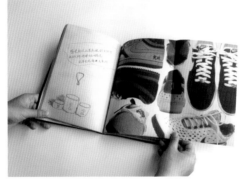
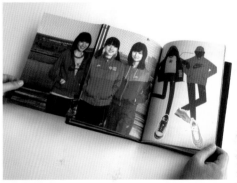

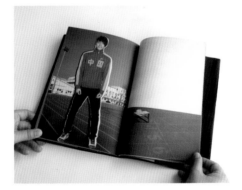
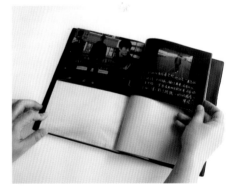

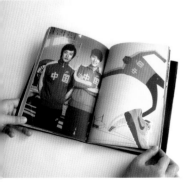
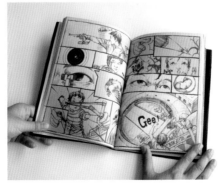

BICO -I- BOBCHEN GRAPHIC DESIGN OFFICE

HANGZHOU, CHINA

Title: Untitled **Type:** Identity **Year:** 2005
Client: BICO -|- Bobchen graphic design office

Description: Taking the letter 'B' as the graphical sideview of a pregnant woman, the symbol of the company is a hotbed of ideas for innovations. To stay fresh and new at all times, Bob continues exploring the letter 'B' for any possible applications that could turn into graphics.

陈飞波
BOB CHEN

杭州陈飞波平面设计事务所
BOB CHEN GRAPHIC DESIGN OFFICE
红石中央花园聚宝轩1栋2单元1701
Office：1701.2-2Unit teicouwuan red stone garden.
liuzhu south Road.Hungzhou 310014 P.R.China
Tel:0086-571-85819466.85861409
Fax:0086-571-85861409
M.T.:13958030782
E-mail:1979@bobchen.cn
Http://.www.bobchen.cn

Title: DAO SPACE Interior Design Company
Type: Identity **Year:** 2007 **Client:** DAO Space
Photographer: Jin Hai Wu

Description: With special treatment, the letter
'A' embodying pioneering spirit is the main
symbol of the logo. The logo will be marked
as part of the direct support graphics, break-
ing through the conventional approach with
unique visual effects.

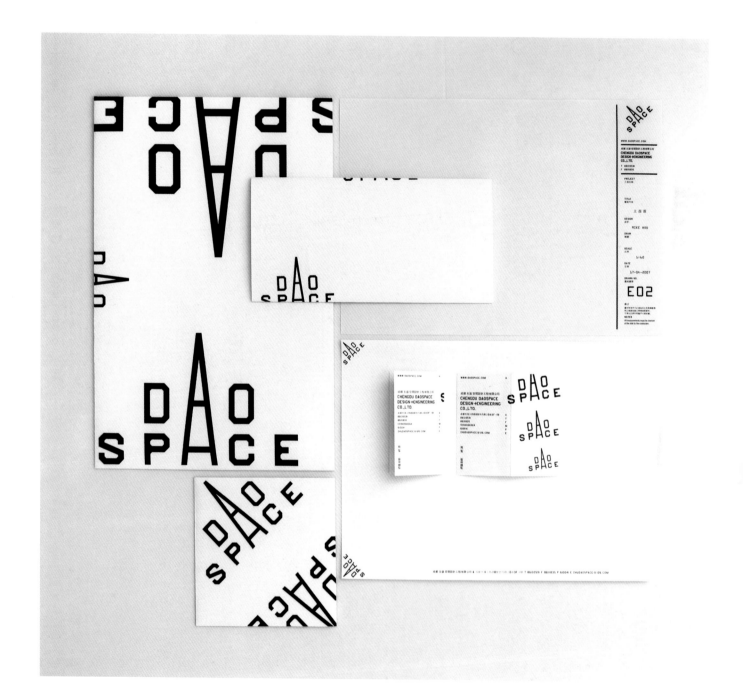

MEWE DESIGN ALLIANCE

BEIJING, CHINA

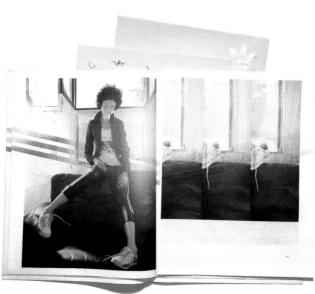

Title: 'Sleek Series' - Adidas Originals Footwear Catalogue **Type:** Catalogue **Year:** 2007
Client: Adidas Originals

Description: Limited edition means the possibility of creating uniqueness in mass production to MEWE.

Material: 65g Carbon paper (3 different colours)
Printing Colour: Pantone 801, Pantone 807, Pantone 803, K
Special Treatment: Foil stamping (the foil rubbed by hand), Die-cutting
Number: 800 unit

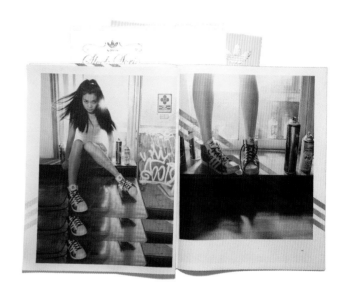

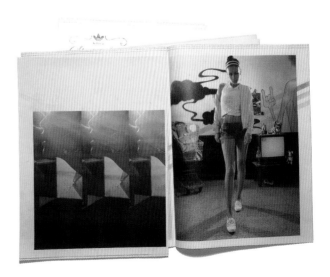

Title: Naughty Kids **Type:** Art book
Year: 2006 **Client:** Star Gallery

Description: 'Naughty Kids' is an art book designed for 32 very young artists. As some of their works might hardly be accepted by the main stream, the curator asked the team to 'hide' these works in the album. However, the team hid the artists' personal information instead. People who are curious to reveal the artist's identity, must scratch off the silver layer, expressing the client's concern in a completely different perspective.

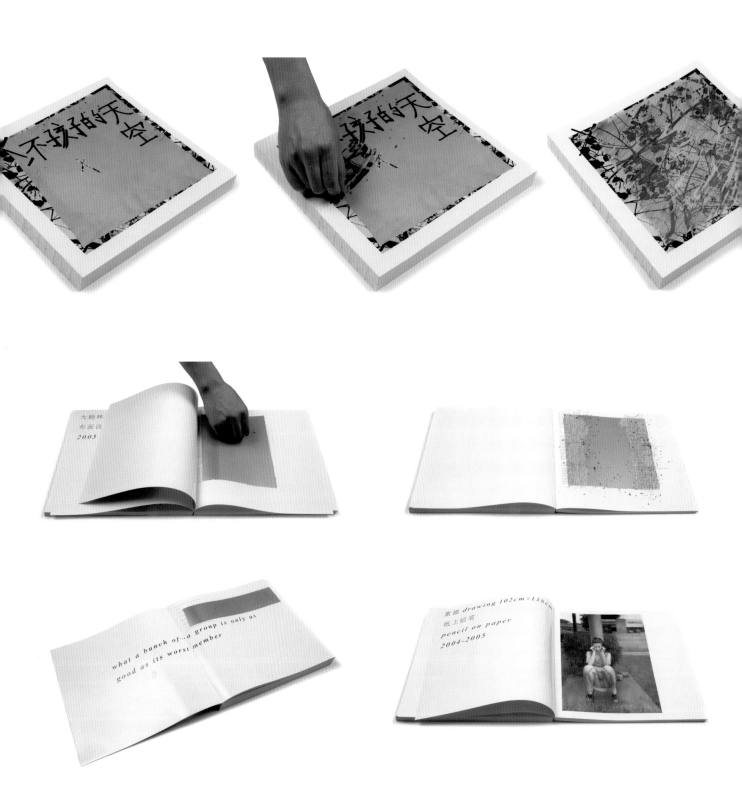

Title: Unmask **Type:** Handbook **Year:** 2005
Client: Unmask

Description: 'UM user handbook' is designed for a human-sized doll named 'UM.' The book is printed on cheap paper material with black and green ink. The book is very large, thin and light, with uncut edges. Readers are made to tear it open for reading and the book would eventually turn into a pile of paper waste after every page is read.

Title: Young Ben **Type:** Catalogue
Year: 2006 **Client:** Antalis

Description: Antalis is an international paper merchant landing in China. They invited a group of creative young students from the Central Fine Art Acdemic to design an original 2007 planning book called 'Young Ben,' 'Ben' is a Chinese word means 'volume' (a unit). Phonetically, 'Young Ben' in Chinese means 'paper sample.' The main theme of this book is Yunnan, a province in China, which is famous for its mild Spring-like weather all year round. 'Young Ben' accomodates many interesting ideas: the cover and the end cover can be cut into a set of poker cards with Yunnan's traditional local buildings as its background pattern; the background pattern of each text page is made by Chinese characters repetitively arranged. Those characters compose an article, Spring, from the primary school textbook, which is familiar to everybody in China. The bookmark is an accessory from Yunnan costume.

Typeface: Clarendon, Helvetica Neuel, M Fan Hei GB, M Fan Kai GB

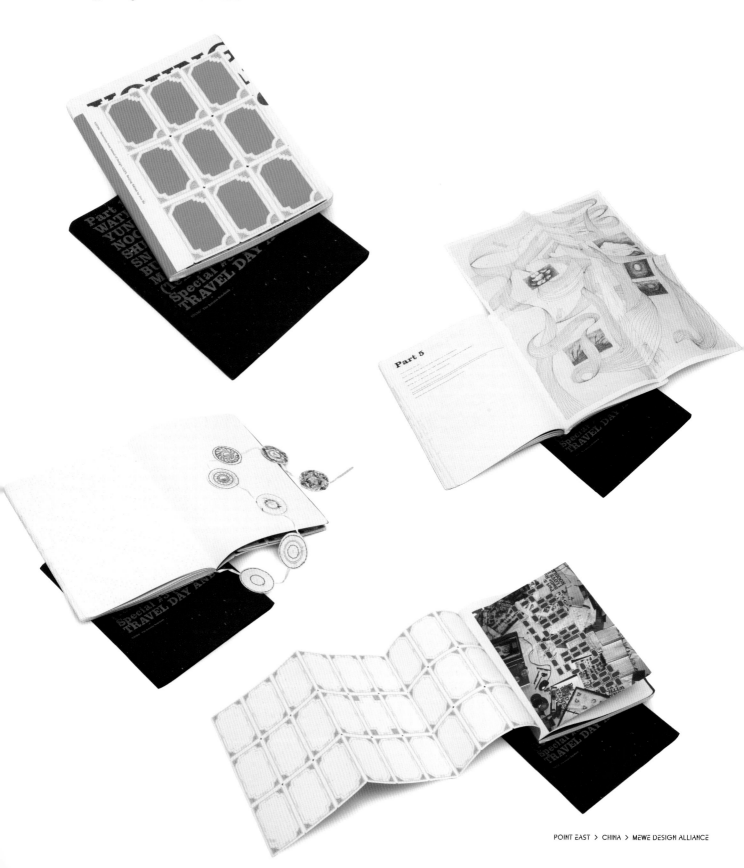

Title: The Poems Of Changrao Wrote by Naizheng Book (昌耀詩 乃正書) **Type:** Book
Year: 2002 **Client:** Zhu Naizheng

Description: 'The Poems of Changrao Wrote by Naizheng' is a book the artist Zhunai wrote for the passed poet L Changrao, combining with calligraphy and poems. It designed with a main figure '+' from the beginning to the end, expressing the writer's commemoration to the poet so as to bring out the subject of this book: 'the artist and the poet, the calligraphy and the poems.' To emphasise on the subject, the team has used the special black Chinese writing paper made from bamboo for the book. Through folding every piece of paper into 8 folds (pages), the peculiar structure is formed and the overlapped edges are just like the rendered ink marks. Meanwhile, not only is it functional, it is propitious to enjoy the calligraphy works when every 4 folds (pages) are one group these are spread out as a complete tableau.

Typeface: Handlettering, Fang Song

Title: Luminescent **Type:** Album design
Year: 2007 **Client:** Star Gallery

Description: This is an art album designed for a very young artist. His works carry the style of children's drawings, as if he didn't make much effort to complete them, so does the book design. Under the hardcover, there are full of exaggerated abstract symbols and patterns, and everything is made in red.

Title: N12 No.4 **Type:** Book **Year:** 2006
Client: N12

Description: N12 is a painter's association founded by 12 members. The string-bind booklet is a collection of 12 booklets, with each showcases the artwork of one specific member among the 12. The colours of the booklets' covers compose a gradient while the blank pages are left for the absent artist. All information regarding the artists themselves as well as the related artworks are printed as stickers in a separate booklet. The artists and readers can complete this art book according to their own taste and understanding. In this process, readers can get better knowledge about the artists and their works. This year, 'N' and '12' are composed by the photograph of the book Itself.

Typeface: FuturaStd, Sabon, M Fan Song

1/ Title: CIGE Visual Identification System
Type: Identity **Year:** 2007 **Client:** CIGE
organizer committee

Description: Identity developed for CIGE
including the design of the tag, bag,
packaging, notebook, etc.

2/ Title: '05 Shenzhan Biennale Of Urbanism
/ Architecture Visual Identification System
Type: Identity **Year:** 2005 **Client:** 2005
Shenzhen Biennale of Urbanism / Architecture
Organizer Committee

Description: The 'Visual Identification Sys-
tem' is designed based on the logical concept
of structuring 'Kanji.' Under the principle
of 'identifiable,' the diamond shape is the
most space-efficient structural element to
form a 'Kanji.' The concept and relationship
of expanding a spot into a large dimension
indicate the relationship between architecture
and the city. All objects that can be described
by 'Kanji' can also be illustrated by the set
of new font, which is the core feature of the
Biennale's 'Visual Identification System.' The
patterns appear on the envelope, invitation,
hand bag, brochure and CD cover etc. are a
repetition of each object's name written in the
new font.

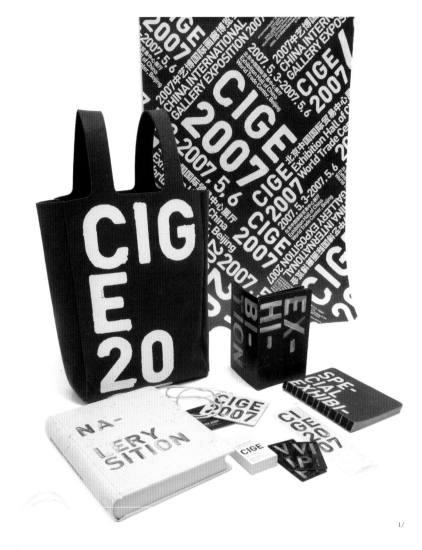

1/

2/

Title: CIGE Visual Identification System
Type: Identity **Year:** 2006 **Client:** CIGE organizer committee

Description: The work is made for the China International Gallery Exposition 2006 VI project. A main grid and a set of auxiliary grids were first set up for the formatting of the text. The letters 'C,' 'I,' 'G,' and 'E' were formed by filling up certain parts of the main grids. Applications, such as business card and invitation, are made with different auxiliary grids, as a part of the main image.
Typeface: (Custom-made) Din, Hua Wen Hei

Title: A & A **Type:** Identity **Year:** 2005
Client: No.47 Architecture & Art Gallery

Description: This is a poster for 'Architecture and Art – Swiss Contemporary Architecture Exhibition.'

'A' is developed into a regular triangle, used as a basic building block. The symbol '+' formed by mirroring the transformed letter 'A' indicates both 'plus' and Switzerland. This poster can be cut into smaller pieces and turned into an invitation and a disc slip, thus the different patterns made by overlapping and mirroring the regular triangles are not only for visual effect, but also indicators of cutting and folding.

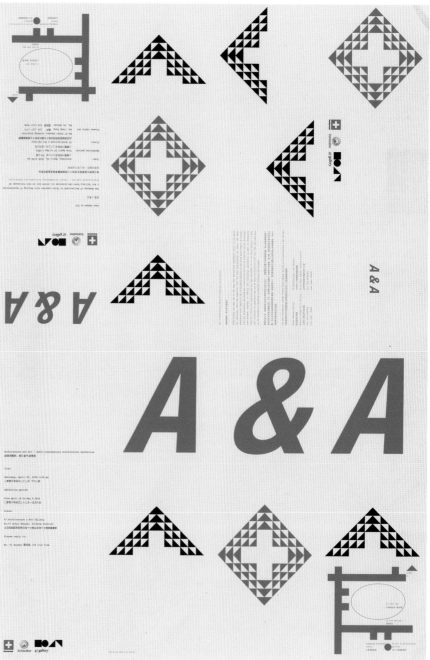

1/ Title: Vol. 3 **Type:** Poster **Year:** 2004
Client: Vol. 3

Description: This poster is made to promote a women's clothing brand 'Vol. 3.' It includes many decorative patterns and images from antique books.

2/ Title: Now PEK **Type:** Poster **Year:** 2005
Client: -

Description: This poster was created in response to an invitation of a non-profitable exhibition. The theme was 'Today's Beijing.' The pronunciation of 'now' in Chinese means 'disorder, noisy and chaotic,' which is exactly what Beijing looks like nowadays. Very funny. The black fireworks in the poster compose the word 'NOW,' indicating Beijing is a very energetic but disordered metropolis.

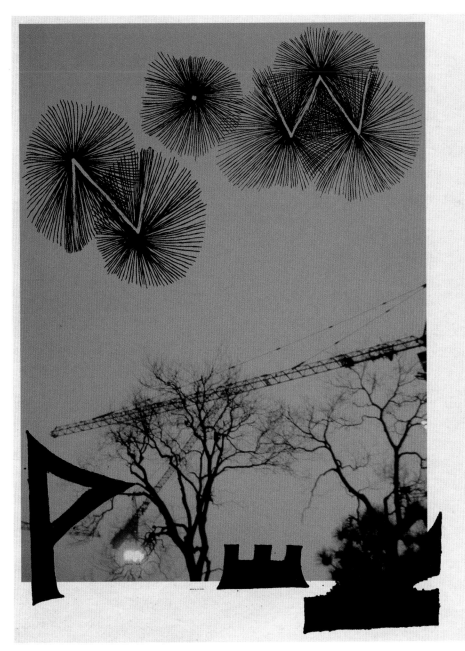

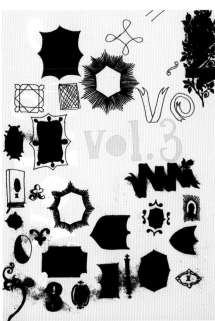

1/

2/

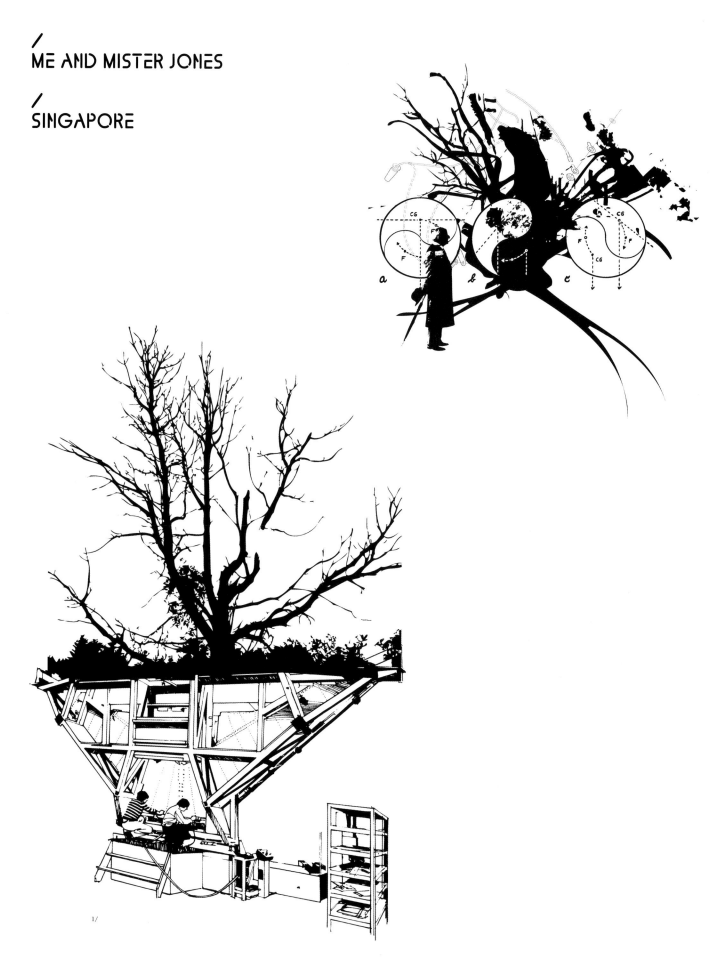

ME AND MISTER JONES

SINGAPORE

1/ Title: Behind The Scenes **Type:** Free work
Year: 2006-07 **Client:** -

Description: Various pieces from Me and
Mister Jones' personal vector collection.

2 - 3/ Title: Absolut Vodak Menu Card
(Continue on next spread) **Type:** Menu
card design **Year:** 2006 **Client:** Absolut for
Maxxium Belgium

Description: Exclusive cocktail menu for top
bars and drinking holes. Custom-made motifs,
illustrations and copywriting based on the
original 'Find Your Flavour' campaign. Each
flavour is distinctly different.

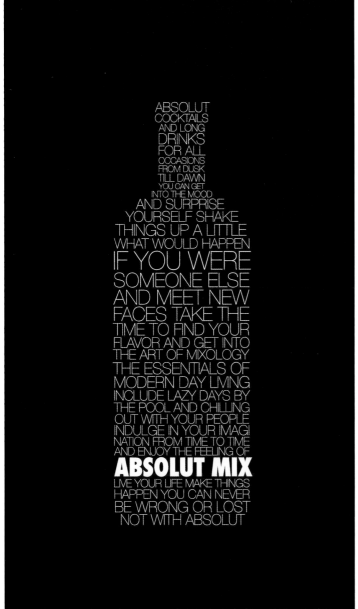

2/

ABSOLUT
MANDRIN

ABSOLUT
VODKA

ABSOLUT
VANILIA

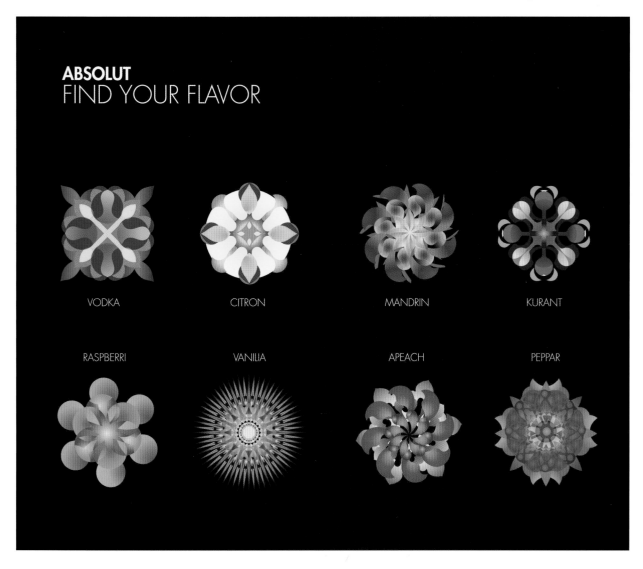

ABSOLUT
FIND YOUR FLAVOR

VODKA CITRON MANDRIN KURANT

RASPBERRI VANILIA APEACH PEPPAR

Title: Eye Sore **Type:** Poster design
Year: 2006 **Client:** -

Description: The winning entry for the '2008 Poster Competition: Design Propaganda,' organised by Foreign Policy for the Singapore Design Festival. It is designed under the theme of promoting public sensitivity towards good design. Tom used visuals that actually hurt your eyes when you look at them, and added the slogan 'warning, bad design causes eye sore' in the same typo that is used for the warnings on cigarette packages.

Description: Identity and promotional material for the Antwerp based guitar-powered electropop band Bobby's Evil.

Bobby's evil

tryout concert in de **muziekdoos**
Verschansingsstraat 63, Antwerpen
vrijdag 12 september om 19.00u.

Bobby's evil

tryout concert in de **muziekdoos**
Verschansingsstraat 63, Antwerpen
vrijdag 12 september om 19.00u.

Bobby's evil

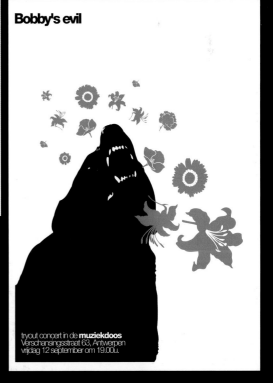

tryout concert in de **muziekdoos**
Verschansingsstraat 63, Antwerpen
vrijdag 12 september om 19.00u.

1/ Title: The Philosophy of Mike Tyson **Type:** Contribution **Year:** 2006 **Client:** -

Description: A submission for a graphic project 'the philosophy of Mike Tyson.'

2/ Title: De Fish Contributions **Type:** Graphic design contribution **Year:** 2007 **Client:** De Fish magazine, Domensino Media

Description: Antwerp street art magazine, De Fish invited Tom to create some art for issues 7 and 8, themed 'beautifull freakshow' and 'space' respectively.

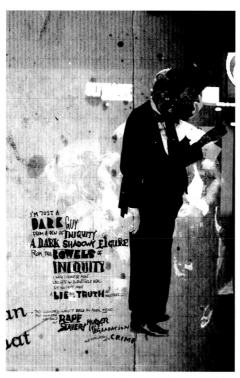

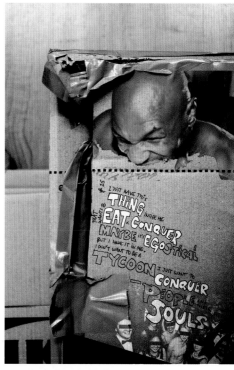

1/

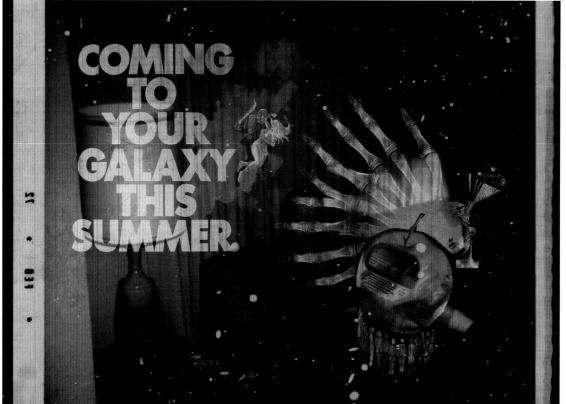

2/

Title: MIDI Posters **Type:** Poster design
Year: 2006 **Client:** MIDI convention (Kuala Lumpur, Malaysia)

Description: Flink was asked to create a series of posters for the upcoming MIDI convention in KL. Tom used all the furniture in the studio to make a composition for each room, and added the name and designer of each piece of furniture, to create posters that are not only informative but also visually pleasing.

Title: The Opposite House **Type:** Visual identity **Year:** 2008 **Client:** Swire Hotels

Description: The Opposite House is the signature hotel anchored within Swire Properties' latest development in Beijing: The Village at Sanlintun.

Designed by world-famous Japanese architect Kengo Kuma, the hotel is a little gem of green and lime glass, understated yet uncommonly unique. With less than 100 rooms, it is truly an exclusive destination at the heart of Beijing.

The identity is intimate yet playful, a true reflection of the spirit within the hotel.

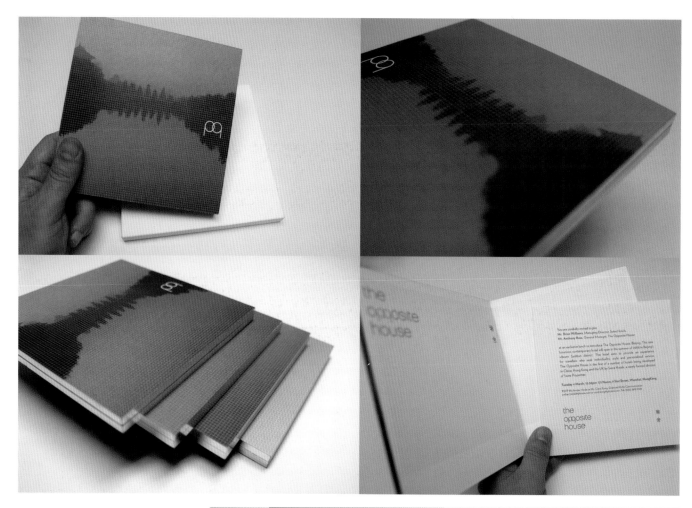

the
opposite
house

Title: Café Causette **Type:** Visual identity
Year: 2007 **Client:** Mandarin Oriental
(Hong Kong)

Description: Café Causette is truly an urban café and one of the most popular all-day meeting places in Hong Kong. The name has been reverted from 'Mandarin Oriental Coffee Shop' to its original name in the 60s with an entirely new, contemporary and vibrant interior feel.

Placed on the small yet detailed graphical lines on the distinctive chartreuse covers of the menus, the word 'causette,' means 'chat' in French, has stimulated the literary journey incorporateing poems in English, French and Chinese. One finds a play of ellipses, quotation marks and dialogue bubbles that are typographic echoes of the chatting in the room.

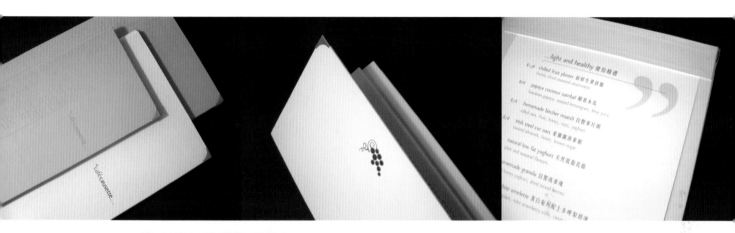

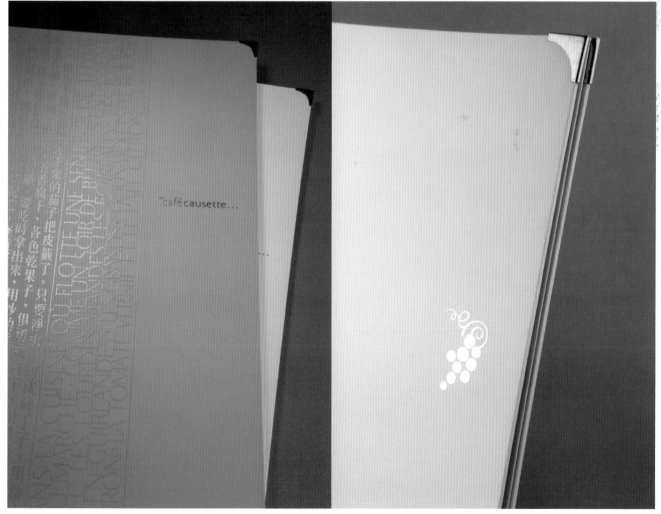

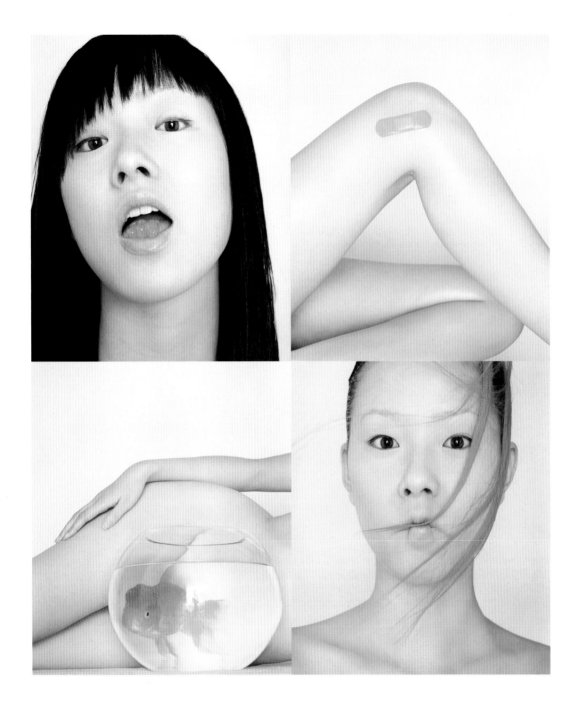

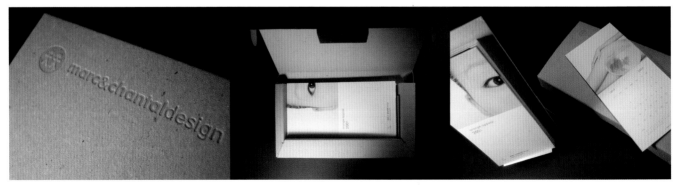

Title: Marc & Chantal Design, New Year gifts
Type: Promotional items **Year:** 2005-07
Client: Marc & Chantal Design

Description: Throughout the years, it has become a tradition to create limited edition New Year gifts for Marc & Chantal Design's clients, collaborators and friends. After the first 10 years, the studio has started a new series – gifts being created in collaboration with other artists or designers. Here is a selection for 2005 and 2007 items:

1/ A playfully sexy calendar in association with fashion photographer Jean-Louis Wolf.

2/ A flip book to animate your Chinese horoscope and a screen saver done in association with Pilot Software.

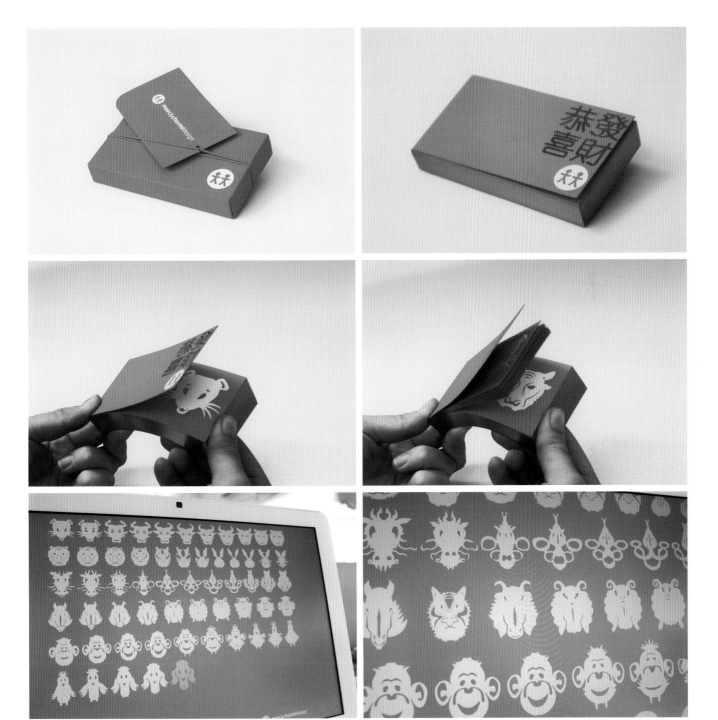

2/

警隊圖書館
Force Library

演講廳
Auditorium

多用途禮堂
Multi-purposes Hall

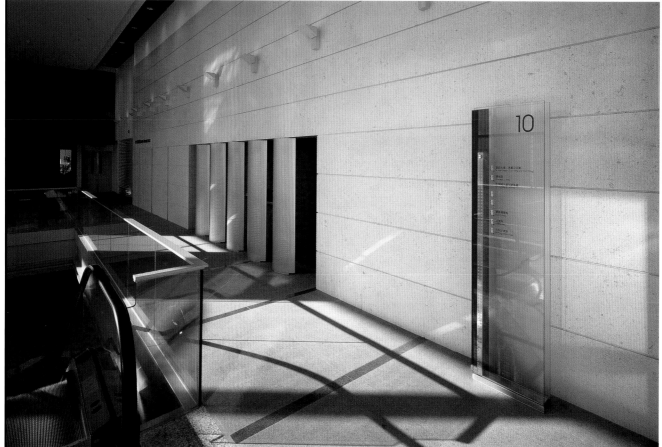

1/

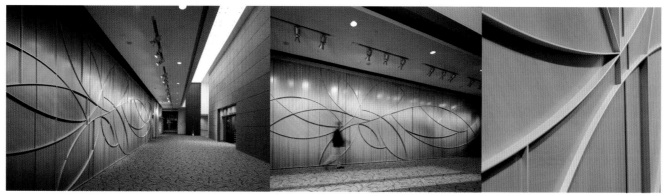

2/

Title: 1/ Hong Kong Police Headquarters – Signage 2/ Hong Kong Police Headquarters – Auditorium Feature Wall **Type:** Environmental design **Year:** 2005 **Client:** Hong Kong Architectural Services Department

Description: 1/ Articulated around the sleek and modern architecture of the premises, the signage system uses an original combination of layered glass panels, stainless steel fixtures and silk-screened graphics to deliver the information effectively and aesthetically.

The abstract bamboo pattern is used as a visual theme throughout the building.

2/ This 20 meter-long feature wall was designed to enhance the long corridor that leads to the 300-seat auditorium located on level 8 of the complex. Loosely based on the design of bauhinia – the Hong Kong's official emblem – the design is executed in fine pear wood panels, set at varying depth and outlined by extruded metal strips creating the effect of a giant 'cloisonné.'

3/ Title: Travel & Travelers **Type:** Exhibition design **Year:** 2007 **Client:** Louis Vuitton

Description: For the design of this exhibition, Marc & Chantal Design was inspired by the idea of times colliding: old and new bonded together by the fabric of the Vuitton brand. They wanted to confront a layer of nostalgia with today's hard-edge radical design that can be seen in the facade of Vuitton's shops all around the world. Dreamy black and white pictures were digitally printed on the aluminium surface of the fins, giving a dynamic change to the whole structure as the visitors walk around it. The checkerboard pattern was their golden number, giving them the proportion and organisation of the structure. Inside, the antique trunks and bags illustrate 150 years of Louis Vuitton's history.

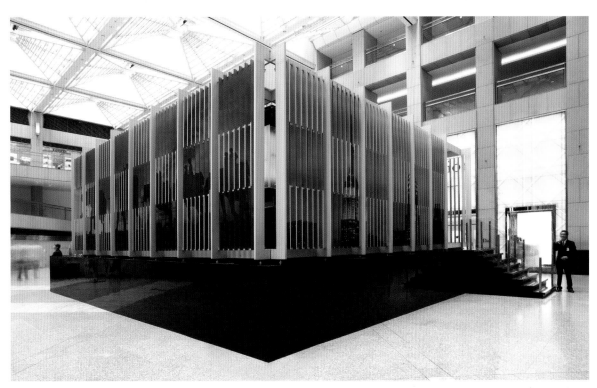

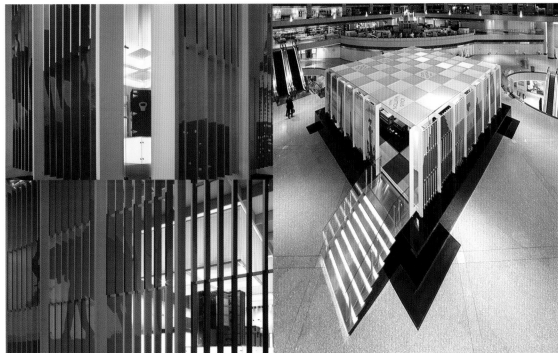

3/

Title: Crystal Passion **Type:** Advertising
Year: 2005 **Client:** Swarovski
Photographer: Luc Carson **Model:** Dawning

Description: A slightly elaborate production for a unique shoot. It marked the first time for Swarovski to allow such type of visuals to be produced outside Europe.

For the occasion, Marc & Chantal Design crafted a sparkling wig out of Swarovski crystals... and graphically enhanced the effect. Besides print ads, the visual was used as a giant 3-dimensional banner in Time Square's atrium, above the exhibition they designed and set up for the event.

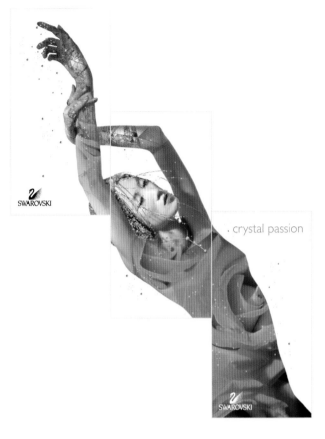

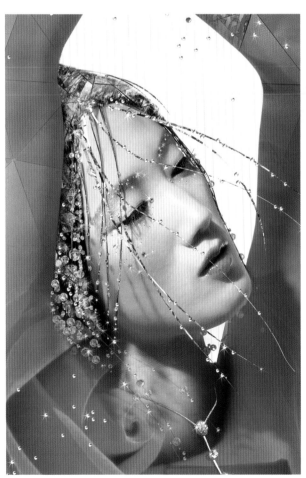

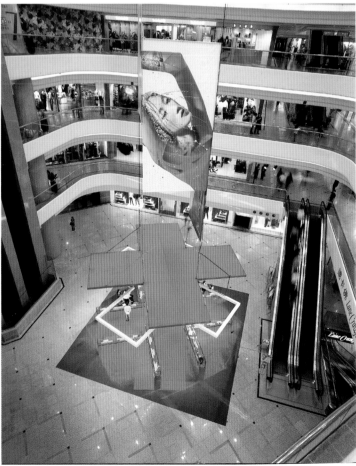

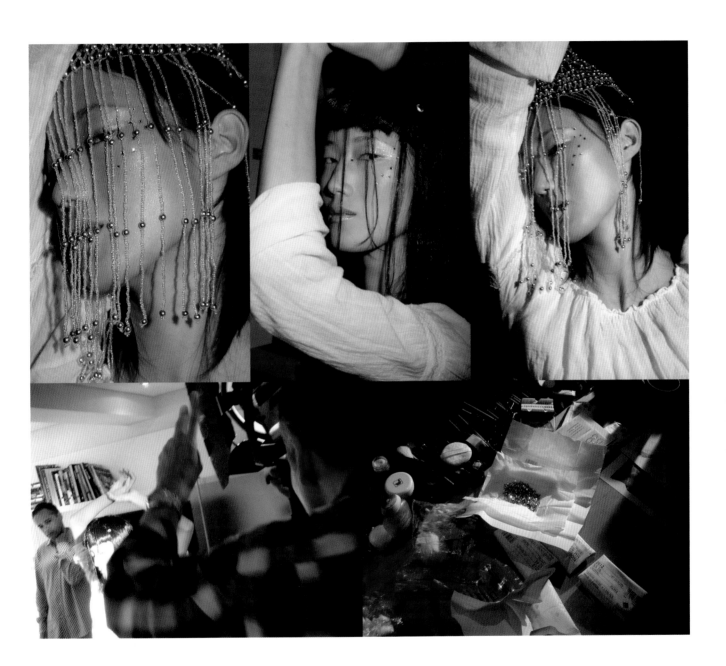

/
BAI.S WORKSHOP

/
SHENZHEN, CHINA

Title: Roadtext **Type:** Identity **Year:** 2006
Client: Roadtext translate

Description: Roadtext travels freely like
a musical stave, symbolising its ability to
translate different languages.

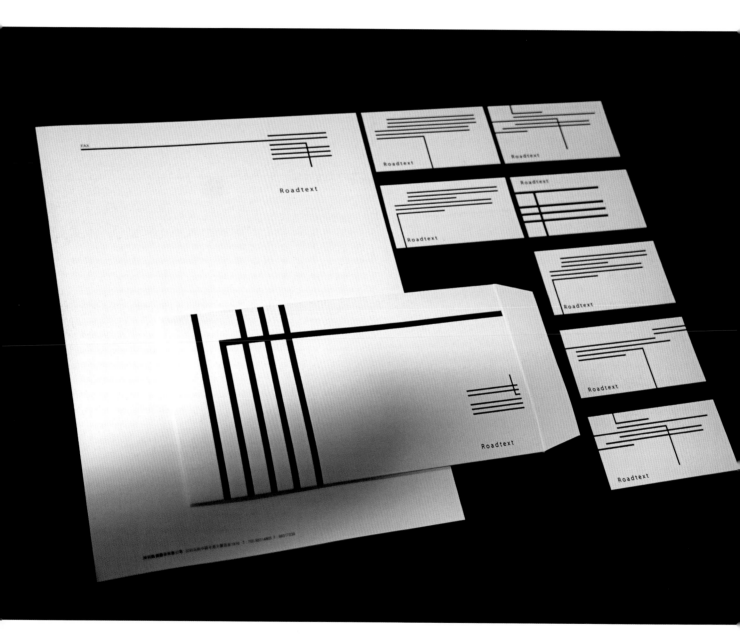

1/ Title: wbread **Type:** Logo **Year:** 2006
Client: wbread

Description: The visual indentity for w-bread shop.

2/ Title: Pure **Type:** Logo **Year:** 2006
Client: Pure

Description: Pure is a public-relation agency. They arrange all kinds of events that stimulate people's emotions: amusement, sadness, agony and ecstasy.

1/

2/

Title: Mahjong Book **Type:** Booklet
Year: 2007 **Client:** Isoul design workshop
Description: Creativity is the key to success
and prestige. The book is a brew of truly
Chinese elements.

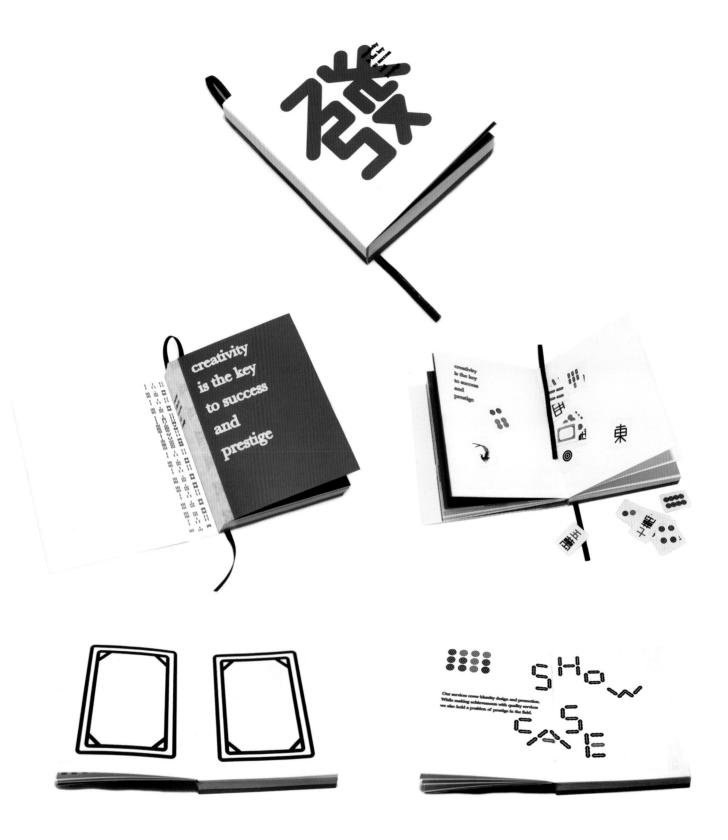

Description: Music party poster.

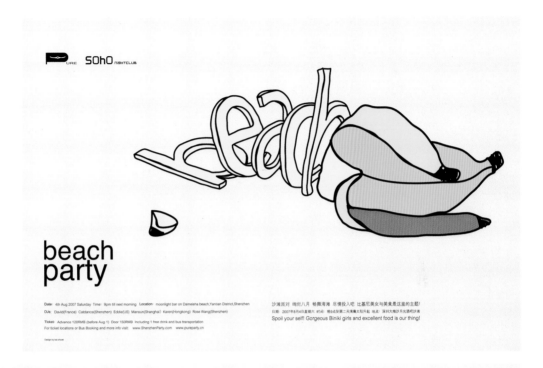

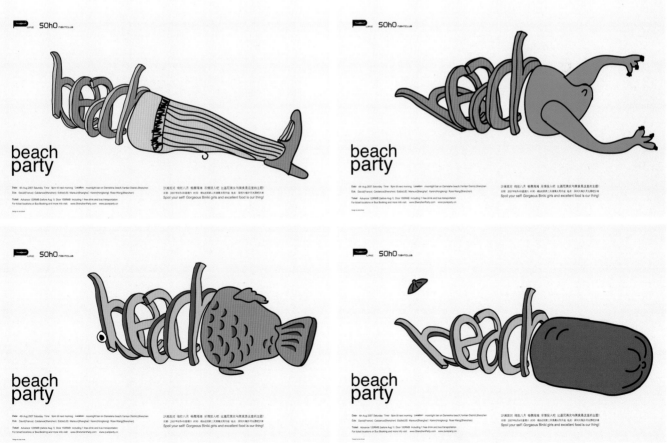

1/ Title: Gather **Type:** Poster **Year:** 2006
Client: Gather Club

Description: Every week, Gather Club invites
people from different areas to their forums
on varied topics. The poster emphasises the
interesting crash among different groups and
individuals.

2/ Title: Horo Here **Type:** Poster **Year:** 2005
Client: Soundfilter

Description: Music party poster.

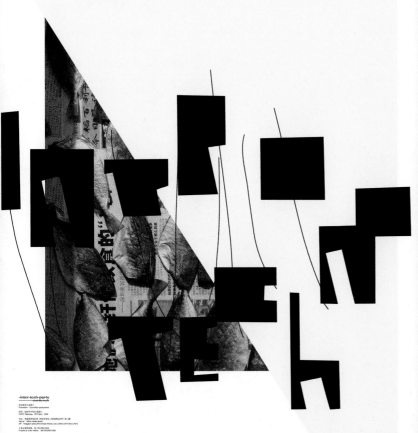

音楽には、翼がある。

DO MUSIC!

AIR DO

MUSIC SUPPORT CAMPAIGN

AIR DO

音楽には、翼がある。

AIR DO×RSR AIR DO×SS05
コラボTシャツなど、もれなく当たる!!
GET the MUSIC! PRESENT
ACCESS NOW!! → airdo21.com

今年の夏は特別設定 DOバリュー21
8/1～31
東京―札幌［1日8往復］片道￥19,000円
東京―旭川［1日4往復］片道￥22,000円
東京―函館［1日2往復］片道￥18,000円

AIR DO
0120-057-333 airdo21.com

Title: Hormon **Type:** Typeface, Patterns
Year: 2006-07 **Client:** Wabisabi

Description: Organic fonts with 2D pattern connoting a 3D world. Each letter is like a cell, and can be combined to construct infinite meanings. These letters are alive just as saying 'combine us, please!'

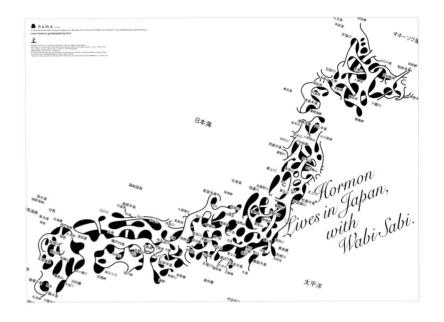

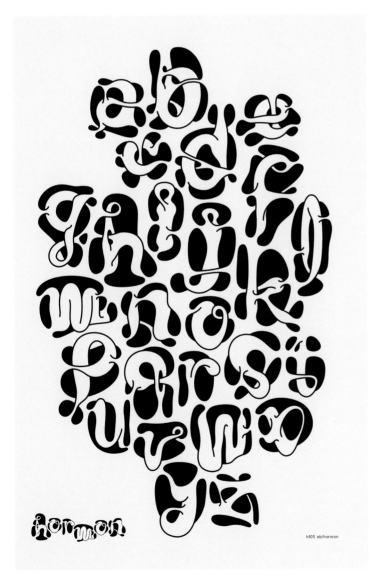

Title: 1, 2/ Aoyama Flower Market 3/ Bonsai
Banzai **Type:** Poster **Year:** 2005-07
Client: 1, 2/ Aoyama Flower Market 3/ Kaisei
Gakuen

Description: Bonsai is a motif that
Wabisabi loves.

1/

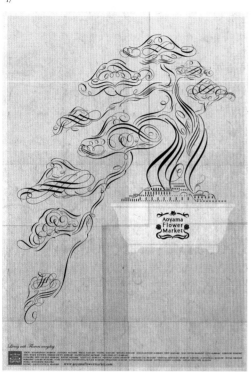

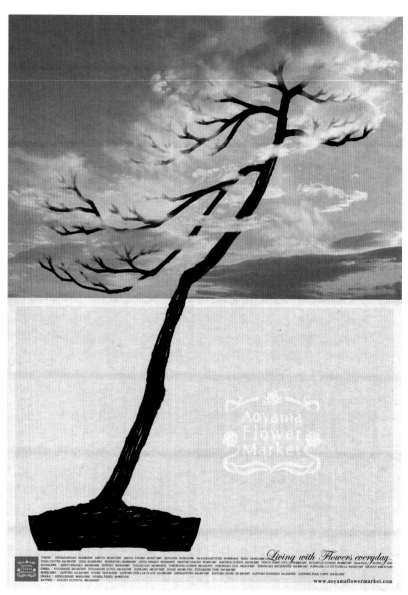

2/

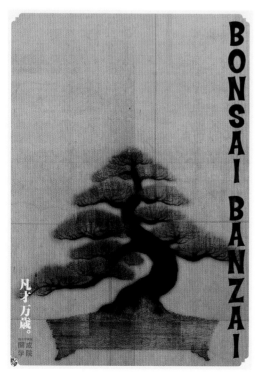

3/

Title: Crow And Trash **Type:** Playing Card
Year: 2005 **Client:** Wabisabi

Description: A set of playing cards to bring
out a social problem of crows and trash. The
highlight of the design is the photo collection
of real wild crows and trash. The cards are in
porker size but very thick, just like the Japa-
nese Hanafuda or Karuta.

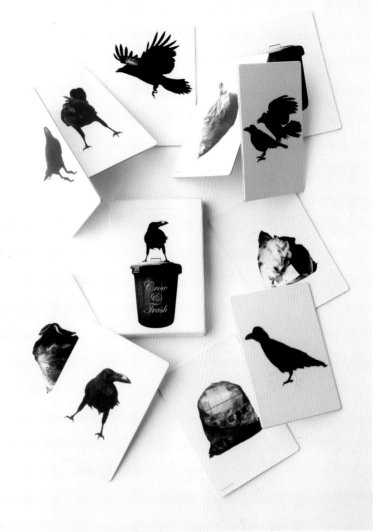

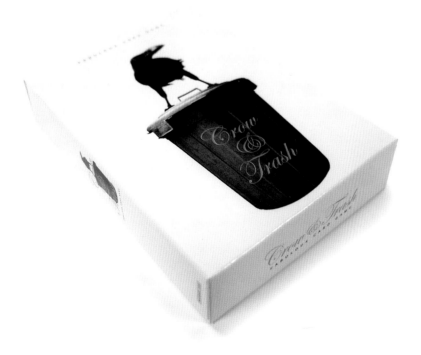

1/ Title: Bando Shuichi Cafe **Type:** Logo
Year: 2005 **Client:** Bando Shuichi Cafe

Description: Logo using three different Characters made for a coffee and cake shop.

2/ Title: home **Type:** Logo **Year:** 2000
Client: home inc.

Description: Inspired by 'h,' an initial character of the company's name, and also 'home.'

3/ Title: OLD NEW **Type:** Logo **Year:** 2005
Client: OLD NEW

Description: A restaurant logo based on the theme 'enjoy food with five senses,' Wabisabi used pentagon-shaped form symbolically.

4/ Title: Kamui **Type:** Logo **Year:** 2006
Client: JAGDA

Description: Kamui means 'Kami (God)' in Ainu, the language of indigenous people of Hokkaido, Japan. Inspired by the unique Ainu patterns, it is designed for an exhibition called 'Praise Hokkaido.'

5/ Title: S.C.C. **Type:** Logo **Year:** 2006
Client: Sapporo Copywriters Club

Description: In Japanese, 'word' means 'kotoba,' and its Kanji characters mean 'leaf of words.' Based on it, Wabisabi designed the initial characters 'S.C.C.' as leaves.

6/ Title: Soul Of Asia **Type:** Logo **Year:** 2007
Client: Hokkaido Museum Of Modern Art

Description: Logotype for an exhibition which introduced the contemporary art of Asia. Wabisabi tried to combine the alphabet letters with Asian culture.

7/ Title: JUJU **Type:** Logo **Year:** 2007
Client: Izakaya Restaurant JUJU

Description: JUJU stands for Juzu (Buddhist prayer beads), and the pub believes in 'connection.' Wabisabi hence linked up the letters which eventually looks like decorative patterns.

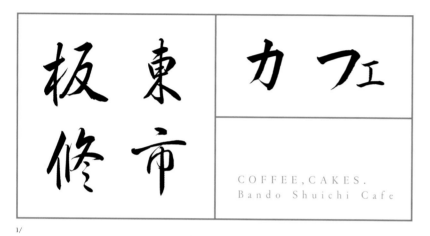

1/

2/

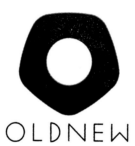

3/

4/

5/

6/

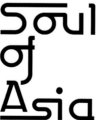

7/

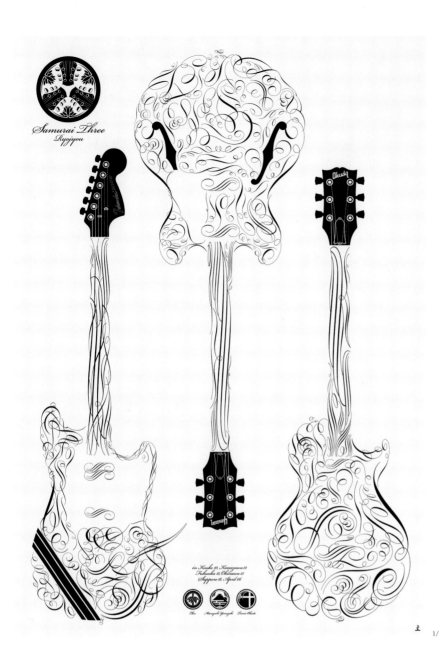

Description: A poster for a concert. The guitars depict three musical instruments that are used by the performers.

2/ **Title:** Love The Guitars **Type:** Poster
Year: 2007 **Client:** cibone

Description: Poster with vintage guitar drawn in original proportion.

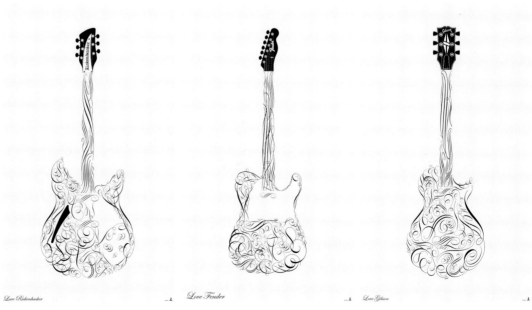

1/ Title: We Have Luv And Peace **Type:** Poster
Year: 2004 **Client:** JAGDA

Description: Poster made for an exhibition under an anti-war theme.

2/ Title: Sapporo Art Directors Club Awards
Type: Trophy **Year:** 2006 **Client:** Sapporo Art Directors Club

Description: It is a winning trophy of Sapporo Art Directors Club Awards. The three towers were drawn with imagination. Each prize is symbolised.

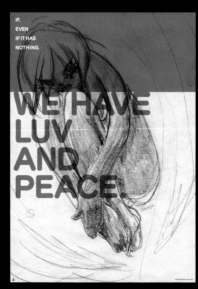
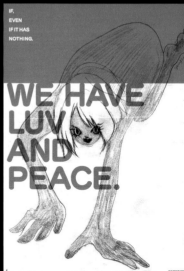

1/

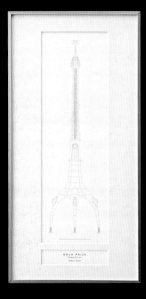

2/

Description: Inspired by the lyrics, the illustration was drawn with a pen depicting an old picture book.

2/ Title: Dubon Lounge **Type:** Poster
Year: 2005 **Client:** Homemade Record

Description: A poster for a lounge event. Inspired by the motif of a famous painting, can you see a Bonsai here?

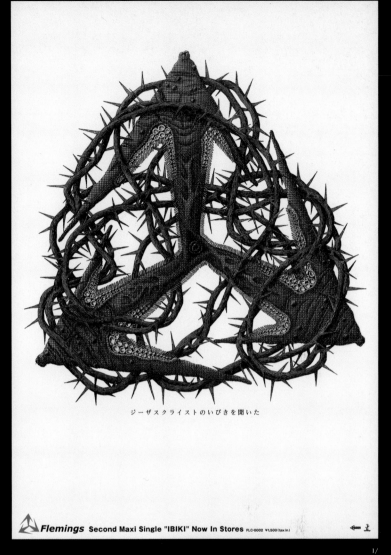

ジーザスクライストのいびきを聞いた

Flemings Second Maxi Single "IBIKI" Now In Stores FLC-0002 ¥1,500 (tax in.)

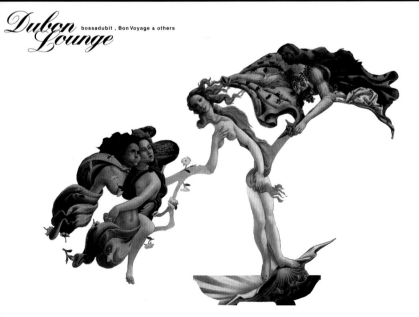

Dubon Lounge bossadubit , Bon Voyage & others

BLESS' 32nd Collection **Type:** Editorial
Year: 2007 **Client:** byul.org, BLESS

Description: Published by club bidanbaem;
edited, designed, written and recorded by
byul.org., the 6th issue is a collaboration be-
tween byul.org and BLESS. Published irregular-
ily, it is a special edition of magazine with an
audio compact disc.

구상우 / 등원탄좌 사북갱입구, 강원 정선군 사북읍
Icon, sungwoo / coal mine, sabook, jeongsungun, kangwondo

구상우 / 등원탄좌 사북갱입구, 강원 정선군 사북읍
Icon, sungwoo / coal mine, sabook, jeongsungun, kangwondo

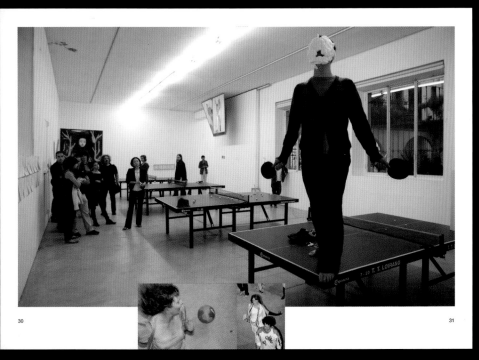

Mode, College of Fine Art[Muit], 2006
c-print, 180x220cm
ⓒ Kim Sangjil

Mode, College of Economics & Commerce, 2006
c-print, 180x220cm
ⓒ Kim Sangjil

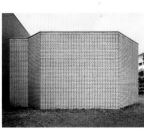

1 - 2/ Title: Atelier Hermès - Donghee Koo Exhibition **Type:** Promotional graphics (Advertisement, Poster, Invitation, Press kit, Wall graphics) **Year:** 2008 **Client:** Hermès Korea

Description: byul.org has been designing for Atelier Hermès since the opening of Maison Hermes Dosan Park. The team finds Hermès Korea one of the best clients they have ever met in many aspects.

3/ Title: 50th Venice Biennale Korean Pavilion **Type:** Promotional graphics (Poster, Advertisements, Invitation, Catalogue, Press kit, Wall graphics) **Year:** 2003 **Client:** The Korean Culture & Arts Foundation

Description: Year 2003 was one of the hottest summers in Europe's history. The unusual hot weather made byul.org almost regret to have accepted this job, which made them carried all

their synthesisers and guitars, and travelled all the way to Venice playing music for the Korean Pavilion's opening ceremony. But once they saw Yoko Ono there, they found it good enough to compensate all the sufferings.

1/

2/

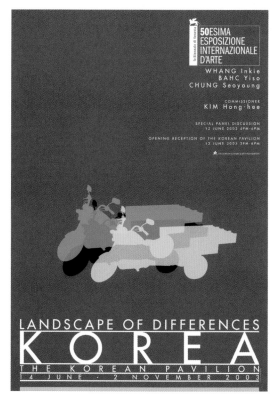

3/

Title: ABSOLUT Vodka Art Promotion - Party Your Flavour **Type:** Graphics for all promotional materials (Motion graphics (VJing), Invitation, Cups, Press kit, Inetrior / Exterior graphics) **Year:** 2007 **Client:** ABSOLUT Vodka (Korea)

Description: byul.org was very excited to have the chance to work with ABSOLUT. However the final work did not turn out well because of some mis-communication with the client. Nevertheless, the after party was real fun and the team is desperately waiting for another chance to work with ABSOLUT.

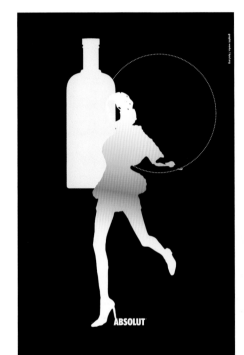

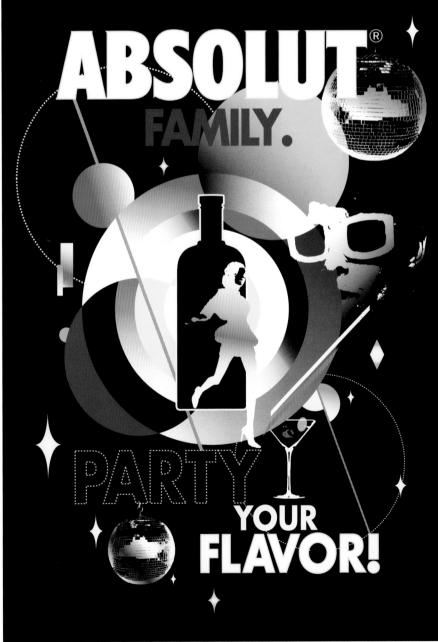

Title: New Balance By Jain Song - Creative Direction For Brand Launching **Type:** Concept, Logo design, Directing collections **Year:** 2007 **Client:** New Balance (Korea)

Description: byul.org has been collaborating with fashion designer, Jain Song, also the team's best friend, for her collections since 2006. The team found it very cool to have the chance working on the New Balance logo since they have been huge fans of the brand since they were kids.

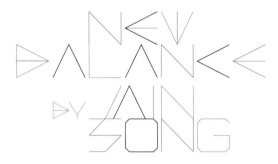

new balance by jain song

new balance

new balance by jain song
www.nbkorea.com/jainsong
-
new balance korea.
-
e.land world b/d 8f. 371-12,
gasandong guemcheongu seoul korea
telephone +82 2 2254 4600
-
new balance by jain song book n.00 / 2008 spring & summer collection

art direction by jain song with byul.org / photography by kim hyunsung / photography & graphic works by byul.org
printed in seoul, republic of korea

photographs copyright ©2007 by new balance. / all rights reserved.

no part of this printed material may be reproduced in any form or by any electronic or mechanical means, including information storage and retrieval systems,
without written permission from new balance korea, except in the case of brief quotations embodied in critical articles and reviews.

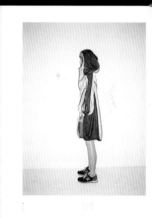

bike

IDN

HONG KONG, CHINA

Title: IdN (International designers Network)
Type: Magazine (Bimonthly) **Year:** 1992-ongoing **Client:** IdN (International designers Network)

Description: Essentially a graphic design magazine, it features artists and designers from a wide range of the design discipline. It is now available in 2 languages and 4 editions distributed around the world. Each issue introduces one main theme / topic as well as a staple of regular columns ranging from graphic design, fashion, photography, music, motion pictures, featured cities, and other popular culture. Editorial and design by IdN.

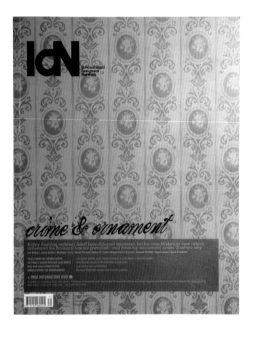

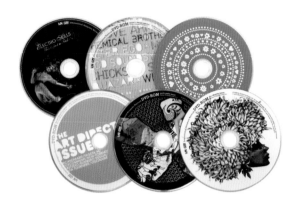

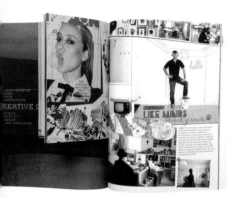
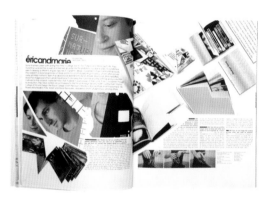
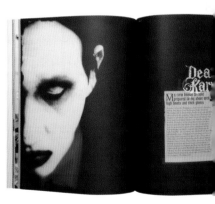

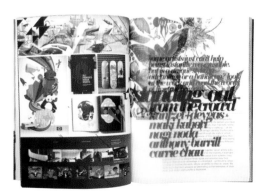
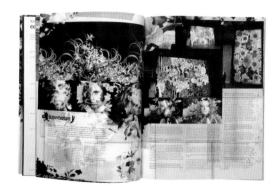

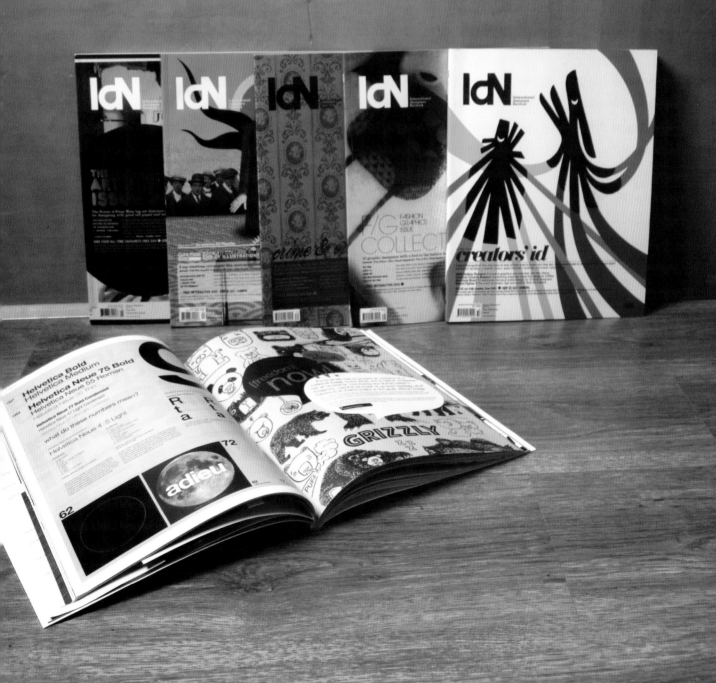

Title: A Nice Set **Type:** Publication, Exhibition at the IdNPRO shop and gallery **Year:** 2007 **Client:** -

Description: Published by IdN and conceptualized by Jeremy Hollister of Plus et Plus and Jeff Staple of The Reed Space, A Nice Set invites a precise portion of 33 and 1/3 artists to customise a pair of blank turntable slip-mats. The dimension of the canvas was the only constraints. (The figure 33 and 1/3 represents the standard, Revolutions Per Minute of a record turntable; the 1/3 of an artist refers to a 10-year-old artist, Maceo Villareal, who has not yet grown to full artistic maturity obviously).

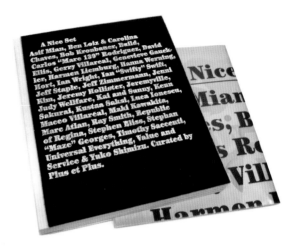

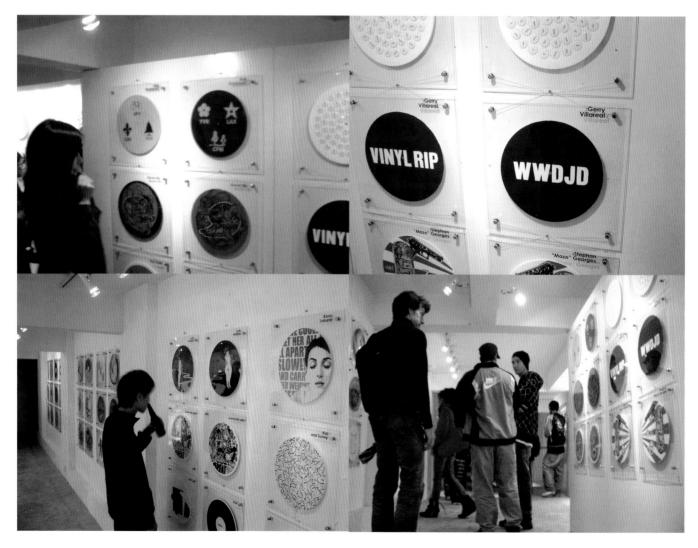

Title: 450 SQ.FT. **Type:** Exhibition at the IdN Gallery **Year:** 2007 **Client:** Hermès (Korea)

Description: Established in 2003, IdN gallery continues to host exhibitions and events to support local talents as well as overseas designers. 450SQ.FT is a group exhibition by the ST/ART street art collective which aims to draw the attention to the growing space VS price issue in Hong Kong. The exhibition comprised of 450 separate canvases painted by the ST/ART core team and many other local artists. At the end of the exhibition, the canvases were auctioned off and proceeds were donated to local HK charities who are dedicated to helping the homeless.

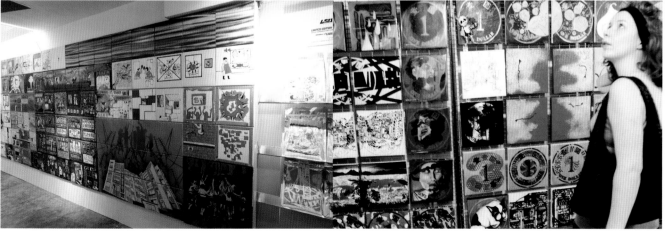

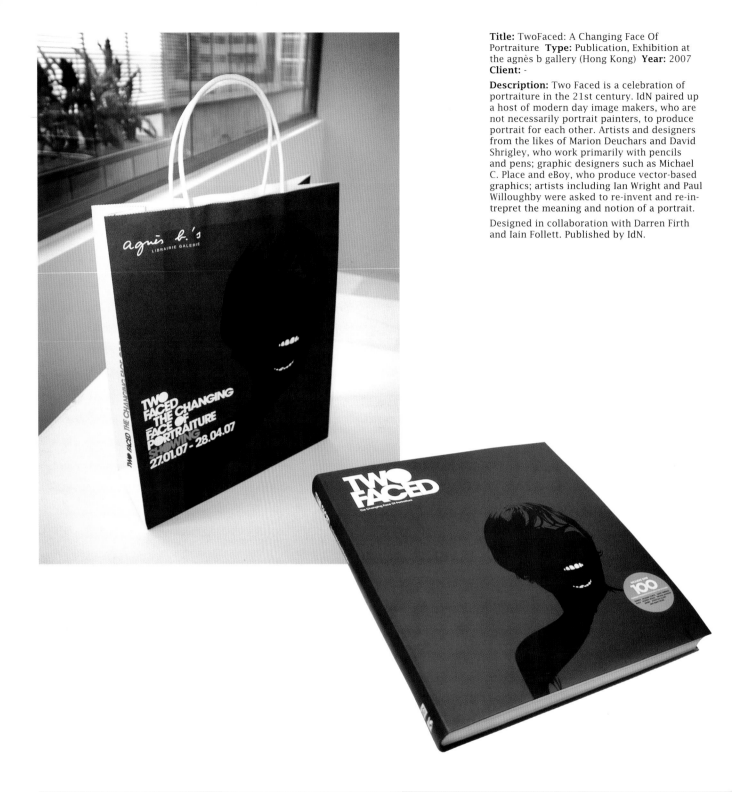

Title: TwoFaced: A Changing Face Of Portraiture **Type:** Publication, Exhibition at the agnès b gallery (Hong Kong) **Year:** 2007 **Client:** -

Description: Two Faced is a celebration of portraiture in the 21st century. IdN paired up a host of modern day image makers, who are not necessarily portrait painters, to produce portrait for each other. Artists and designers from the likes of Marion Deuchars and David Shrigley, who work primarily with pencils and pens; graphic designers such as Michael C. Place and eBoy, who produce vector-based graphics; artists including Ian Wright and Paul Willoughby were asked to re-invent and re-intrepret the meaning and notion of a portrait.

Designed in collaboration with Darren Firth and Iain Follett. Published by IdN.

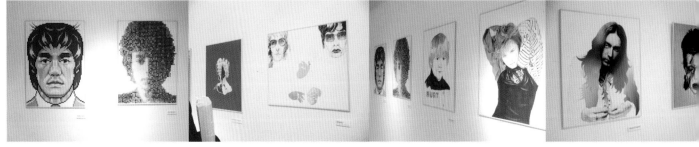

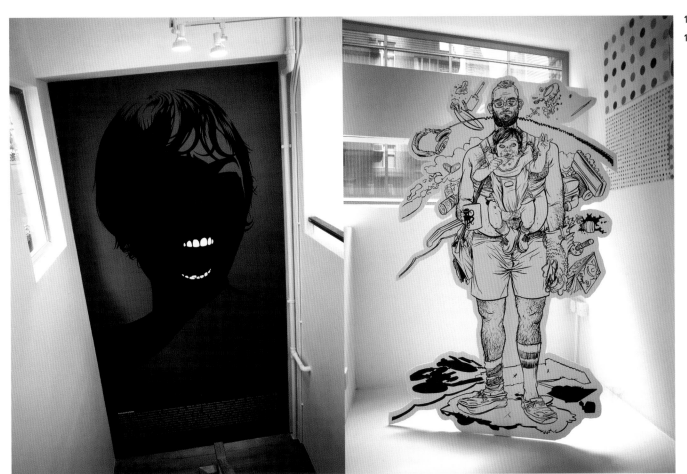

/
RESONANCE DESIGN
GROUP

/
BEIJING, CHINA

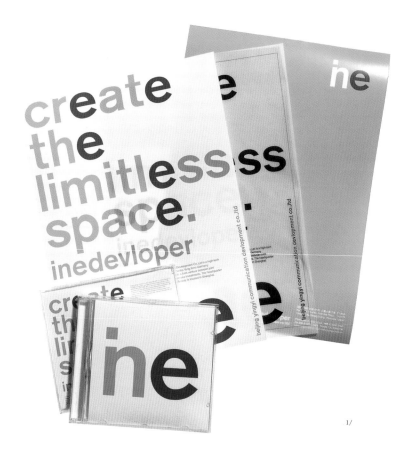

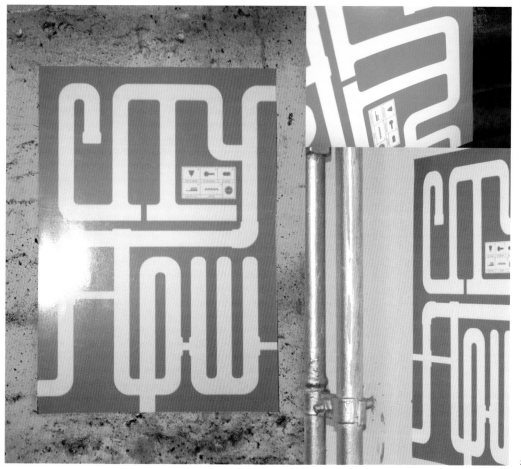

1/ Title: Yingyi Devloper **Type:** Brand identity
Year: 2005-06 **Client:** Beijing Yingyi Commu-
nication Devloper Co., Ltd.

Description: Brand identity designed for
Yingyi Communication containing all elements
ranging from the log, to a series of posters
and a design standard manual.

2/ Title: City Flow **Type:** Poster **Year:** 2005
Client: Beijing City Art Space

Description: Poster design for 'Century'
exhibition.

3/ Title: 05 Juince **Type:** Package **Year:** 2006
Client: 05 Juince

Description: Packaging design for 05 Juince.

4/ Title: GongHui **Type:** Poster **Year:** 2006
Client: GongHui

Description: Poster design for GongHui.

4/

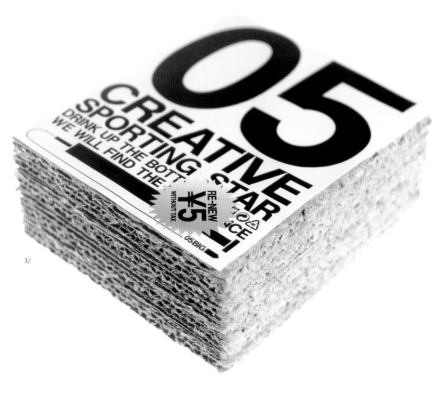

3/

Title: ZhengYuanXingChuan **Type:** Brand identity **Year:** 2005 **Client:** ZhengYuanXing-Chuan

Description: Brand identity designed for ZhengYuanXingChuan containing all elements ranging from the log, to a series of posters and a design standard manual.

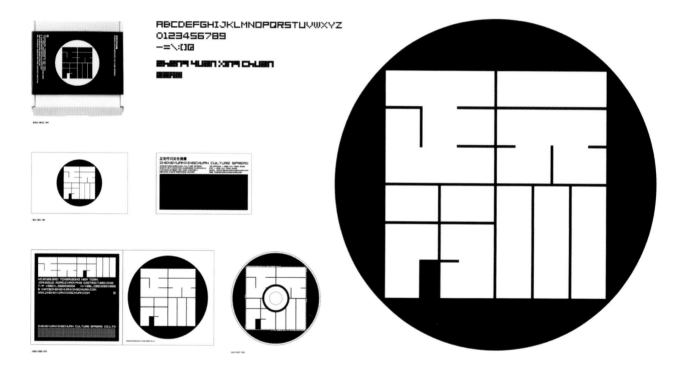

1/ Title: JCW **Type:** Brand identity
Year: 2003 **Client:** Beijing JCW Tech
& Trade Co., Ltd.
Description: Brand identity designed for
Beijing JCW Tech & Trade Co., Ltd. containing
all elements ranging from the log, to a series
of posters and a design standard manual.

2/ Title: GuanTeng Law Offices **Type:** Logo
Year: 2008 **Client:** GuanTeng Law Offices
Description: Logo design for GuanTeng Law
Offices.

杰希威（北京）科贸有限公司
JCW (BEIJING) TECH & TRADE CO.,LTD.

杰希威（北京）科贸有限公司
JCW (BEIJING) TECH & TRADE CO.,LTD.

杨　津文　Jinwen Yang
董事长 总经理　General Manager

杰希威（北京）科贸有限公司
JCW (BEIJING) TECH & TRADE CO.,LTD.

地址：北京海淀区紫竹院豪柏国际公寓 A1-1105
邮编：100044
邮件：yjw3305@263.net
电话：86 10 8842 0900
传真：86 10 8842 0901
手机：86 139 0135 1865

1/

GuanTeng Law Offices
冠腾律师事务所

GuanTeng Law Offices
冠腾律师事务所

主任律师　　　　　　　　Director Director
顾 兆坤　　　　　　　　　Zhaokun Gu
北京市东城区 朝阳门内大街 298 号朝内 298 大厦 622 室　100010
Room 622,Chaonei 298 Build,No.298 Chaoyangmennei Road
Dongcheng District,Beijing　100010
T：+86 10 5812 1018　　M：134 3996 8678
F：+86 10 5812 1022　　E：gulvshi@hotmail.com

2/

Title: Qi Hanyong Exhibition **Type:** Logo
Year: 2006 **Client:** Qi Hanyong
Description: Identity design for Qi Hanyong
Exhibition.

Qi Hanyong Exhibition

Beginning

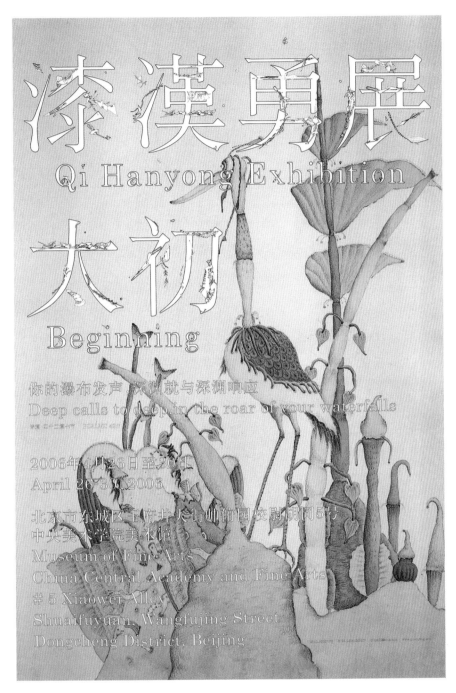

D.I.T.
LIBRARY
MOUNTJOY SQ.

Title: Resonance Design **Type:** Book, Editorial
Year: 2006 **Client:** Resonance
Description: Book design for Resonance.

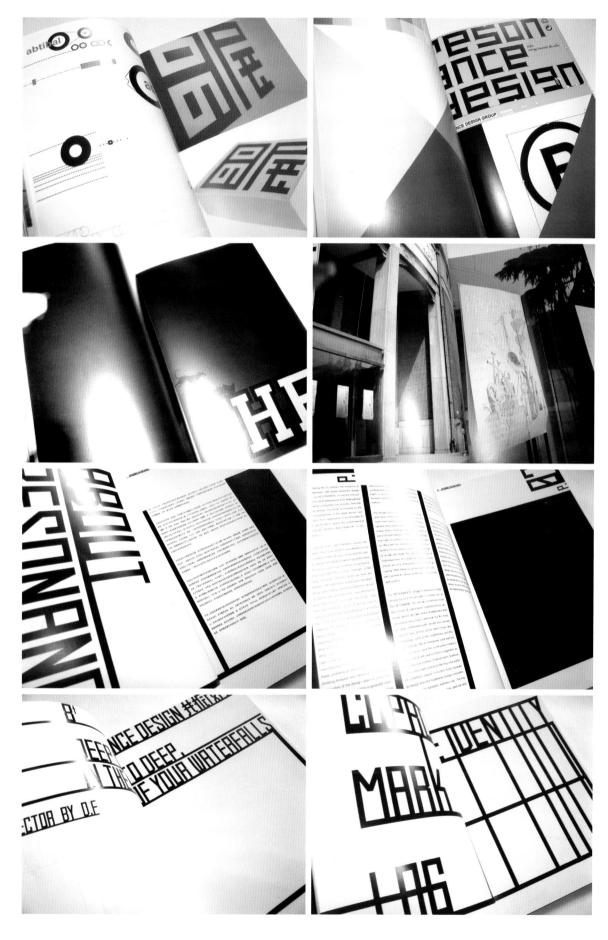

NAKAJIMA DESIGN LTD.

TOKYO, JAPAN

1/ Title: Argentine Hag Banana Yoshimoto
Type: Novel book design **Year:** 2002 **Client:** -
Description: A bilingual book in English and Japanese.
Writer.Banana Yoshimoto
Aritist: Yoshitomo Nara
Editor: Ken Sato
Translator: Fumiya Sawa
Publisher: rockin'on

2/ Title: Portrait Session **Type:** Art book design **Year:** 2007 **Client:** -
Description: A book made of papers with special effects.
Creative Director: Tatsumi Sato
Editor: Miwa Suzuki
Aritists: Various Artists
Publisher: Daiwa Press

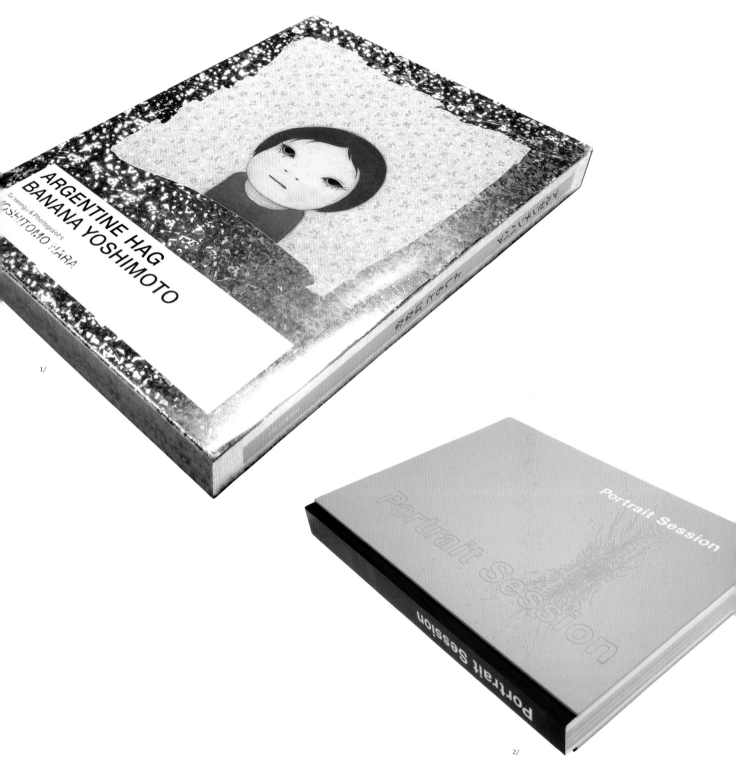

1/

2/

1/ Title: 04 Ryuichi Sakamoto **Type:** CD design **Year:** 2004 **Client:** Warner Music Japan

Description: The pictures used were taken by Ryuichi Sakamoto. The blurry and unique visual effects were attained by pure accident.
Artist: Ryuichi Sakamoto
Creative Director: Norika Sora (sky)

2/ Title: Heaven **Type:** CD design **Year:** 2005 **Client:** avex entertainment **Photographer:** Ryu Tamagawa

Description: The three cubes represent the three members of the group.
Artist: Tourbillon

3/ Title: Phut Cr@ckle Tokyo [K] **Type:** CD design **Year:** 2005 **Client:** Sublime Records

Description: They combined and knitted the photographs of the two band members.
Artist: SL@yRe & The Feminine Stool

1/

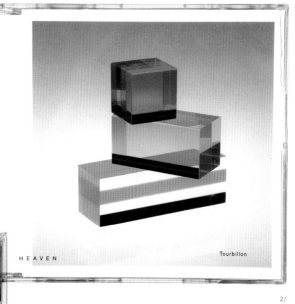

HEAVEN

Tourbillon

2/

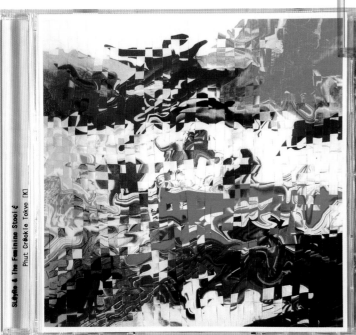

3/

Title: 1/ SHU UEMURA Cleansing Oil 'SKIN PURIFIER' 2/ SHU UEMURA eye shadow
Type: Print ad **Year:** 2006 **Client:** SHU UEMURA **Photographer:** 1/ Ryu Tamagawa 2/ Koichiro Doi

Description: Nakajima wanted to depict the products floating like a butterfly.

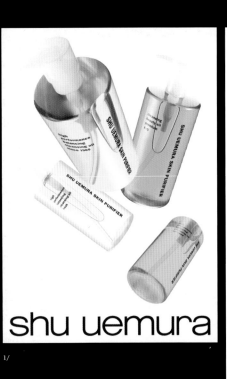

1/

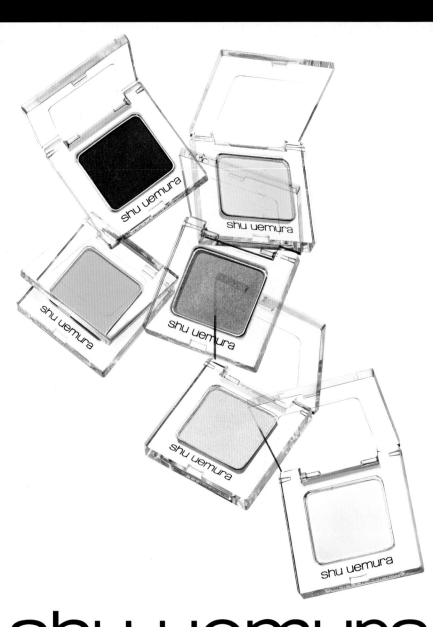

1/ Title: Playing The Piano / 05 Ryuichi Sakamoto **Type:** DVD design **Year:** 2008 **Client:** commmons **Photographer:** Mikiya Takimoto

Description: The focus was put on the piano; a minimal but rich instrument.

Creative Director: Norika Sora (sky)

2 - 3/ Title: Essay In Idleness **Type:** Book design **Year:** 2007 **Client:** TOKYO TDC BCCKS

Photographer: Hideki Nakajima

Description: A hand-made book with only 50 copies.

Writer: Kenko Yoshida

Translator: Ryo Uchida

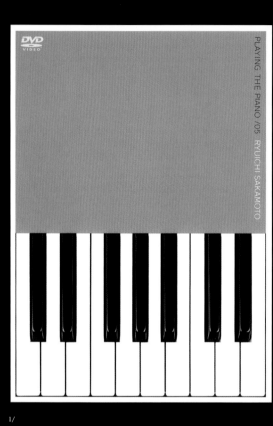

1/

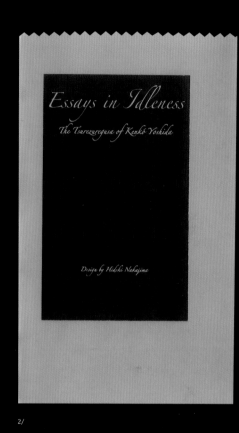

2/

1/ Title: Via Bus Stop 2003 S/S Campaign
Type: Print campaign **Year:** 2003 **Client:** BUS STOP **Photographer:** Kazunari Tajima

Description: It was about a child and an imaginary giant father.

2/ Title: Levi's NSBP Meets Creators
Type: Fashion promotion **Year:** 2004
Client: Levi Strauss Japan

Description: Graphics of Nakajima's surroundings.

Creative Director: Masatoshi Nagase

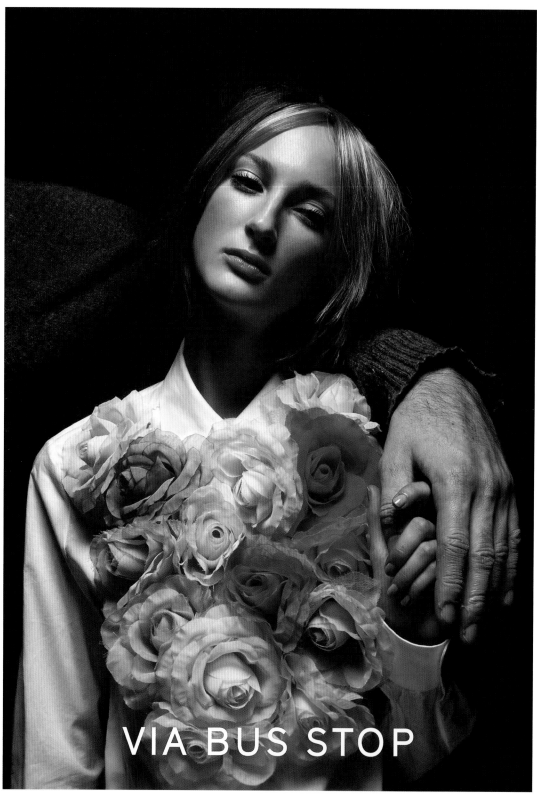

VIA BUS STOP

1/

I TRY TO BE LEFT ALONE WITH IT.

$\frac{1}{24}$

CONTENTS OF MOST BOOKS I HAVE ARE VISUAL.

$\frac{12}{24}$

I PREFER H-MONO.

$\frac{5}{24}$

LOOKS LIKE FRANKENSTEIN

$\frac{2}{24}$

I OFTEN USE SLEEPING PILLS.

$\frac{3}{24}$

I HAVE LOWER BACK PAINS.

$\frac{4}{24}$

I CAN NOT DO WITHOUT THESE.

$\frac{11}{24}$

WISH I COULD PLAY LIKE JIMI HENDRIX.

$\frac{18}{24}$

$\frac{25}{24}$

1/

1/ Title: Untitled **Year:** 1998-99 **Client:** Max Factor **Photographer:** Cheung Man Wah at JoinArt **Model:** Devon Aoki

Description: Print advert for 'Images of Max Factor by Zing' campaign.

2/ Title: Untitled **Year:** 2006 **Client:** Lane Crawford **Photographer:** Cheung Man Wah at JoinArt **Model:** Liu Dan

Description: Print advert, installation and video for Lane Crawford's 'Beauty Revealed' campaign.

3/ Title: Explosion #1 **Year:** 1998-99 **Client:** - **Photographer:** Cheung Man Wah at JoinArt **Model:** Devon Aoki

Description: Personal work.

2/

3/

1/ Title: Explosion #2 **Year:** 2007
Client: Marie Claire China **Photographer:** Paul
Tsang at UN Workshop **Model:** Shu Qi

Description: Editorial.

2/ Title: Untitled **Year:** 2007 **Client:** Lane
Crawford **Photographer:** Paul Tsang at UN
Workshop **Model:** Josie Ho

Description: Print for Lane Crawford's 'Vision
of Beauty' campaign and exhibition.

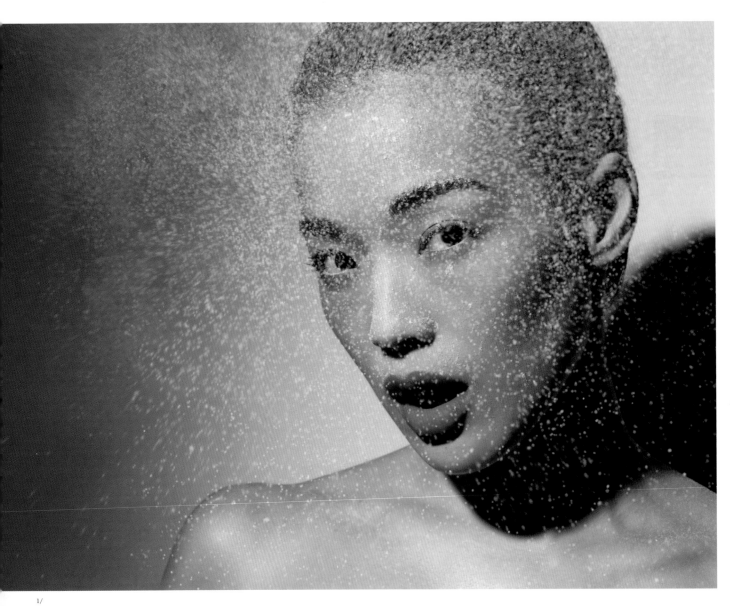

1/

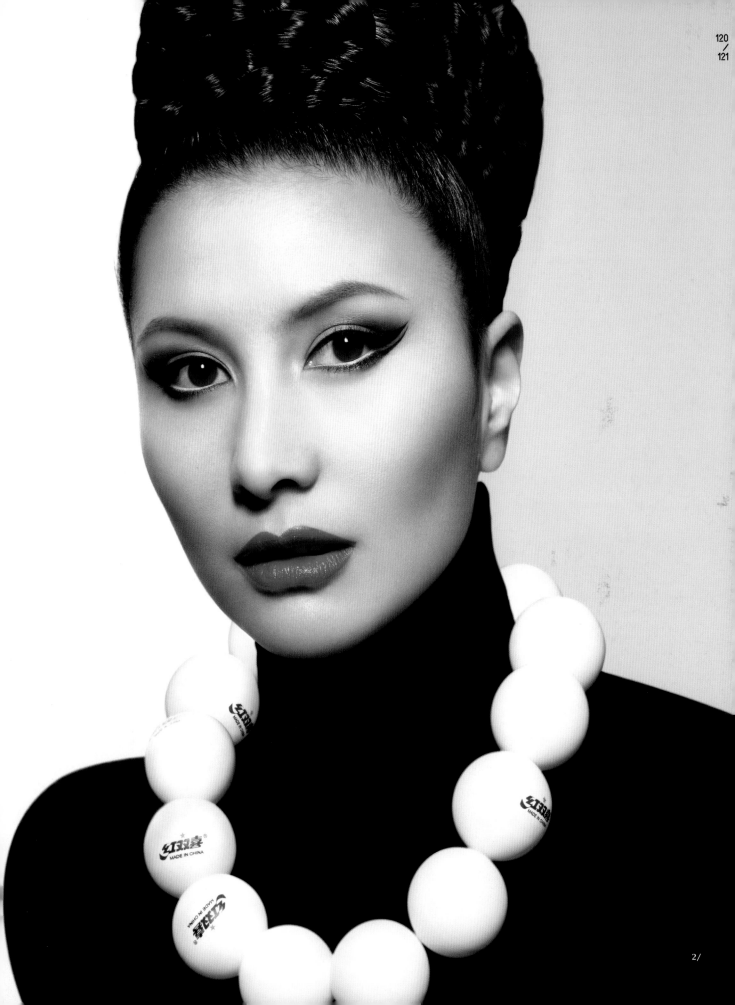

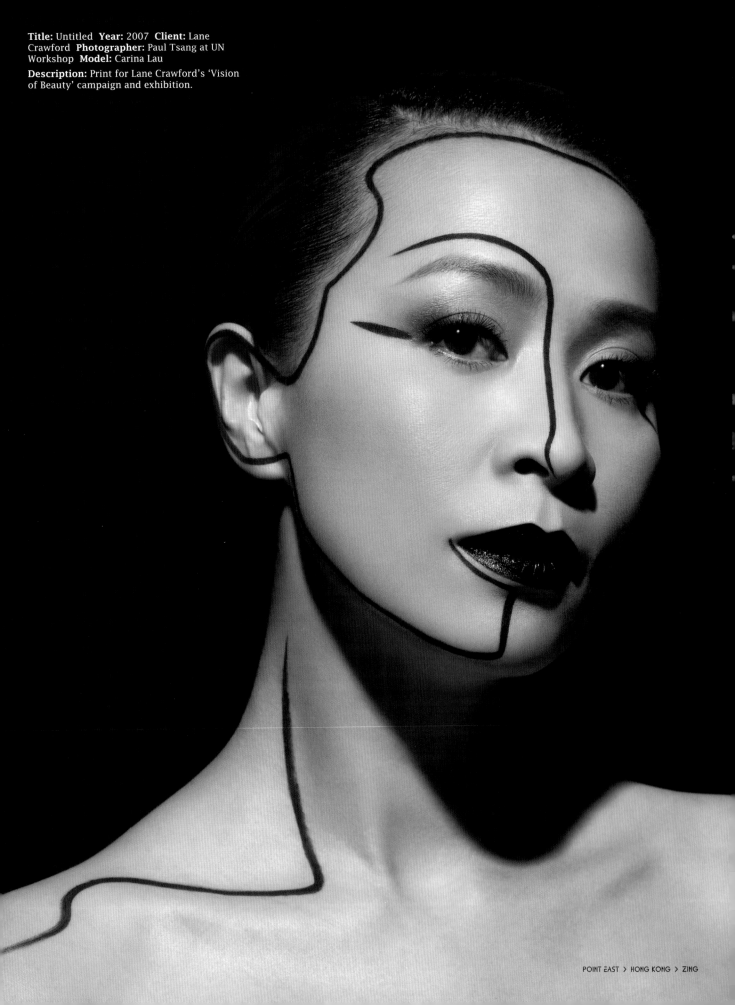

Title: Untitled **Year:** 2007 **Client:** Lane Crawford **Photographer:** Paul Tsang at UN Workshop **Model:** Carina Lau

Description: Print for Lane Crawford's 'Vision of Beauty' campaign and exhibition.

Title: Untitled **Year:** 2007 **Client:** ME Magazine **Photographer:** Paul Tsang at UN Workshop **Model:** Isabella Leung

Description: Cover and spread for ME Magazine.

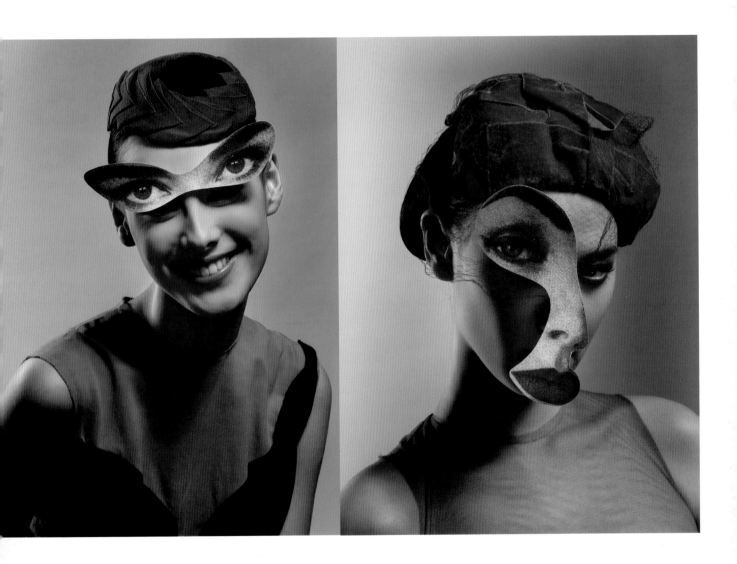

WOODS & WOODS

/ SINGAPORE

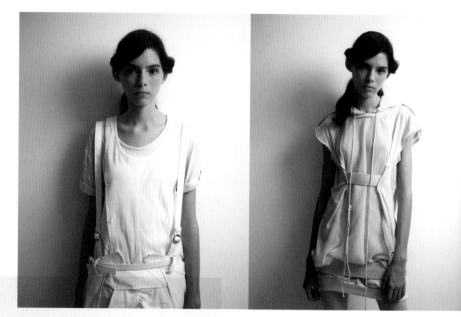

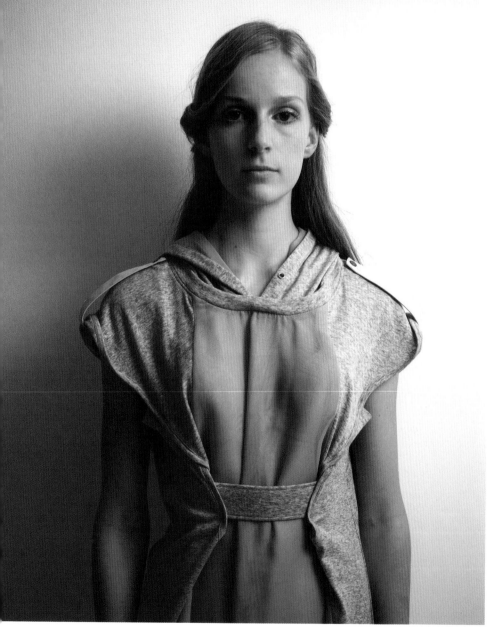

1/

1/ Title: WOODS & WOODS **Type:** Fashion
Year: 2007 **Client:** WOODS & WOODS
Photographer: Ivanho Harlim, Shysilia Novita
Hair: Bobby at The Make-Up Room
Make-up: Bobby at The Make-Up Room

Description: Art direction and styling for
WOODS & WOODS Women A/W 07-08.

2/ Title: WOODS & WOODS Women A/W 07-08
Type: Fashion **Year:** 2007 **Client:** WOODS &
WOODS **Photographer:** Ivanho Harlim
Hair: Passion **Make-up:** Bobby at The Make-Up
Room

Description: The collection was presented in
the Paris Men Fashion Week alongside its Men
A/W 07-08 collection at Musée Galliera. The

photos taken were excerpts from a fashion
presentation at WOODS & WOODS showroom
in Singapore. Models were loitering on the 2nd
floor before they entered into the presenta-
tion ground on the 3rd floor. A live-feed of
the models ascending from the 2nd to the
3rd floor was projected on the wall of the
3rd floor where audience could anticipate the
models' appearance.

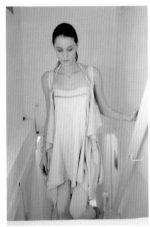

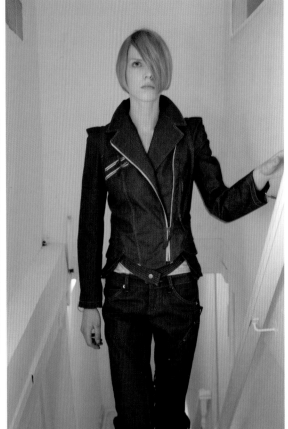

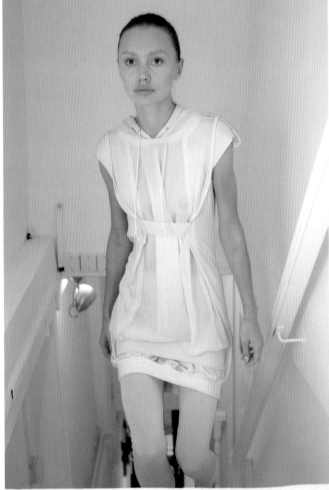

2/

1/ Title: WOODS & WOODS **Type:** Fashion
Year: 2006 **Client:** WOODS & WOODS
Photographer: Ivanho Harlim, Shysilia Novita
Hair: Ann Lim **Make-up:** Ann Lim

Description: Art direction and styling for
WOODS & WOODS A/W 06-07.

2/ Title: WOODS & WOODS Men S/S 2008
Type: Fashion **Year:** 2008 **Client:** WOODS &
WOODS **Photographer:** Ivanho Harlim

Hair: Alan Milroy & Team **Make-up:** Alan Milroy & Team **Model:** Jean Marc Masala
Show music: Xhin

Description: WOODS & WOODS Men S/S 2008
collection, titled 'ONE ON ONE,' was presented
on the official Paris Men Fashion Week on 30
June 07 at 79 Av Marceau. The collection was
inspired by a series of boxers photographs,
especially those taken by Kurt Markus during

the early 90s. The designer is inspired by his
photographic style where his photos study
more into the fighters, and the aura imbued
with the fighters, but less of the sports itself.
The collection was exhibited at Rendez-vous
HOMME in Galerie Patricia Dorfmann during
the fashion week.

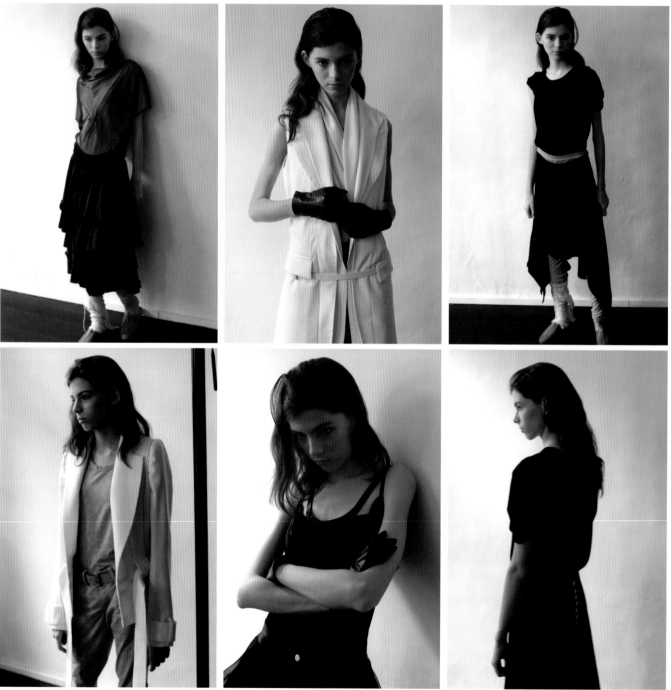

1/

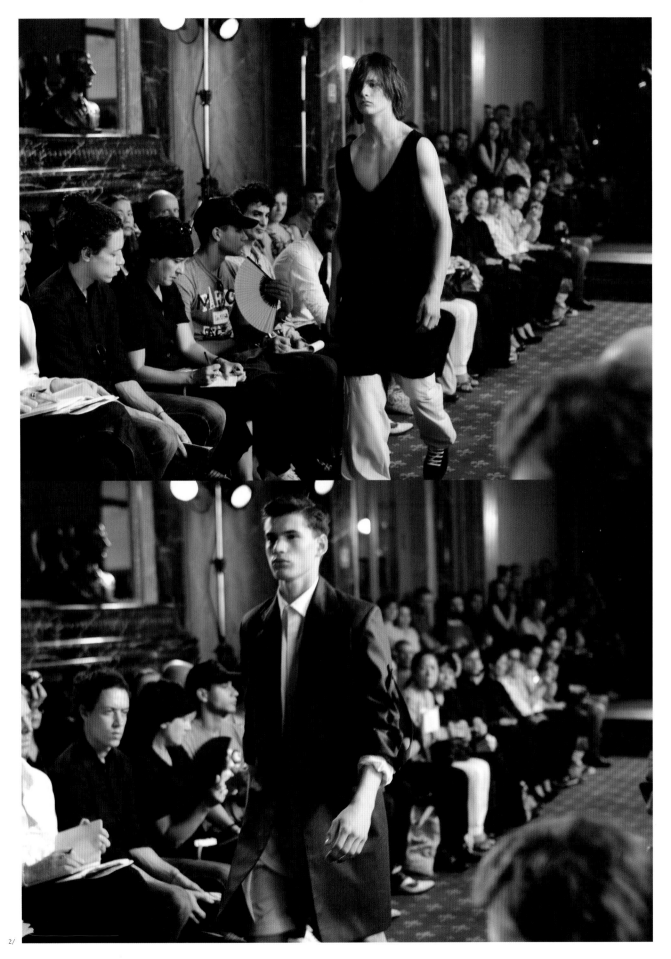

2/

/ CHENMAN

/ BEIJING, CHINA

Title: 1/ Prince On The Cream 2/ Untitled
3/ Double Mickey 4/ Desperate Mickey
Type: Art **Year:** 2004 **Client:** -
Description: Photography.

2/

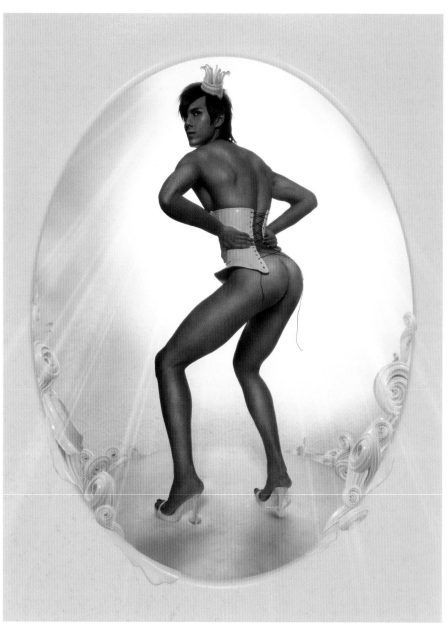

1/

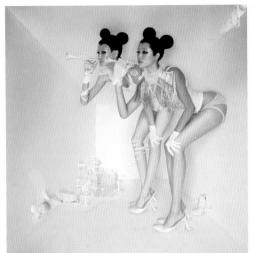

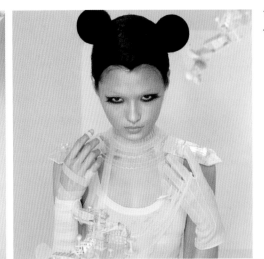

3/

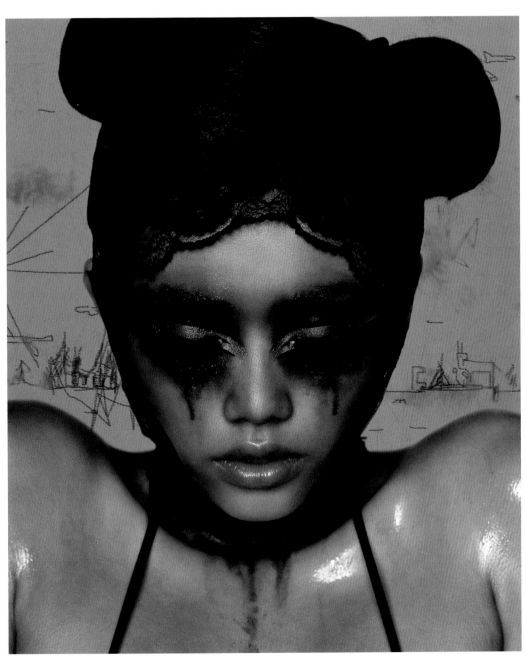

4/

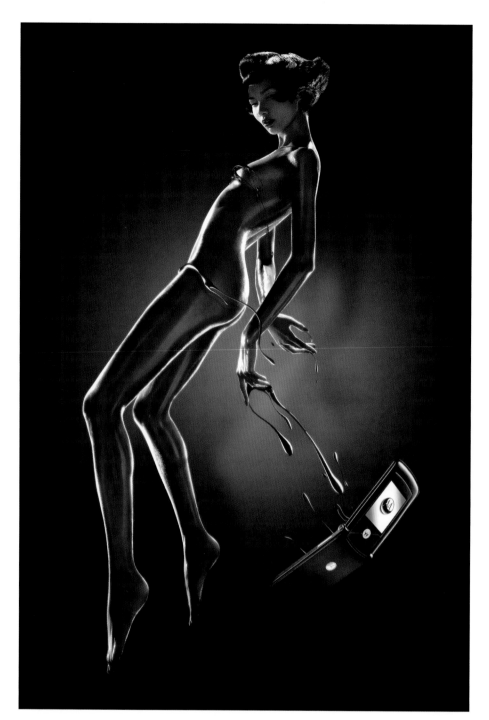

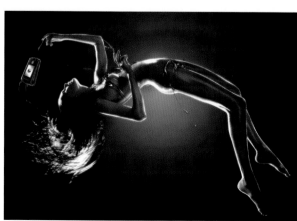

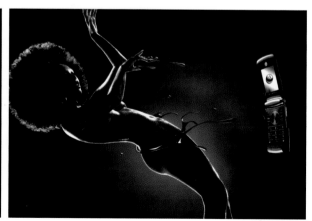

Title: 1/ Untitled 2/ Funky Great Wall
Type: Art **Year:** 2007 **Client:** 1/ Motorola 2/ -
Description: Photography.

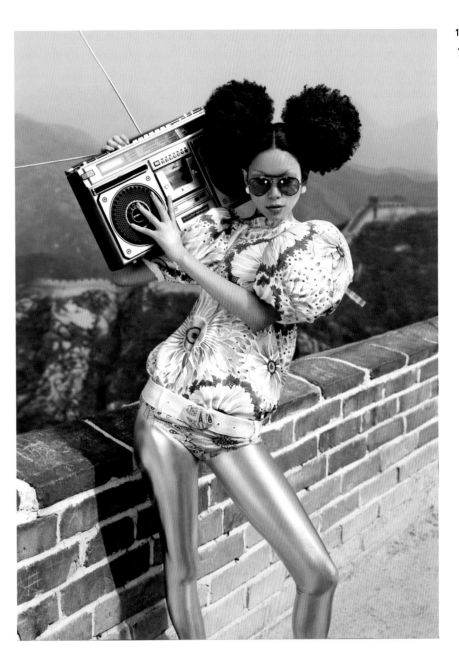

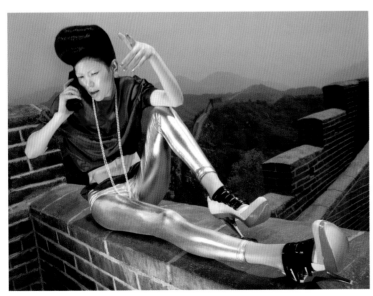

2/

Title: 1 - 3/ Old Girl 4/ Crash On The Head
5/ Back **Type:** Art **Year:** 1 - 3/ 2006 4/ 2007
5/ 2008 **Client:** -
Description: Photography.

132
/
133

5/

Title: Untitled **Type:** Art **Year:** 1 - 2/ 2005
3/ 2006 4/ 2007 **Client:** 1 - 3/ - 4/ MAC
Description: Photography.

1/

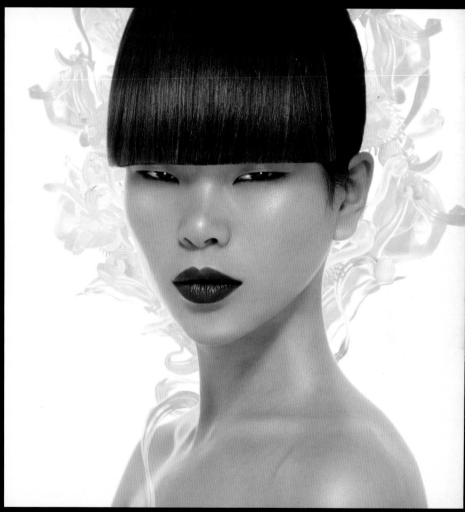

2/

3/

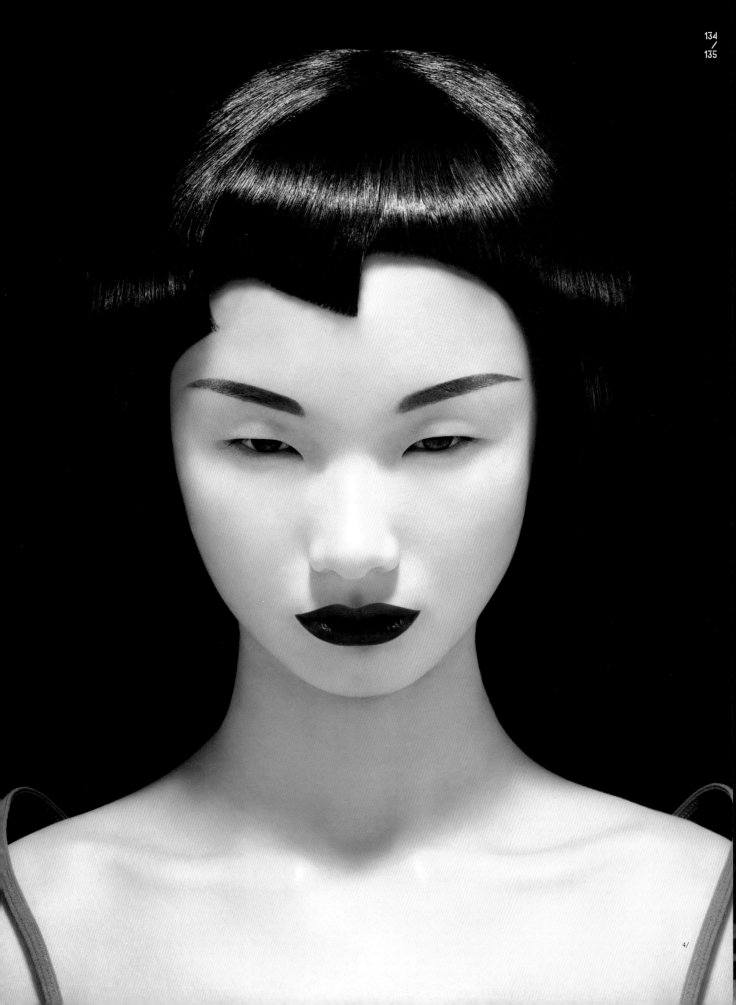

Title: Untitled **Type:** Art **Year:** 2007
Client: 1/ Shu Uemura 2/ Vision Magazine
Description: Photography.

1/

2/

Title: Untitled **Type:** Art **Year:** 2007
Client: Sheihui Skateboards
Description: Photography.

136
/
137

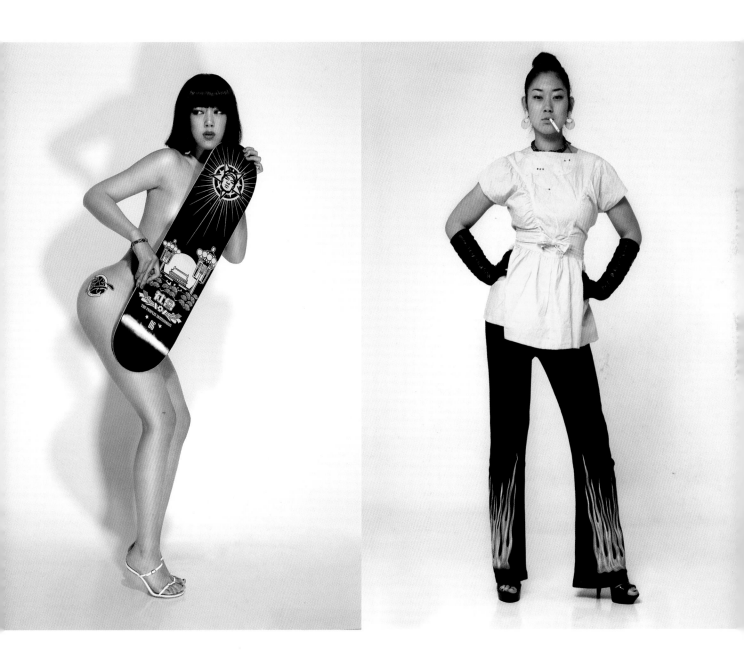

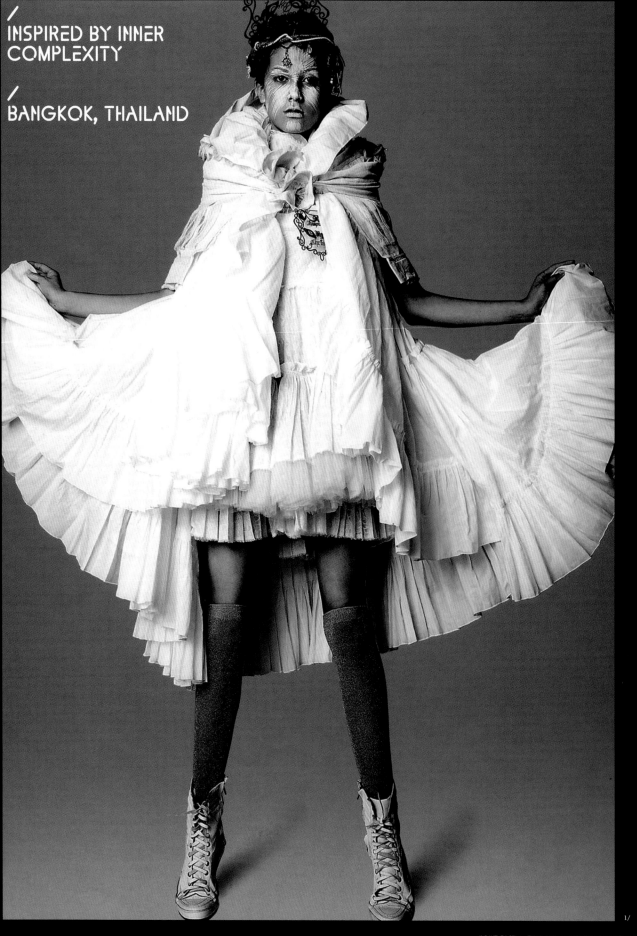

INSPIRED BY INNER COMPLEXITY

/
BANGKOK, THAILAND

Title: Hyper-Salience **Type:** Fashion Shooting
Year: 2006 **Client:** LUXE Magazine
Photographer: Nat Pakorbsuntisuk

Description: 1/ The fashion shooting is inspired by The Queen of Tribal's look adopting the technique of clothes layering as the styling theme.

2/ The exaggeration of models' posing and the movement of clothing in a 'mix and match' styling demonstrate how garments can speak by itself.

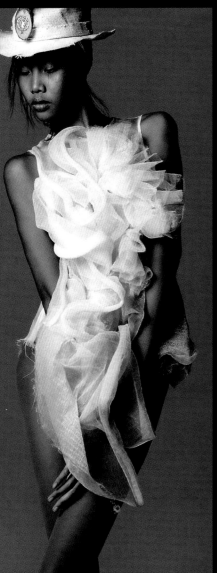

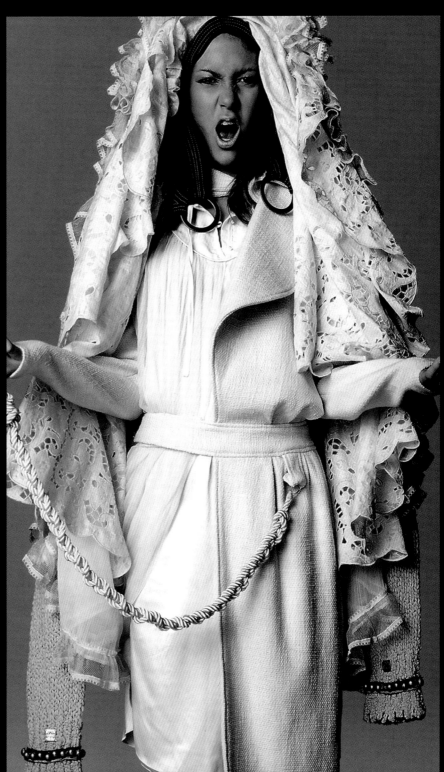

Title: Hyper–Salience **Type:** Fashion
Year: 2006 **Client:** Bangkok Fashion City's
Project **Photographer:** BFW reporters

Description: Bangkok International Fashion
Week A/W 2006-07 Runway Show - the three-act
show was inspired by the biblical and meta-
phorical meaning of the word 're-born,' the
power of God.

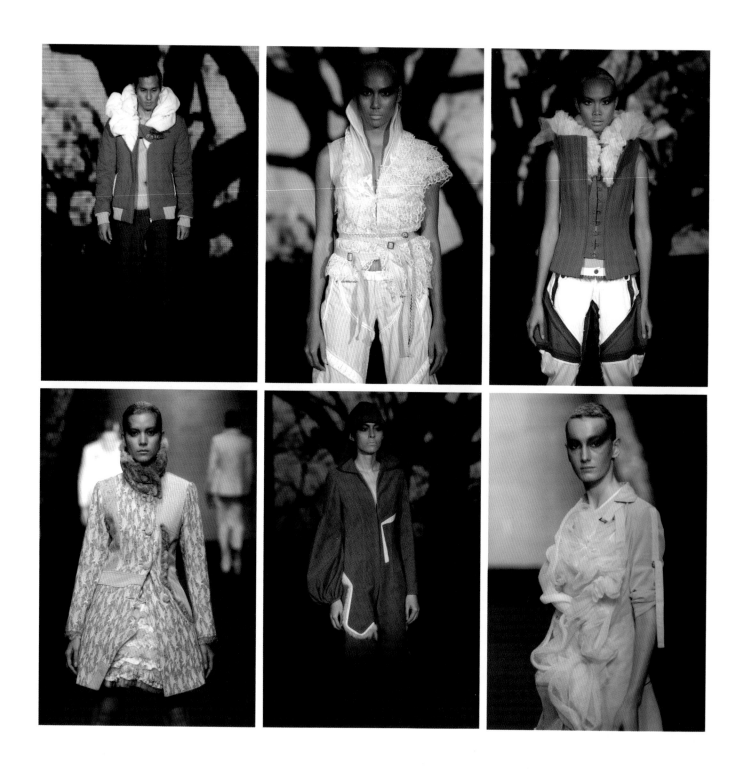

Title: The Days of God's Wrath: The 7 Years Of Tribulation **Type:** Fashion **Year:** 2007 **Client:** Siam Paragon **Photographer:** BIFW reporters

140 / 141

Description: This beyond-imagination collection was inspired by The Book of Revelation 13:16. It aims to bring audience travel through time, to 7 years before the Judgment Day when the world was ruled by the Anti-Christ. The Bangkok International Fashion Week S/S 2007 Runway Show is divided into 3 acts to tell stories of different times. The highlight is the never-before-seen colours of the world reflected by sports-couture outfits with neat cutting and elegant details.

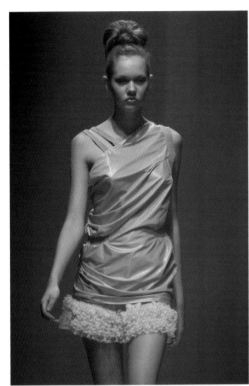

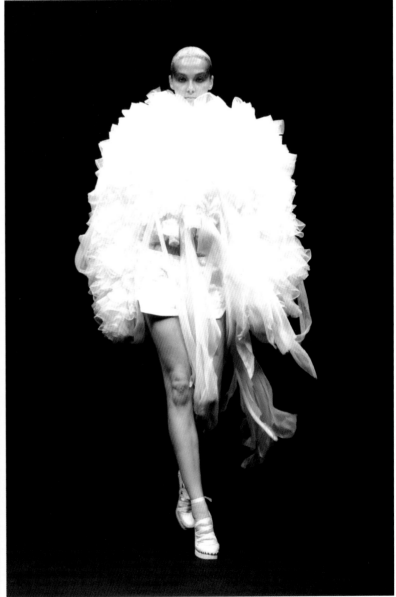

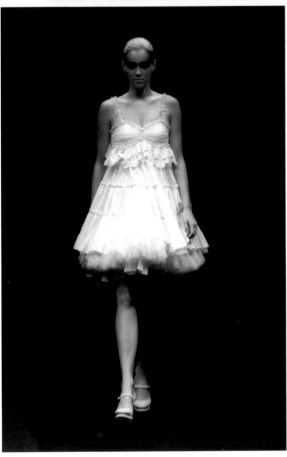

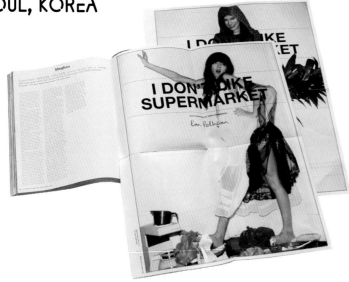

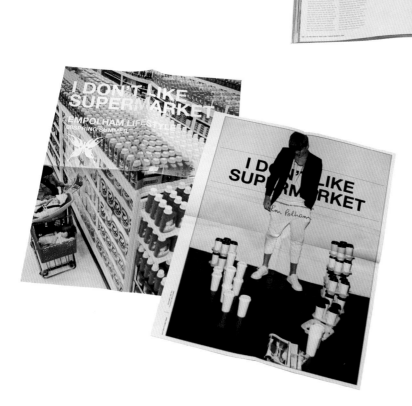

Title: Empolham 08 S/S Advertisement Campaign 'I Don't Like Supermarket'
Type: Fashion advertisement campaign, Poster
Year: 2008 **Client:** Ation Fashion Co., Ltd

Description: Empolham is known for developing socially-conscious campaigns every season. In this advertisement the primary concept is 'I don't like supermarket.' Here, 'supermarket' refers to mass production and excessive consumption.

The advertisement aims to encompass the brand philosophy by encouraging organic lifestyle and criticizing materialism. The advert was shot by a renowned photographer, Terry Richardson.

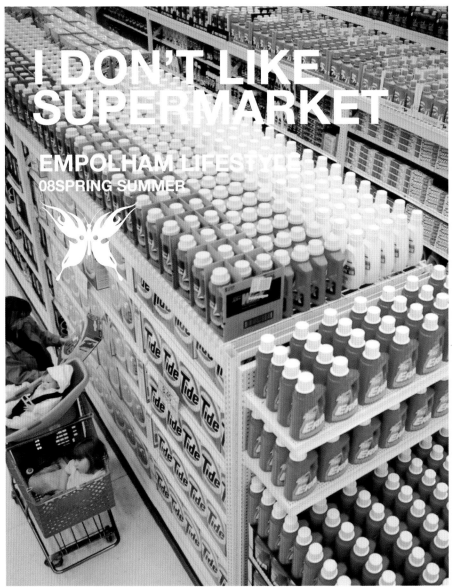

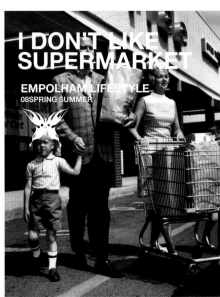

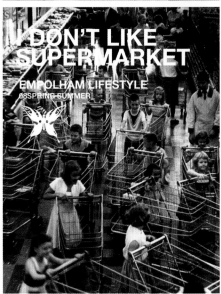

1/ Title: Minnings 07 F/W Advertisement Campaign **Type:** Fashion advertisement campaign **Year:** 2007 **Client:** Netishion.com

Description: A launching advertisement mixing New York chic and Parisian attitude. It features a unique and polished design set in Paris, an identifiable and dramatic visual location. It ignites curiosity by creating intensive shadows in a classic portray.

2/ Title: SS311 **Type:** Fashion advertisement campaign **Year:** 2005 **Client:** SS311 (Sports casual brand)

Description: SS311 abandons the established target customers and tries to appeal to the younger generation by introducing an European casual sportswear brand. It breaks the previous advertisement formats of sportswear brands by showing a witty mood. What's more, it is intensified with its newly developed logo.

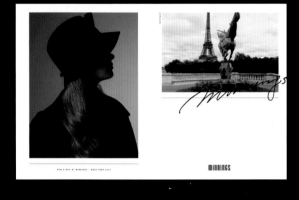

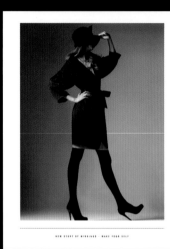

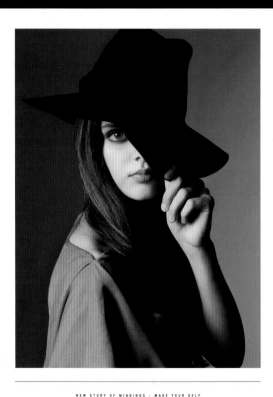

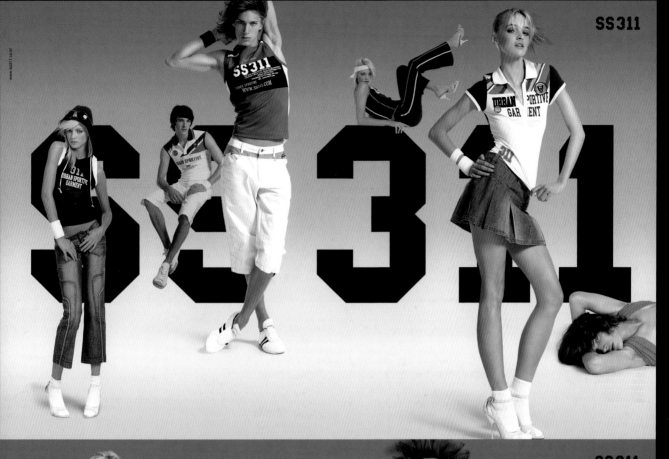

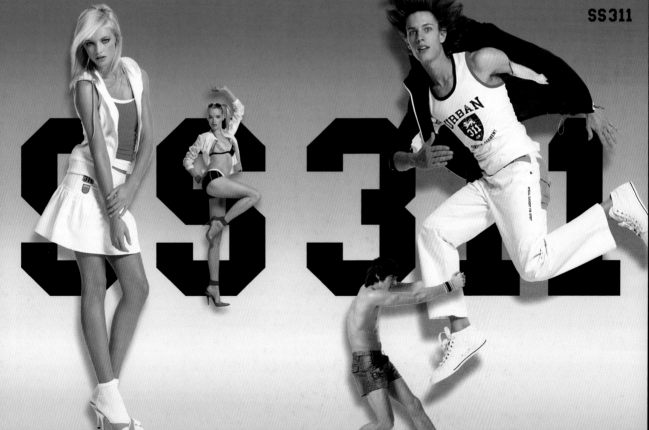

Title: Make Green In Heart **Type:** Fashion advertisement campaign **Year:** 2006
Client: Yeshin Persons Co., Ltd

Description: The campaign aims to bring our attention to the environment. It conveys simple messages using easy yet powerful ty-pographics to create a positive and fair brand image with green.

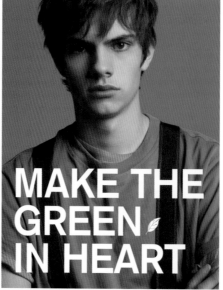

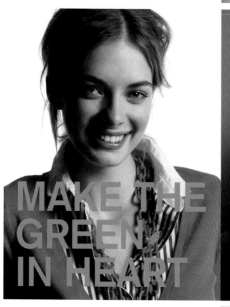

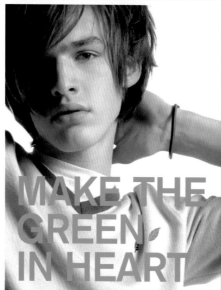

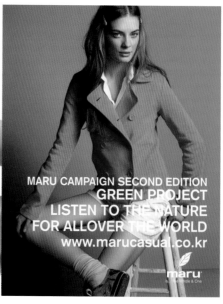

Description: This advertisement was trans-
formed from a previous advertisement into
an edgier display with numerous different
poses. The images have reflected the modern
and chic ideas of 96ny in the course of per-
formances played in a modern and solemn
gallery.

The images will give a reflective impact on the
spreads.

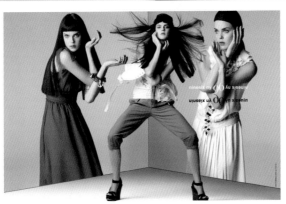

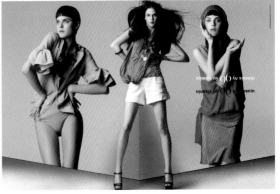

hansel

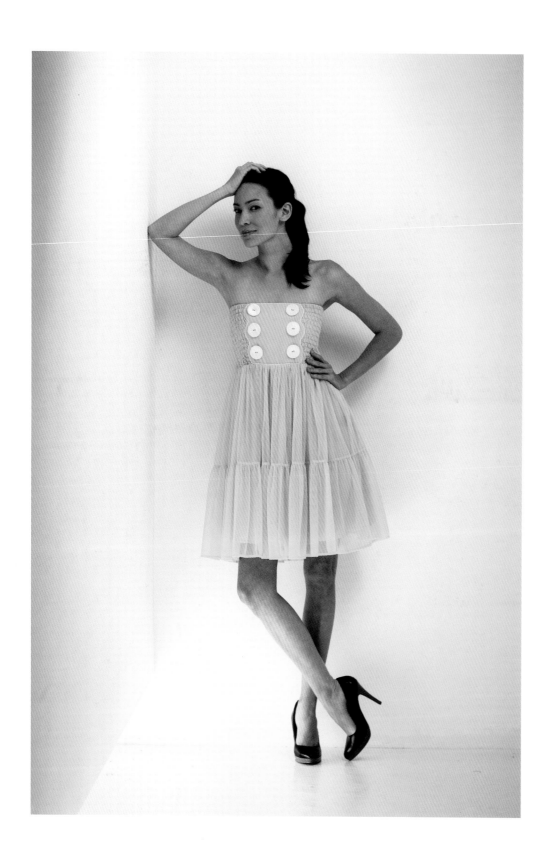

Title: Spring/Summer 2007/08 **Type:** Fashion
Year: 2007 **Client:** Hansel Productions

Description: Inspired by superhero costume styles such as cape-like features, Hansel's Spring/Summer 2007 Superhero Captain Cheese spreads his infectious joy through this collection. Fabrics such as light-weight suitings and striped silks in somber black, white and grey are accented with a piercing yellow in a fun bouncy polyester mesh.

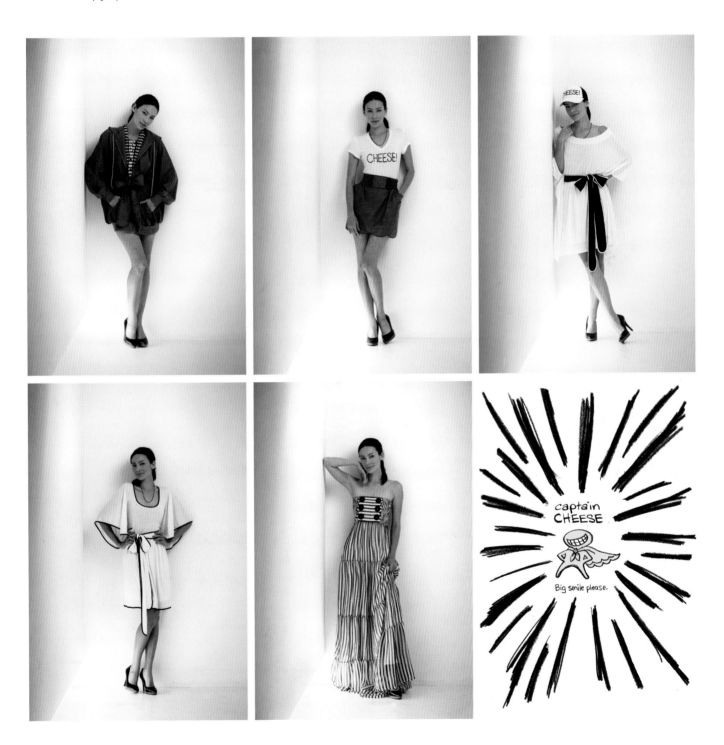

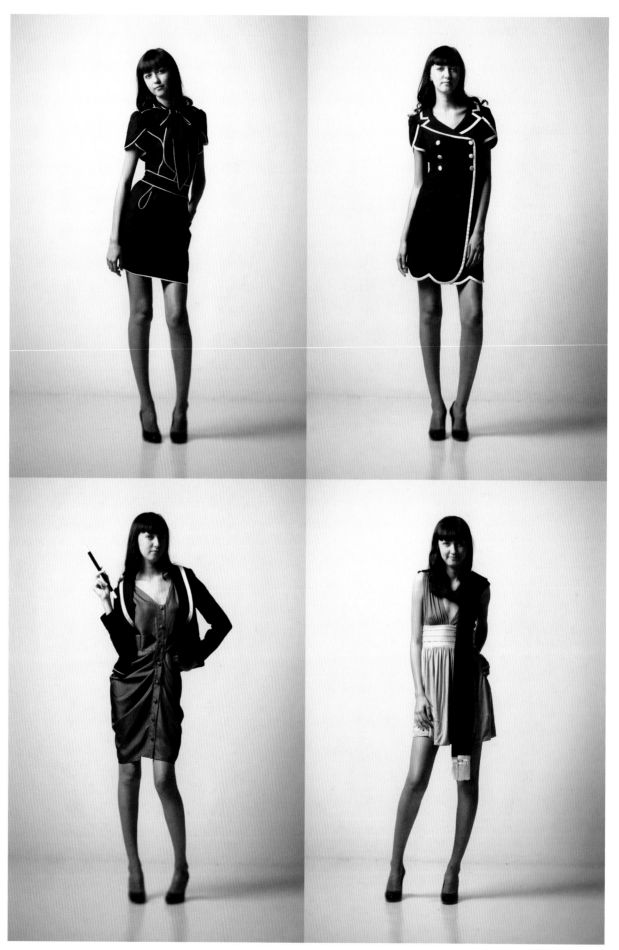

Title: Autumn/Winter 2007 **Type:** Fashion
Year: 2007 **Client:** Hansel Productions

Description: The Hansel's Autumn/Winter
2007 Abracadabra! collection is inspired by
the 1950s cabaret-style magic shows. This
darkly sensuous range stars glamorous outfits
with ruched bustiers and sculptural Tulip
skirts. The sexy silhouettes are executed in
fabrics from fine wool suiting to sheer silk
georgette in classy black, teal, ecru and grey.

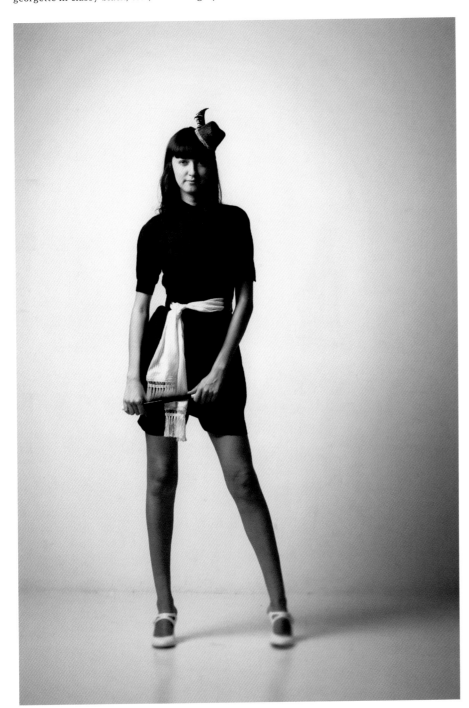

ABRACADABRA!

DAYDREAM NATION

/ HONG KONG, CHINA

DAYDREAM NATION
dreaming out loud

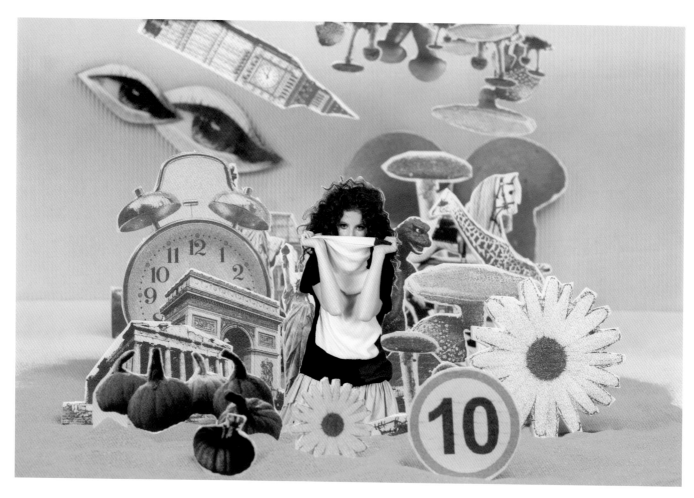

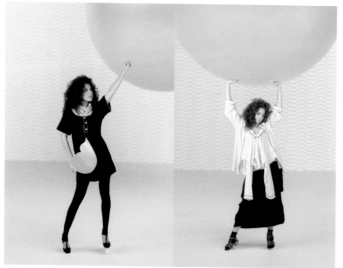

Title: Good Morning I'm Sleeping (Spring/Summer 2008 Collection) **Type:** Fashion into theatre **Year:** 2007 **Client:** - **Photographer:** Tim Wong **Make-up:** Karen Yiu **Hair:** Mike Tam

Description: 'Good Morning, I'm Sleeping' is about the blurred vision between dreams and consciousness, the yearning for comfort and disorder in the midst of fragmented images. This performance was staged in The Institute of Contemporary Arts, London as part of the London Fashion Week Off-Schedule.

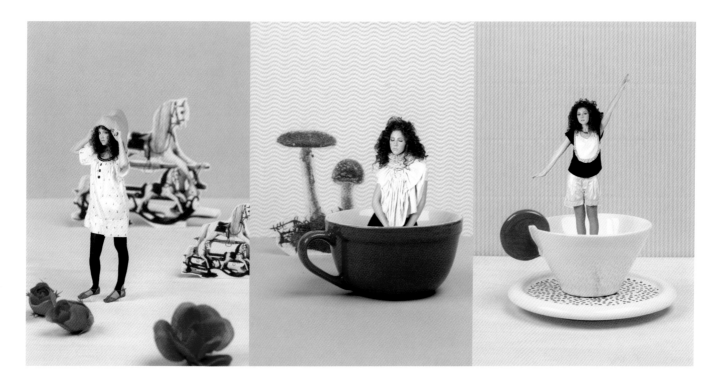

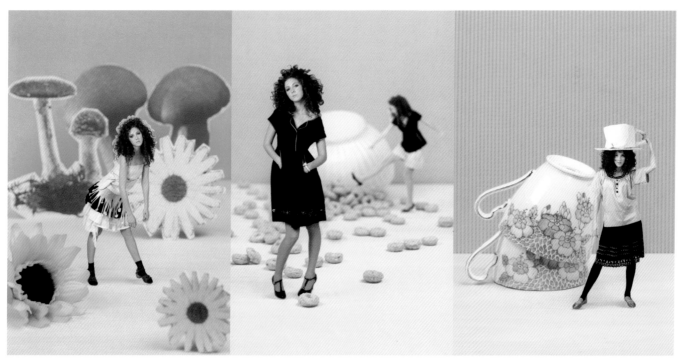

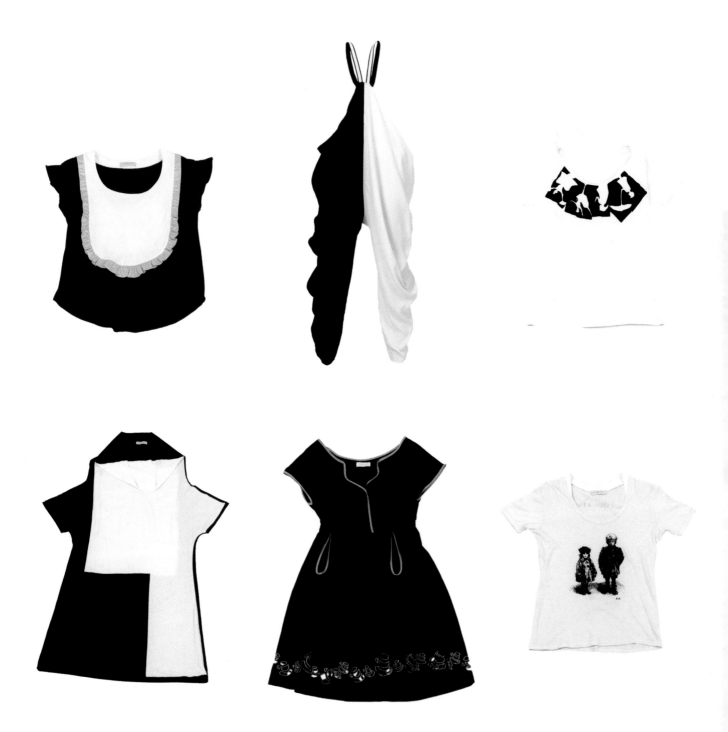

Title: Good Night Deer (Autumn/Winter 2008 Collection) **Type:** Fashion into theatre **Year:** 2007-08 **Client:** - **Photographer:** Tim Wong **Make-up:** Karen Yiu **Hair:** Mike Tam

Description: 'Good Night Deer' is a foreboding tale of revenge bursting with haunting visuals. Imagine Tim Burton directing Kafka's Metamorphosis in a forest on stage. A hunter wakes from a kill one day and finds himself transformed into the deer he killed... Who's the hunter and who's the prey if you are your own curse? This performance was staged two days in February 2008 at The Institute of Contemporary Arts, London as part of the London Fashion Week Off-Schedule.

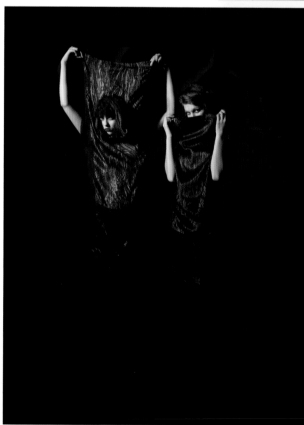

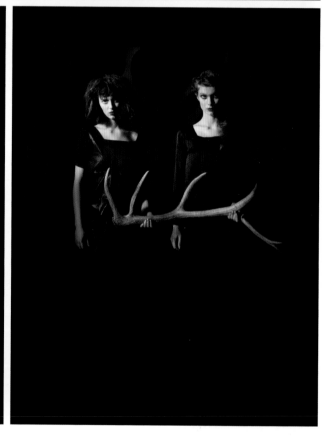

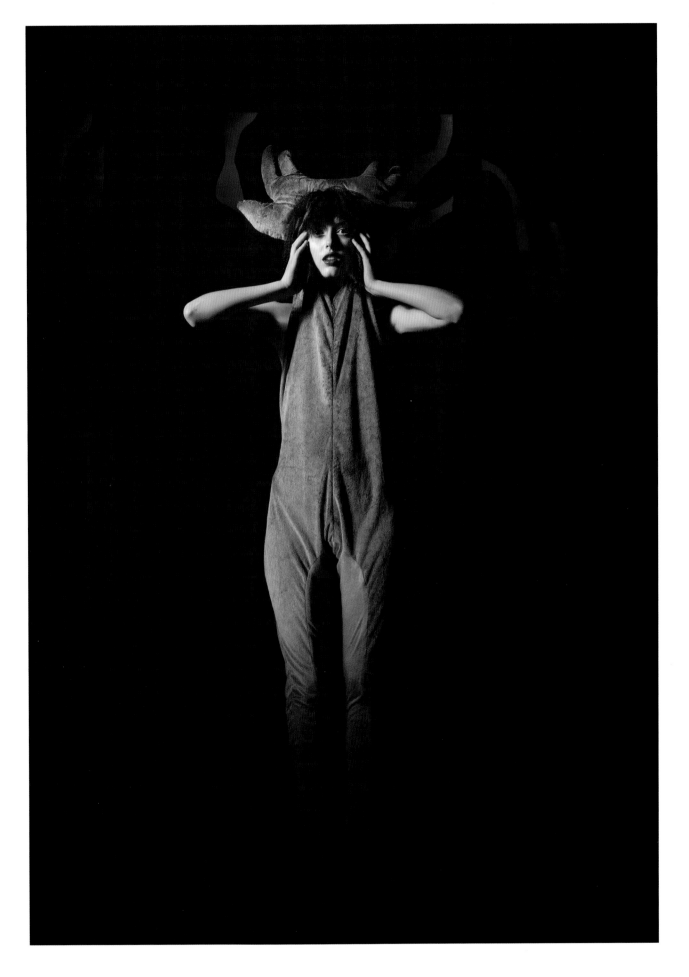

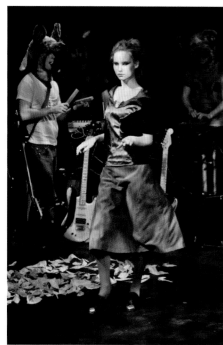

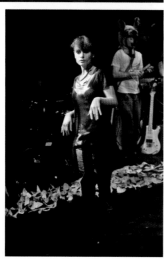

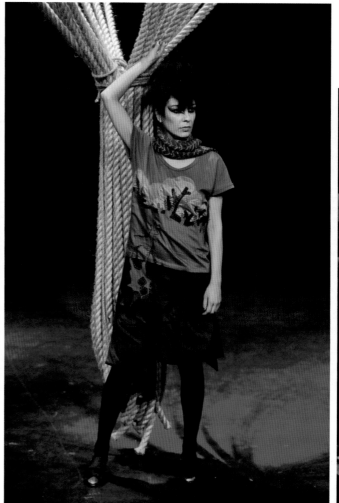

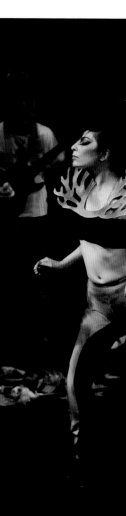

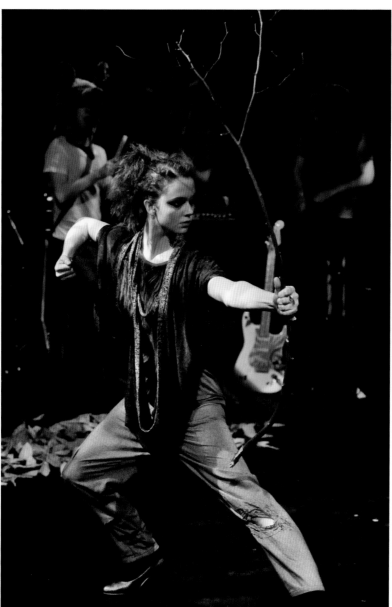

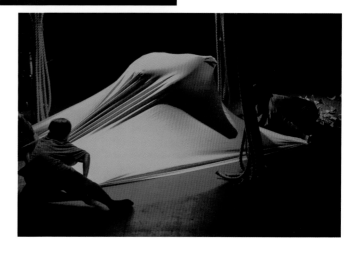

Title: Good Morning I'm Sleeping (Spring/
Summer 2008 Collection) **Type:** Fashion into
theatre **Year:** 2007 **Client:** - **Photographer:**
Tim Wong

Description: 'Good Morning, I'm Sleeping' is
about the blurred vision between dreams and
consciousness, the yearning for comfort and
disorder in the midst of fragmented imagers.

Every season, the accessories collection
combines the hard and the soft, masculine and
feminine, metal and fabric, chains and cro-
chet. Every piece is painstakingly hand-made
in the Daydream Nation studio.

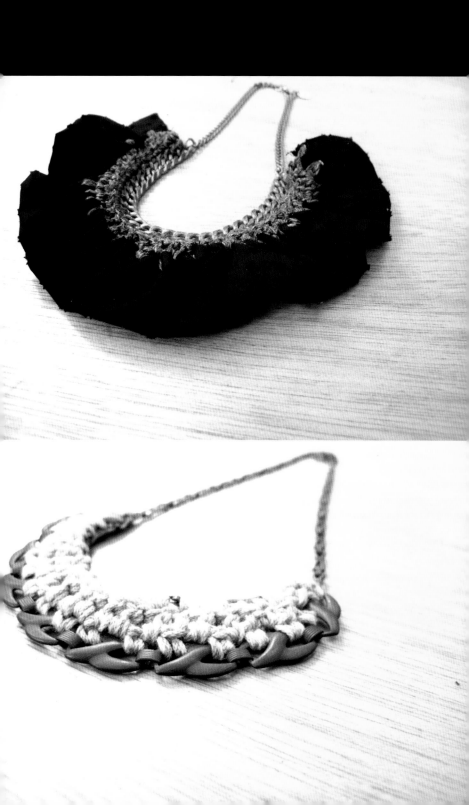

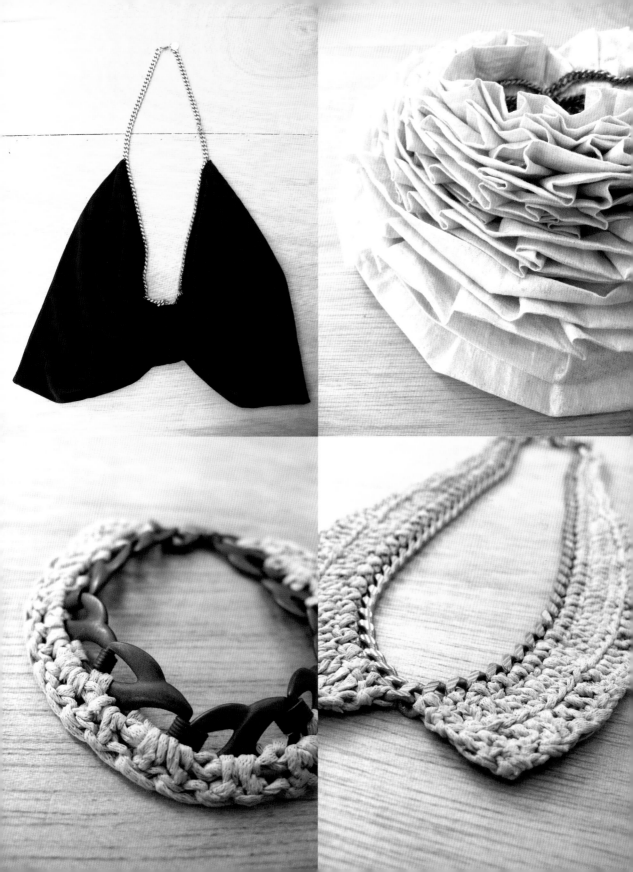

/ ARGENTUM

/ SINGAPORE

Title: 'Let X = X' Neck Piece **Type:** Neck piece
Year: 2008 **Client:** -

Description: 'Let X = X' neck piece is part of the ready-to-wear series for Spring/Summer 2008. The characteristic detail of the neck piece is the mass of convoluted interwoven chains, which is made from one continuous length without any breaks. The entire length is 12 metres, to be specific. This intricacy gives way to and melds with a seemingly harmonious, single solid chain. With the gradated finishing from dark to light, it is a reflection of a journey through time.

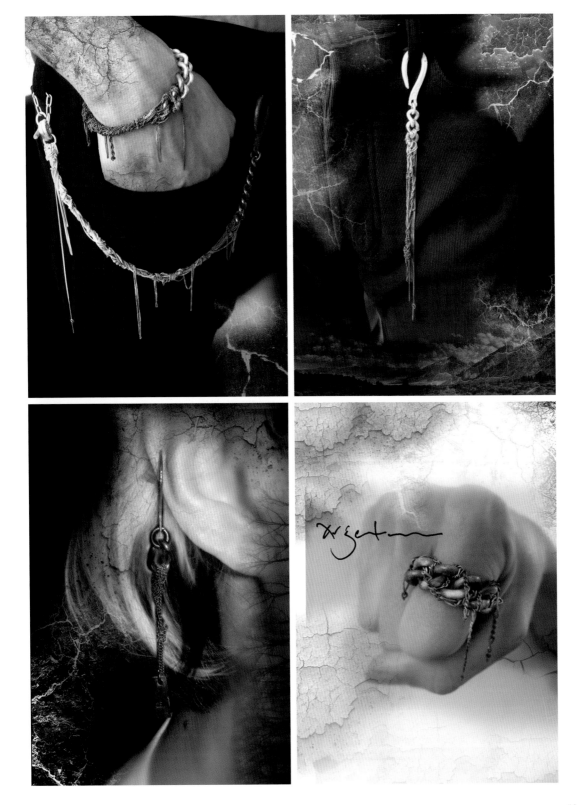

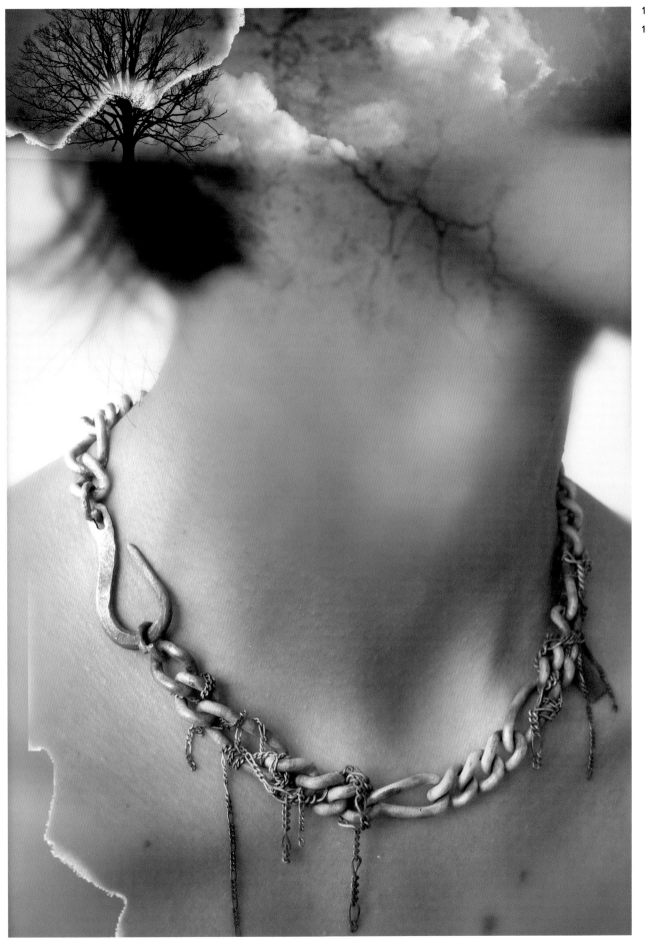

1/ Title: 'Let X = X' Neck Piece (Continue)
2/ Title: 'A Long Division' Neck Piece
Type: Neck piece **Year:** 2006 **Client:** -

Description: 'A Long Division' neck piece is part of the ready-to-wear series for Autumn/ Winter 2006. The main feature of this neck piece is the detachable receptacle that holds and displays the wearer's personal treasure. The materials are all specially chosen. For example in this work, the carved balls of yellow serpentine are used to symbolise eternity and the dangling strands of knotted yarn connoting our strings of attachment. The neck piece is created to evoke a reminiscent mood for contemplation.

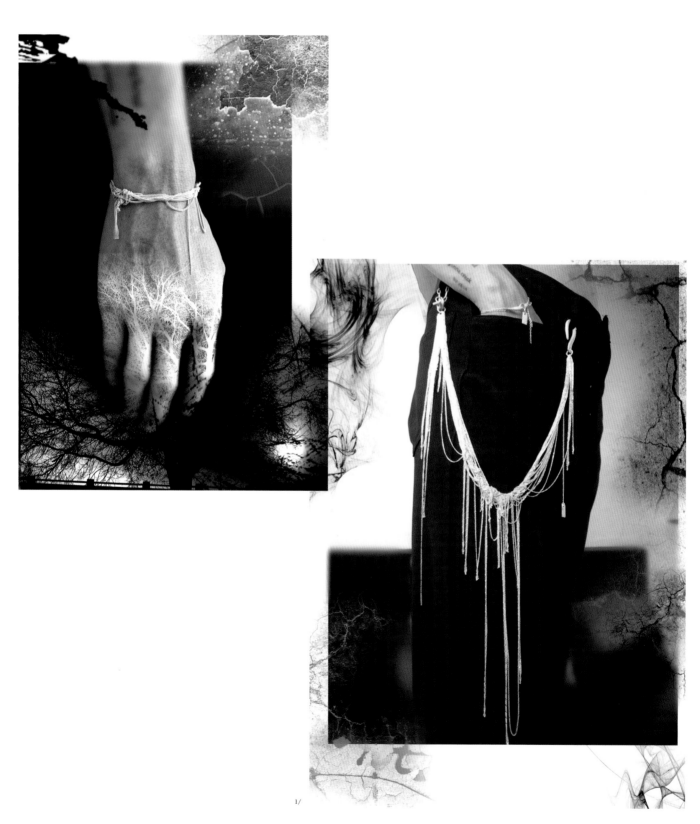

1/

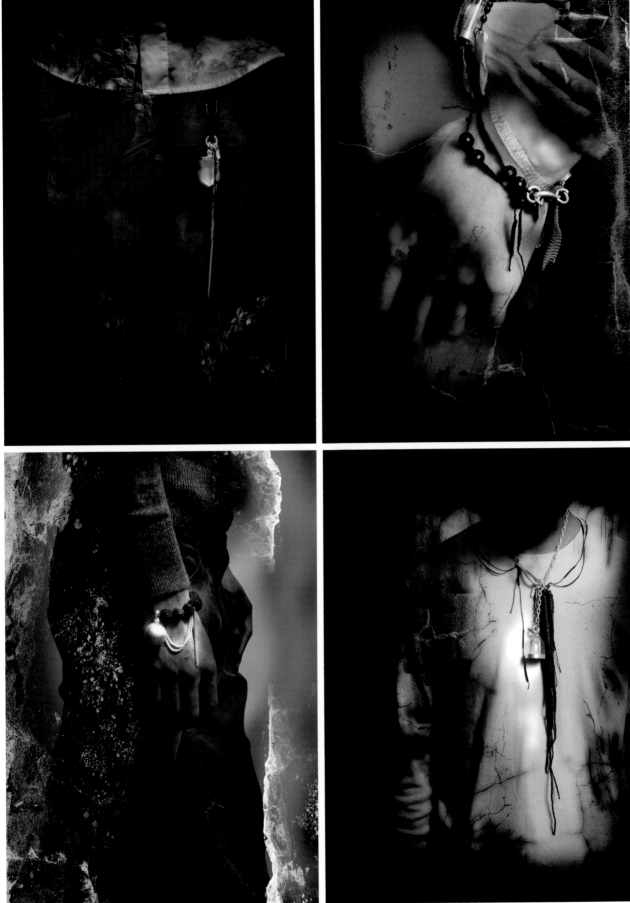

2/

SANGYOUNG SUH

SEOUL, KOREA

Title: Field & Air **Type:** Fashion **Year:** 2006
Client: -

Description: Suh Sangyoung 06 Spring/
Summer collection.
Sponsor: Nike

Title: Seoul **Type:** Fashion **Year:** 2006
Client: -

Description: Suh Sangyoung 06-07 Autumn/
Winter collection.
Venue: Chungdam Parking Lot
Sponsor: Nike, Ventura design on time

166
/
167

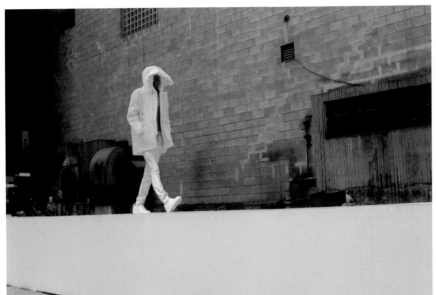

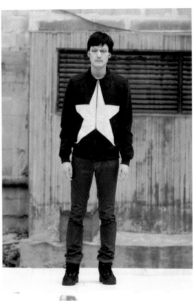

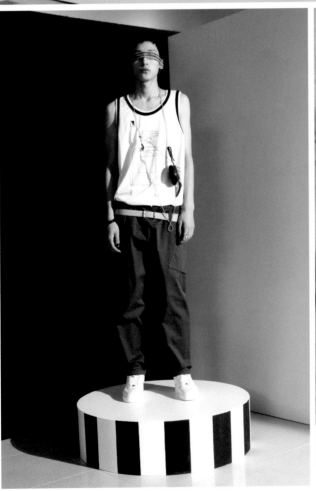

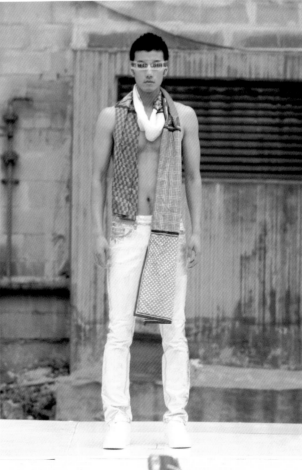

Title: Mirror **Type:** Fashion **Year:** 2004
Client: -

Description: Suh Sangyoung 04-05 Autumn/
Winter collection.
Venue: 8F, 86 Chungdamdong
Kangnamgu Seoul
Sponsor: Clarks, Tateosian London

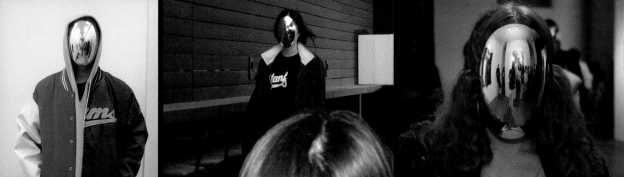

Title: SIZE MAKER Haute Couture
Type: Fashion **Year:** 2004 **Client:** -
Description: Project Mix Max 2004.
Venue: ArtSonje Center
SIZE MAKER. Collaboration with Haegue Yang.

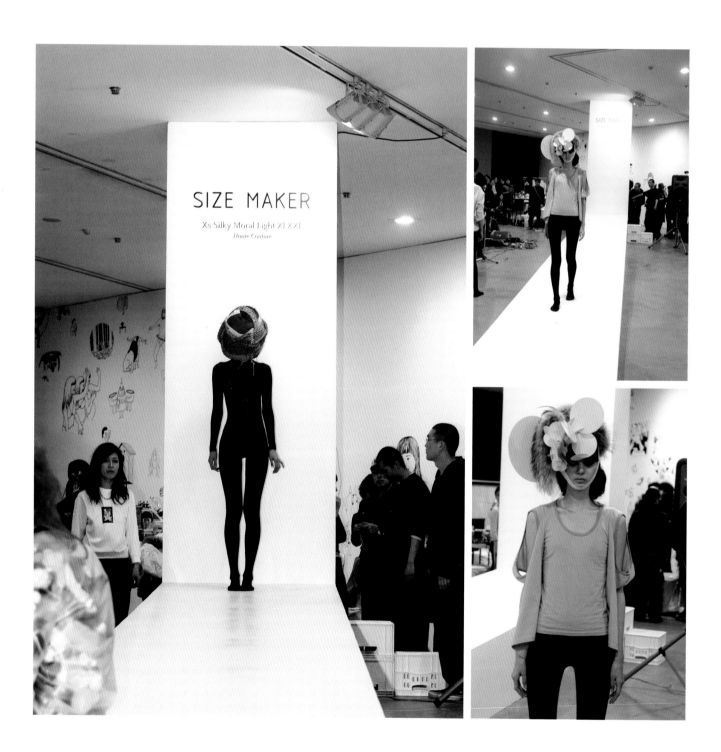

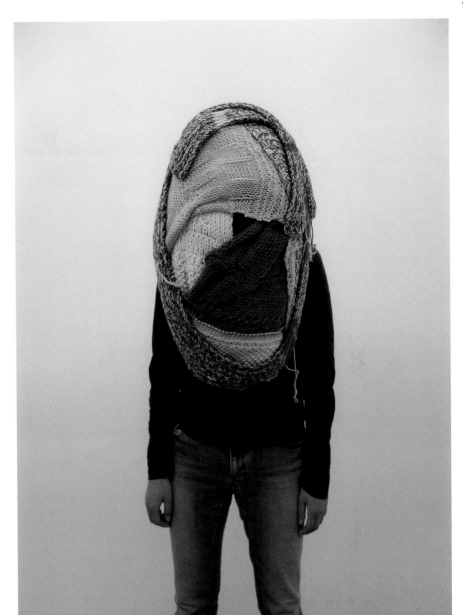

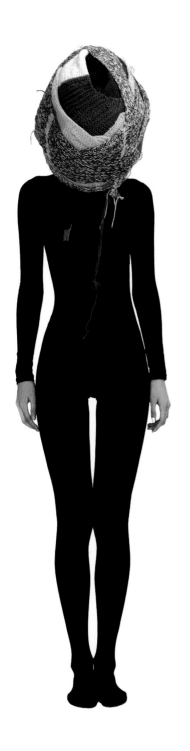

Title: Framed **Type:** Fashion **Year:** 2007
Client: -

Description: Suh Sangyoung 07-08 Autumn/
Winter collection 2007.
Venue: café PAPER GARDEN
Photo: Sabine Reitmaier
Graphic: Frederique Daubal
Sponsor: Nike

1/ Title: A Representation Of A Sketch Of A Striped T-Shirt **Type:** T-shirt design
Year: 2005 **Client:** Forest

Description: As its name suggests, the Rabbit t-shirt is a full-blown version of an incomplete sketch of a striped t-shirt. It brings to light the beauty of a work-in-progress, and shows how sketches serve as an important dialogue and negotiation exercise with H55 as they transform thoughts into form. Silkscreened after the t-shirt is made, the print reminds one of an aborted inkjet prints. It was sold at Comme des Garçons' Dover Street Market in London, amongst other design stores from around the world.

1/

2 - 3/ Title: Rabbit And RedFox: Rrrrrisky Adventures At +65 Comme des Garçons Guerrilla Store **Type:** Toy design, Packaging design **Year:** 2004 **Client:** +65 Comme des Garçons Guerrilla Store, Forest

Description: In 2004 Christmas, H55 was invited to exhibit their Rabbit project at the first +65 Comme des Garçons Guerrilla Store in Singapore. It marked the birth of RedFox, a new character specially created for the collaboration.

There is a natural struggle between Rabbit and RedFox. Rabbit has to risk his life to conquer his red friend's hunger pangs by his love and passion for this relationship.

Vacuum-packed with a RedFox gingham picnic handkerchief, a badge and a red Comme des Garçons item, these limited edition packages were sold as Christmas gifts. The Rabbit soft toy is not for sale because it might have already been 'consumed' by the RedFox!

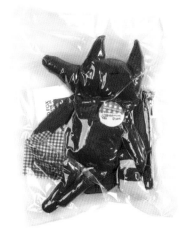
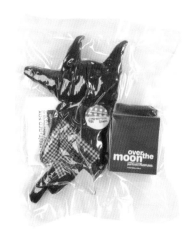

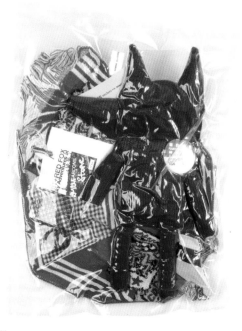

3/

RABBIT
A CONVERSATION WITH DOVER STREET MARKET COMME des GARÇONS

2/

Title: The Sandwich Shop Identity
Type: Retail branding **Year:** 2003
Client: The Sandwich Shop

Description: Collaborated with Weave Interior, The Sandwich Shop identity was created to complement some of the store's brand values: sincerity, honesty, transparency, personal customer relationship, great food management, freshness and goodwill. Covering all retail, business applications, and space planning, the overall identity is made modern and timeless, while still remaining friendly and 'appetising.'

As the core of the identity system, the logo with a clean and orderly appeal is made up of 3 bars that represent the cross section of a sandwich. The variation of the middle bar referring to the 'fillings' suggests the wide range of sandwiches that the store offers. Not to forget their east-west fusion recipes, the idea of 'san wen zhi' ('sandwich' in Chinese), was incorporated by highlighting the 'san' in 'sandwich' (including the hanyu pinyin intonation). Plus, '3' from '3 bars' is also read as 'san' in Chinese. The idenity varies for different applications such as stationery items, environmental graphics, custom-moulded sandwich packages and serviette designs.

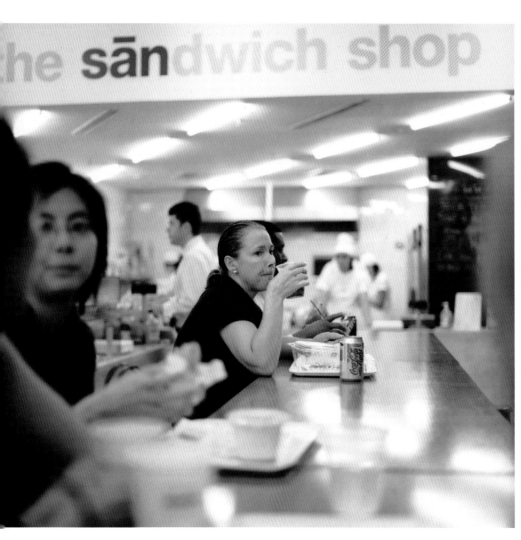

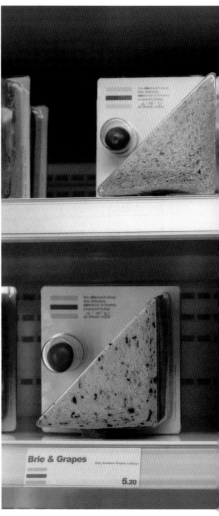

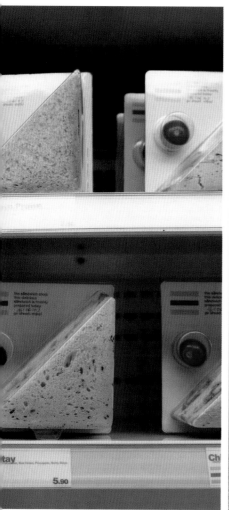

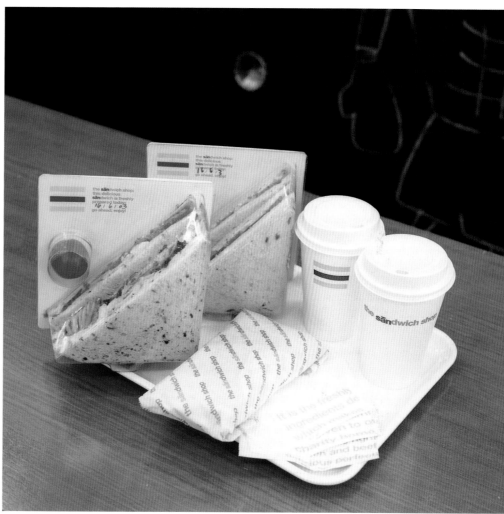

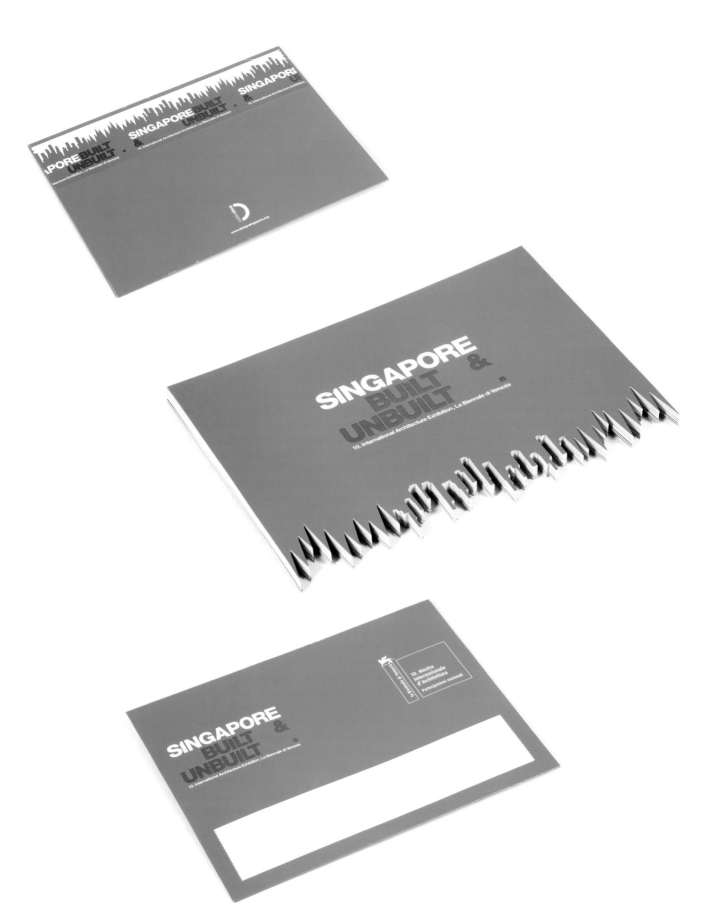

Title: Identity For The Singapore Pavilion At The Venice Biennale **Type:** Identity design **Year:** 2006 **Client:** DesignSingapore Council

Description: The 'Venice Biennale International Architectural Exhibition' is the world's biggest showcase of architectural design while the Singapore Pavilion's exhibition, titled as 'Singapore Built & Unbuilt,' had offered a glimpse of Singapore's future landscape by sharing ideas from both local and international architects.

To express the idea of 'City in the Garden,' H55 created visuals regardinig buildings under construction and made it part of the logotype for 'Singapore Built & Unbuilt.' Composed of a graphical skyline of the work-in-progress buildings, it varies from the nature, it varies from a die-cut line, as shown on the invitation card, to a random landscape pattern, as shown on the poster. Interesting enough, some might interpret the 'landscape' one as sound-wave-like pattern from a distance.

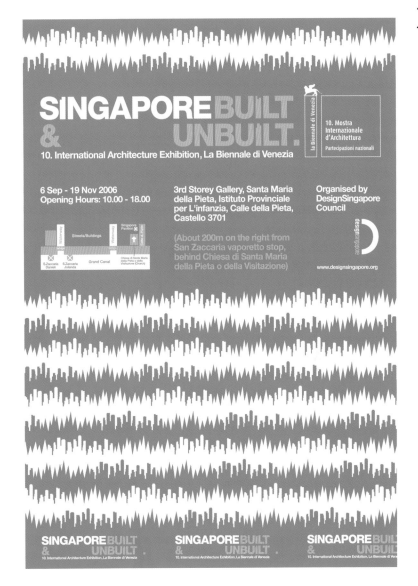

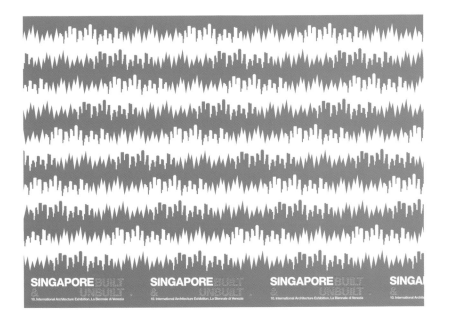

Title: Hoff Dylan 'Psycho Pop Killer Bee' CD
Jacket **Type:** Art direction, Design, Illustration
Year: 2002 **Client:** Nippon Columbia Co., Ltd

Description: The work is art directed with
Yuhi Komiyama, who is the musician of 'Hoff
Dylan.'

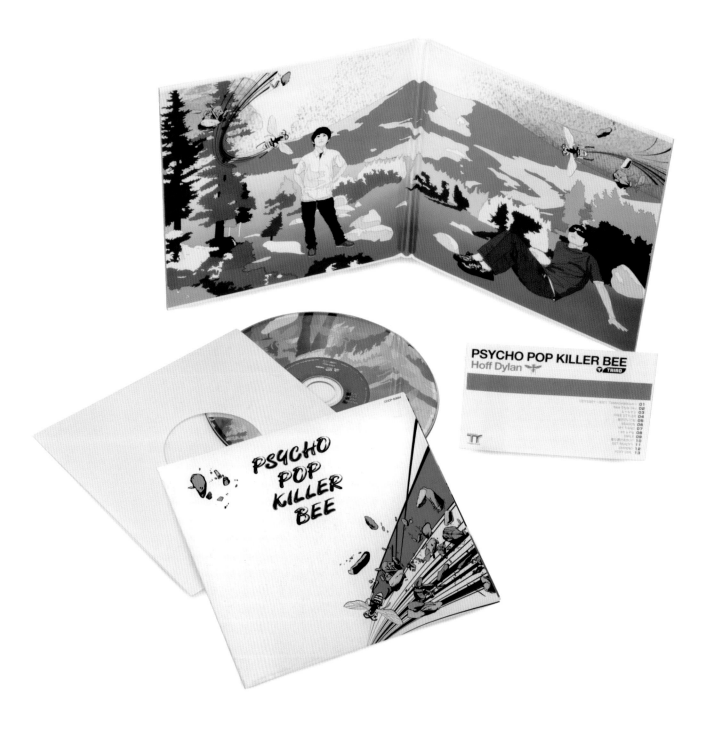

Title: Naruyoshi Kikuchi 'Futsuu No Koi' CD
Jacket **Type:** Art direction, Design, Illustration
Year: 2004 **Client:** VIEWSIC DISC

Description: The CD jacket is complete with
the portrait of the musician designed by
SUNDAY VISION.

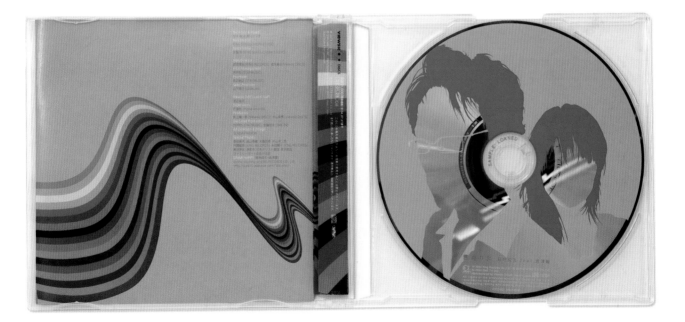

Title: modi 1st Anniversary (modi 1st Anniversary Campaign Visual) **Type:** Art direction, Design **Year:** 2007 **Client:** AIM CREATES

Description: This is an advertisement for the 1st anniversary of a department store 'modi.'

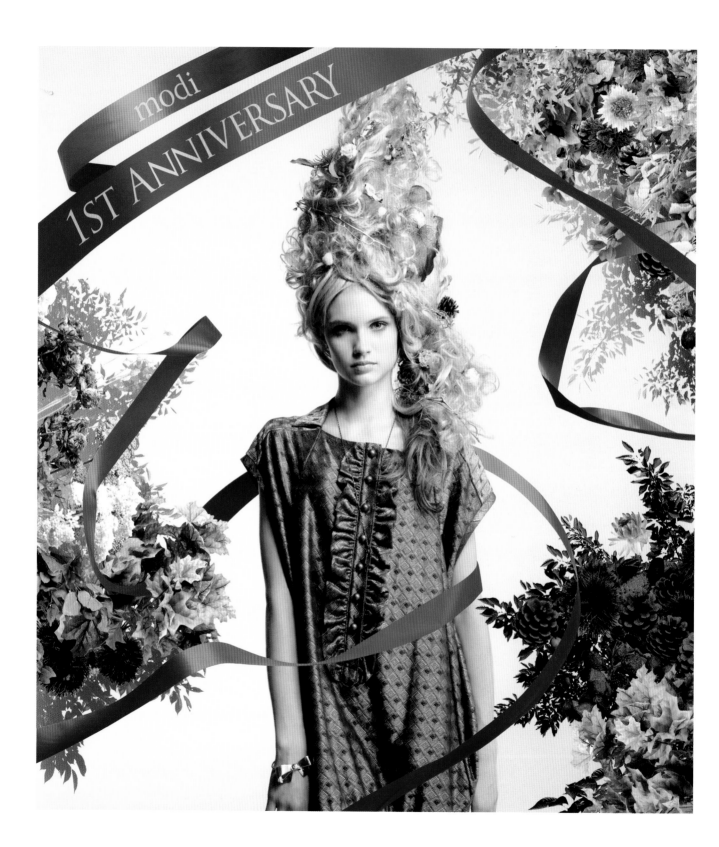

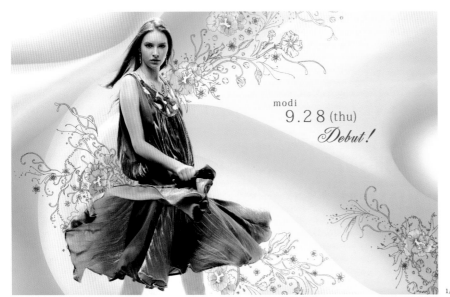

1/

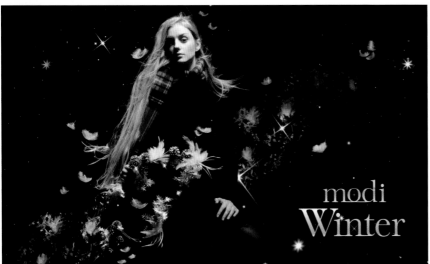

3/

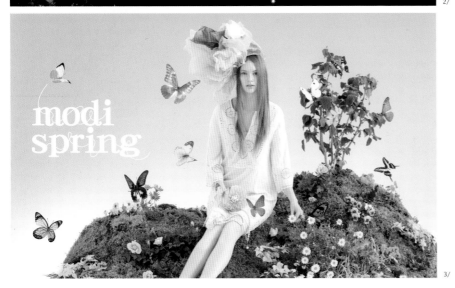

2/

1/ Title: modi Opening Visual **Type:** Art direction, Design, Illustration **Year:** 2006 **Client:** AIM CREATES

Description: SUNDAY VISION has been in charge of modi's advertisements since it opened in 2006.

2/ Title: modi Winter (modi 2007 Winter Campaign Visual) **Type:** Art direction, Design **Year:** 2007 **Client:** AIM CREATES

Description: This is an advertisement for modi's 2007 winter campaign.

3/ Title: modi Spring (modi 2008 Spring Campaign Visual) **Type:** Art direction, Design **Year:** 2008 **Client:** AIM CREATES

Description: This is an advertisement for modi's 2008 spring campaign.

1 - 2/ Title: 1/ Zoo Sticker 2/ Aquarium Sticker **Type:** Illustration **Year:** 2006 **Client:** Magazine House

Description: 1/ Special supplement to BRUTUS magazine's 'Zoo' issue.

2/ Special supplement to BRUTUS magazine's 'Aquarium' issue.

3/ Title: Coffee And Cigarettes (BRUTUS Magazine Cover) **Type:** Graphic design **Year:** 2005 **Client:** Magazine House

Description: The illustration is a cover of BRUTUS magazine 'Coffee and Cigarettes' issue.

4/ Title: Minna No Yoga (BRUTUS Magazine Cover) **Type:** Visual Direction, Illustration **Year:** 2006 **Client:** Magazine House

Description: The illustration is a cover of BRUTUS magazine 'YOGA' issue.

Concept work: Mr.Maeda (Editorial Department of BRUTUS)

Photo direction, Illustration: Shinsuke Koshio (SUNDAY VISION).

5/ Title: Rediscover Japan (Casa BRUTUS Magazine Cover) **Type:** Illustration **Year:** 2003 **Client:** Magazine House

Description: Japanese traditional textile pattern filled with illustrations. It was made for the 'Rediscover Japan' issue.

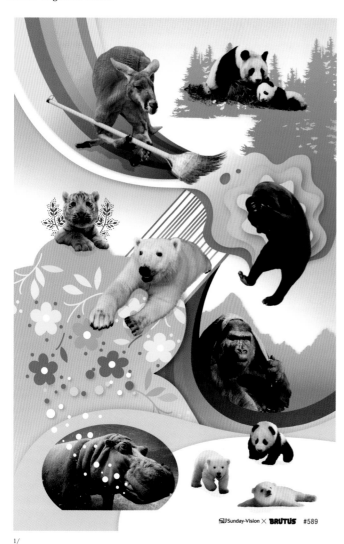

1/

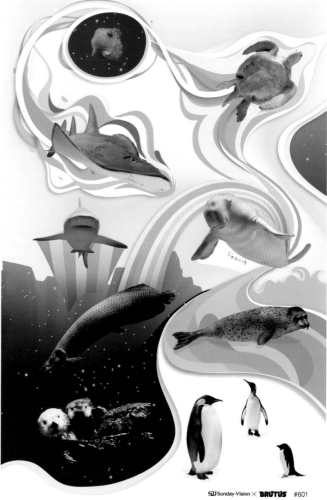

2/

3/

4/

5/

1/ Title: Source Of Wonder **Type:** Illustration **Year:** 2003 **Client:** Source of wonder by DAY14 Exhibition

Description: DAY14 invited eighteen world's leading graphic artists to each contribute one piece of artwork based on the theme, 'What was your source of wonder as a child?' The fascinating book showcases all the works from this exhibition.

2/ Title: World **Type:** Illustration **Year:** 2004 **Client:** KITTY EX Exhibition

Description: 'KITTY EX.' KITTY EX is a significant artwork produced by more than 100 groups of local and international artists as well as fashion brands designers using 'Hello Kitty' motifs.

1/

2/

Title: PARCO 2006 Spring/Summer Campaign
Visual 1/ New AIR Sports 2/ New AIR Life
3/ New AIR Mens 4/ New AIR Denim
Type: Art direction, Design, Illustration
Year: 2006 **Client:** PARCO

Description: One of the five advertisements
made for the Spring/Summer campaign of a
department store 'PARCO.'

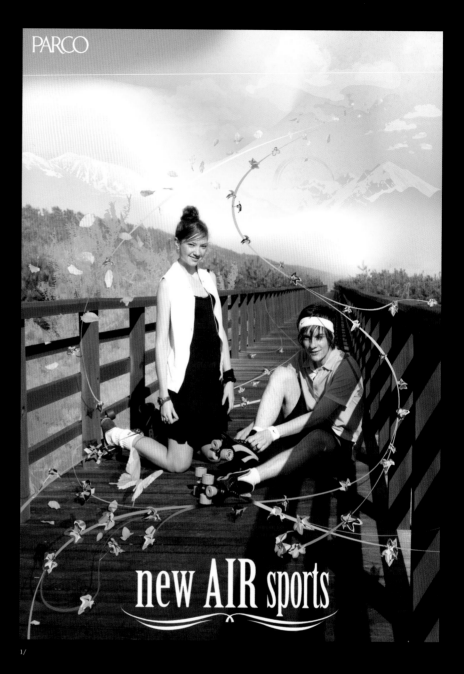

1/

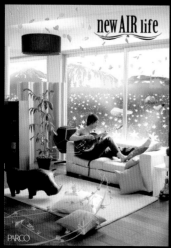

2/

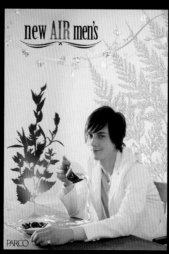

3/

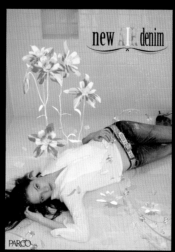

4/

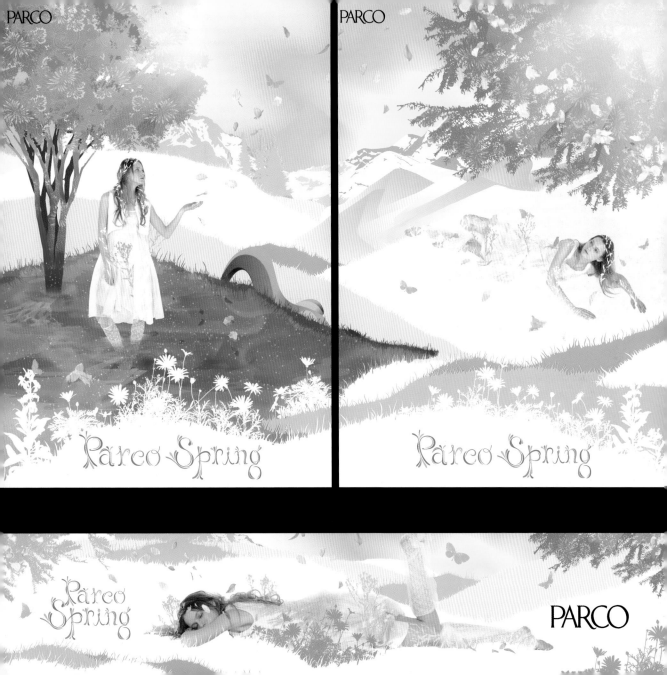

Title: Hanpanda **Type:** Character design, Art
direction, Illustration **Year:** 2006-08
Client: -
Description: Artwork of Nagi Noda.

©2004 nagi noda/uchu-country

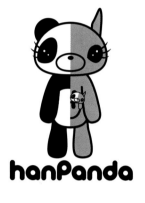
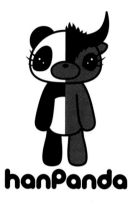
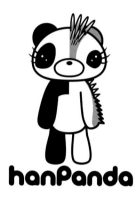
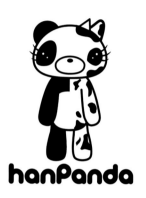

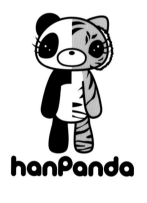
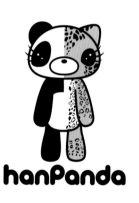
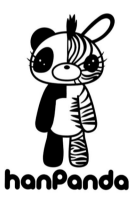
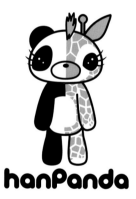

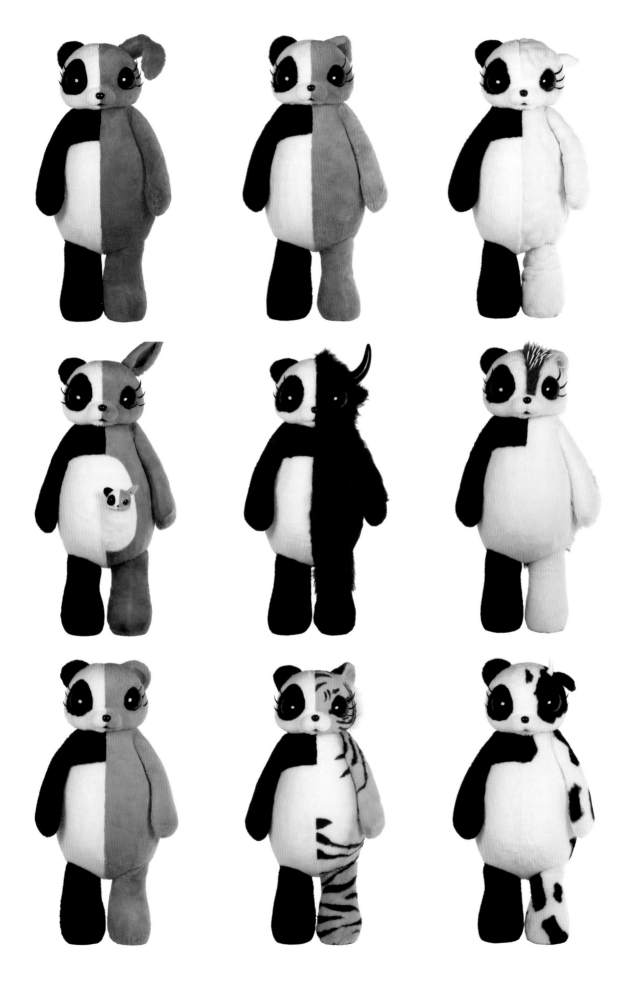

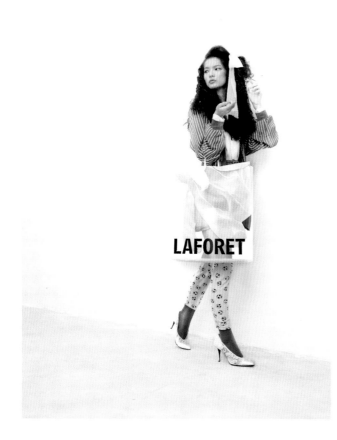

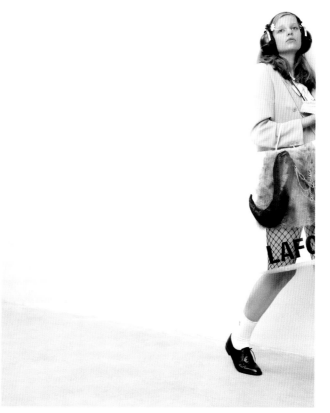

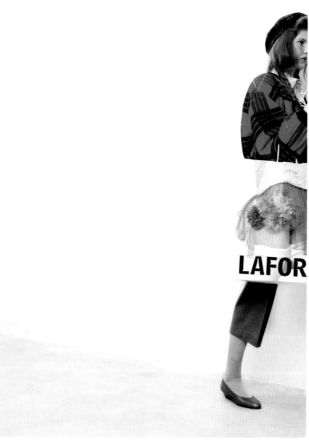

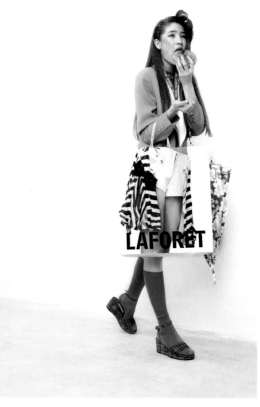

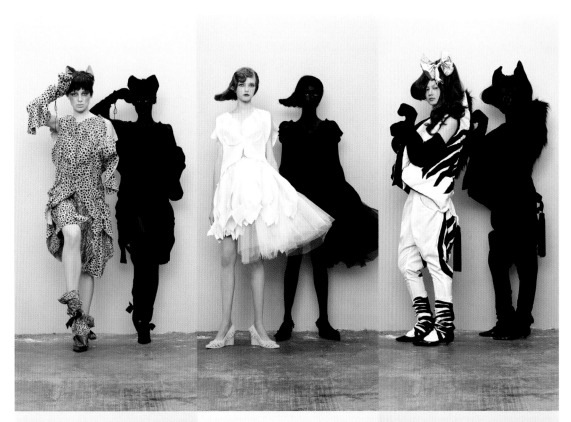

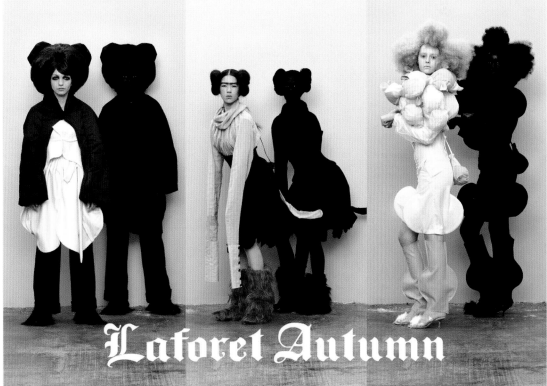

2/

Title: b+ab (b+ab 2007, 2008 S/S Campaign
Visual) **Type:** Art direction **Year:** 2007-08
Client: it company

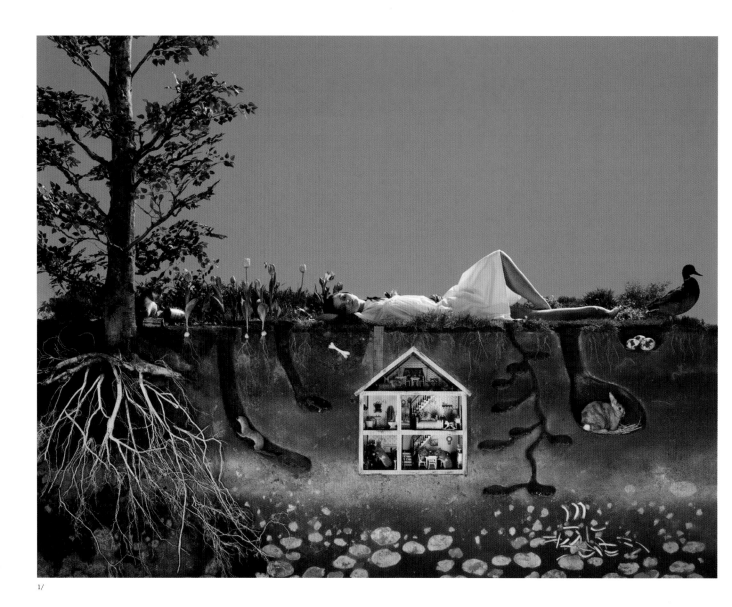

1/

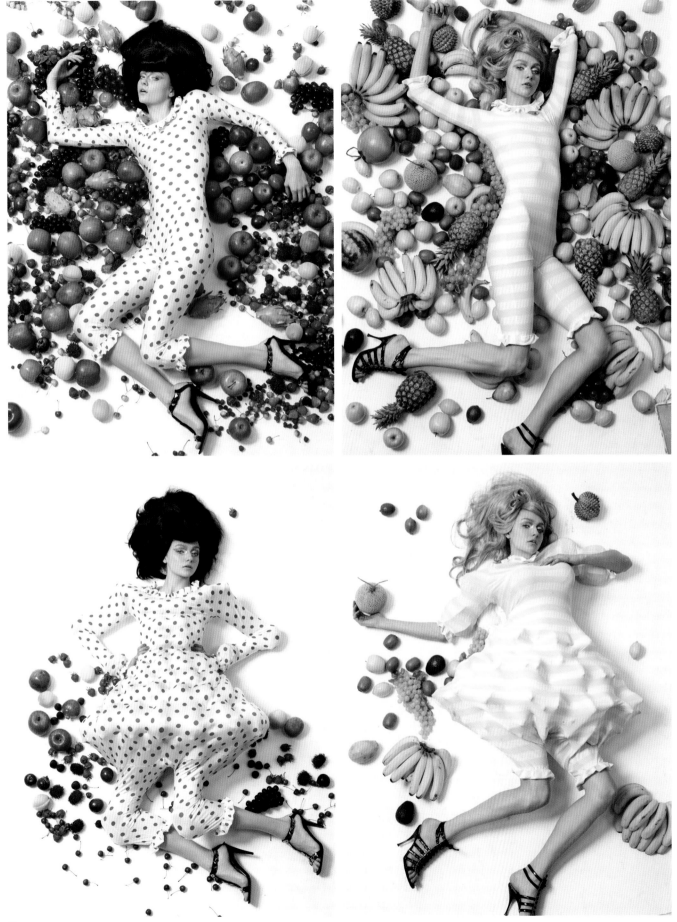

Title: Laforet Spring **Type:** Art direction
Year: 2006 **Client:** Laforet

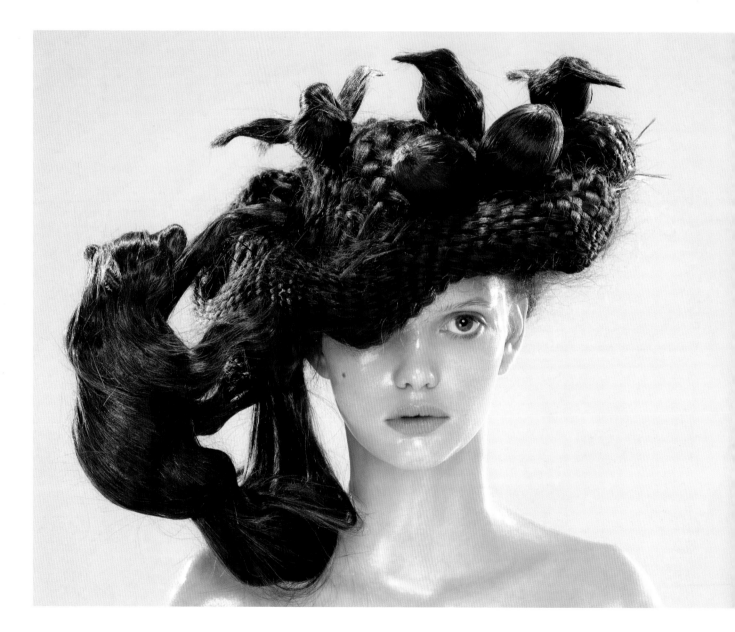

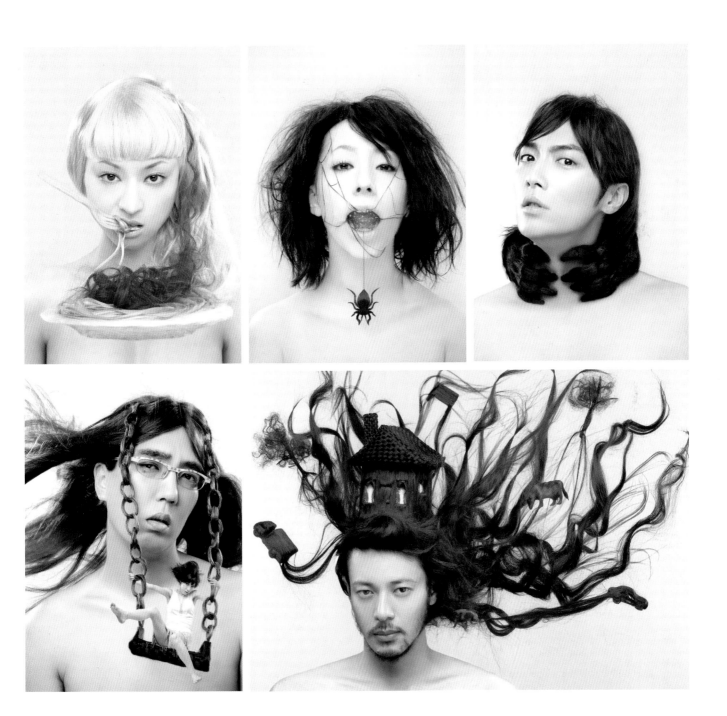

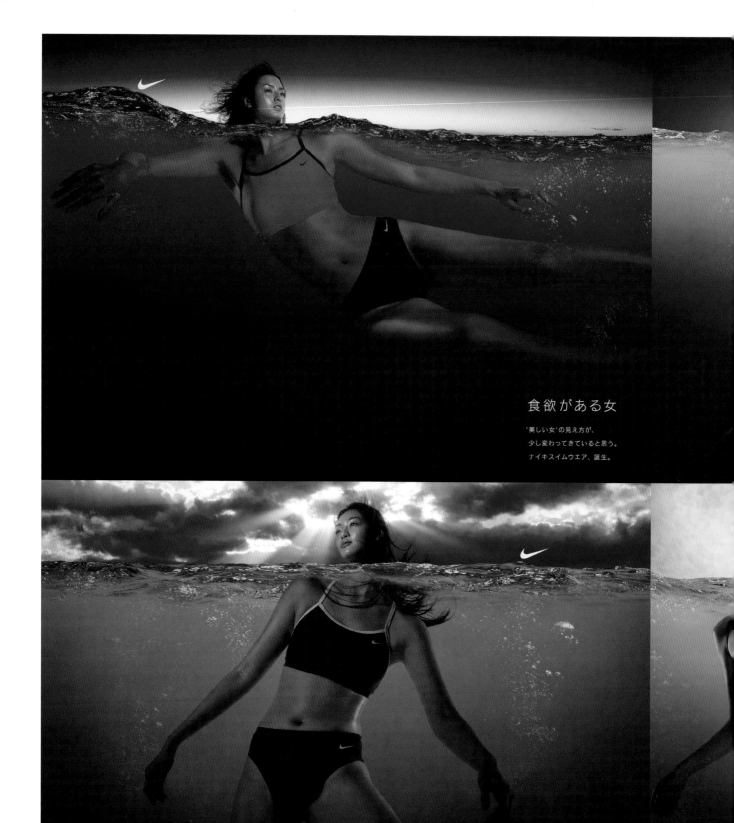

食欲がある女

'美しい女'の見え方が、
少し変わってきていると思う。
ナイキスイムウエア、誕生。

体力がある女

'美しい女'の見え方が、
少し変わってきていると思う。
ナイキスイムウエア、誕生。

Title: Nike Swim **Type:** Art direction **Year:** -
Client: Nike
Description: Advertising.

196
/
197

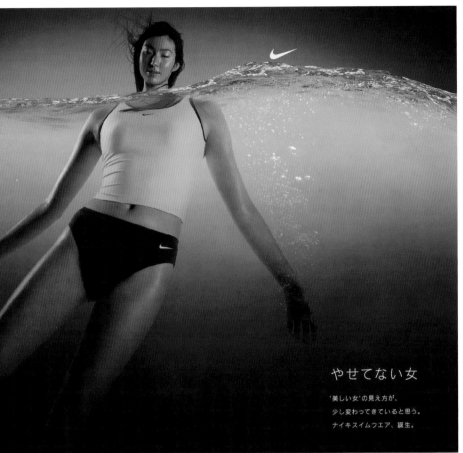

やせてない女

'美しい女'の見え方が、
少し変わってきていると思う。
ナイキスイムウエア、誕生。

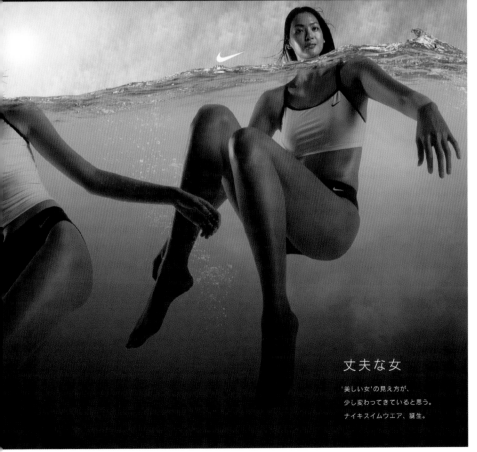

丈夫な女

'美しい女'の見え方が、
少し変わってきていると思う。
ナイキスイムウエア、誕生。

Title: 1/ Laforet Autumn/Christmas
2/ Laforet Spring **Type:** Art direction
Year: 1/ 2006 2/ 2005-07 **Client:** Laforet

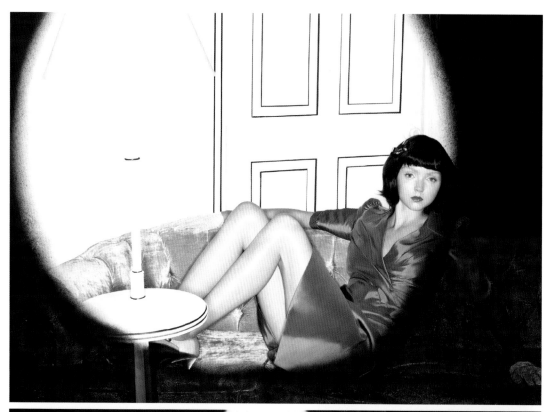

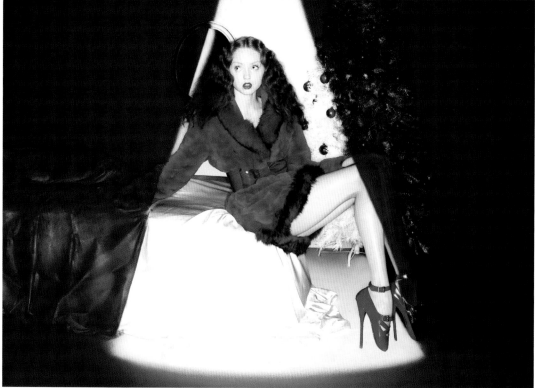

1/

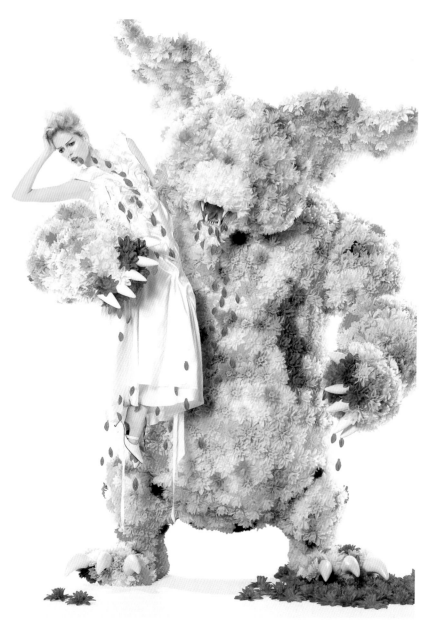

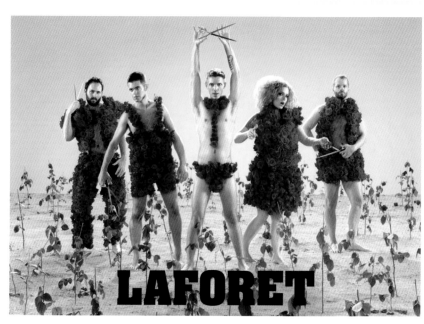

Title: Broken Label **Type:** Fashion **Year:** -
Client: Broken Label

Description: Fashion brand of Nagi Noda and
Mark Ryden.

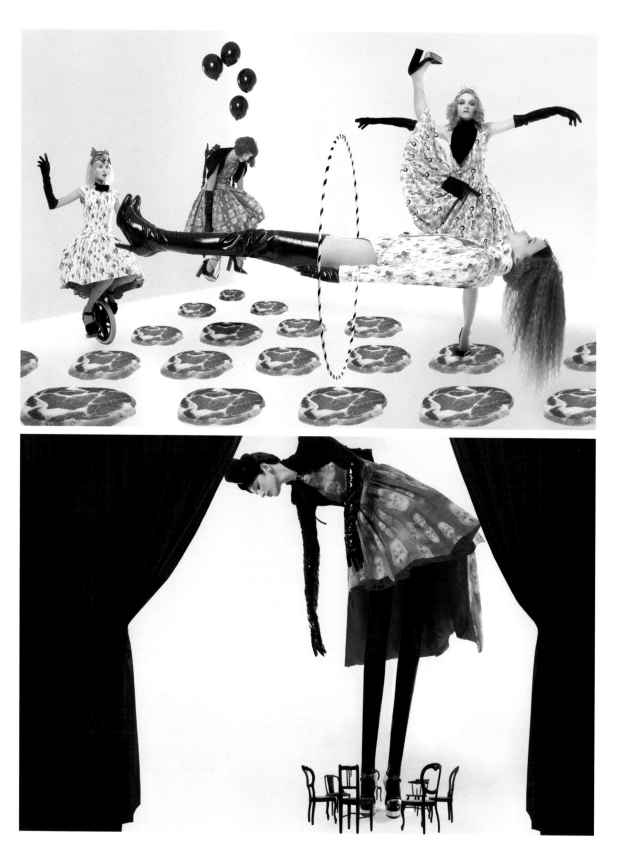

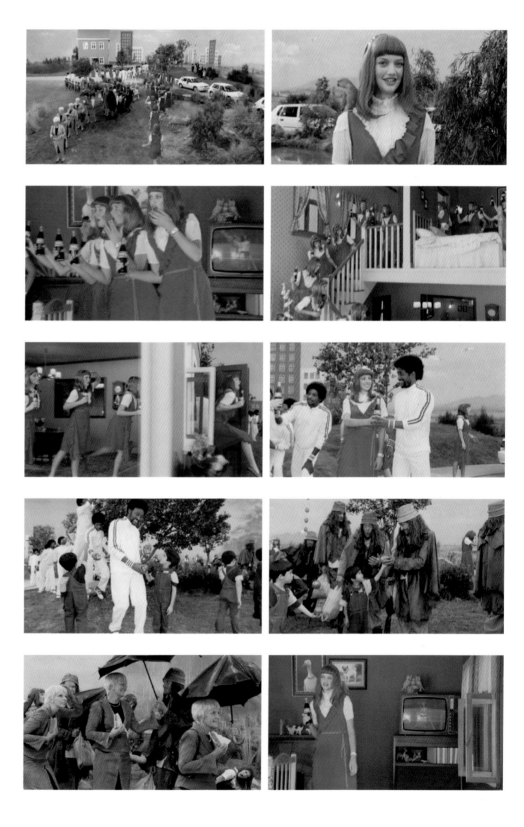

JMGS/JELLYMON

SHANGHAI, CHINA

1, 4/ Title: eno + 'A Tribe Called' **Type:** Clothing design **Year:** 2008 **Client:** eno Shanghai **Photographer:** Tony Law

Description: The line called 'A Tribe Called...' was based on 6 of the 56 indigenous minority tribes of China. For girls' line, JMGS/Jellymon took inspiration from the Manchu, Pumi and Miao tribes while for boys', the Nu, Weiwuer and Dulong tribes. In April 2008, the collection hits eno stores China and a few selected retailers worldwide.

2/ Title: Reine et Roi x Jellymon: 2 Windbreakers **Type:** Apparel **Year:** 2008 **Client:** Reine et Roi (New York)

Description: 2 wind-breakers, one for men and one for women, in the signature JMGS/Jellymon style. They feature robots, pagodas, planets, little squares in perspective, zips, hoods, drips, black, white, gold, silver, purple, blue, red and many other colours and things. They could be found in Classic Kicks in New York and other Reine et Roi stockists like Colette in Paris and Essence in Japan.

3/ Title: Casio x Jellymon **Type:** Digital watches (in progress) **Year:** 2007-08 **Client:** Casio

Description: 3 G-Shock watch designs for Casio.

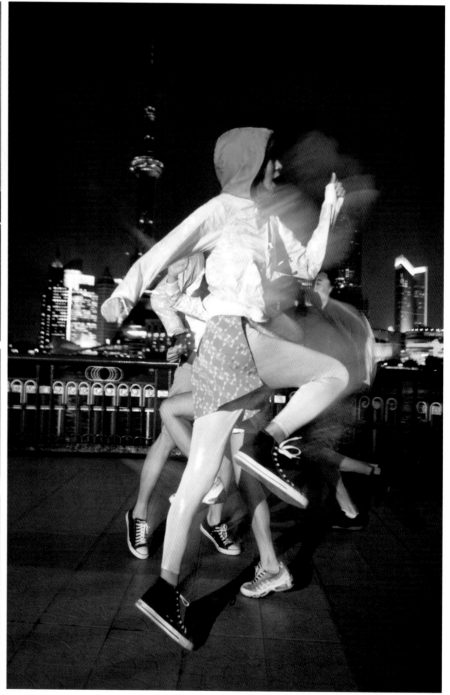

1/

2/

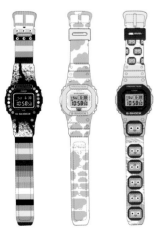

3/

4/

Title: Adidas Photography Stuff **Type:** Art direction, Styling **Year:** 2008 **Client:** Adidas
Photographer: Tony Law

Description: Art direction and styling for Adidas' photo-shoots.

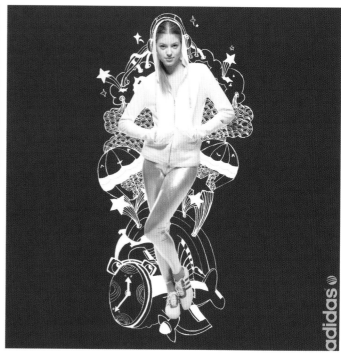

Title: Ping Pong Shoe Box Set **Type:** Fashion, Sneaker Design **Year:** 2007 **Client:** eno Shanghai

Description: A limited edition box set including Ping Pong sneakers, Ping Pong paddles, 2 Ping Pong balls and a t-shirt.

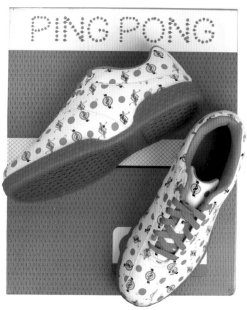

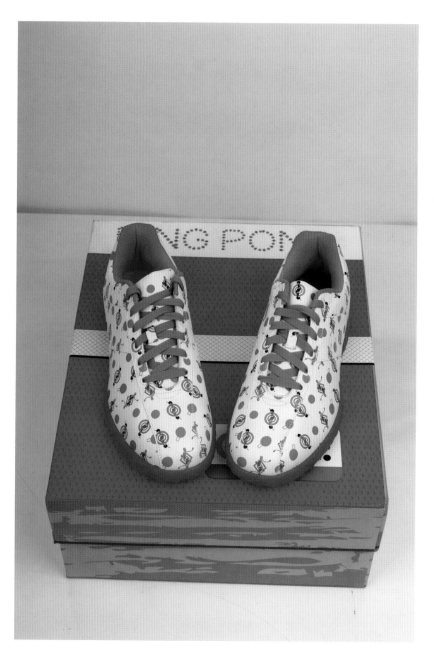

1, 3/ Title: Jellymonogram **Type:** Series of 6 toys, Production run of 300 sets **Year:** 2006 **Client:** -

Description: Jellymonogram is a repetitive pattern toy that generally lives on luxury bags. Jellymonogram members are here to seek revenge on materialistic girls who starve and prostitute themselves for high-priced fashion bags.

2/ Title: Choking Hazard **Type:** 4 electric ABS plastic toys, Art piece **Year:** 2006 **Client:** -

Description: Choking Hazard consists of 4 toy members: Major Voltage, Charles Switch-ington, Felicity Fansworth and Phillip Von Filament. Their feet could be connected to become one. With a flick of Charles Switchington's nose, they could form a circuit in which Phillip's head would pathetically glow and Felicity's fan would spin slowly that no wind would be produced. Almost nothing would be done by Choking Hazard except for a tiny little something as JMGS/Jellymon knows that even a little something would take a long way.

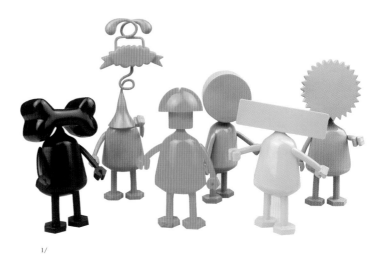

1/

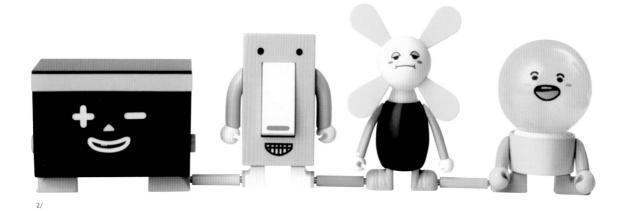

2/

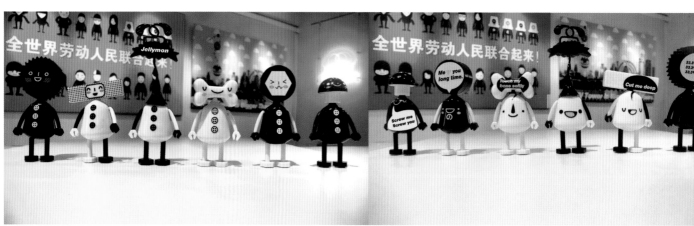

3/

Title: Jesus Wong **Type:** Material skeleton
Year: 2007 **Client:** Evisu

Description: Made for the Evius China Cube Gallery exhibition, Jesus Wong is an art piece created with Evius denim, fabrics and buttons. JMGS/Jellymon's piece is a skeleton that has a confusing identity mixing up the dead body of a Mexican guy and a Chinese opera star.

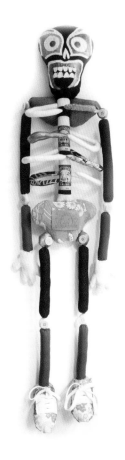
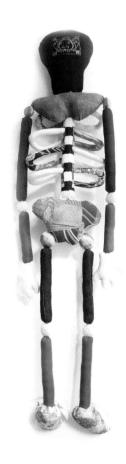

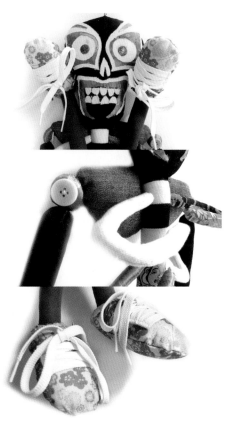

1/ Title: Sweetest Propaganda **Type:** Art, Design, Fun **Year:** 2005-08 **Client:** -

Description: This is part of JMGS/Jellymon's 'Sweetest Propaganda' work. It came from a famous slogan they saw on the wall of a Ningbo restaurant in Shanghai: 'Workers of the World Unite.' JMGS/Jellymon believes they are a part of the new work force and that creative people should push the new agenda forward. The picture has featured illustrations by some of their friends who are also creatives, designers and artists from China.

2/ Title: The Secret Life of Pagodas and Other Assorted Structures **Type:** Art **Year:** 2008 **Client:** -

Description: 'The Secret Life of Pagodas and Other Assorted Structures' is an exhibition JMGS/Jellymon working on slowly but surely. A lot of beautiful buildings have been destroyed in the name of progress and the design duo wish to retain their spirit in this series of images. The series will depict many types of buildings from pagodas to skyscrapers and even silly-looking TV towers.

1/

2/

Description: Images of the design duo's good friend, the Oriental Pearl Tower, or 'Pearly' as they would call her. 'Pearly' towers majestically on the side of the Huangpu river declaring 'I look funny and silly and provide you with hours of bad television.' Just a short while after her presence, 'Pearly' reminded JMGS/Jellymon of the song 'My funny valentine; sweet comic valentine; you make me smile with my heart. Your looks are laughable; unphotographable; yet you're my favourite work of art.'

COMMUNION W LTD

/
HONG KONG, CHINA

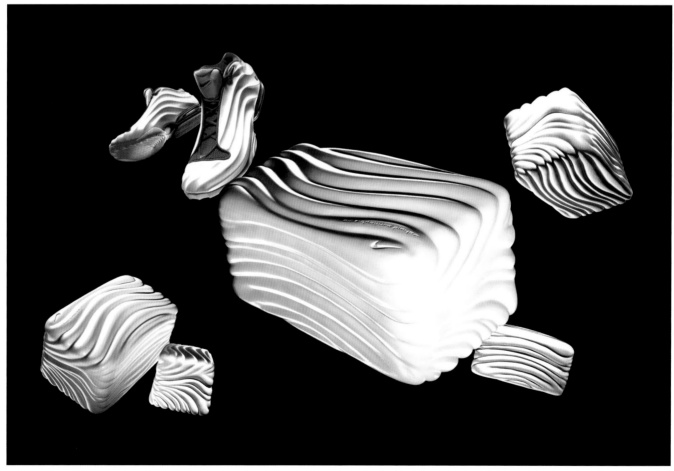

1 - 2/ Title: NIKE Shoe Box **Type:** Product
Year: 2003 **Client:** NIKE Hong Kong

Description: A tailor-made box to highlight
the design of the Nike shoes.

210
/
211

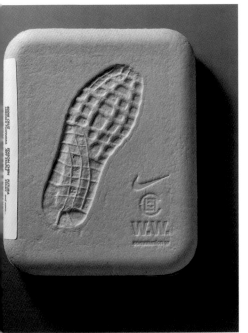

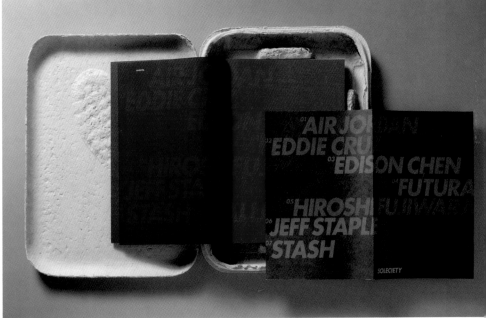

1/ Title: Soleciety **Type:** Book **Year:** 2006 **Client:** CLOT

Description: Featuring high glossy photos and artists like Futura, Jeff Staple, Hiroshi Fujiwara, to name a few, the book is wrapped inside a pulp mold box. Its cover is debossed with a size 10.5 shoeprint of the Air Max I Hong Kong Edition.

2 - 3/ Title: NIKE Campus Spring Catalogue **Type:** Catalogue **Year:** 2005 **Client:** NIKE Hong Kong

Description: Nike apparel catalogue combining real models in an illustrated background drawn by 4 illustrators.

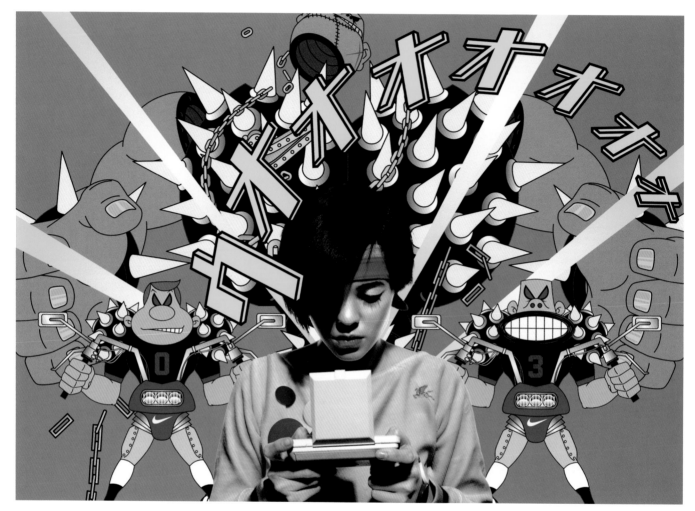

1/

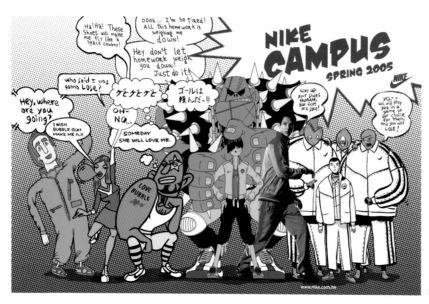

2/

www.nike.com.hk

六福 FOREVERMARK 　楊千嬅
all about Love
2007演唱會

Title: Miriam Yeung Concert Poster And Stage
Design **Type:** Concert **Year:** 2007
Client: Miriam Yeung

Description: Stage and poster design for a
local pop singer riding on the theme 'Love.'

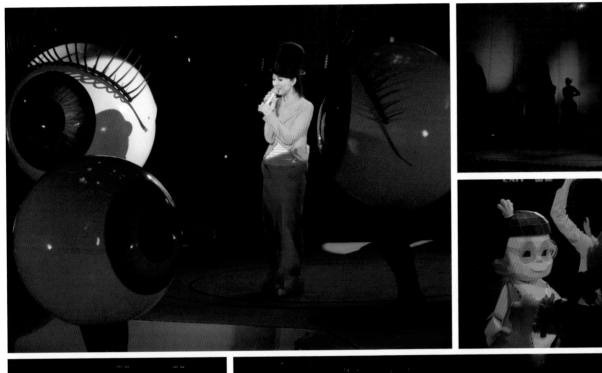

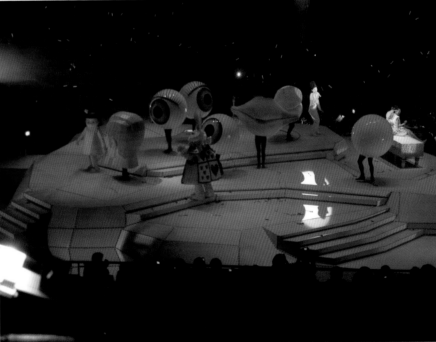

1/ Title: Wyman 'After Ten' CD Album
Type: CD Album **Year:** 2005
Client: Wyman Wong

Description: An album design for a local lyricist's 10th anniversary collection.

2/ Title: Edison 'Please Steal My Album' CD Album **Type:** CD Album **Year:** 2004
Client: Edison Chan

Description: 8 different cover designs featuring renowned artists from around the world.

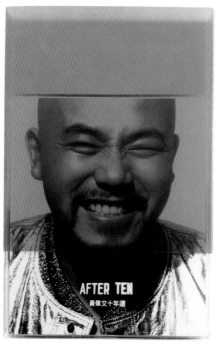
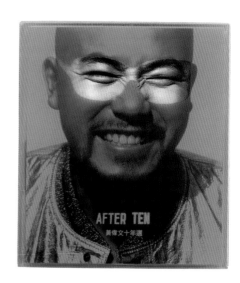

1/

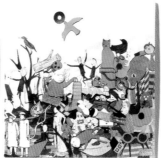
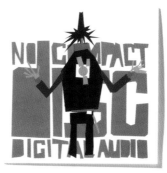
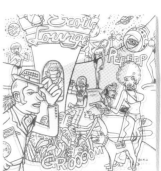

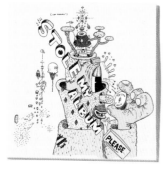

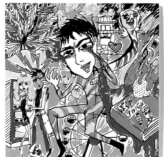

2/

Title: Bread n Butter Catalogue
Type: Catalogue **Year:** 2004
Client: Bread n Butter

Description: A themed catalogue for the launching of a new fashion brand called 'Bread n Butter.'

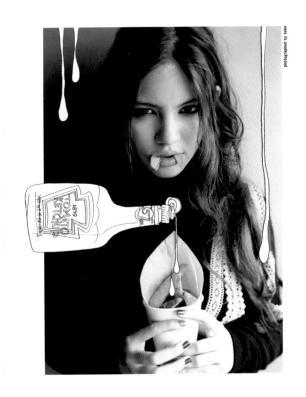

2MAGAZINE

BANGKOK, THAILAND

Title: 2magazine Design **Type:** Inside fashion, Lifestyle spreads **Year:** 2006 - present
Client: 2magazine

Description: Fashion and lifestyle layouts. The theme was to give an impact of clean, simple and masculine with bold graphics. The magazine contains sections like interview and profiles, fashion editorials, and feature stories.

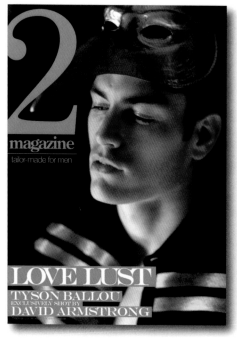

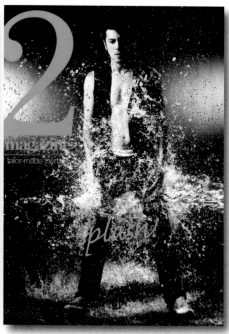

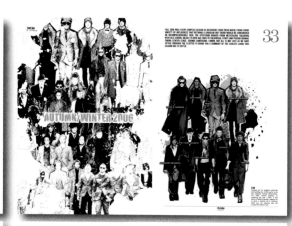

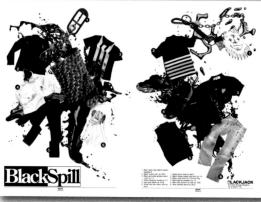

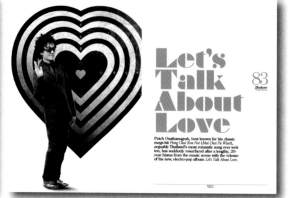

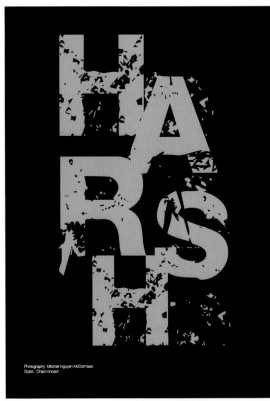

HARSH

Photography: Mitchell Nguyen McCormack
Stylist : Chad Kincaid

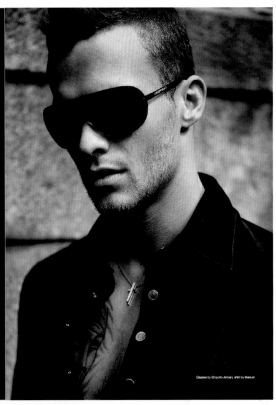

Glasses by Emporio Armani, shirt by Manuel

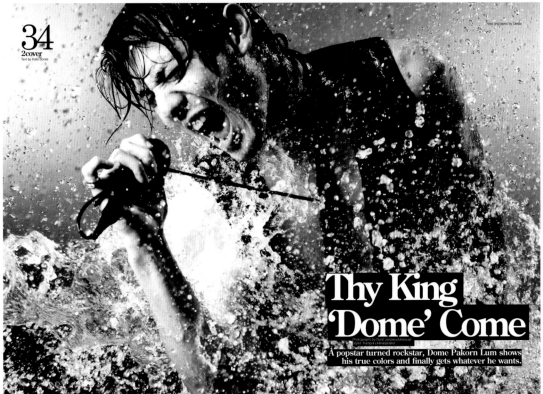

34
2cover
Text by Kelly Jones

Vest and jeans by Diesel

Thy King 'Dome' Come

Photographs by Suraj Janyawatidharawut
Stylist: Kampol Likitkanjanakul

A popstar turned rockstar, Dome Pakorn Lum shows
his true colors and finally gets whatever he wants.

W WALKMAN The Walkman™ logo and symbol are registered as trademarks of Sony Corporation.

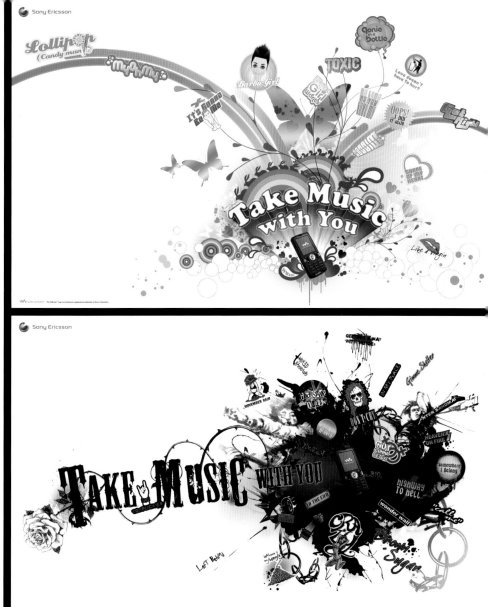

Title: Space Odyssey **Type:** Fashion spread
Year: 2005 **Client:** Bed Supper Club

Description: Fashion editorial designed to promote Bed Supper Club merchandise. Space Odyssey conceptually used the space age design of Bed Supper Club, to create a spread featuring futuristic space tribes, aliens and robots.

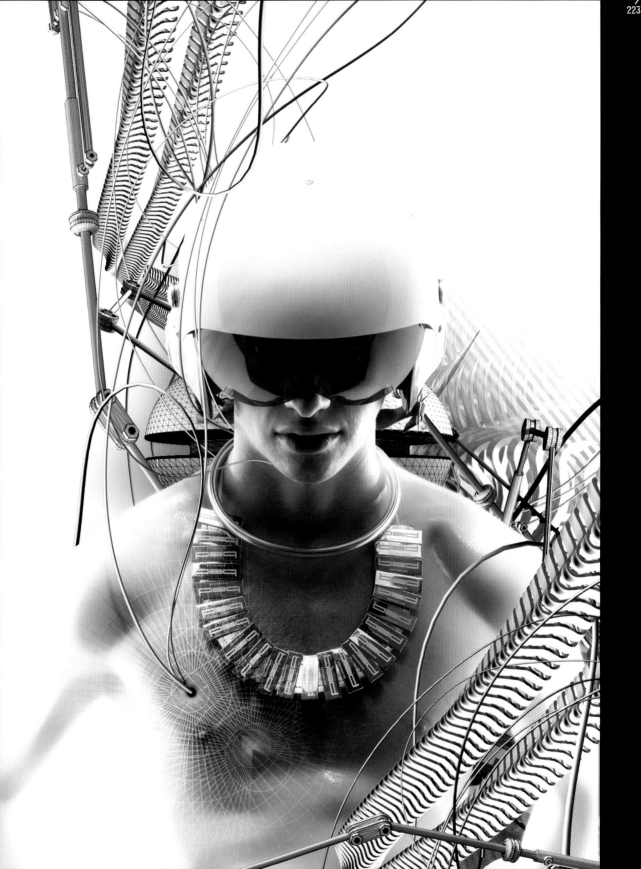

Title: Astrology **Type:** Calendar photo
illustration **Year:** 2005 **Client:** Lyn

Description: Models of Lyn shoes digitally
manipulated to create 12 astrological symbols
for a calendar, each for a month.

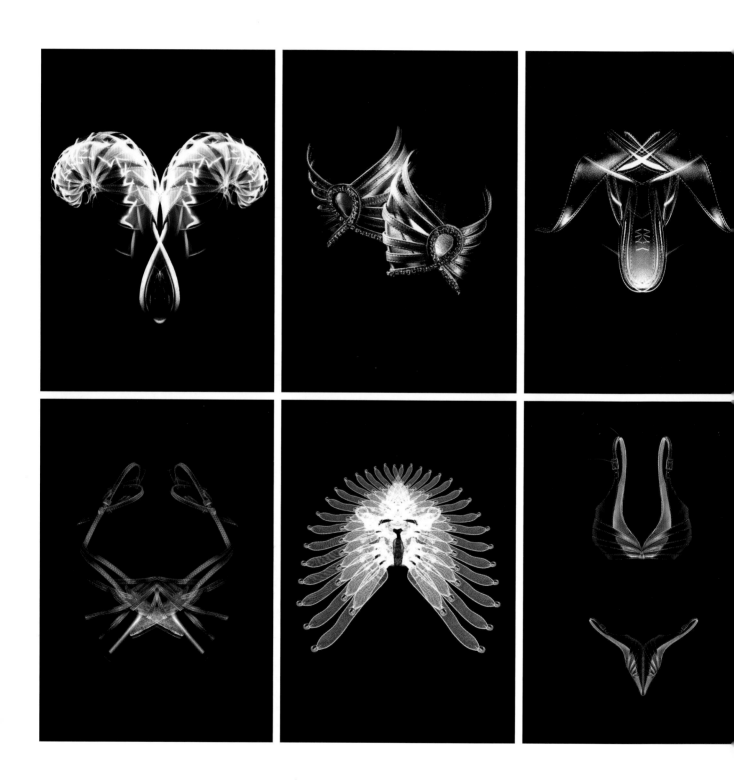

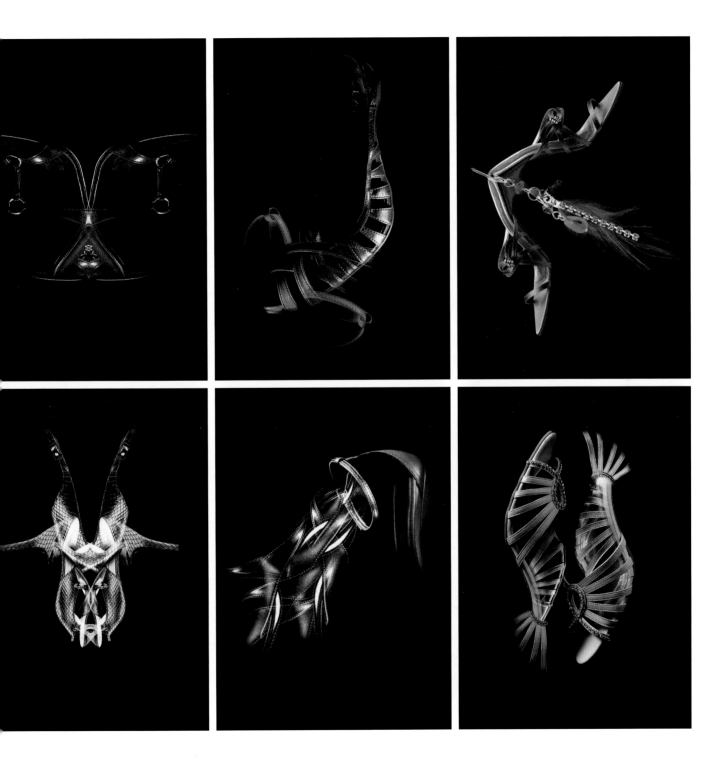

XXXL REMIXED CREATIVE FACTORY

/ BEIJING, CHINA

1/ Title: Vision On Ears **Type:** Poster
Year: 2007 **Client:** A8music

Description: XXXL Remixed Creative Factory exhibition poster for A8music. It marked the first collaboration between the designers and musicians visualising music in the exhibition.

2/ Title: Rise (上升) **Type:** Poster **Year:** 2007
Client: Tiger Beer

Description: The work blending the theme of 'rise' and Chinese culture, has merged the new norms with the traditions. It was made for the exhibition by Tiger beer and IdN.

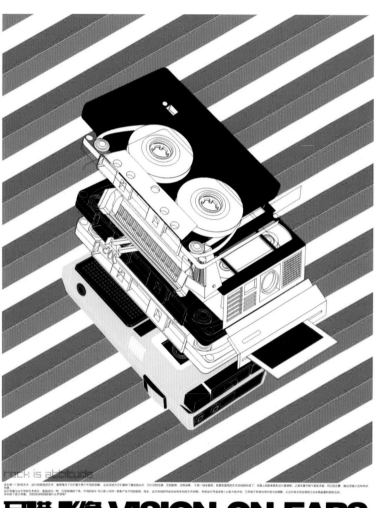

1/

2/

Title: Graphire Advertising **Type:** Advertising
Year: 2006 **Client:** Woacom

Description: An advertisement for Graphire,
Woacom's new product in 2006. The client
wanted a glossy world in the ad.

226
/
227

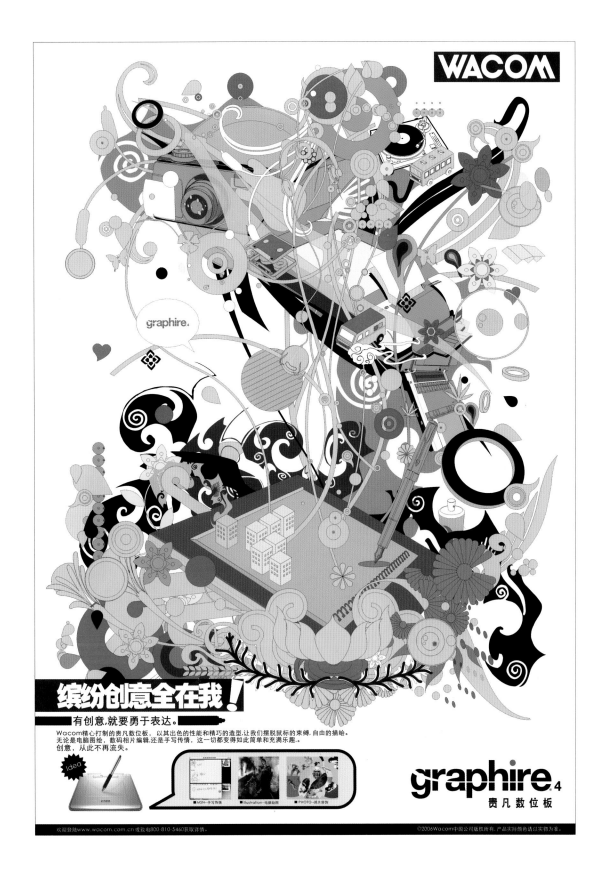

Title: Beautiful Football (美麗足球)
Type: Wallpaper **Year:** 2006 **Client:** NIKE

Description: Football is the representative spirit of modern Chinese culture and thus XXXL Remixed Creative Factory used flowing lines to represent a subtle yet powerful mentality.

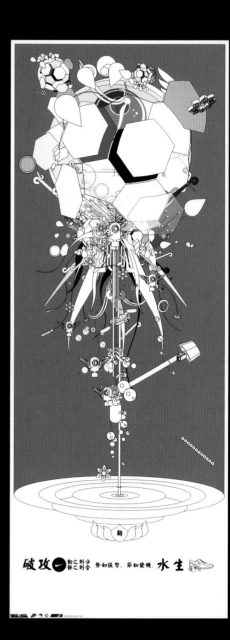

Type: Website **Year:** 2007 **Client:** NIKE

Description: XXXL Remixed Creative Factory
created graphics for Nike Chinese athletes.
The theme was to promote the never-give-up
spirit of the Asian Games Chinese athletes.

潜力第一 2004获中国职业足球最佳新人奖，同年也是最年轻队长

2006年，212 cm，中国专业篮球赛历史最年轻MVP

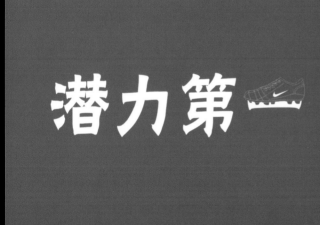

潜力第一 2004获中国职业足球最佳新人奖，同年也是最年轻队长

2006年，212 cm，中国专业篮球赛历史最年轻MVP

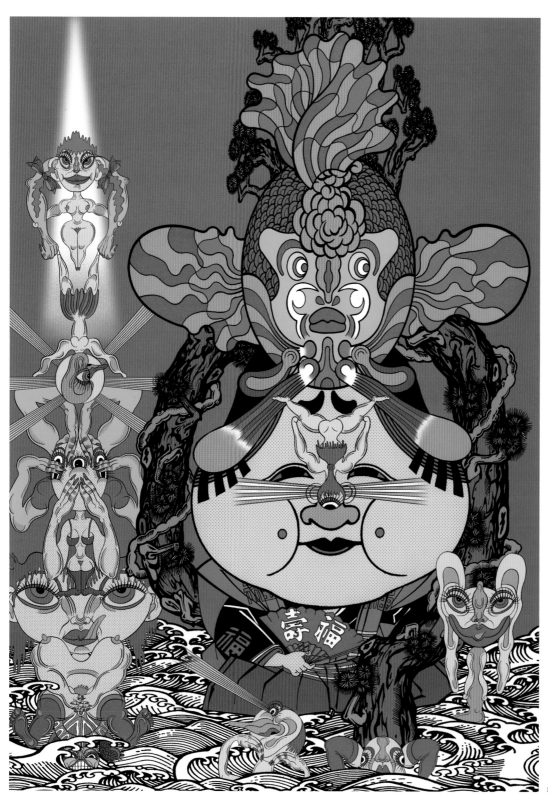

1/

1/ Title: Eternal Afternoon **Type:** Artwork
Year: 2006

2/ Title: Body Painting, Keiichi Tanaami x
Chiye Namegai **Type:** Artwork **Year:** 2007

3/ Title: KAMON **Type:** Artwork **Year:** 2005
Client: KING OF MOUNTAIN

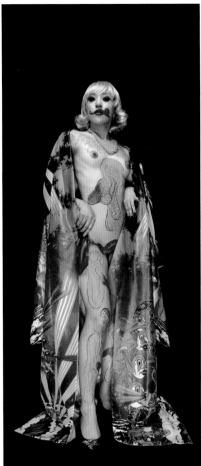
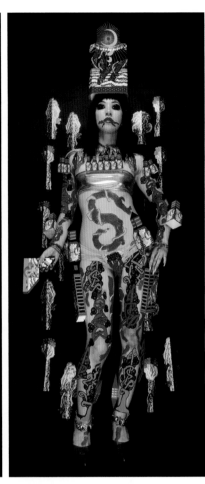

2/

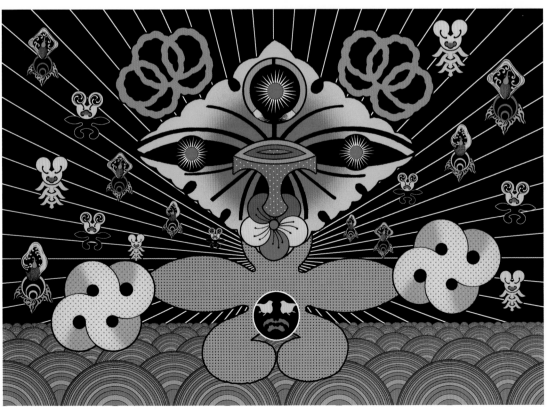

3/

1/ Title: Rolling 60s **Type:** Fashion
Year: 2005 **Client:** KING OF MOUNTAIN
2/ Title: Rainbow-Coloured City
Type: Artwork **Year:** 2006

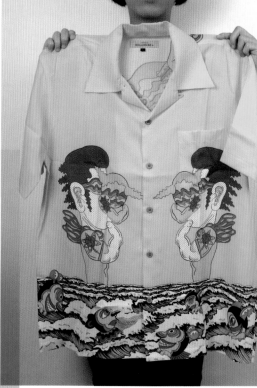

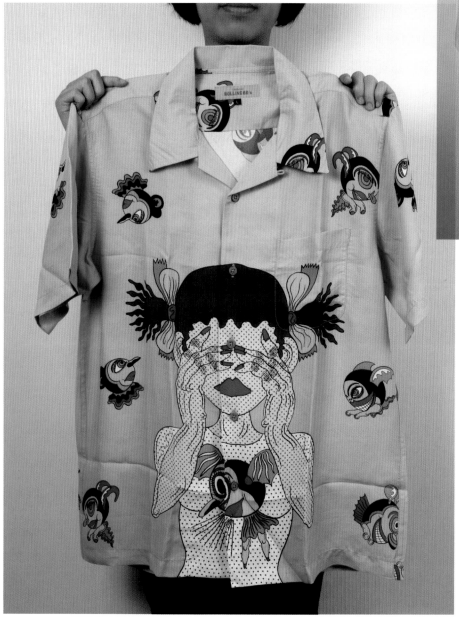

1/

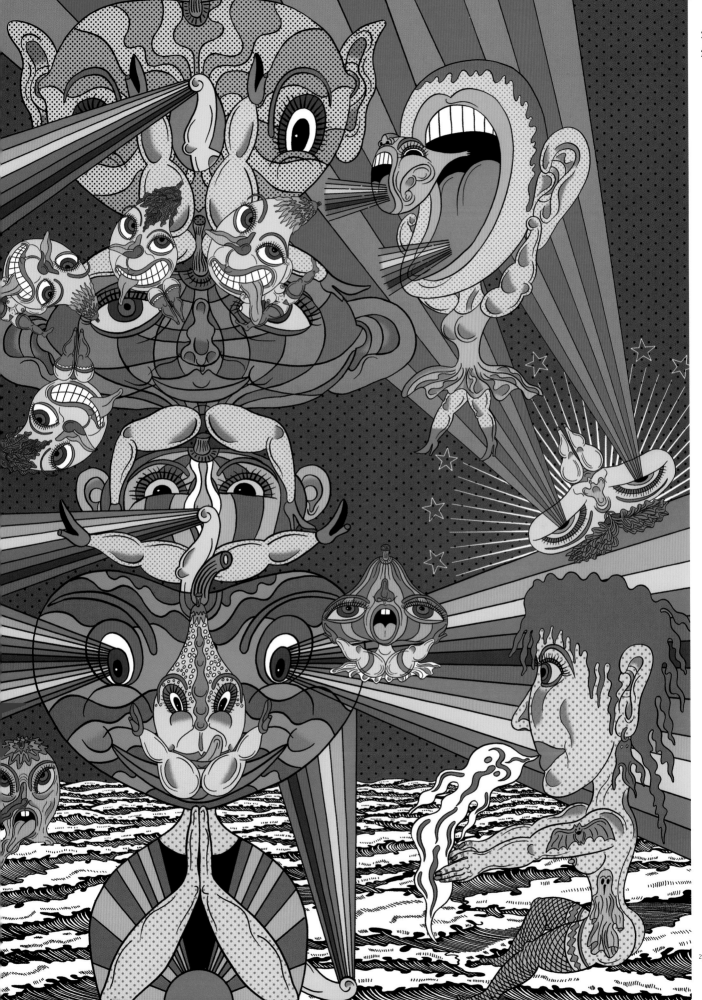

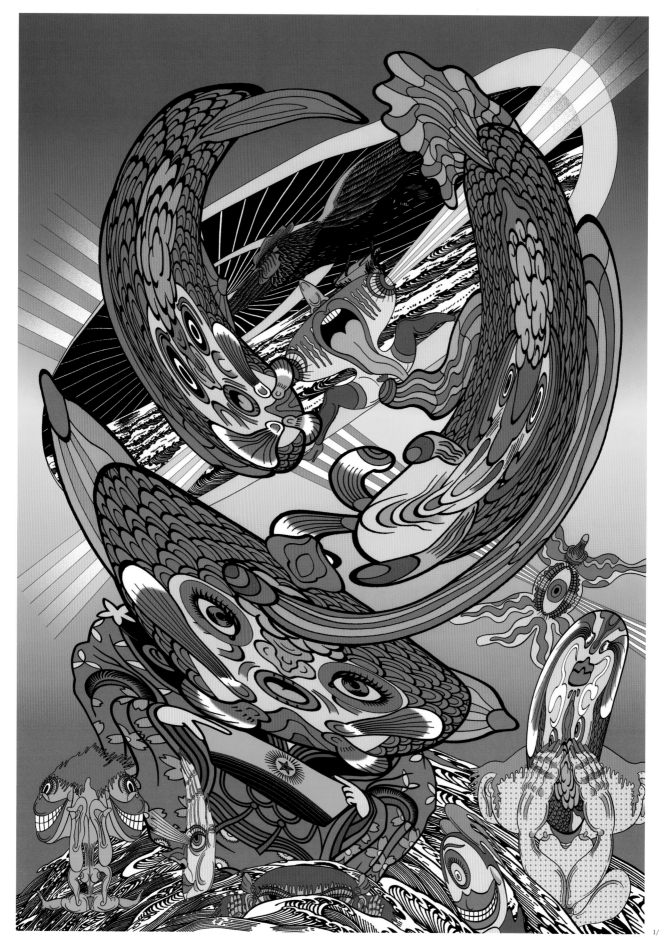

1/ **Title:** Madly Dancing Goldfish
Type: Artwork **Year:** 2006
2/ **Title:** City of de Chirico **Type:** Artwork
Year: 2006
3/ **Title:** Rainbow Twilight **Type:** Artwork
Year: 2007

234
/
235

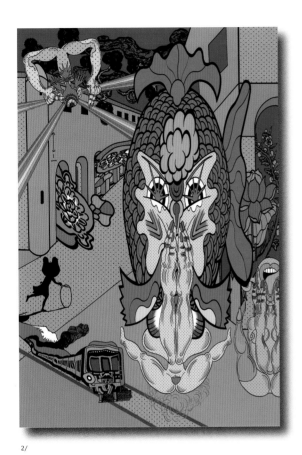

2/

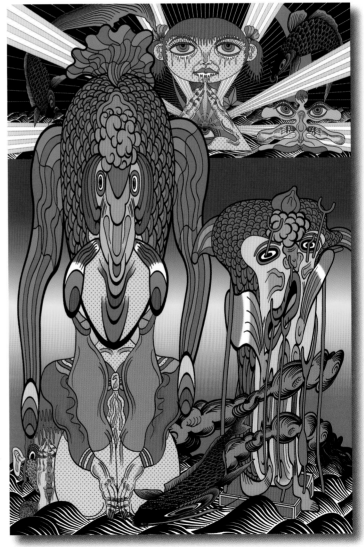

3/

1/ Title: Rolling 60s / NEW YORK
Type: Fashion **Year:** 2005 **Client:** KING OF MOUNTAIN
2/ Title: Rolling 60s / I LOVE GIRLS
Type: Fashion **Year:** 2005 **Client:** KING OF MOUNTAIN
3/ Title: Rolling 60s / WONDER GIRL
Type: Fashion **Year:** 2005 **Client:** KING OF MOUNTAIN

2/

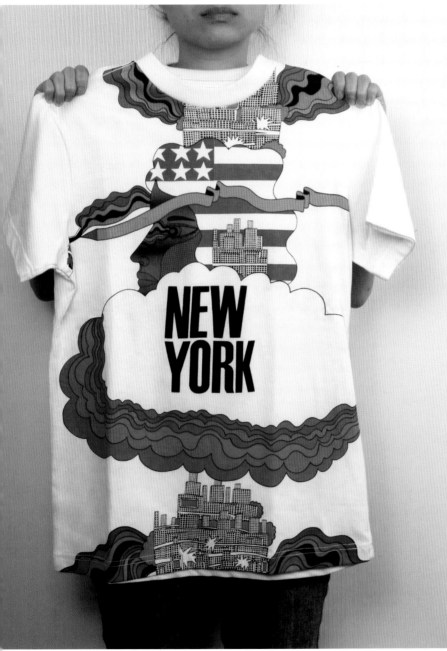

1/

3/

1/ Title: Variation Of Waves **Type:** Artwork
Year: 2007

2/ Title: Seaside Eros A **Type:** Artwork
Year: 2006

3/ Title: Skeleton Bonsai **Type:** Artwork
Year: 2005

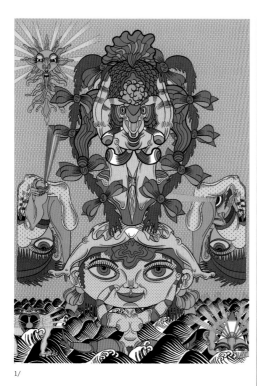

1/

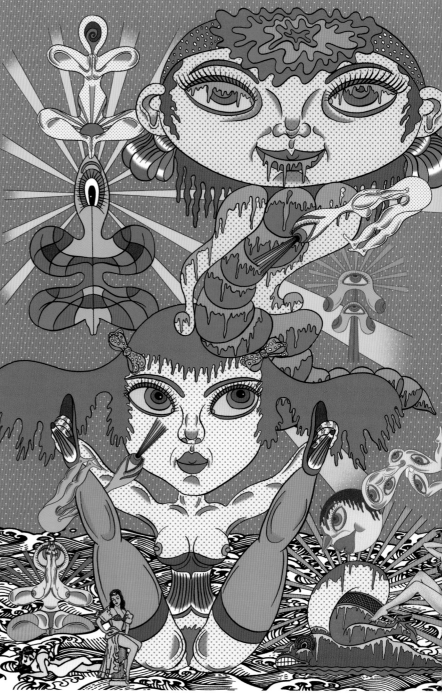

2/

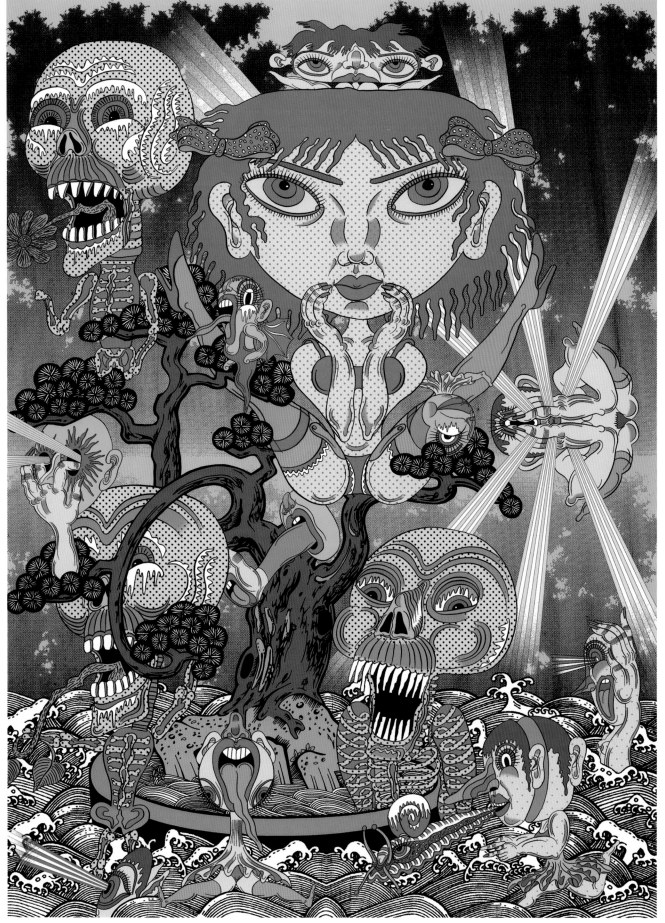

TED, HOK TAK YEUNG

/

HONG KONG, CHINA

1/ Title: Urban Sanshui **Type:** Illustration
Year: 2006 **Client:** Ming Pao Weekly

Description: Second trial for Chinese style painting, incorporated into the common scenes of Hong Kong.

2/ Title: Curtain **Type:** Cover illustration
Year: 2007 **Client:** Muse Magazine

Description: 'Curtain blocks' appeared in Hong Kong's shore as a major threat to the community behind their 'shadows.' Yeung hopes viewers would be able to recognise that the 'Mushroom' is poisonous in this case.

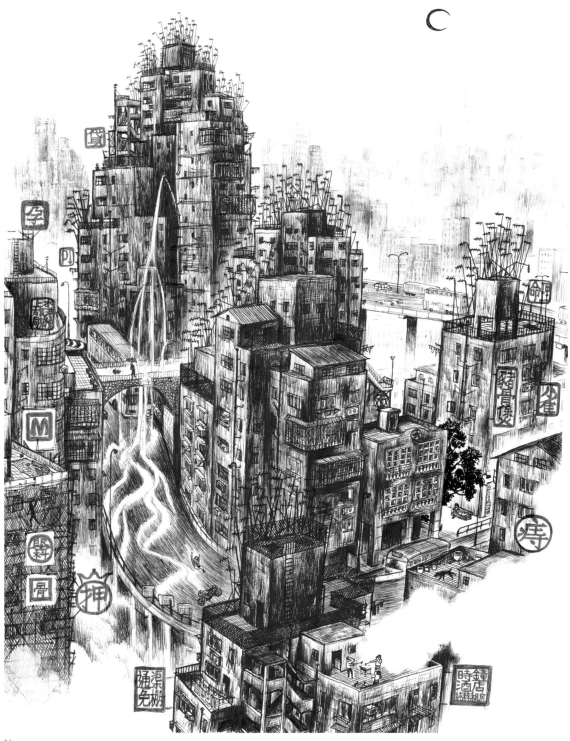

1/

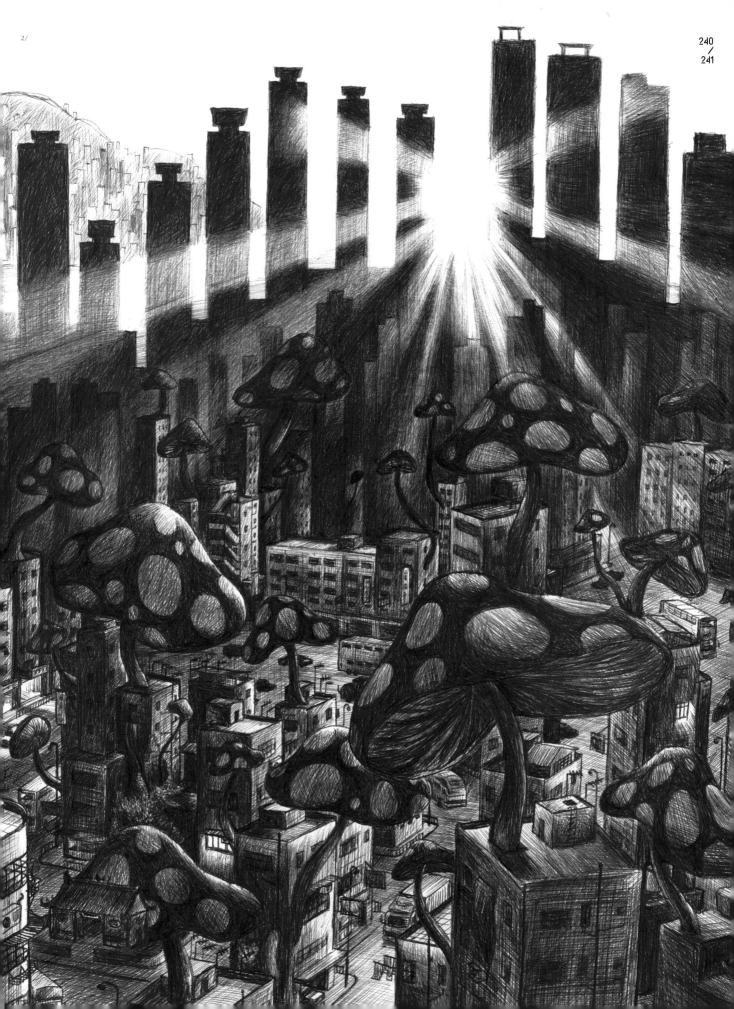

Title: 1/ Lamtin 2/ Lamtin Market
Type: Illustration **Year:** 2006 **Client:** -

Description: Illustrations made for the cover
of Yeung's French edition of 'How Blue Was My
Valley.' The first one is not selected.

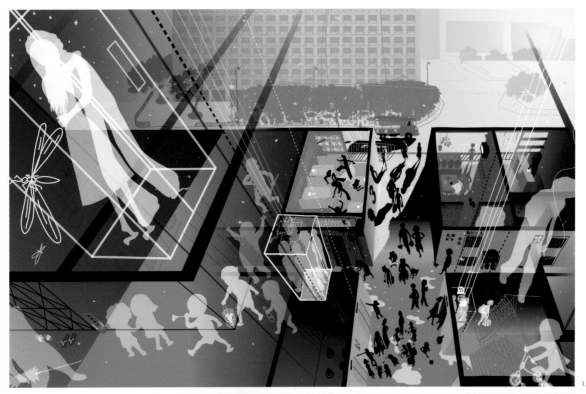

1/

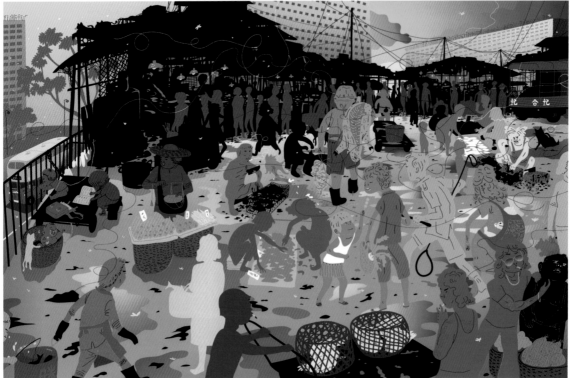

2/

Title: How Blue Was My Valley **Type:** Graphic novel **Year:** 2002 **Client:** -

Description: It is the cover illustration for Yeung's first personal graphic novel. The sewing machine is a symbol of 'sewing' that goes together with the fragments of his childhood memories.

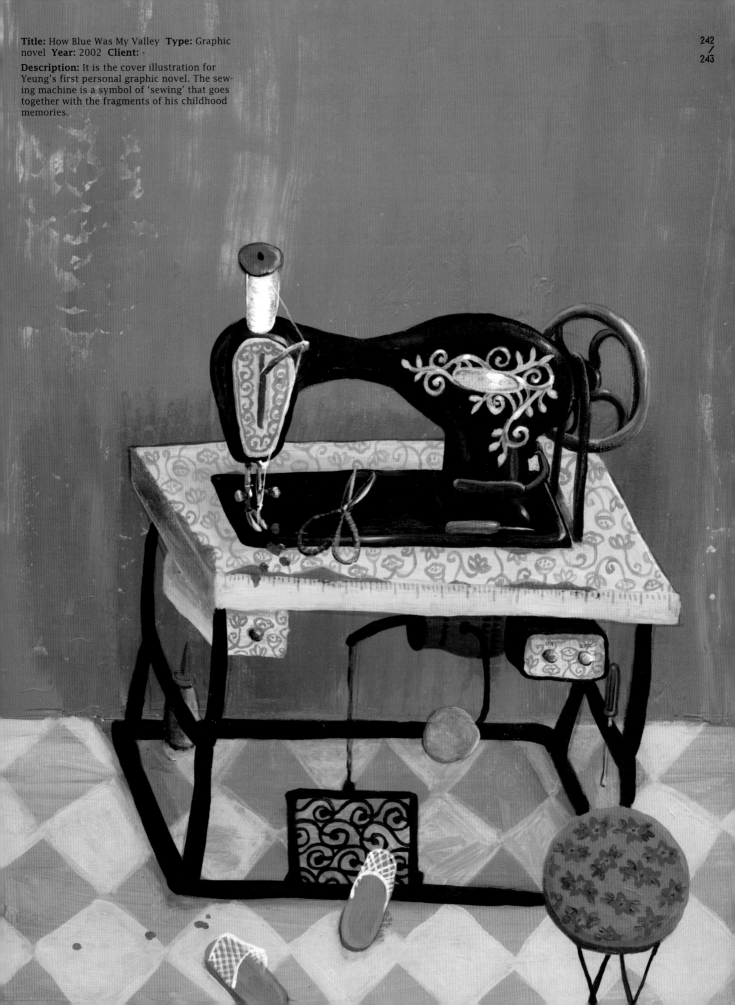

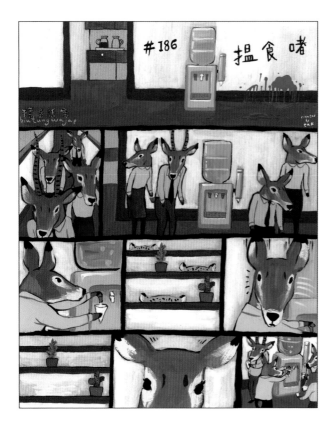
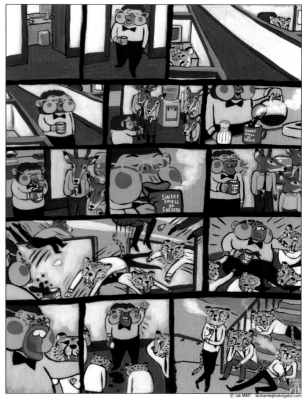

© tak MM7 kicklamb@netvigator.com

1 - 2/ Title: 1/ Safari 2/ Species **Type:** Comics **Year:** 2007 **Client:** East touch weekly

Description: An idea sparked off by the common scenes that appear on National Geographic. Yeung is a fan of the TV channel.

3/ Title: AV **Type:** Comics **Year:** 2007
Client: East touch weekly

Description: Inspired by the common scenes of Japanese AV videos, Yeung denies that he has watched any of them though.

/
J✱WLS

/
TOKYO, JAPAN

1/ Title: '????' **Type:** Illustration **Year:** 2008
Client: Glamarchy

Description: Homemade screen-print tee
shirts project.

2/ Title: Shimominimo **Type:** Illustration,
Flyer design **Year:** 2007 (Tokyo)
Client: Bar326, MIRAGE promotion

Description: Flyer designed with hand-drawn
illustration for a weekly minimal-techno
lounge-party at BAR326, in Shimokitazawa,
Tokyo (www.bar-326.com).

3/ Title: Blackpool Magazine Front Cover Con-
test **Year:** 2008 (Tokyo) **Type:** Illustration
Client: Blackpool Magazine (France)

Description: Cover contest proposal for Black-
pool Magazine.

1/

2/

Title: Pop Geisha **Type:** Illustration
Year: 2007 **Client:** -

Description: Illustration done with Illustrator®, and colour with Photoshop®.

1/ Title: Glamarchy **Type:** Logo / Illustration
Year: 2008 **Client:** Glamarchy

Description: Logo for personal homemade
screen-print apparel project.

2 - 3/ Title: Carnival **Type:** Illustration, Post-
er, Flyer **Year:** 2007 (Tokyo) **Client:** Minimal
Carnival (London)

Description: Poster and flyer designed for
Minimal Carnival party in London.

3/

1/

2/

RISA FUKUI

TOKYO, JAPAN

Title: Black Jack **Type:** Papercut artwork
Year: 2007 **Client:** UNIQRO / Tezuka Production
Description: UT project 'Tezuka Osamu x Risa Fukui.'

Title: Personal Distinction 1/ Black Woman
2/ White Man **Type:** Papercut artwork
Year: 1999 **Client:** -

Description: JACA (Japan Art & Culture As-
sociation) Japan Visual Art Exhibition Special
Award.

1/

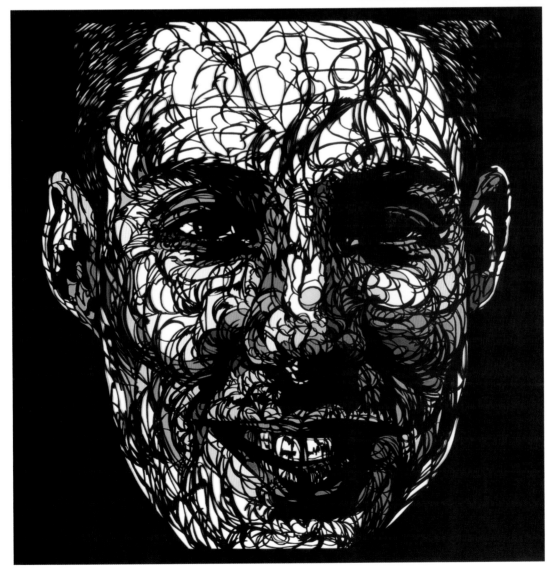

2/

Title: Untitled # for 'SAMSARA' **Type:** Paper-cut artwork **Year:** 2007 **Client:** Wani Books
Description: Artwork for Mika Nakashima's photo book 'SAMSARA.'

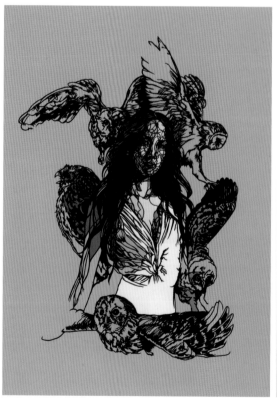

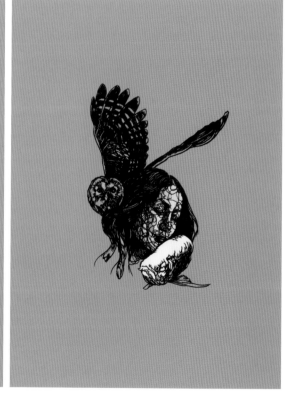

Title: Untitled # for 'MUSIC' **Type:** Papercut artwork **Year:** 2004 **Client:** Sony Music Associated Records Inc.

Description: Artwork for Mika Nakashima's album 'MUSIC.' The photo is the visual for its booklet.

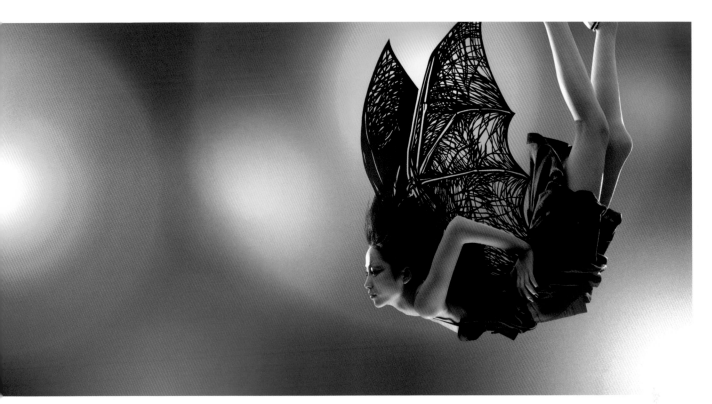

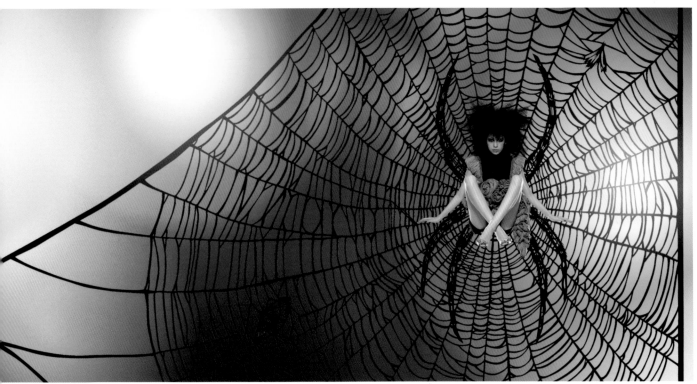

Title: January / Feburary **Type:** Papercut
artwork **Year:** 2004 **Client:** +81 magazine /
GARCIA MARQUEZ
Description: Works for a calendar.

Description: KI RI GA graces the cover of Fukui's first art book titled 'KI RI GA.' It is a papercut using one of the traditional techniques of Japanese craft, Kirie which is making a picture by cutting both white and black paper and putting colour paper between space.

2 - 3/ **Title:** 2/ Rhino (Green) 3/ Atom
Type: Papercut artwork **Year:** 2002, 2007
Client: -

Description: Original work in 2002 and 2007 respectively. Pay attention to the texture of Rhino.

1/

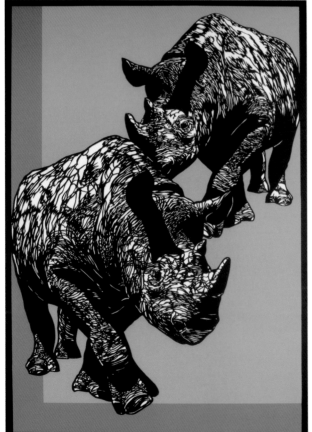

2/

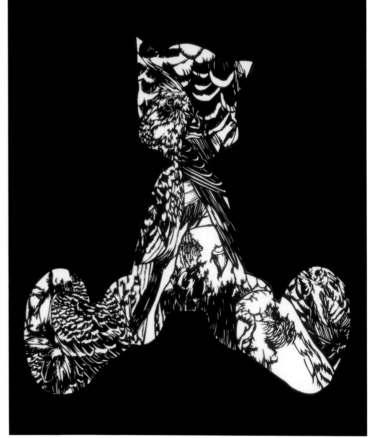

3/

1/ Title: Carp **Type:** Papercut artwork
Year: 2002 **Client:** Reebok

Description: Sneakers designed with papercut artwork in collaboration with Reebok.

2 - 4/ Title: Yugenbi of Nou – 2/ Henshin 3/ Keshin 4/ Hisurebahana **Type:** Photo, Papercut artwork **Year:** 2005 **Client:** -

Description: Collaboration work with Yoshi-hito Sasaguchi (Photography) and UDA (Hair & Makeup).

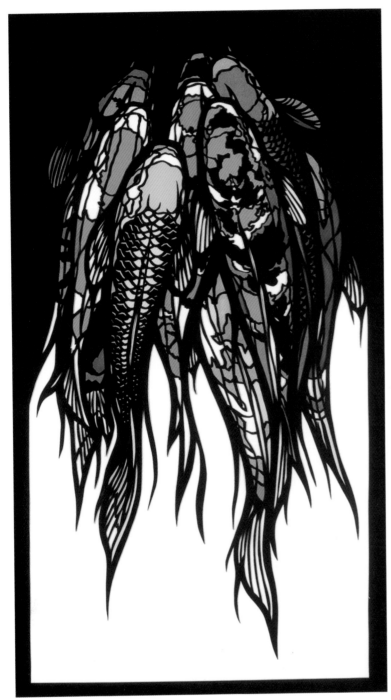

1/

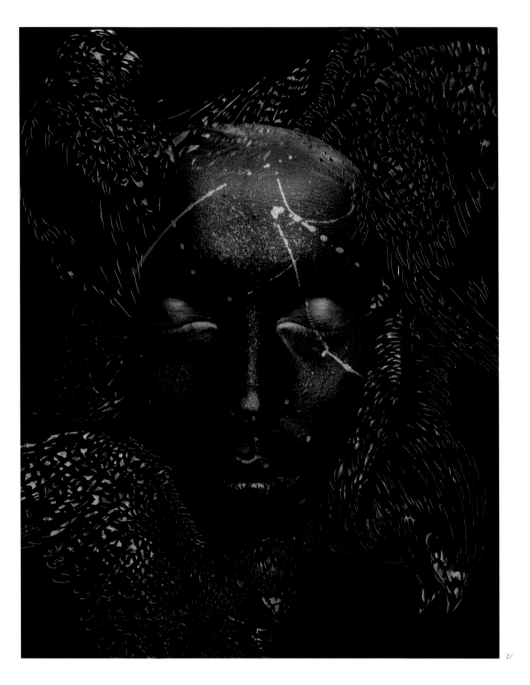

2/

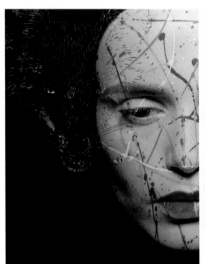

3/

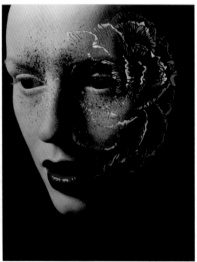

4/

REX KOO

HONG KONG, CHINA

1/ Title: Odeon Production Stationery
Type: Branding **Year:** 2004 **Client:** Odeon production

Description: Koo decided to use different typeface and graphics to create a series of stickers as the logo of Odeon Production, instead of a fixed logotype and symbol.

2/ Title: Helvetica Poster Exhibition
Type: Poster **Year:** 2005 **Client:** Cantonyama

Description: A poster created by the alphabet 'R' with Helvetica.

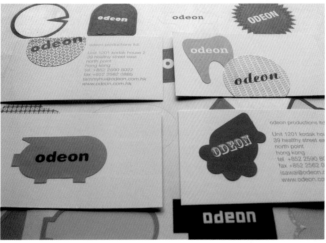

1/

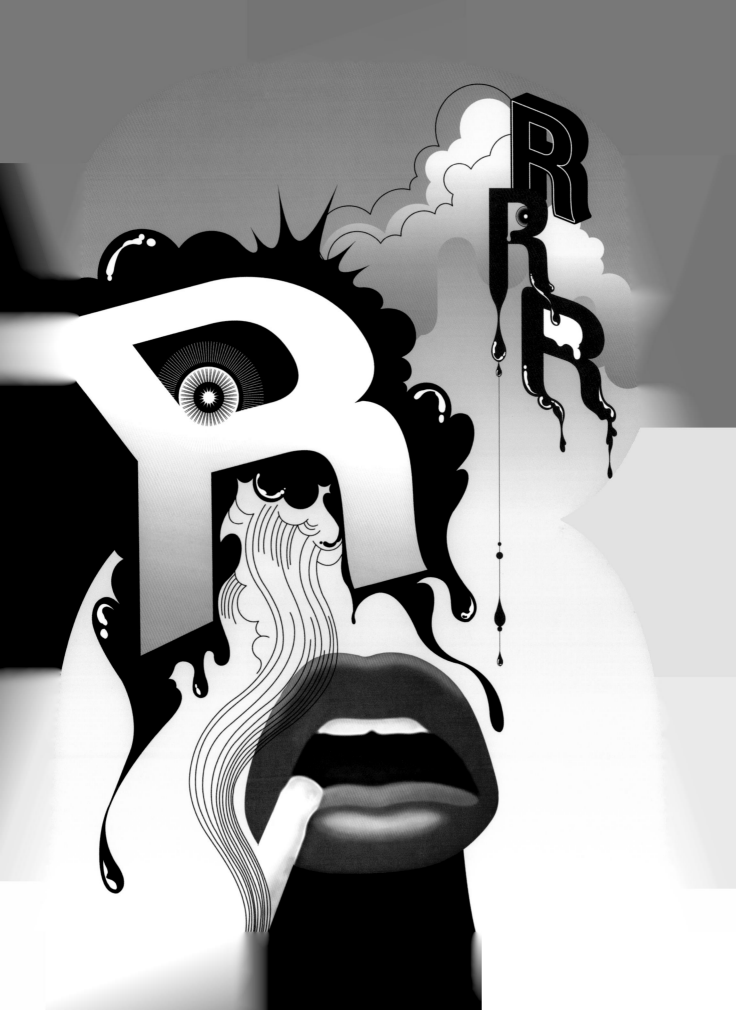

Title: Graduation Fashion Show, Exhibition 2003 For School Of Design **Type:** Book design **Year:** 2003 **Client:** The Hong Kong Polytechnic University

Description: A graduate booklet for the School of Design. In order to create a free form for the audience to read, no binding techniques were used for the book.

Title: Erotic Carpet **Type:** Illustration
Year: 2003 **Client:** -

Description: A carpet graphic Koo designed
for HOME exhibition (held by Store magazine).

260
/
261

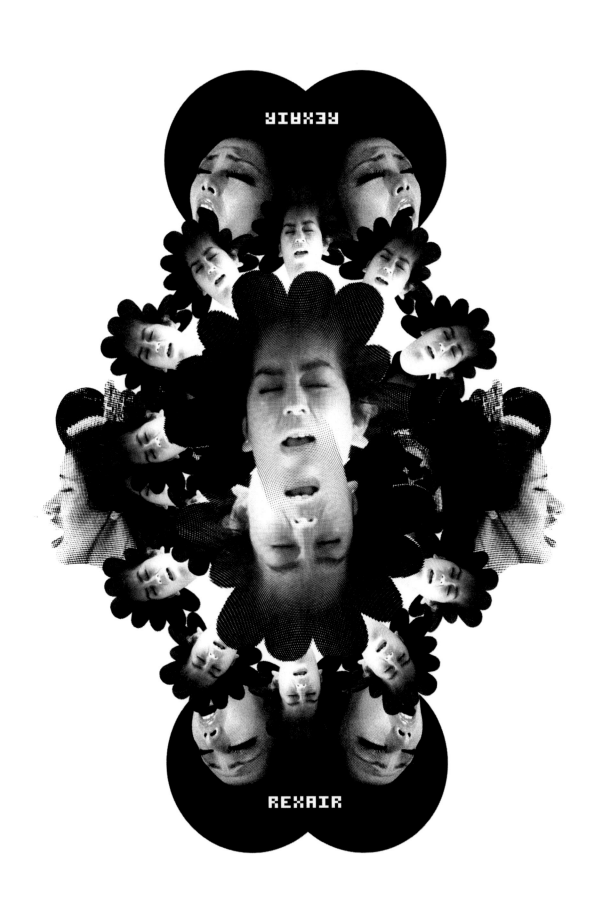

Title: Cocktail Grand Opening Invitation
Type: DM **Year:** 2007 **Client:** Sidefame group

Description: An invitation card for Cocktail
(A local ladies' wear boutique) grand opening.

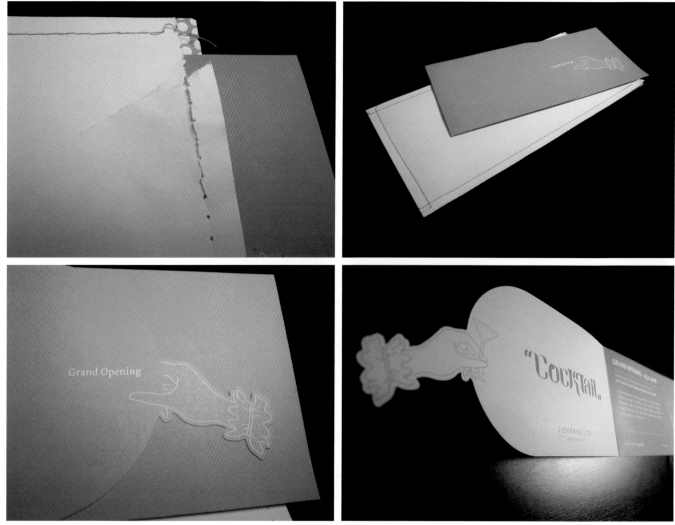

Title: Eason Chan Sound & Sight CD Album
Type: Packaging **Year:** 2006 **Client:** Emperor
Entertainment Group

Description: A best selective CD album of
Hong Kong pop singer Eason Chan. The ad-
aptation of hand drawing typeface is used to
make a difference from most of the Hong Kong
pop singers' album covers.

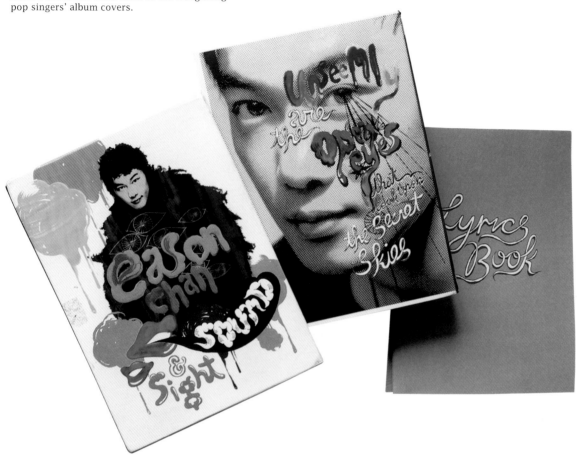

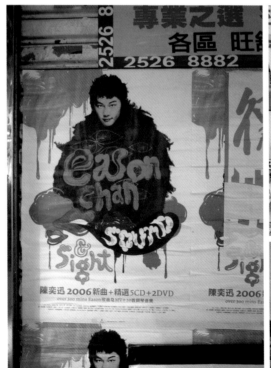

1/ Title: Yo-park **Type:** Site specific art **Year:** 2007 **Client:** Red box

Description: Yo-park is a local entertainment area for the young generation, it includes karaoke rooms, restaurants, cafes, a tv game area and a live performance area. This project is to apply Koo's illustration on various areas in Yo-park.

2/ Title: Poster For Get It Louder 2007 **Type:** Poster **Year:** 2007 **Client:** Modern Media

Description: The promotion poster for a young creative exhibition 'Get It Louder 2007' in China. The official logo was made with various shapes of talking bubbles. This poster shows how the bubbles can be mixed together to create different forms and compositions.

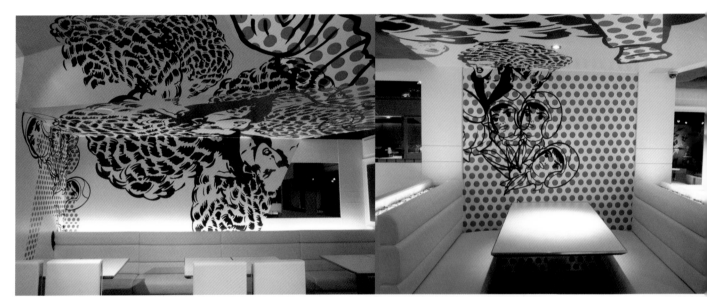

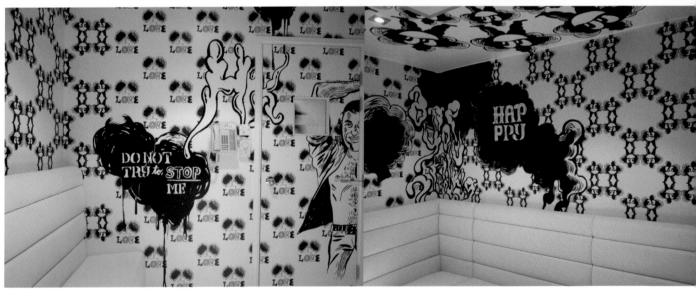

1/

大声展

Get It Louder 2007
organized by modern media

NOISE
MADE BY young creatives

Guangzhou 6.23-7.7 / Shanghai 7.21-8.4 / Beijing 8.16-9.1

 现代傳播
Modern Media www.getitlouder.com

/
:PHUNK STUDIO

/
SINGAPORE

1/ **Title:** Decade Of Decadence **Type:** Exhibition Poster **Year:** 2005 **Client:** Singapore History Museum

Description: The image was created for :phunk studio's Decade Of Decadence retrospective exhibition at the Singapore History Museum.

2/ **Title:** Kraftwerk **Type:** Personal Illustrations **Year:** 2003 **Client:** :phunk studio

Description: The image is a self-portrait of the founders of :phunk studio as their favourite electronic band Kraftwerk.

1/

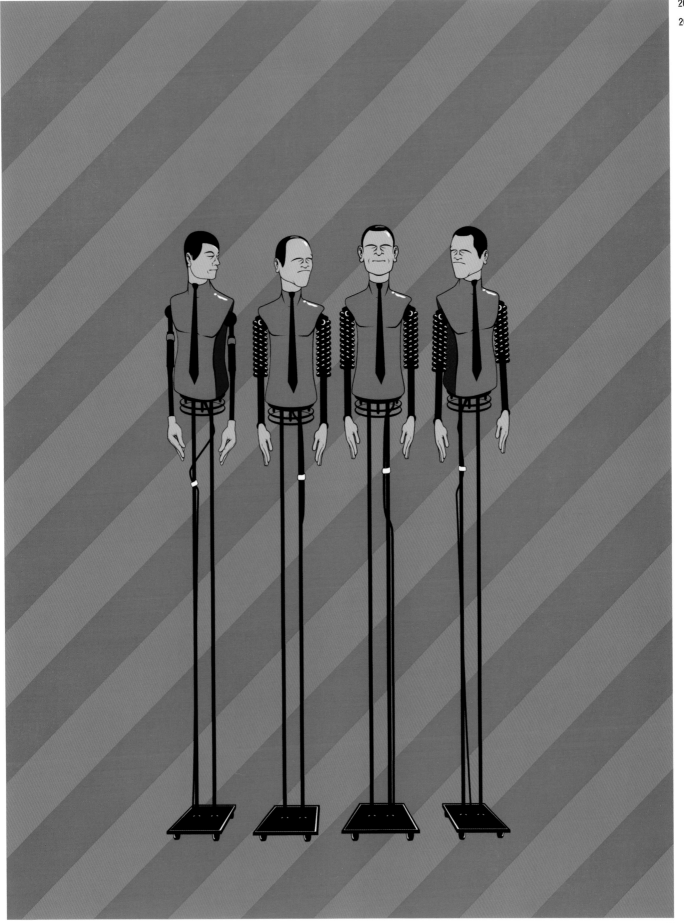

1/ Title: Love City **Type:** Mural **Year:** 2004 **Client:** Cocolatte

Description: :phunk was comissioned by Cocolatte to create a 9 metres mural for their Latte Lounge.

2/ Title: The Bees **Type:** Magazine illustrations **Year:** 2004 **Client:** TOKION magazine

Description: The illustration was commissioned by TOKION magazine to illustrate the UK Band The Bees. The illustration was later featured on the cover of August 2004 Issue of Creative Review magazine, when the magazine did a feature on :phunk studio.

3/ Title: Men Of Leisure **Type:** T-shirt print design **Year:** 2007 **Client:** White room

Description: The artwork was designed as a limited edition t-shirt print for White room.

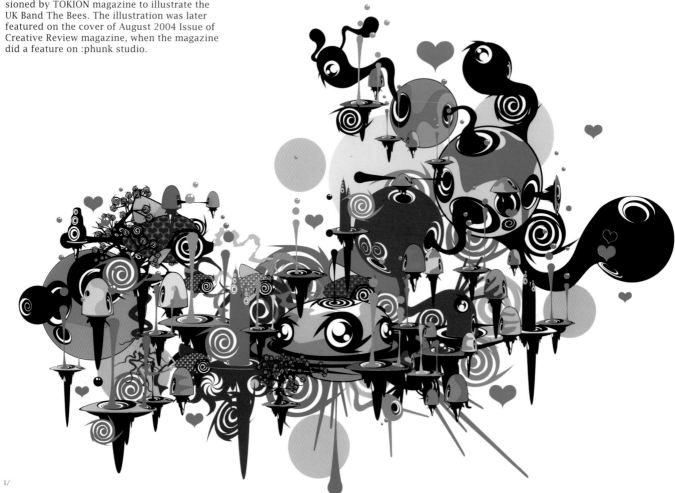

1/

2/

3/

1/ Title: WhoreHaus **Type:** T-shirt print design **Year:** 2007 **Client:** White room

Description: The Artwork was designed as a limited edition t-shirt print for white Room.

2/ Title: Control Chaos **Type:** Silkscreen Artworks **Year:** 2003 **Client:** :phunk studio

Description: :phunk has been invited by The Reed Space to launch their inaugural exhibition in New York City. The title of the exhibition is called 'Control Chaos.' It is a place influenced by the pugilistic world of a 80's Hong Kong TV serial. Using :phunk's own visual vocabulary, the collective renders a dysfunctional / apocalyptic take on the classic tales of good versus evil set in the backdrop of heaven, earth and hell. :phunk has injected their distinctive style of illustration to create a giant mural that would cover the whole exhibition wall area. The mural is made up of 12 pieces of custom-designed canvases made from corrugated boxes. The limited edition artworks are individually silkscreen printed.

1/

2/

Title: Universality **Type:** Silkscreen Artworks
Year: 2007 **Client:** :phunk studio

Description: :phunk studio has been invited by the Museum of Contemporary Art, Taipei to show their works in a solo exhibition titled 'Universality.' The exhibition showcased :phunk studio's new art and design works based on the theme of 'Universality.' :phunk studio will explore 'the creation of universal values' through contextual experimentation with different art and design media and applications.

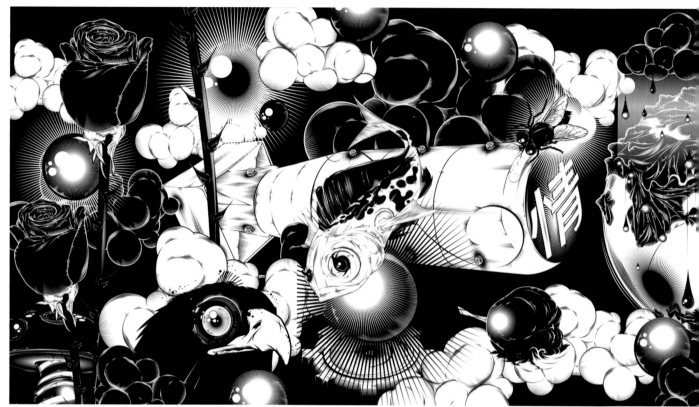

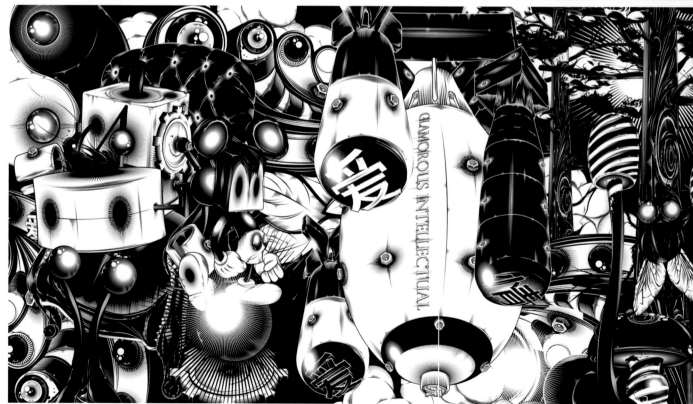

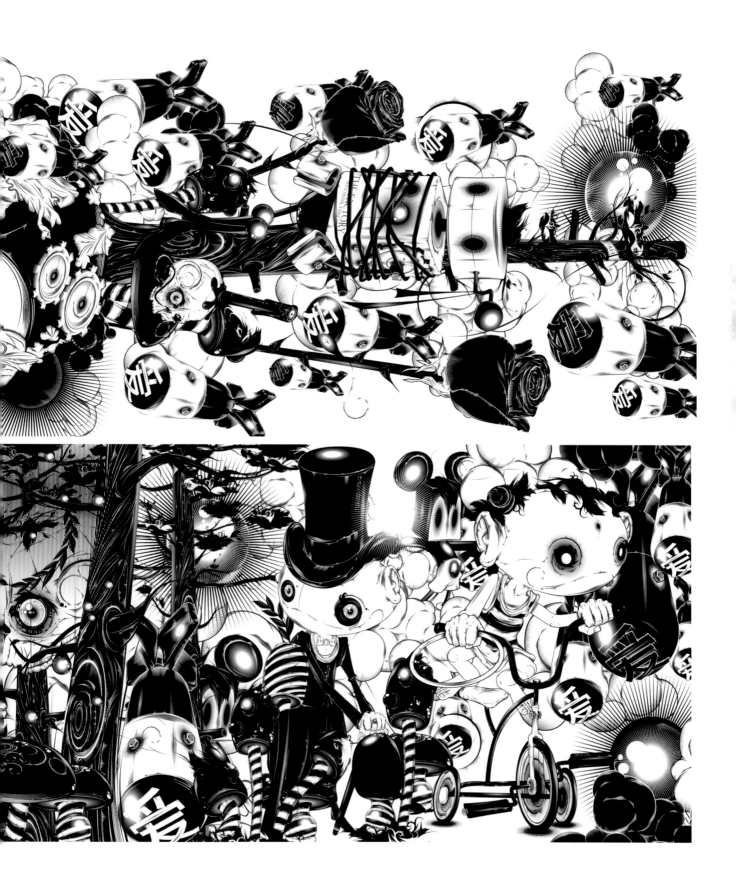

1/ Title: MTV Top 100 Hits **Type:** Motion Graphic **Year:** 2007 **Client:** MTV

Description: Show packaging for the MTV Top 100 Hits.

2/ Title: MTV ASK **Type:** Motion Graphic **Year:** 2004 **Client:** MTV

Description: Show packaging for MTV ASK.

1/

2/

Title: Universality - Fat Boy **Type:** Sculpture
Year: 2007 **Client:** :phunk studio

Description: A2 meters in height, 'Big Boy' sculpture is part of the 'Universality' exhibition at the Museum of Contemporary Art, Taipei.

1/ Title: The Berliner **Type:** Sneakers
Year: 2005 **Client:** Nike Europe

Description: A small run of :phunk x SBTG Nike trainers were produced for their Yut Chi Mah Show, Berlin.

2/ Title: Lei Gong **Type:** Vinyl Figure
Year: Released in 2007 **Client:** Pixie

Description: :phunk studio worked with Pixie on a vinyl figure that was based on one of their 'Control Chaos' characters.

1/

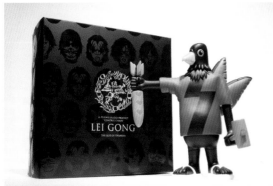
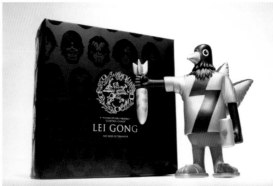
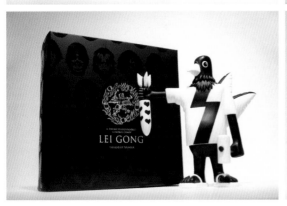

2/

1/ Title: :phunk x Be.Bike **Type:** Bicycle
Year: 2005 **Client:** Be.Bike

Description: :phunk is working with Be.Bike
Japan to release a limited edition :phunk x
16Street bicycle.

2/ Title: Mono Number One :phunk studio, A
Decade Of Decadence **Type:** Book **Year:** 2004
Client: Published by Rebel One

Description: The debut issue of Mono features
renowned design collective :phunk studio, and
is presented as a retrospective subtitled 'A
Decade of Decadence.' Celebrating 10 year's
worth of creative collaboration and experi-
mentation, it charts :phunk's ascent from
freshly-graduated guerilla designers to one of
the most sought-after creative outfits
in the international design arena.

1/

ISBN 981-05-0730-5

ЯEBEL ONE®
MONO IS A REBEL ONE PRODUCT 2004
Visit www.rebelone.net

MONO
NUMBER
ONE
:PHUNK
STUDIO
A DECADE OF DECADENCE

2/

1/ Title: Martini Woman **Type:** Advertisement
Year: 2005 **Client:** Il Lido

Description: Illustration proposed for
advertisement for fine ladies dining.

2/ Title: Red **Type:** SelF promo **Year:** 2007
Client: The Hong Kong Polytechnic University

Description: Self promo illustration.

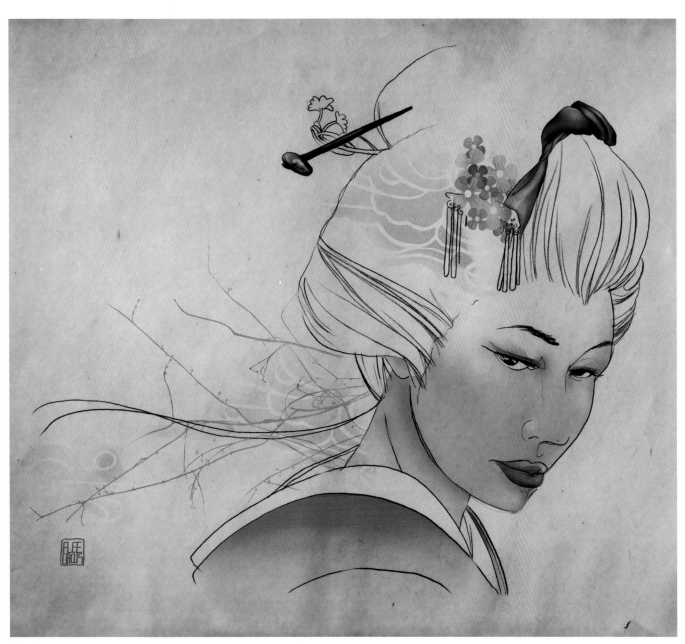

2/

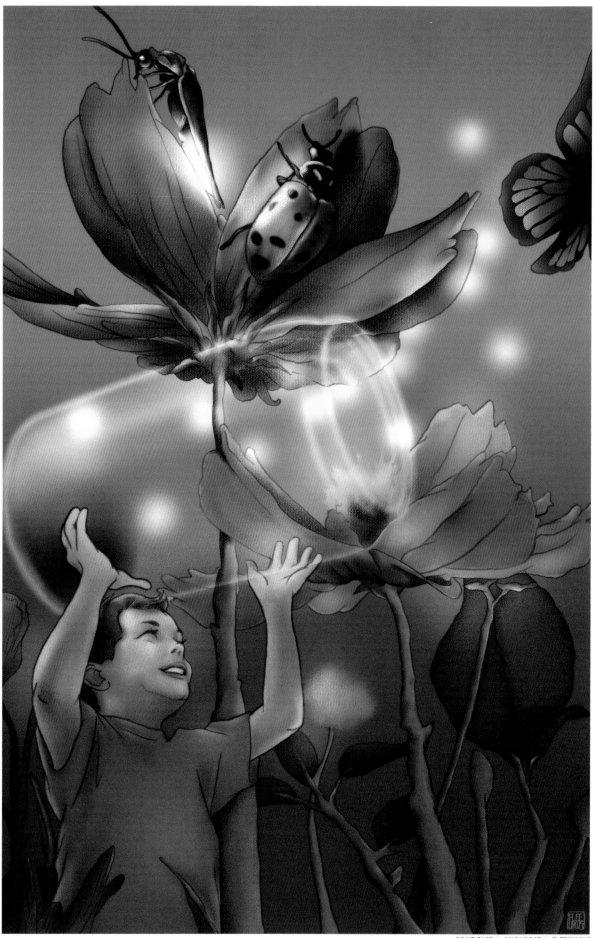

1, 3/ Title: Childhood Series 1, Childhood
Series 2 **Type:** Self promo **Year:** 2007
Client: -

Description: Self promo.

2/ Title: UnMask **Type:** Poster **Year:** 2007
Client: MAAD & Organisation of Illustrators
Council (OIC)

Description: Poster illustration for MAAD, OIC
monthly event.

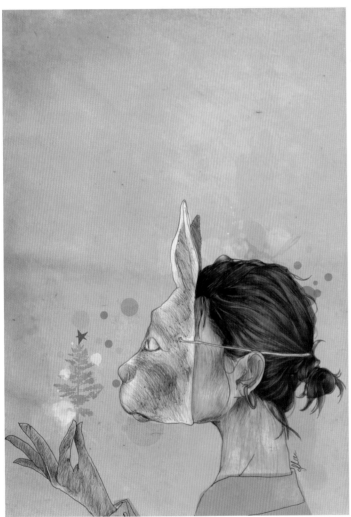

2/

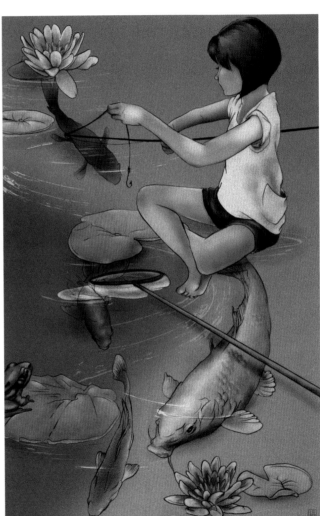

3/

Description: Illustration for 'My Favourite Moleskine' exhibition.

2/ **Title:** To Fly Again **Type:** Self promo **Year:** 2007 **Client:** -

Description: Illustration for website self promo.

3/ **Title:** Bubbles **Type:** Painting **Year:** 2004 **Client:** Self promo

Description: Acrylic on linen canvas painting for self promo.

2/

3/

/ NOD YOUNG

/ BEIJING, CHINA

1/ Title: Peking - I Love You **Type:** Print
Year: 2007 **Client:** IdN

Description: 'Peking - Ai Lao Hu You,' is a phrase that dates back to the days of early English learners who were learning to say 'I love you.' It's funny that 'Lao Hu' also happens to be the word for Tiger in Mandarin.

Work in Beijing is a theme of change – from traditional to today. Changes have occurred in areas such as architecture (type of house), artistic style (watercolour VS digital design), and the connections to the world (globalization).

Using 'Ai lao hu you' to learn to say 'I love you' was a practice originated only about 100 years ago. Times have drastically changed on a number of fronts since then.

With all these reforms, many people could easily get lost, confused, and distracted. Young thinks he is fortunate to live in Beijing that has held onto the old, just as he is.

2/ Title: Holla Halloween (Halloween Party)
Type: Print, Postcard **Year:** 2005
Client: Nod Young

Description: These are made for Young's personal Halloween party in 2005. Halloween is all about 'trick or treat' and ghosts, but he wishes to see them right beside everyone in his party.

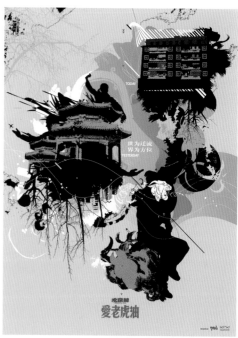

Yo dude, he killed Kenny,
You bustard!
Yes,It is the Halloween carnival.

孥
Hola,Halloween
Oct 31,2005

Hola,Halloween
Oct 31,2005

孥
Robbie, Who did this to you?
Fun anymore?
Yes, It is the Halloween carnival.

Shit, Noel is giving his heart out.
Always think before you do it!
Yes,It is the Halloween carnival.

孥
Hola,Halloween
Oct 31,2005

I think I'm drowning, asphyxiated
I thought I told you, this world is not for you!
Yes,It is the Halloween carnival.

孥
Hola,Halloween
Oct 31,2005

1/ Title: Love You **Type:** Wallpaper
Year: 2008 **Client:** Nod Young

Description: A chandelier wallpaper designed for Young's home using a combination of European classical and animal motifs.

2/ Title: Graphic Revolution **Type:** Namecard
Year: 2007 **Client:** Nod Young

Description: This is Young's new name card design. Some 'old' style and elements came into his mind when he was thinking about the design. The style reminds him of some keywords belonging to the old China such as 'Shanghai,' 'revolution' and '1930's' and so on, which are still classical today.

1/

Title: 'Journey To The West' - Chinese Traditional Papercut **Type:** Digital **Year:** 2005 **Client:** Nod Young

Description: A pack of six images illustrating the characters of a traditional Chinese tale 'Journey to the West,' a story that has played great significance in Young's life. He began reading this story, like once in a year, since the age of 6. This work is the culmination for almost two decades in his life.

Title: Crush & Rebuild **Type:** Print **Year:** 2007
Client: Nod Young

Description: There are two kinds of traditional Chinese paintings. One of them is using abstract lines, shapes and colours to draw landscapes, people, animal, etc. In here, Young drew several pieces in this style, scanned and rearranged them into different characters and animals with his computer. As a result, they all have Chinese faces with drops of modern western composition of art.

1 - 2/ Title: 1/ Plantgirl 2/ Cloudragon
Type: Print **Year:** 2006, 2007 **Client:** Takashi Okada

Description: Collage of original drawing produced for a graphic design competition in 2006 and 2007 respectively.

3/ Title: CREATURE **Type:** Print **Year:** 2008
Client: Takashi Okada

Description: Digital works produced from original paintings for a graphic design competition.

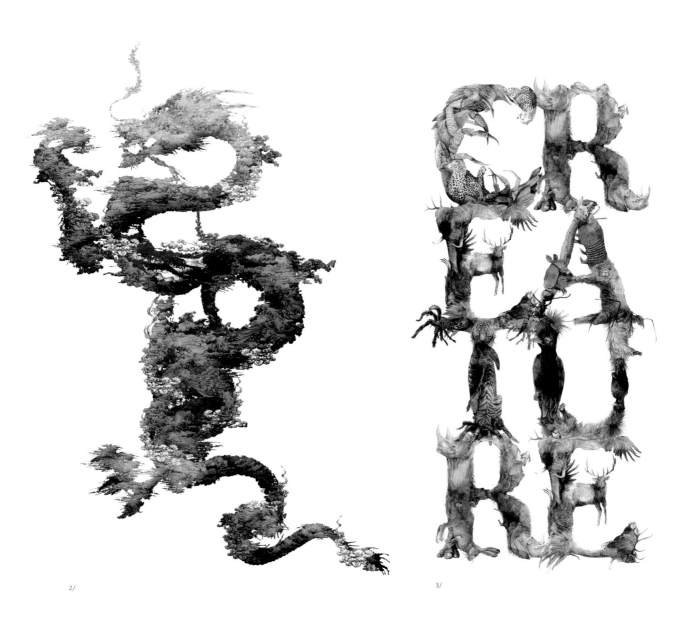

2/

3/

Title: DAYDREAMING **Type:** Print **Year:** 2008
Client: Takashi Okada

Description: Digital works produced from
original painting for a graphic design
competition.

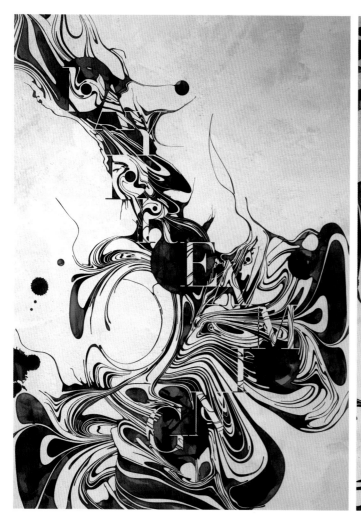

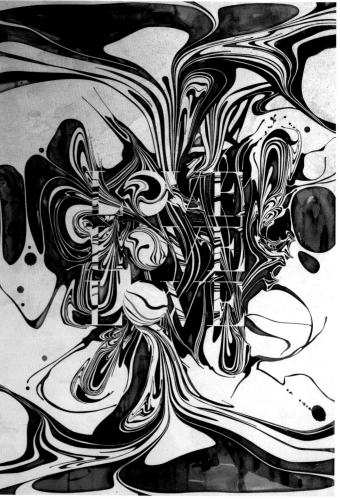

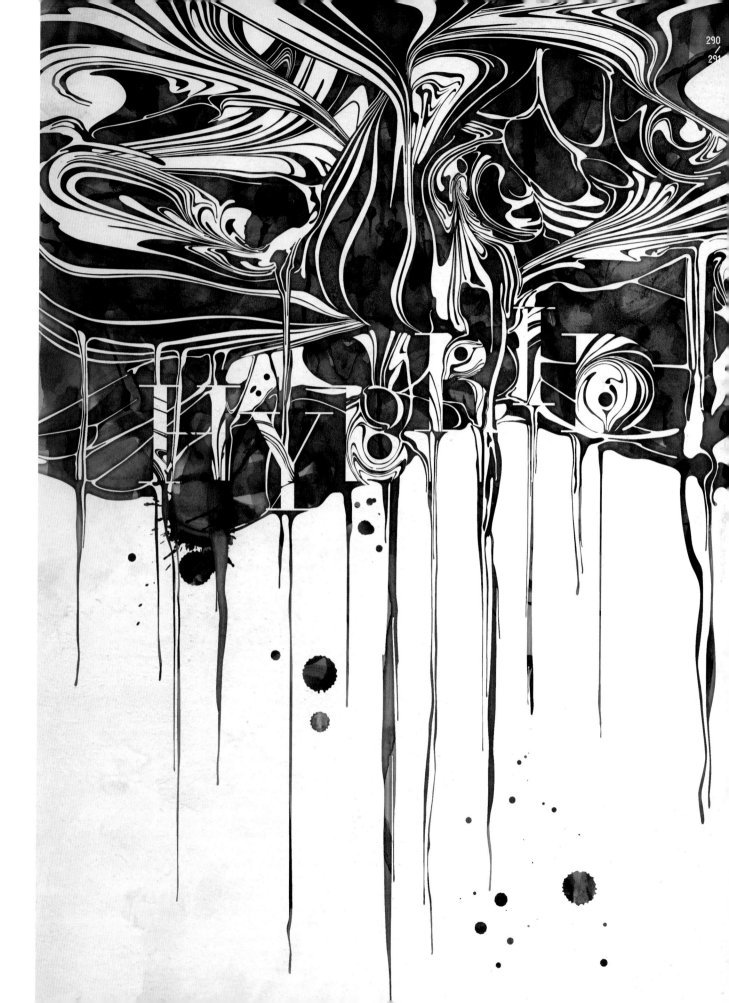

Title: LOVE LOVE LOVE **Type:** Print
Year: 2008 **Client:** Takashi Okada
Description: Digital works produced from
original painting for a graphic design
competition.

1/ Title: Trffdg **Type:** Flash **Year:** 2007
Client: Takashi Okada
Description: Motion graphic works for 11th
Japan Media Arts Festival / Art Division Jury
Recommend Works.

2/ Title: What - Scary - Strange - Amazing
- Complexity **Type:** Flash **Year:** 2007
Client: Takashi Okada
Description: Motion graphic works for Adobe
Motion Award / Flash Animaition Winner.

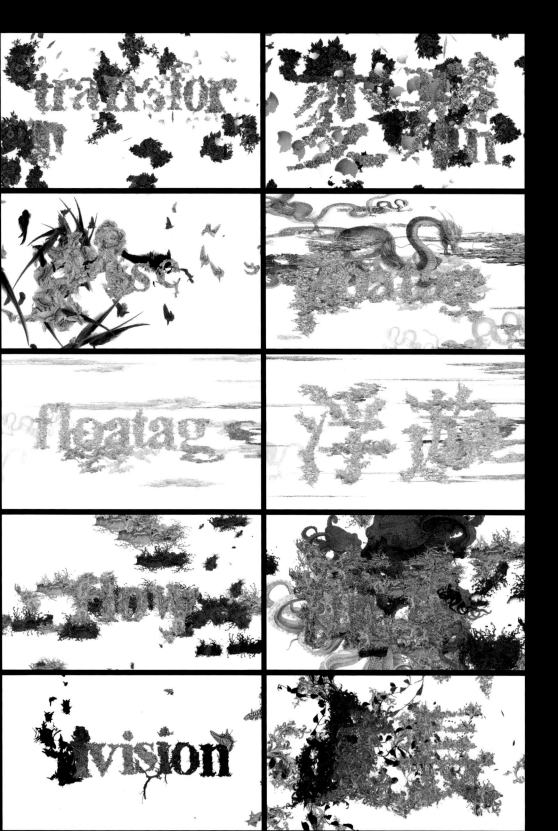

ZNP CREATIVE

SEOUL, KOREA

Title: Party Your Flavour **Type:** Digital graphic, Mobile installation **Year:** 2007
Client: Absolut Vodka

Description: Visualised 4 flavours of Absolut Vodka (Vanilla, Citron, Mandarin, Peach) in Zinoo's unique style. He has mingled disco music and beach style party culture into the 4-flavoured-Absolut-Vodka mobile installation. It was installed on a 5-ton truck which toured around major spots in Seoul for promotion.

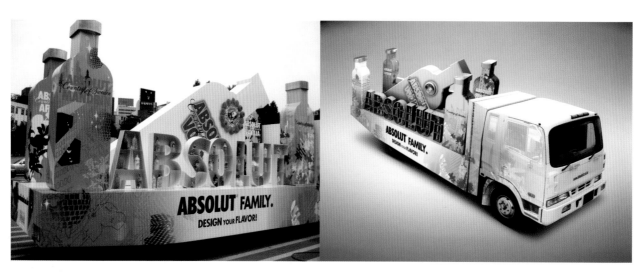

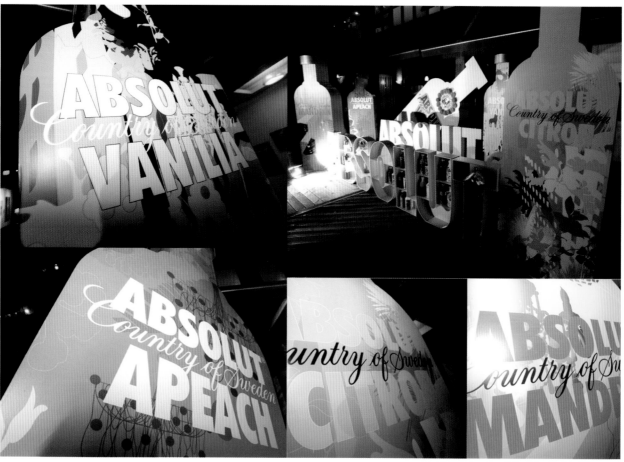

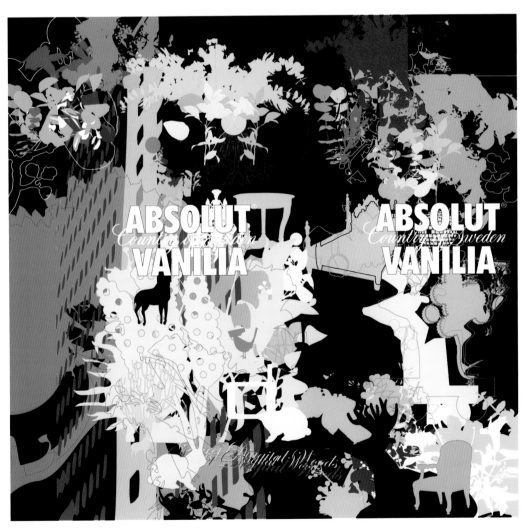

Title: Spray Love **Type:** CD, Poster artworks
Year: 2006 **Client:** MTV, Body Shop
Photographer: SukMu Yun

Description: The 'Spray Love' was a non-profit
project proposed by MTV and the Body Shop,
where all money collected was donated to the
'Staying Alive' organization for increasing the
public awareness of AIDS. Zinoo participated
as the art director for this project, and the
pictures were taken at Yun's studio in 2006.

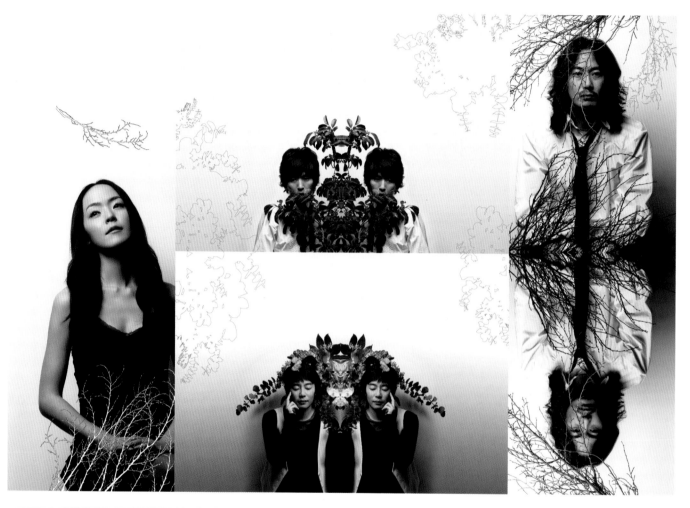

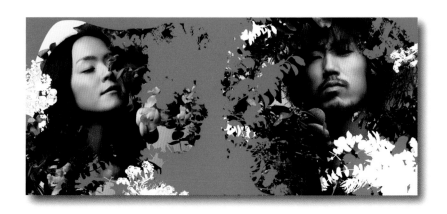

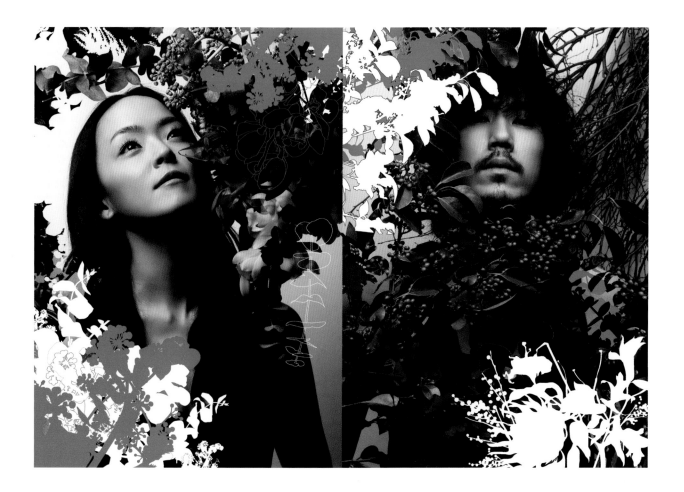

Title: Truth & Irony **Type:** Text on products
Year: 2005-07 **Client:** DNA, Magazine Maison

Description: 'Truth and Irony' reflects your ironical routines and illustrates every-day objects with texts and images.

1/ MANIFESTO - Words written on the bicycle are filled with symbols that ZNP Creative does not agree on, but rather with codes that contrast their recognition. The bike runs completely irrelevant to what is said or written on its body.

2/ LUXURY PLASTIC - Combination between the 'monoblock chair'- a low cost chair that is mass-produced all around the world. Golden text of 'luxurious,' 'expensive,' 'arrogant,' 'posh' etc. are used to constitute a shiny plastic world.

Title: SonicBrat CD **Type:** CD packaging
Year: 2006 **Client:** Asylum sounds

Description: Asylum designed the first packaging for Sonicbrat, a local musician who creates ambient compositions. The die-cut holes were overlapping to depict soundscapes, just like the contours of landscape.

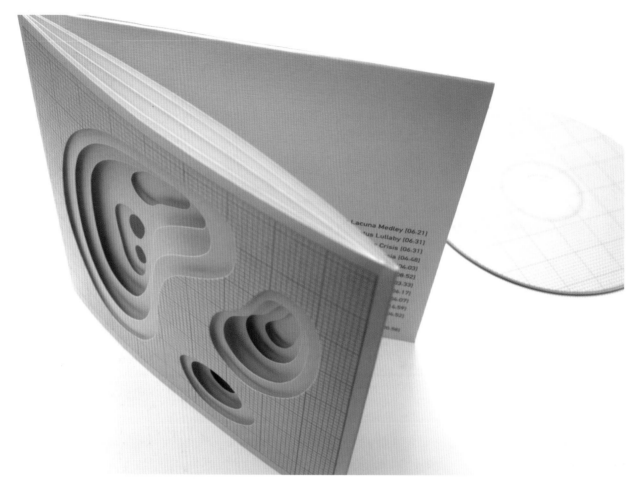

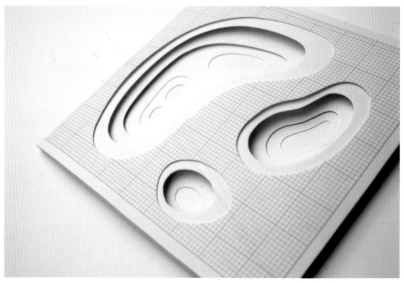

Description: Published by Asylum, the book highlights certain passionate individuals and reveals how they spent their spare time creating stuff. Each section is designed in different style to reflect the uniqueness of each interviewee's personality.

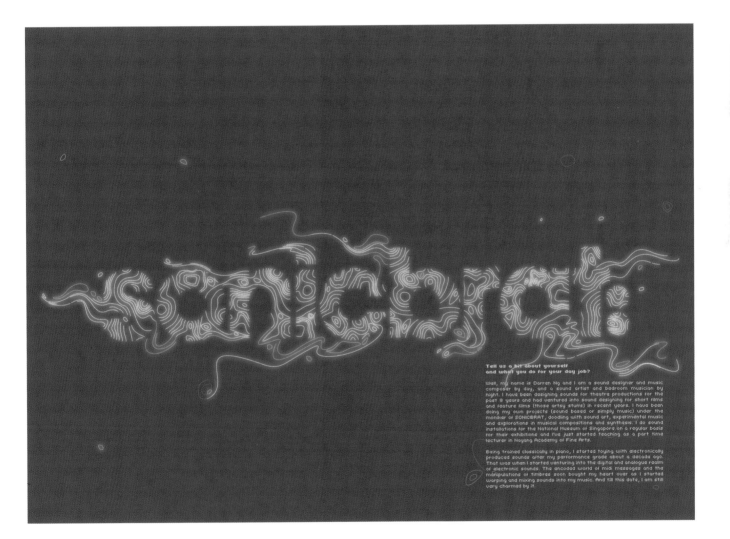

1/ Title: M.A.D **Type:** Wine packaging
Year: 2006 **Client:** Auric Pacific

Description: The wine was a result of 3 passionate individuals, Michael, Andy and David. Asylum collaborated with French artist Agathe to design this quirky and artistic label playing with the idea of a mad person.

2/ Title: Sodabrew **Type:** Beer packaging
Year: 2004 **Client:** Asia Pacific Breweries

Description: Asylum did about 100 different designs for a new beer product. This one has its concept from bad pick-up lines.

1/

2/

1/ Title: YangTan Card **Type:** Corporate identity **Year:** 2008 **Client:** YangTan

Description: A business card for a photographer with his details printed in different density within a card. The sticker dot is randomly placed. The idea is taken from the process of choosing the right exposure in a film strip which is no longer a practice since the world has gone digital. Asylum wanted to show the craft that is lost.

2/ Title: Utterrubbish Notebooks
Type: Notebooks **Year:** 2007 **Client:** Utterrubbish conference

Description: Asylum wrapped recycled junk mails on the covers of the notebooks and silkscreen their identity (type) on it. It was distributed to the public for free to send the message of recycling wastage.

1/

2/

Title: Frolick Yogurt **Type:** Branding
Year: 2008 **Client:** Frolick

Description: Asylum created the branding
for a frozen yogurt product and gave it a very
edgy personality. They designed over 30 but-
tons that carried naughty and sexy messages
used as secondary graphics within the stores.

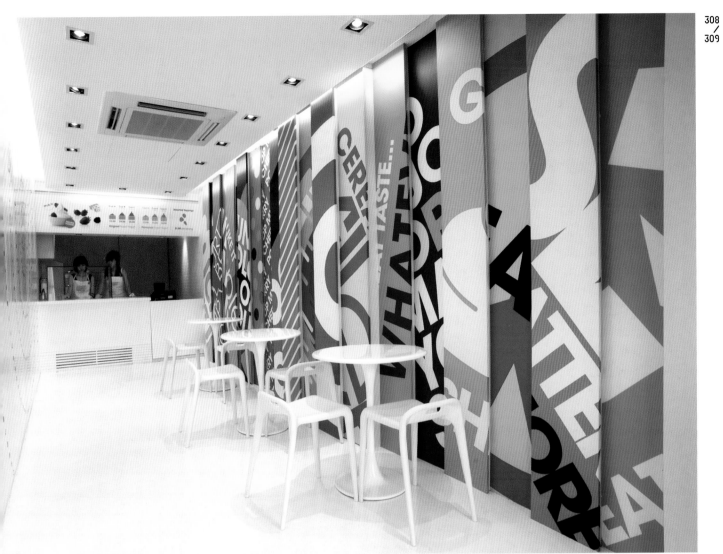

Title: Classroom Of The Future **Type:** Interior design, Interactive design **Year:** 2006
Client: Microsoft, IDA, MOE

Description: Asylum were asked to design a classroom of the future that would showcase how technology can be applied to education in various scenarios. They came out with the script, designed the interface and created different rooms within the space of a local university.

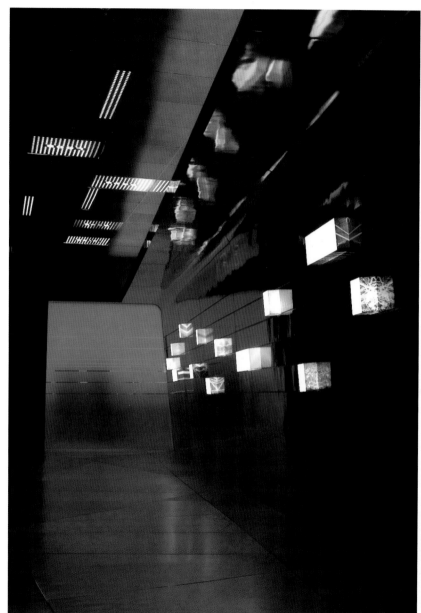

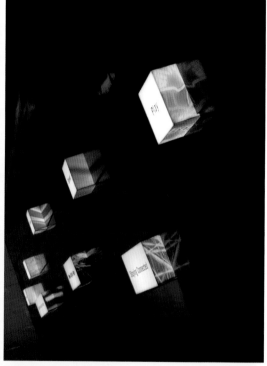

Title: Asylum Retail Store **Type:** Retail store, Gallery, Workshop **Year:** 2005 - present **Client:** Asylum

Description: The Asylum store sells experimental music, books on culture and design, limited edition fashion products and contemporary art from local artists. The store is also a gallery where monthly art exhibitions are held. It also plays host to a series of free workshops where local and international luminaries can share their passion.

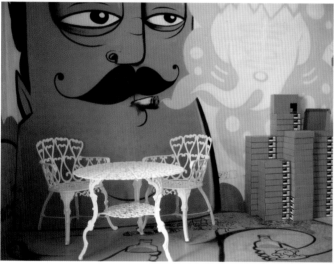

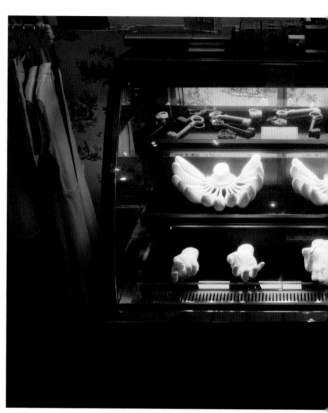

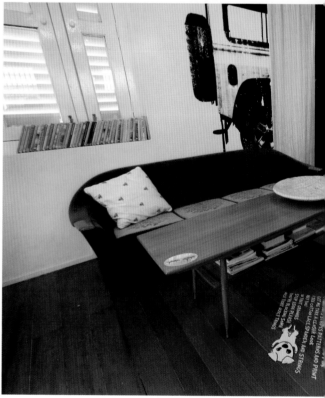

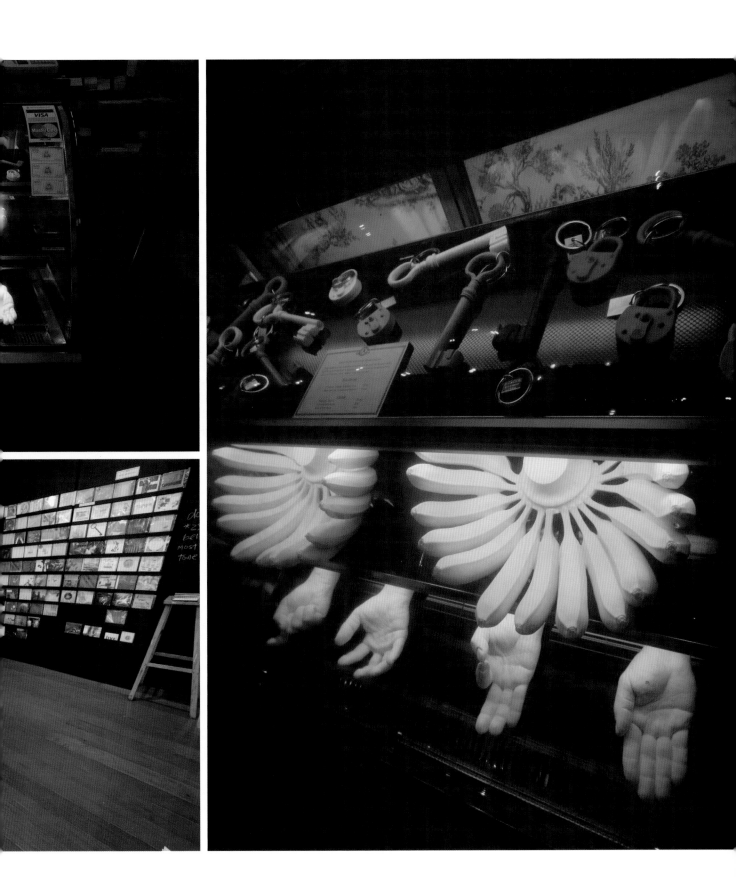

1/

2/

Title: PPP (Piecing / Pieces / Patterns)
Type: Pattern, Installation **Year:** 2006-07
Client: -

Description: 1/ 8 creatures extracted from PPP.
2/ PPP study – one PPP pattern sample.
3/ Installation at Minami-aoyama – It shows the
process of mixing two pieces a and b from left

to right. (Curtsey of Bluestudio)
4/ Installation at BankArt Yokohama – Stamp-
ing study. (Curtsey of BankArt Yokohama)
5/ Installation at Design Tide Tokyo – Stamp-
ing study on paper and furinture. (Curtsey of
Design Tide Tokyo)

3/

4/

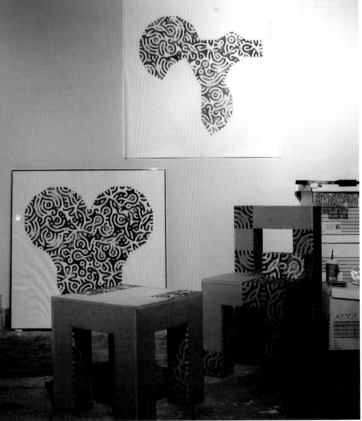

5/

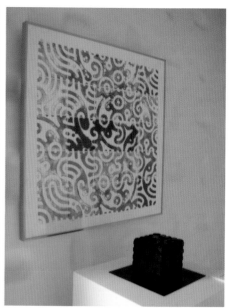

1/

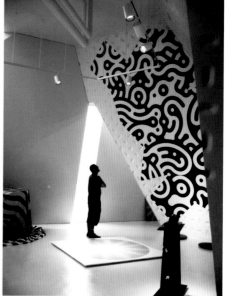

2/

3/

1 - 3/ Title: PPP (Piecing / Pieces / Patterns)
Type: Various **Year:** 2007 **Client:** -

Description: Kanno Museum Solo Exhibition
'Linkable Matters.' (Curtsey of Kanno Museum)
1, 3/ Various works include magnet, hard rubber
and stamps.
2/ Pattern sewing, collaborated with AAO Hitoshi
IMAKITA.

4/ Title: PPP (Piecing / Pieces / Patterns)
Type: Installation **Year:** 2006 **Client:** -
Photographer: 5/ Hiroshi Fujii

Description: 4/ Installation at BankArt Yoko-
hama – Stamping on cloth, collaborated with
AAO Hitoshi IMAKITA.

5/ Installation at Minami-aoyama, collaborated
with AAO Hitoshi IMAKITA. It shows the pro-
cess of mixing of two pieces a + b from left to
right and the stamping process on furniture.
(Curtsey of Bluestudio)

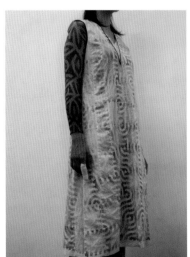

4/

5/

1/ Title: Blue Room **Type:** Wallpaper
Year: 2003 **Client:** R-FUDOSAN
Photographer: Tetsu Hiraga (Blue Room)

Description: Paper wrapping project.

2/ Title: Shohoku College **Type:** Wallpaper
Year: 2004 **Client:** Shohoku College,
Director: Haruaki Tanaka (Flow)

Description: Renovation project

2/

1/

Title: 5050 Dots Male **Type:** Picture on wood frame **Year:** 2004 **Client:** -

Description: One sample of how to discribe the numbers from 1-100.

G.O.D. LIMITED

HONG KONG, CHINA

Title: Amah Bag **Type:** Carrier Bag
Year: 2006 **Client:** G.O.D. brand

Description: A tribute to the traditional amah
bag by an unknown designer. This version is
made of printed cotton with leather details but
of the same shape and construction details as
the original.

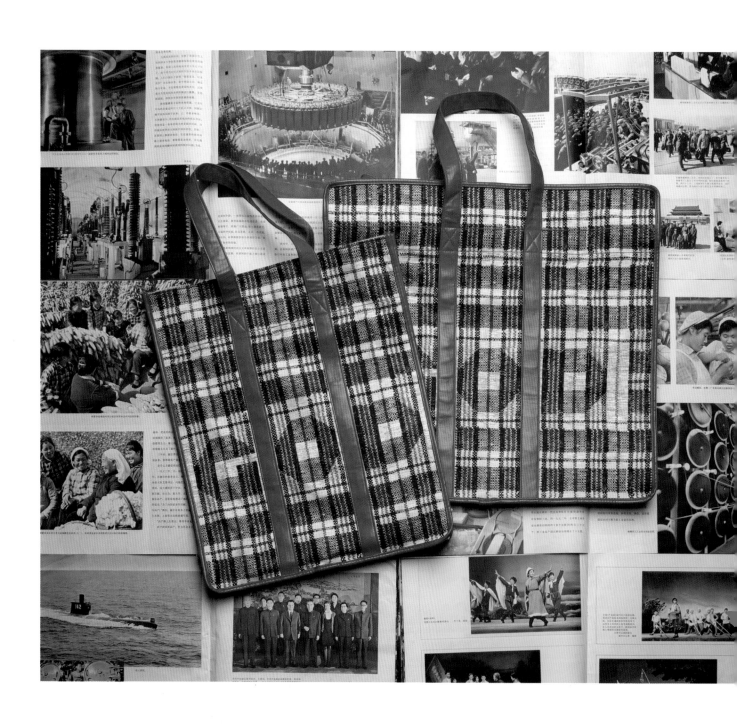

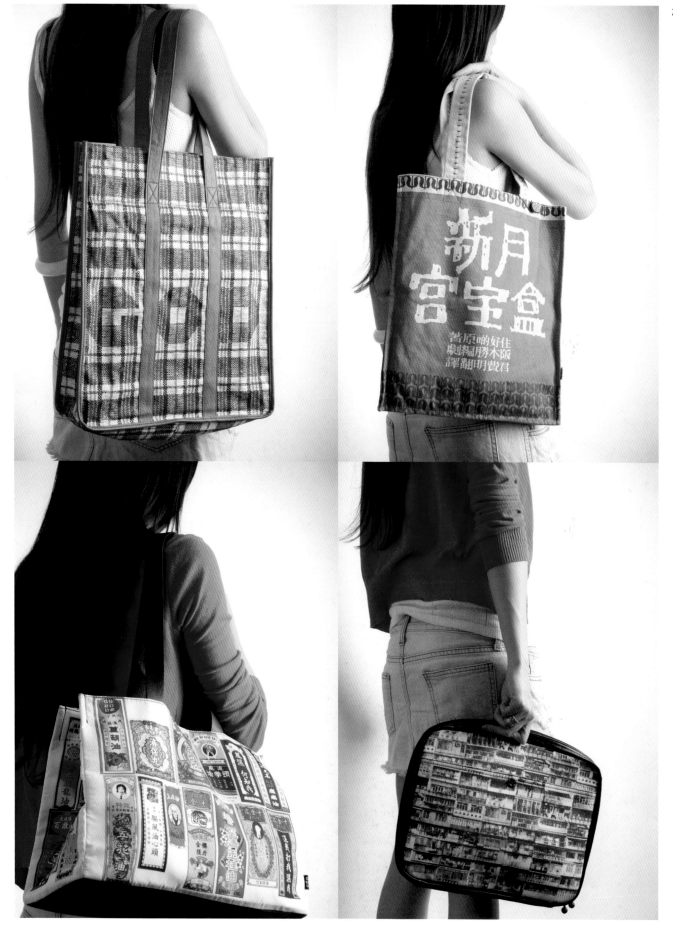

Title: Serve The Public **Type:** T-shirt
Year: 2008 **Client:** G.O.D. brand

Description: To serve the public ('people') has been the chairman of the People's Republic of China, Mao's favourite slogan. This is an ironic take on it. The chairman's hand writing has been twisted to read 'to serve myself' and 'to serve my boss.'

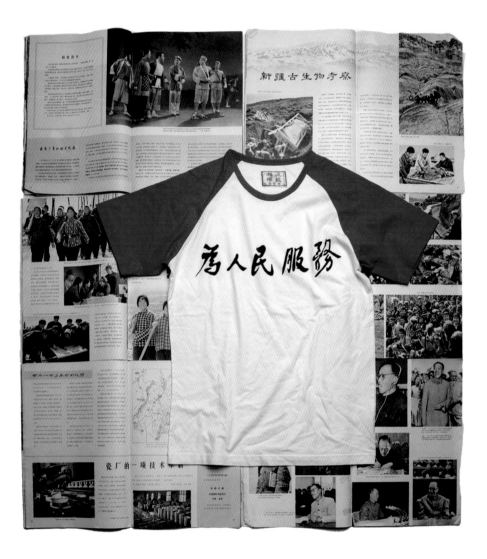

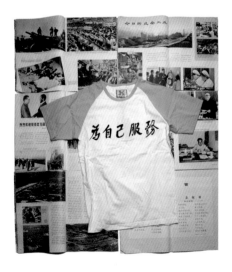

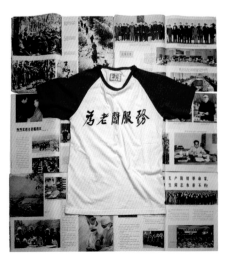

Title: Signature Prints **Type:** Garments
Year: 2008 **Client:** G.O.D. brand

Description: A range of garments where a variety of traditional Chinese motifs and calligraphy were applied to the up-to-date fashion shapes and garments forming a fusion of the old and new, the East and the West.

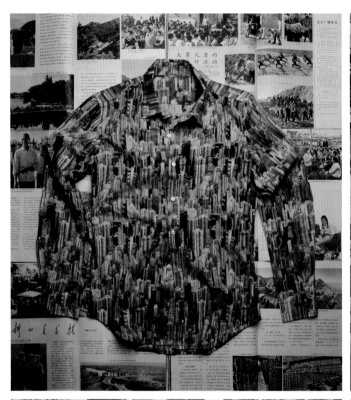

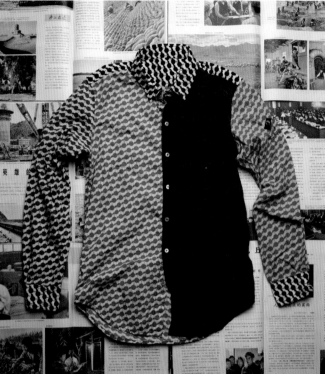

Title: Exercise Bag **Type:** Tote bag
Year: 2006 **Client:** G.O.D. brand

Description: The classic 'Exercise Book' graphics is familiar with all Hong Kong students over many generations. This design is a twist on the icon by adapting it onto a gym bag and reflects today's popularity with health exercises.

1/ Title: The Yaumati Print **Type:** Graphic, Products **Year:** 2003-06 **Client:** G.O.D. brand

Description: G.O.D. is the first brand to be inspired by the street culture of Hong Kong. The Yaumatei print is one of its signature prints which celebrates Hong Kong's unique vernacular architecture. The strong graphic quality of these building facades enables the print to be used across many product categories from bags, slippers to home accessories.

2/ Title: The Newspaper Print **Type:** Graphic, Products **Year:** 2003-06 **Client:** G.O.D. brand

Description: The designs of the G.O.D. brand are inspired by Hong Kong's rich culture, and the newspaper signature print is one such example. It is a replication of the classic Chinese language classified ad in Hong Kong. The instantly recognizable graphic style lends itself to being applied to a large variety of fashion and household products.

3/ Title: The Mailbox Print **Type:** Graphic, Products **Year:** 2003-06 **Client:** G.O.D. brand

Description: Metal letter boxes in older buildings are scattered throughout common areas such as hallways and staircases. In order to differentiate themselves with one another, every box is marked and painted in distinctive colours. This print is to be used across many product categories from bags, slippers to household accessories.

1 - 3/

1/

Title: Double Happiness Candle **Type:** Graphic, Products **Year:** 2001 **Client:** G.O.D. brand

Description: The age-old Chinese 'double happiness' symbol can be startlingly modern as a piece of three dimensional graphics. In this application, the form is reduced to a minimum without losing its meaning in order to emphasise its sculptural quality. The celebratory notion of lighting a candle is consistent with the meaning of 'double happiness.'

If shopping is entertaining, then customers have to expect the unexpected. G.O.D shops owe more to the Disney theme parks than traditional department stores. Displays are constructed as sets and are arranged sequentially along the route. Journeying through the shop, customers are treated with a wealth of sensual delights from aromas, visuals, music and touch. The delights of the shopping environment is therefore added to the appeal of the merchandise. Every purchase brings with it a reminder of the wonderful experience.

G.O.D is definitely not a convenient store where customers shop with a shopping of list; it is where people find themselves wanting something they have never thought they would need in the first place!

GOODS OF DESIRE

/
ANOTHERMOUNTAINMAN

/
HONG KONG, CHINA

Title: Wu Yong **Type:** Installation **Year:** 2007
Client: Jia Zhang Ke / Mixmind Art & Design
Co., Ltd.

Description: Jia Zhang Ke's movie 'Useless'
press kit for premiere at the 64th Venice Inter-
national Film Festival, Orizzonti.

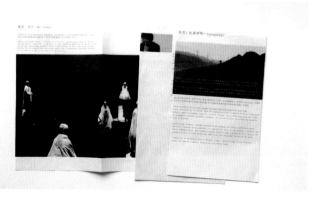

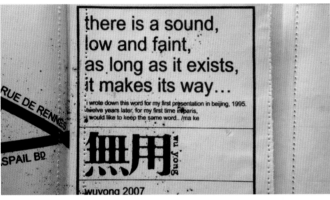

Title: Lanwei **Type:** Art photography
Year: 2006 - present **Client:** -

Description: Thanks to the China's economic policy of opening its door in the 80s, the property market boomed all over the country. People made big investment on residential buildings even before the completion of the development. They did not want to miss out any potential profits. The result was corruption and the overheated economy. The property bubble burst had eventually led to the stall of many development plans over the past 20 years. Wong's photographic series dedicates itself to exploring the issue of these idle construction sites flooding with abandoned and incomplete buildings, which is called 'Lanwei' in Chinese. The project also mirrors his views on modern China and life.

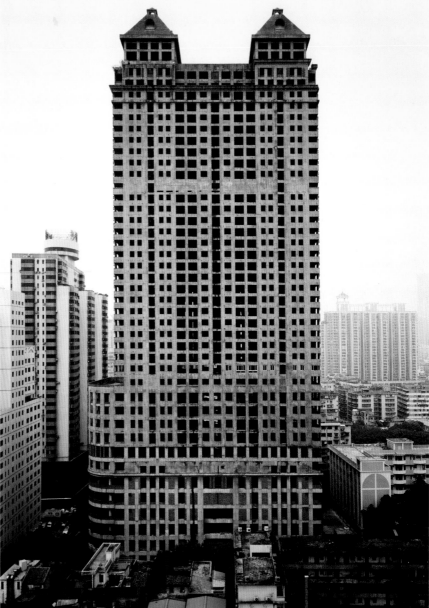

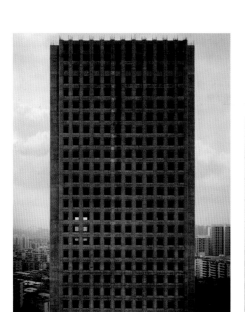

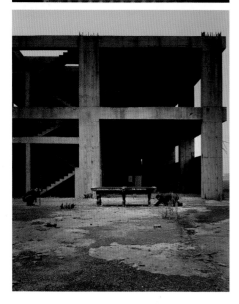

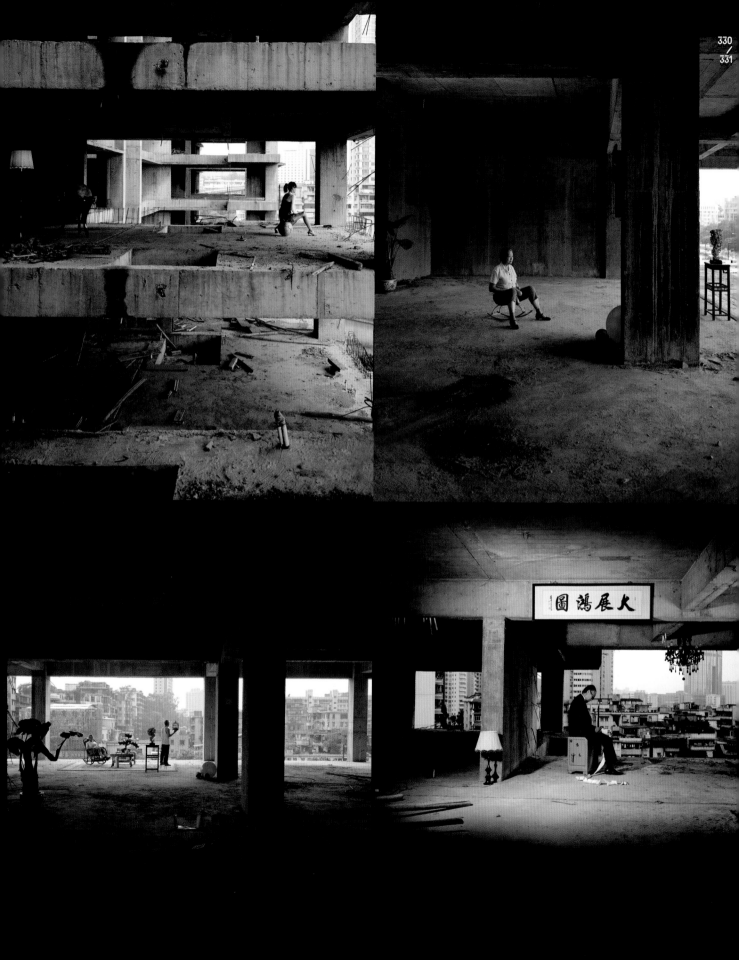

1/ Title: Half / Half **Type:** Installation
Year: 2007 **Client:** Victoria Prison Art Museum
/ Artist Commune

Description: Virtue or vice. Spacial Installation.
Written by: anothermountainman (Convicts'
Toilet) (Correctional Services Staff Office) 2007

Are the punished persons the vicious ones?
Are all law executors sinless and eminent?
Does law and order build the heaven? Then it
would depend on who defines the term - by law
executors or politicians. Does human ruling
create the abode of condemned souls? Not if
the world orientates its ruling towards the ben-
efits of all mankind. Can we find heaven in the
man's world? Hell does not have to come after
death. The present life, the afterlife.

Today, and tomorrow. Shall we bring ourselves
together, with the lyrics of 'Half and Half' by
Master Hsing Yun? Situating in a space between
the confronting convicts' toilet and the Cor-
rectional Services staff office, let us ponder the
issue between virtue and vice, self and others.
(With tributes to Master Hsing Yun.)

2/ Title: Superwoman **Type:** Poster
Year: 2002 **Client:** Hong Kong Poster League
/ Poster Exhibition in Hong Kong / Heritage
Museum

Description: 4 women are key influences on
Stanley Wong: Mother Teresa, who lived life
for only today; Eileen Chang, who has a sharp
eye in details; Rei Kawakubo, who dares to
be different in the age of conformity; and his
mother, who loves him unconditionally.

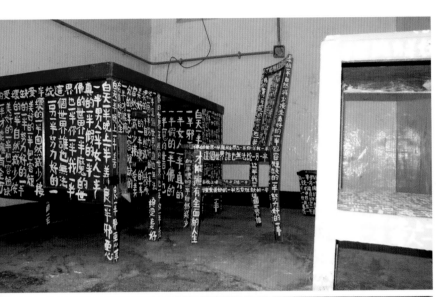

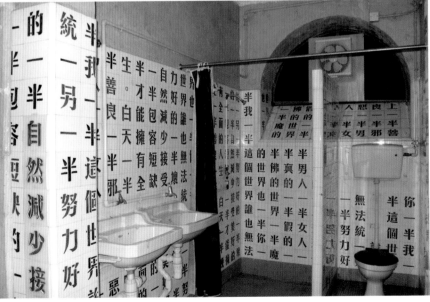

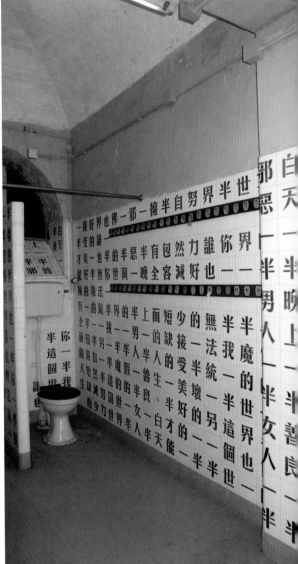

1/

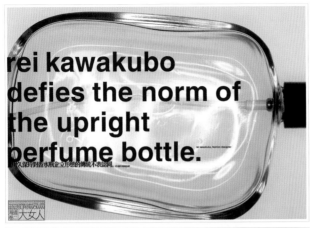

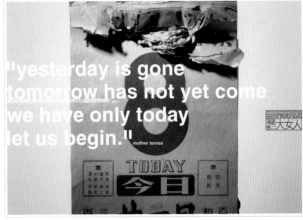

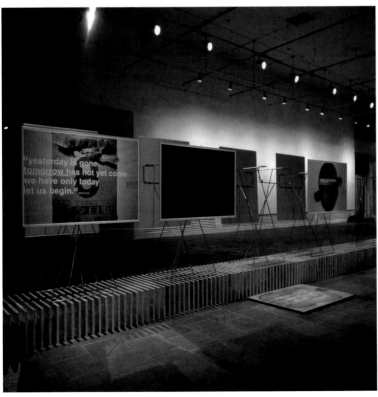

Description. A catalogue for A/W 2007 the theme Now / Here.

Title: Redwhiteblue Here / There / Everywhere **Type:** Book **Year:** 2005 **Client:** Mccm creations

Description: A book of Redwhiteblue's invention / production / history / culture / and creativity /

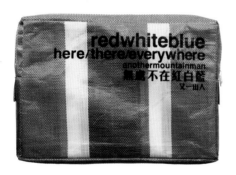

1/ Title: [Redwhiteblue] ∞ **Type:** Poster
Year: 2001 **Client:** Hong Kong Heritage
Museum

Description: No one knows when red, white
and blue first came to the world. Nor do we
know where those colours first landed. Hong
Kong? China? Or any other corner of the
world? It pops up in our mind at the very be-
ginning that the red, white and blue have their
own individuality...

As time goes by, they have become popular.
It appears everywhere, with everyone, in any
identity, with its infinite ability. May red,
white and blue be with us forever.

2/ Title: Redwhiteblue / Back To Future
Type: Artwork **Year:** 2006 **Client:** -

Description: A journey from industry to art
and craft. A journey from the 21st century to
the 15th. A journey from now to the future.

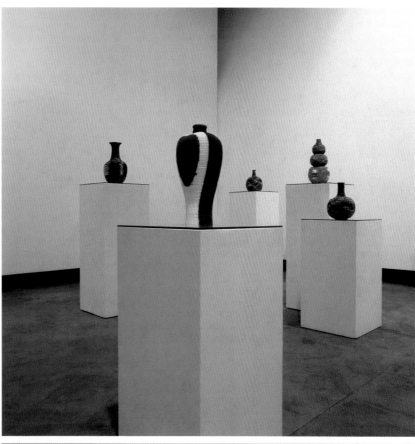

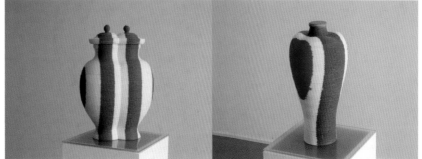

2/

1/

Title: Redwhiteblue / Building Hong Kong 03
Type: Poster **Year:** 2002 **Client:** -

Description: No one knows when red, white and blue first came to the world. Nor do we know where those colours first landed. Hong Kong? China? Or some other parts of the world? Everyone should take part in for any archievement made. People gernerally hope Hua Tuo (a renowned doctor in Chinese history) to save mankind from infection and epidemic. Wong dreams for the reborn of Lu Ban (a Chinese carpenter master) who would have built our home and our country with his magic axe.

Title: Investigation Of A Journey To The West By Micro + Polo: Redwhiteblue / Tea And Chat
Type: Installation **Year:** 2005 **Client:** Venice Biennale / Hong Kong Arts Development Council

Description: Thanks to the Internet, online communication has never been easier. Yet Wong thinks that Hong Kong people are therefore shy to have face to face communication and to chat over a cup of tea has become rare and strange. Wong uses the alias of another-mountainman to promote his city's positivity through his works. In 'Redwhiteblue / Tea and Chat,' he recreated a Chinese tea house using the colours red, white and blue to symbolise the spirit of Hong Kong. Spectators to the exhibition are welcome to sit and ponder the computer age, communication, trust and open-mindedness.

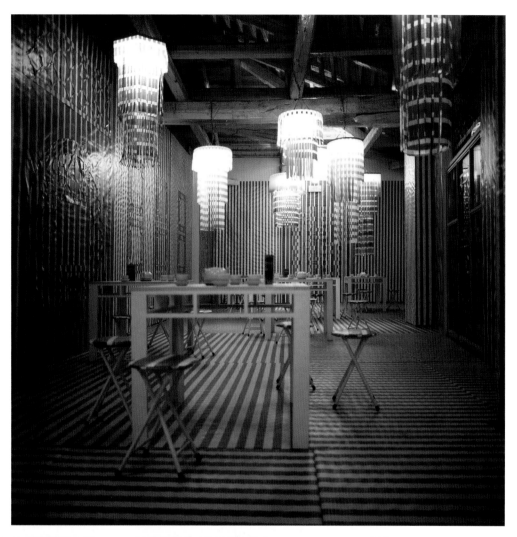

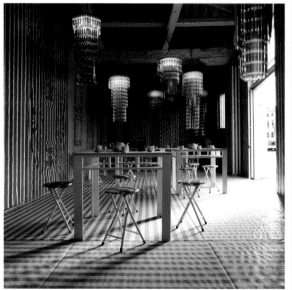

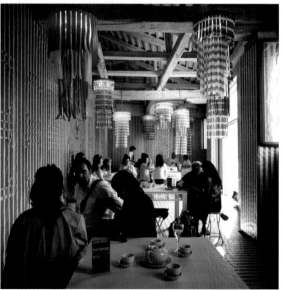

/ MINSEUNG JANG

/ SEOUL, KOREA

Title: T1 Champagne **Type:** Furniture
Year: 2006 **Client:** -

Description: Furniture designed with table T1, the project was sponsored by Moët Hennessy Korea. Jang altered the frame colour through the anodizing procedure. She did the same for the 12 limited edition tables.

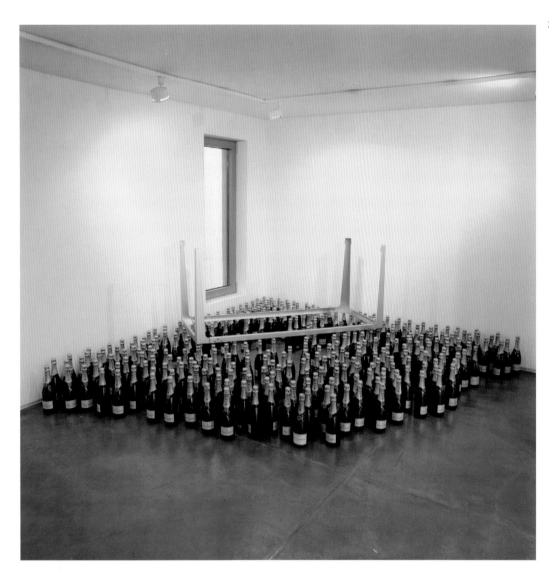

1 - 4/ Title: T1 series **Type:** Furniture design, Photography **Year:** 2003-07 **Client:** -

Description: Made in 2003, T1 was presented in Jang's first solo exhibition in 2005. Meeting manufacturers is not the only aim of her exhibitions, but also to present her work as fine art piece. Plus, limited number of items are allowed to sell in recognised and leading galleries in Seoul. With a sculptural background, Jang treats her work rather as sculpture. She understands the importance of space. Jang usually gains structural durability and form through cutting and folding plywood and sheet metal. She makes all the distinguished works in her studio.

1/ TITANIUM - A titanium table in a solid background.

2/ ROSE - Table frame and Moët glass flower in the colour of Moët & Chandon Rose champagne.

3/ SOLID - A combination of square tables and a screen of auto theatre.

4/ HEAVY INDUSTRY - Made in 2007, a table with photos of various heavy equipments in different colours.

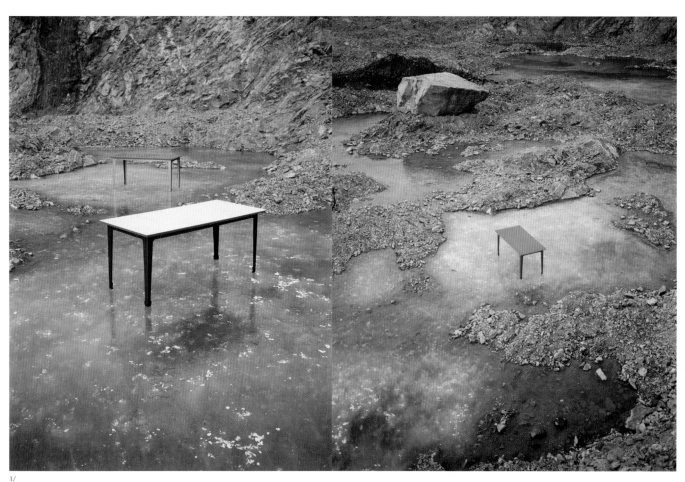

1/

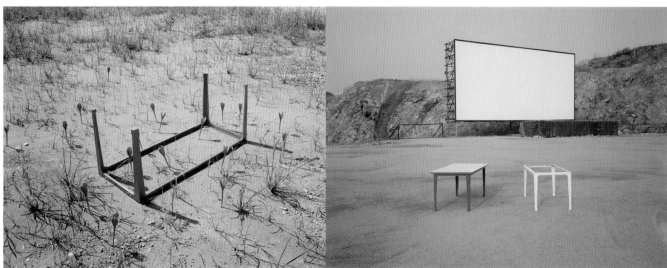

2/ 3/

* Every single photography was taken by a large format film camera without any synthesizing effect or correction.

5/ Title: Pieces of 17 **Type:** Photography
Year: 2007 **Client:** Nissan Korea

Description: Made for the art-marketing of Nissan Korea, this work is a reassembly of broken pieces of Nissan infiniti. Pictures were taken at a mini soccer ground.

5/

4/

Title: Peach Cargo Works **Type:** Furniture
Year: 2002-04 **Client:** -

Description: The wooden furniture of the
Chosun Dynasty period (1392-1910) is well-
known for its pragmatic value, tecgniques,
and maintenance. Peach Cargo Works is
a reproduction project composing the
Korean traditional values, material and
contemporary lifestyle.

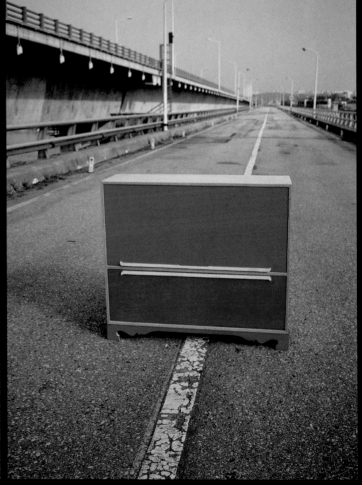

/
OSISU

/
NONTABURI, THAILAND

Title: Bud **Type:** Eco-products **Year:** 2007
Client: -

Description: Bud is a whimsical stand made from reinforcing steel off-cut found at construction sites. The small wooden bowl at the top is a section of tree-root left behind after logging. Bud can be placed indoor or in the garden to keep snacks, matches or other small items.

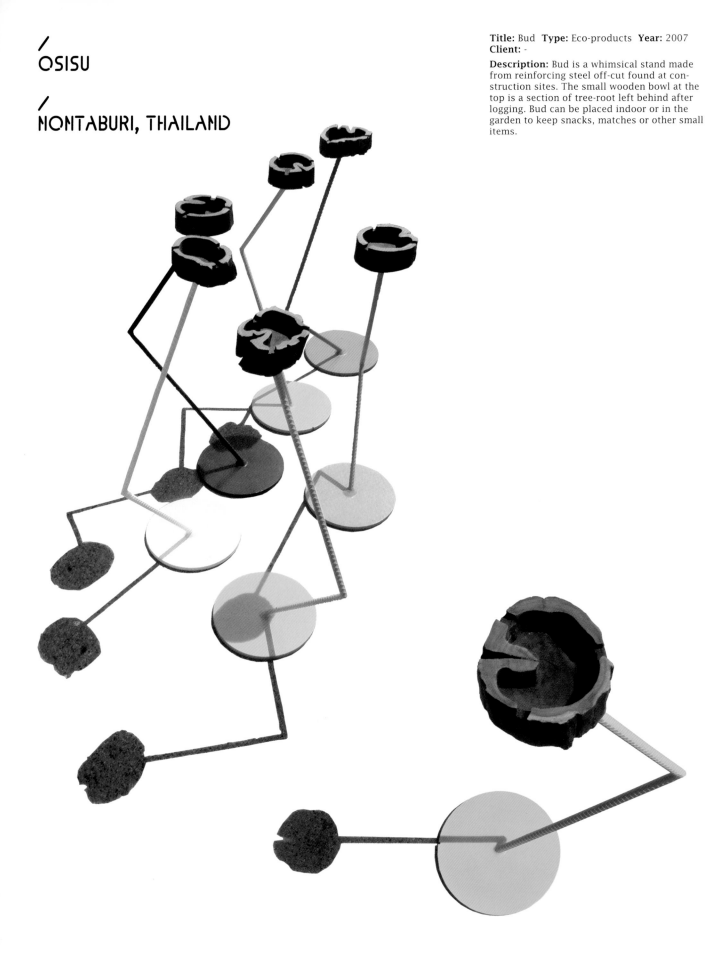

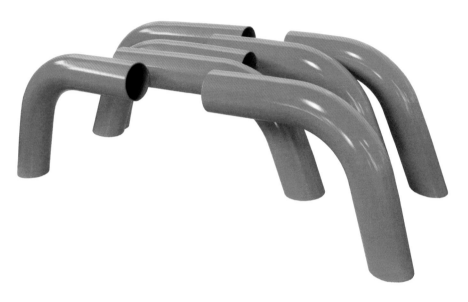

Description: Spider is created from salvaged steel pipes discarded from the production of automotive fenders. These 3" steel pipes are of highest quality but the lengths and angles are random. The design is straightforward. The pipes are used without alteration and are attached in parallel – this randomness gives the design its unique simplicity and movement. It can be used as a garden furniture.

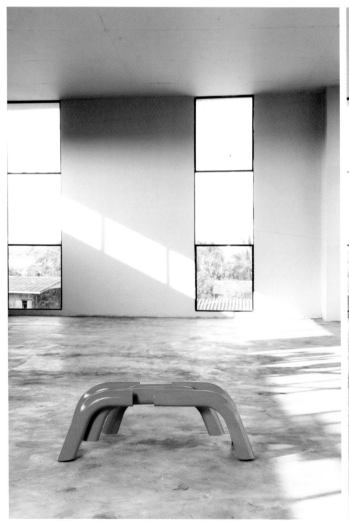

1/ Title: Frog **Type:** Eco-products **Year:** 2008
Client: Surivipa

Description: Agricultural wastes are abundant in Thailand. Frog is a low coffee table made from orange peel panels. The top of the table is a recycled glass produced from construction scraps. By using low temperature to recycle tempered glass scrap, unique granular texture is preserved.

2 - 3/ Title: Twin Desk **Type:** Eco-products
Year: 2007 **Client:** -

Description: Twin desk was designed for dual functions. It can be a coffee table for a living room as well as a desk for two kids facing each other doing their homework. The top was built with pressed juice cartons while the two legs are handcrafted from teak scraps.

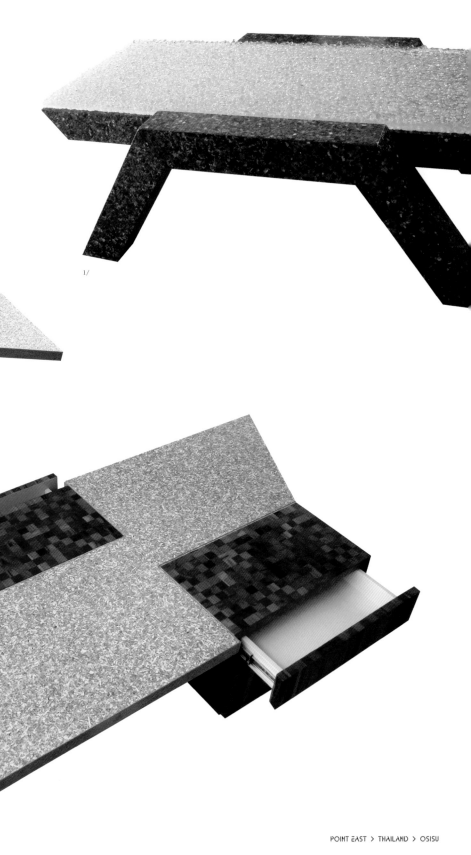

1/

2/

3/

1/ Title: Hippo **Type:** Eco-products
Year: 2007 **Client:** Future Park

Description: Hippo is a 12" high coffee table made from orange peel, an abundant agricultural waste. A piece of laminated glass off-cut from a renovation was integrated into the design giving it a sense of head and tail and a perfect surface for hot coffee pots.

2/ Title: M-orange **Type:** Eco-products
Year: 2007 **Client:** -

Description: Designed for snug sitting, atypical of a wooden bench. Orange peel was reclaimed and pressed into panels; and later

assembled with a slight angle to achieve a surprisingly comfortable seating surface.

3/ Title: Grasshopper (Artwood) **Type:** Eco-products **Year:** 2007 **Client:** -

Description: A bench in the Walker series, a comical piece of artifact made with sawdust (compressed into panels). Grasshopper is slender and mobile. Its four angled supports express motions - recalling a creeping creature in the wild.

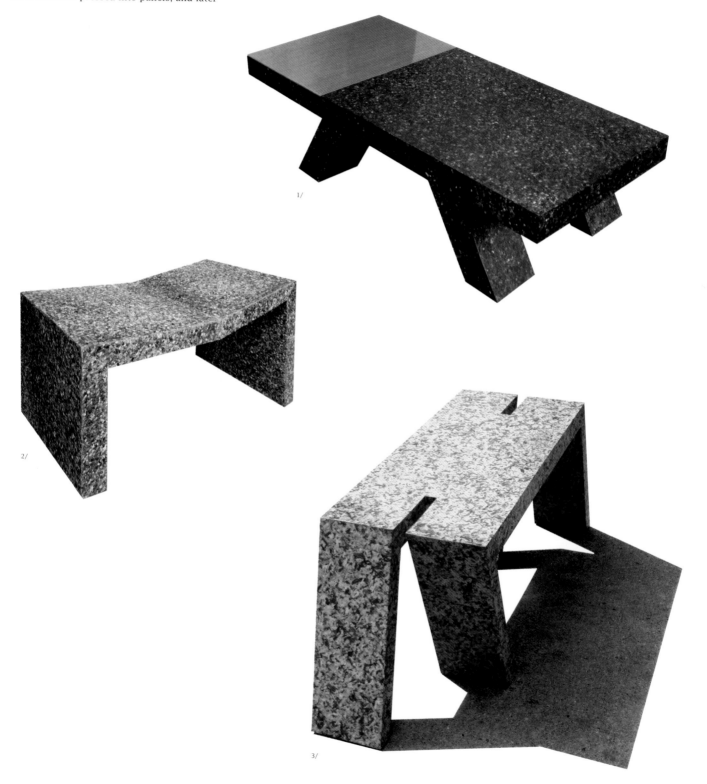

1/

2/

3/

Title: Muffin **Type:** Eco-products **Year:** 2008
Client: Experimental

Description: Muffin is a soft seat made from foam excess.

The colourful layers are created as liquid foams being discarded into moulds, which were used in place of trash cans. The result of the natural dumping process made stunning patterns for the Muffin seat.

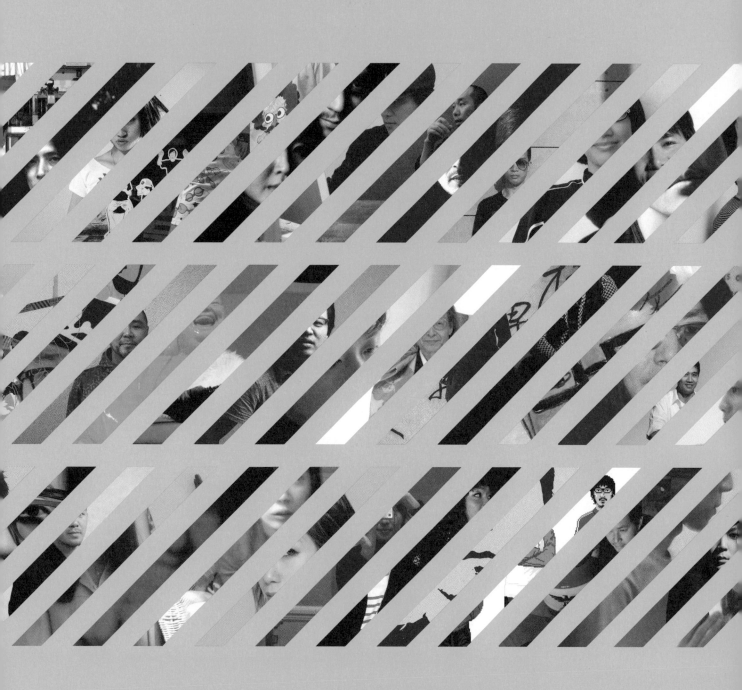

REVITALISE YOUR MIND
WITH INSPIRING INTERVIEWS

:PHUNK STUDIO

ALVIN TAN, MELVIN CHEE, JACKSON TAN & WILLIAM CHAN

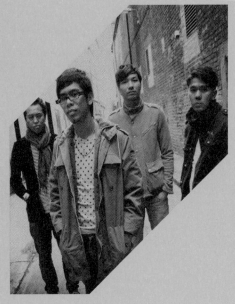

Profile:

Alvin Tan, Melvin Chee, Jackson Tan and William Chan are 4 Singaporean artists/designers of Chinese descent. They met in Lasalle-SIA College of the Arts, Singapore and got together in 1994 to form ':phunk studio,' a creative collective based in Singapore. Described as 'The Champion of Singapore's Graphic Scene' by Creative Review, UK, 'Asia's hottest agency' by Computer Arts, UK and 'Iconic representatives of the new wave of young Asian creators' by Get it Louder, China, the studio is a leading art and design collective in Asia.

What made you pursue design as your profession?

That's the only thing we could do well and enjoy doing.

What made you guys decide to collaborate in the first place?

We met each other in art school in 1992. We shared many common interests, ranging from old Hong Kong kung fu TV serials, Chinese mythology and Japanese manga, to British indie music, American pop culture, pretty girls, alcohol, and parties. We tried starting a band initially, but gave up after realising we sucked big time. Out of boredom, we started jamming visuals with graphics on the Mac in Jackson's bedroom and sent the 'EPs' out to people we liked. That's how it all started. The rest, as they say, is history.

Why the name ':phunk studio?'

After our failure to start a rock band, we decided to create our own street wear label. We were fresh out of college and knew nobody and nothing about running a business. When we were looking for a name for the brand, we stumbled upon a flyer/poster of the British record label Mo' Wax designed by Ian Swift, who was also the designer of Straight No Chasers magazine. It was called 'Mo' Phunky.' It connotes the idea of the future of funk and so we decided to use the word 'phunk.' Later when we decided to work as a collective studio, we added the word 'studio' behind it and ':phunk studio' was born.

What are your inspirations?

The main access and outlet is through visuals, information and cultural influences of our own collective interests and background. We are avid collectors and 'junkies' of popular culture. This is a habit we cultivated when we were kids. It is a recurring theme in our works. We have constantly sampled and referenced these influences in our works. It is an instinctive and natural approach for us, as it is a visual language that we relate to and understand very well.

We were born in the 70s, the golden era of television, movies and pop culture. To name a few: popular Hong Kong kung fu movies produced by the Shaw Brothers studios and Cantonese TV series such as 'The Return of The Condor Heroes' ('神鵰俠侶'); Japanese cartoon anime such as 'Gatchaman,' 'Doraemon' and 'Gundam;' American television programmes such as 'Sesame Street,' 'The Six Million Dollar Man' and 'Solid Gold;' Hollywood movies like 'Star Wars,' 'Indiana Jones,' and 'E.T. The Extra Terrestrial.' We also read a lot of comic books: Hong Kong comics by Tiger Wong; Japanese manga such as 'Akira' and 'Fist of The North Star;' American superhero comics such as 'Superman,' 'Batman' and 'Spider-Man;' and British comics '2000 AD.'

As teenagers in the 80s, we were fascinated by the music and visual culture of British indie pop and new wave music and American rock and MTVs. It was a time when the experience of walking into a record store to look at the record sleeves, such as Peter Saville's designs for New Order and Peter Blake's cover art for the Beatles are as enriching as viewing a masterpiece at the museum. The various art and design movements in the 19th and 20th centuries, such as Bauhaus, Fluxus, Situationist, Pop Art, Swiss Modernism and Post-Modernism design are just as influential to us.

And now, we are mostly influenced and informed by travelling to different parts of the world and meeting different creative people who share our interests.

What's your biggest challenge to date? Why and how did you overcome it?

We get bored easily. To get around with it, we like to explore and express our ideas through different media and blur the lines and boundaries between art and design; creative and commerce; craft and technology; the East and West; control and chaos; love and hate; friendship and partnership; audio and visual; etc.

Which project/work of yours you find the most memorable? Why?

The next one is always gonna be the best.

The concept of 'universality' in the age of modern globalisation is a constant theme in your works. Can you elaborate on this?

It is about the relativity and relationship between man and the universe in the age of modern globalisation and technological advance.

Universality is a recurring theme that has evolved from our previous works into our own universal system of modern mythology. We wanted to examine the relationship between ourselves and the imaginary universe we have created, and to find out what connects us to our ideology.

In the old days, people used to celebrate and worship different gods daily, such as the kitchen god, the tree spirit or the door god, who could be man-made or natural. It is a systematic way of worship similar to how it works in a hierarchy. It can also be done through everyday objects such as our modern household appliances.

But is there a god in the washing machine or a spirit in the television? Is technology the new divinity that is fast gaining power over the nature? Who and what do we embrace now? Who are our modern saints and gods? Is it Mickey Mouse or Madonna? What are the modern symbols and icons? Does the door god still exist in our modern glass sliding doors? What is the relationship with these gods and us? How do they make us equal? Do these gods travel by clouds when we travel by jet planes? How does the system function in the modern days? Are our morals still the same? Does what you embrace and believe in reflect your inner self? What is the universal truth?

We are interested to find out more by exploring the system. It has evolved into a constant recurring theme in our works and the recurring message is 'love.'

Please tell us about your latest collaboration with Levi's for a series of T-shirts for Valentines' Day. Any fun stories to tell?

It was interesting for us to collaborate with Levi's on the Valentines' Day T-shirts as we are a group of 4 guys. But we thought that would be a nice challenge to translate our recurring theme of universality and the message of love through the context of the occasion using t-shirts as the carrier of the message.

Please tell us about your collaboration with Maxalot for TodaysArt 2007. What led to the collaboration, what inspired the pieces, etc.?

We were invited by Maxalot to participate in TodaysArt 2007. The brief was to create an artwork to be projected on the walls of a high-rise building in Hague, the Netherlands. We created a piece based on the artworks of our 'Universality' series to depict the story of our universe.

Your graphics have adorned bikes, buildings, clothes, vinyl toys, etc. On which medium do they look the best on?

We like to work on various mediums. We are currently making works and conveying our messages through the mediums of fine art, print, painting, sculpture, installation, etc.

What are your views of the Asia's design scene? What are your expectations for it?

It is very exciting to see its development and the diversity of influences and cultures among the new generation of Asian creators. At the same time, it relates to the similarities in their personalities and backgrounds. I believe the scene will grow and mature further.

How do you feel about your motherland? And how does it influence your design sense/style?

Singapore is a very young nation with a unique personality and identity. It is unique in the sense that, unlike most other modern cities, it doesn't have much cultural baggage. There aren't a whole lot of visual or cultural history and traditions to weigh us down. In a way, it is a blank canvas, where the new generation of creators are defining it. So yes, it's really an exciting time.

Which creative catches your attention the most recently? Why?

The Nintendo Wii, which brings fun and entertainment back to the people.

What is the most exciting/impressive work of others you find lately? Why?

The transformation of Beijing for the Olympics. It's amazing to see the enormous scale of changes in architecture and city development.

The Singapore History Museum hosted :phunk's 10-year retrospective exhibition 'A Decade of Decadence' in 2005. How do you see yourself in 2015?

Celebrating 20 rocking years as friends, partners and brothers.

If you weren't a designer, what would you be?

Bad musicians.

ZHIWEI BAI

BAI.S WORKSHOP

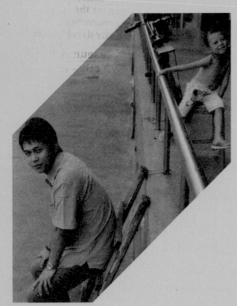

Profile:

Designer and BAI.S workshop Art Director Zhiwei Bai is dedicated to discovering new visuals. He hopes to use creative concepts to show the value of business. His award-winning work has been featured in many international design exhibitions including New York ADC Awards , New York TDC Annual Awards and Tokyo TDC Annual Award.

When and how did you find yourself talented in design?

In high school when the Internet was all the rage.

What made you pursue design as your profession?

Because it's fun and refreshing.

What did you do in the years between your graduation from Shenzhen Polytechnic in 2004 and the establishment of Bai Design in 2007?

Freelanced and worked for various design companies.

Where do you get your inspirations?

Be conscious of the little things around you.

Your design is characterised by simplicity. Has it always been like that? How would you describe your style?

Design style is a way of expression determined by your aesthetics, likes and dislikes at the time. I'll stick to my creative principles no matter what.

What was/is your biggest challenge to date and why? How did you overcome it?

My biggest obstacle so far is balancing work and play.

Which project/work of yours you find the most memorable? Why?

Looking back at all my works is an experience. I was involved in the binding and design of the book 'A book of Mahjong' ('麻將書') which went beyond my limits and I once thought that I was a binding master.

Which work of yours has been collected by museum(s)? How special is it?

My earlier work 'The Impression of Suzhou' ('蘇州印象') because it shows my country's unique urban culture.

You have won many important awards in and out of China, which are the more significant ones for you? Why?

'The Impression of Suzhou' ('蘇州印象'), which won a Taiwan International Poster Design Award. It was a work that struck a chord with our peers in Taiwan where it was exhibited.

You are quickly established in China, what's your future plan?

I'll continue to work hard.

What is the most exciting/impressive work of others you find lately? Why?

'Prosays' by Tommy Li where he translated black comedy into a cosmetic brand. If I were a woman, I would have bought it simply because of the design.

Who do you admire the most in the same field as yours in Asia?

Nagi Noda. Her designs are really crazy.

How do you feel about Asia's design industry and what are your expectations towards it?

The style of Asian design will change since China's star is on the rise, and more and more exhibitions and conferences will be held there, which is very exciting.

How do you feel about your motherland, China? And how does it influence your design sense?

My motherland will be moving forward at a cutthroat speed and I'm proud of its rich cultural elements.

Chinese designers are getting more and more attention and recognition over the past few years, how do you find the design industry in today's China? In what ways can it be even better?

Only a few people and works in China have received critical acclaim: my country's design standard is not very high in general, especially when it comes to commerical projects. Even though this is related to our economy, I think our government should promote design, support the industry, and be more engaged in the enhancement of local design education.

Now many young people want to become a designer, do you have any suggestions for them including your students?

Be down-to-earth and passionate.

If you were not a designer, what would you like to be?

A musician.

JULIE BOUIGUEROURENE

J*WLS

What does 'J*WLS' stand for?

It doesn't stand for anything particular but it's been my nickname for some time. Friends and teachers back in Seattle always called me that. Apart from ringing a bell with my first name Julie or 'Jools,' I liked to play on the double meaning of jewels and I decided to keep it to sign my artworks.

How did you find yourself interested in design and what made you pursue design as your profession?

I've been interested in art as far as I can remember. I've always been drawing and making things with my hands since I was a little girl.

For many years, it's been a way to let go the dreamy and introverted sides of my personality. I wanted to push it further as I grew up. I had the opportunity to study graphic design and 3D modelling in Seattle, not knowing anything about computer at the time. So, I started from scratch. I was curious in anything about techniques, programs and things that would make my work evolves from paper to computer-based graphics and motion.

After many years working in marketing and print advertising for several companies in France, I thought I have had enough experience to start working on my own and exploring more on personal inspirations.

What made you decide to leave France for Japan?

After I graduated in the US, I came back to Lille France, my hometown, and worked there for a couple of years. Even though this city is full of young talents and inspirations, I was in the need of new horizons. Tokyo had intrigued me for some time and I was inspired by the Japanese culture from an European eye. I wanted to go beyond the usual clichés and start experiencing the Tokyo life from an insider's point of view. In the meantime, I met my boyfriend who already had this plan to spend a year in Tokyo. He offered me to join and we boarded on a plane to Tokyo Narita 6 months later, with his music and my designs.

Did you have any work experience in design before you relocated to Japan? If so, what was it about?

Yes, indeed. And even though I am trying hard to hit the Japanese scene, networking with local talents, and getting all my fresh inspirations from this new Japanese surrounding. The truth is that most of my job requests still come from Europe, at least for now.

What made you switch from 3D motion to illustration?

Before studying 3D, my personal works were only linked to still life, drawing, sculpting. But I soon had this feeling that computer technology would surely redefine worldwide aesthetics. Therefore I wanted to experience as many things as I could, such as producing a video, web animation, action-script, etc. But still, I remain more attracted by the nature to the poetry of an instant and a pose.

So, both computer technology and 3D studies helped me to understand how this whole new world worked at the time. But most of all, how I could adapt my works onto the screen, and make something new out of it, something in between sketching and computer-based illustration, and which is still a work in progress.

Have you encountered any difficulties when you first started the freelance business in Japan?

Being unable to speak any conversational Japanese makes things tough, as expected. However, I managed to have a contract with a Japanese company for printing my designs on its lingerie. But so far, most of my works have been requested from clients in Europe or in the States.

How does your love for Pop Art, Hip Hop and comics translate into your work?

Most girls I draw are influenced by trends without being fashion victims. What I try to communicate is that those girls are able to retain their own identity and style while being emancipated from their social restrictive feminine role and also from standards of conformist high fashion. For example, I would never ever present a girl carrying a Prada or Louis Vuitton bag in my personal illustrations, even if I see a lot of them wandering in Tokyo's streets. I would rather make my clothes, bags and accessories in J*WLS-personalised style.

My girls are smoothly individualistic. They reply Andy Warhol's call for the universal minute of glory for everyone, also the call of hip hop for emancipation versus all the gangsta rap yelling at women's kilometres of the 'B****' word. Regarding comics, I try to present realistic women with a sketchy feel. I like my works to be a cross between drawing and vectorism, but the inspiration stops here.

Profile:

*J*WLS is the nickname of Julie Bouiguerourene, who is a 28-year-old French graphic designer and illustrator. Based in Tokyo, she has been working freelance since 2006. Although she studied 3D motion in Seattle, her illustration and design skills are self-taught. She used to draw a lot but the computer-based illustrations form the biggest part of her work.*

As mentioned in your profile, how have London and Tokyo inspired you lately?

So far, I think London and Tokyo are 2 of the main platforms regarding the fashion, art and music scenes. I have always been attracted to big cities. I have lived in Seattle and London for some time. Those cities never sleep, there's always something happening at any time during the day or night, which is very exciting. It's very refreshing, and since I've been living in Tokyo, my inspirations and productivity have got even more boosted.

Plus, I'm always amazed by the people I met on the streets, in clubs and in concerts. They dress and act as they want to, and always have this unique touch that will make them stand out from each other.

What was/is the most challenging for you so far? What is/was your biggest challenge to date? Why and how did you overcome it?

Leaving everything behind and coming to Tokyo was a big challenge. I didn't have any exact idea of what I would do, but I knew that it was the right time for me to do so. I'm finding my place little by little, and I am planning take part in different exhibitions and fairs this year.

I started doing silkscreen printing recently here in Tokyo, and my first designer T-shirt line was presented at the Tokyo Design Festa Fair in May. My man and I invested a lot of time in our own silkscreen clothes. It's been difficult at first because we started from scratch and our apartment space wasn't the most appropriate for this. Still, we managed to prototype high-end quality products, so we're very excited to get it started on the May event.

What project/work of yours you find the most unforgettable? Why?

Surely the posters and flyers I did for the 'Minimal Carnival' party in Bricklane, London. A year ago, my boyfriend and his 2 other mates launched a minimal techno night and needed a design. They had little money and time for promotion, so I used a vectorised picture of my face with a mask. They printed the black design on fluo pink and fluo yellow posters, hanged them all over London East End, and the party actually became a real success. It was really funny for me to see my face all around. Even one day, I saw a guy carefully removing the poster off the wall, to keep it for himself. Since then, the party celebrated its first birthday with a new version of the same design, which still rocks the spot.

What's your plan in the future?

If time and money allow, I would love to keep on travelling for some time and experience other places like Berlin or New York. I can't really see myself settling in one place for now. Of course, my family and friends are missing me, so I might go back to France for some time until I get enough money and energy to move somewhere else.

Which creative catches your attention the most recently?

I've always been fascinated by Japanese animations and Asian movies in general, and still love to have the time to discover new pearls since I'm here. Regarding animations, Studio Ghibli is way beyond anything else; Princess Mononoke, Pompoko and Totoro remain my favourites, I admire their aesthetics as much as the poetry and meaningful messages they give kids and adults.

Recently, I fell for this animé called 'Death Note,' the characters were smartly shaped and the story was totally outstanding. Looking back at the movies, one of my favourite was 'The Taste of Tea' by Katsuhito Itchii. The picture is superb, but most of all, the manga style and special effects added has turned it into a masterpiece of art. The last 2 movies I watched were 'Gozu' and 'Ichi the Killer' by Takeshi Miike. His universe is terrifying. It's mainly about yakuza and violence, but the way he changed it with dark humour really made them my top 10.

What is the most exciting/impressive work of others you find lately? Why?

A few months ago, I was looking through the 'Drop Dead Cute' postcards in a shop, and I totally fell for Chiho Aoshima's pop and computer-based work. It actually reminded me of her early works in 2001 at the Superflat exhibition in Seattle, among Takashi Murakami and Yoshitomo Nara, whose work carries the simple, sketchy and childish feel I like. I also admire a friend of mine who took me to his café in Tokyo the other day. He rebuilt his own studio at the centre of the café, with original sketches hanging on walls. It was like a little gallery, and it was amazing.

How do you feel about the design industry in Asia and what are your expectations towards it?

Unfortunately, it seems that design is much more considered as a hobby than a real job. Japan's conception of art is more related to crafts and luxury products such as sword making, pottery, etc. whereas graphic design is mainly utilised for advertising purposes. I think digital art, in contrary to Europe, has not been fully recognised as art in Asia yet.

What does the Japanese design scene have that the French design scene lacks, and vice versa?

Besides the biggest biennial Asian Design Fair held at the gigantic Tokyo big sight complex, where famous designers from all over the world could show and sell their work, Japan definitely lacks places for young designers to exhibit their work for free.

If you want to hold an exhibition in Japan, even in a bar or a café, you have to rent the spot. Usually it ends up very expensive as people don't understand that it could be a mutual collaboration and promotion. Most of the exhibitions are hosted by collectives or sponsored by designers' platforms. Entrance fee is imposed on visitors so that they could cover the costs. It still looks very awkward to me because I never have this kind of problem in France.

Do you find any benefits/advantages to work as a foreigner in Asia?

I think being a foreigner in Tokyo gives you credibility in both Asia and Europe. People in Europe are curious and somehow envious of your efforts staying in a city such as Tokyo, which is so far away from all their principles, culture, etc.

On the other hand, being a 'gaijin' in Tokyo is also a good thing because Japanese are fascinated by France and they respect your efforts for coming and struggling here as a graphic designer/illustrator. It's also easy to build up my network, linking up the people who are in arts and music. In the end, you would realise Tokyo is a very small world but it's full of opportunities.

Foreigners are very helpful to each other because they are all trying to make their dreams come true. However it's still hard to find contract jobs with Japanese agencies, brands or magazines.

BYUL.ORG
CHO TAESANG, GANESHA, JOWALL (CHO YOUNGSANG), HUR YU, YI YUNYI, PARK CHANGYONG

How long did it take for you to get your first Japanese client? Would you say you are getting more attention in Japan now?

At first, I did a lot of searches through the Internet and networking websites. People gave me lots of links to contact magazines and brands that might be interested in my designs. One month later, I had an interview with a Japanese brand and have some of my designs printed on lingerie for a boutique called 3RDWARE in Harajuku.

The products could be found in stores now and I'm very excited about it. Since then, I had a few project requests, such as flyers, CD covers and T-shirts. Meanwhile, I keep taking part in art events for free like art projections and collaborations with other artists, to demonstrate my work and efforts to the public.

Do you find the Japanese culture/tradition interesting? And why?

I'm interested in the Tokyo's paradox between tradition and modernity. I noticed that it is a city with constant changes, especially on the architectural front. New buildings and roads rise and fall in an impressively little amount of time. Japan has evolved very quickly from their ancestral way of living after World War II into one of the most modern cities in the world today. This contrast makes me feel like I'm in a parallel universe where I can let my creativity flow without any restrictions, as if I am daydreaming.

If you were neither a designer nor an illustrator, what would you like to be?

I don't think I could have done anything else with as much passion as what I am doing now. Being a freelancer gives you incredible freedom to explore your skills and creativity, I wish I would never have to work in an agency again, where I will feel like a shiny bird in a cage. For the time being, I can work anywhere in the world. My life feels truly like a luxury, but in which I have succeeded to do so in the long run. No pain, no gain.

...

Profile:

...

byul.org comprises Cho Taesang, Ganesha, Jowall, Hur Yu, Yi Yunyi, and Park Chanyong. The team started as a psychedelic band but they now focus on art direction for fashion houses, museums, construction companies, etc. Their most memorable work to date is their design for 50th Venice Biennale Korean Pavilion 2004. Their client list boasts Absolut Vodka, Aterlier Hermes and W Korea.

...

What made you pursue design as your profession?

We have 6 members now and we all have different interests and backgrounds. We started as a psychedelic band but now we do anything that looks interesting to us, including direction for fashion designers, museums, and construction companies.

What are your inspirations?

Our friends and daily life.

What's your biggest challenge to date? Why and how did you overcome it?

We have had many challenges and we overcame them with alcohol.

What project/work of yours you find the most memorable? Why?

Design works for 50th Venice Biennale Korean Pavilion (2004). We went to Venice for our design works and we also performed our music at the Korean Pavilion opening ceremony. It was extremely hot and humid that year in Europe and we were just so exhausted. We saw Yoko Ono there. We're not sure if she heard us play but we were very excited already to see her walking pass us.

How does your passion for music translate into your graphic design?

We started off as a band. Some of our members have no relation to art and design works at all, but we are all having fun together.

How does your passion for graphic design translate into your music?

I studied architecture at college, which involved studying everything. We mixed everything up and eventually it became experts in nothing. It was nice though. I still see myself as just one of those wannabes artists. And to be honest with you, I don't think I have the passion for graphics. But I do like/love this job.

Your art direction for W Korea is simply stunning. What inspired the piece?

We were asked to art direct 8 to 12 pages for W Korea without any limitations. We decided to tribute John Lennon and Yoko Ono's 'bed peace' performance in the late 60s. Focusing on the fact that 'bed peace' was placed in top luxury hotels with room service at the time, we put Hermès, Chanel and Jil Sander on all model figures include top film star 'Moon, Sori' as Yoko Ono and ourselves as John Lennon

BOB CHEN
BICO -I- BOBCHEN GRAPHIC DESIGN OFFICE

and photographers surrounding the bed. We worked sensitively on balancing fun with messages we want to express. We wanted to make fun of those ironic peace strikes, but not too seriously.

Your works are 2D-oriented. Are there plans to create 3D works?

We've collaborated with several clients on apparel collections already. But we do hope we can have the chance to do something more than that such as designing buildings.

What are your views of the Asia's design scene? What are your expectations for it?

Korea, Japan and China are actually very different in a lot of ways. But we also have many similarities such as chopsticks, shiny black eyes and summer typhoons.

How do you feel about your motherland? And how does it influence your design sense/style?

We love Seoul, Korea, and the Han River which runs across its centre. The big river influences us a lot in many ways, for instance, the cover with the image of the Han River and Seoul we made for the 6th issue of Monthly Vampire magazine. Also, our lyrics are always in Korean. We think, we talk and we write the language.

Which creative catches your attention the most recently? Why?

Raf Simons' collections. They are just so beautiful.

What is the most exciting/impressive work of others you find lately? Why?

Hyunjhin Baik's first solo album 'Time of Reflection.' It includes one of the best songs I've ever heard in my life.

Please tell us one thing about yourself that people don't know yet.

Our official name is 'byul.org' not 'byul.'

If you weren't a designer, what would you be?

Cho Taesang: A soldier.

Profile:
..

The graphic designer and art director was born in 1979 and graduated from Zhejiang Commerce College in 1998. In 2004, he established Bob Chen Graphic Design Office. He has participated in numerous exhibitions, including the 20th International Socio-Political Poster Biennale, the 2nd Chinese International Poster Biennale, the 1st and 2nd Chinese Letter Poster Exhibition in Political, and 2007 Get It Louder Exhibition. His works are collected in the V&A Museum.

..

What made you pursue design as your profession?

Hong Kong and Mainland China's design industry are developing at a different pace. Mainland China's design scene started to bloom when Hong Kong's has already been going on. I didn't understand design when I graduated from college 11 years ago. But I wasn't the only one, our society didn't understand what design is. Thus, I didn't choose to become a designer, I stumbled into the profession. I once said that I didn't choose design but it chose me.

You studied fashion design at Zhejiang Commerce College, what made you leave fashion for graphics?

Even though what I did at college was called 'fashion design,' most of the courses I studied were related to graphic design. This is a weakness in China's education system. To be honest with you, I didn't understand fashion design and graphic design back then. I didn't leave fashion for graphics since I wasn't into fashion.

The level of design education back then was primitive and perceived as technical training where only illustration and presentation skills were involved. We were deprived of creative thinking training and didn't know what we could do with our design skills. I got into graphic design upon graduation since a graphic design job chose me. I didn't take the job because I found it not interesting. You have to understand that this happened 11 years ago when graphic design was a new term in China.

Where do you get your inspirations?

In general, my inspirations are come from my experiences while good inspirations arise from intuition. The best inspirations spring from accurate interpretation of intuiton.

Your company's philosophy is 'fit design.' Tell us a bit about it and illustrate it with one of your submitted works.

'Fit design' is like a piece of clothing that fits you like a glove. The clothes on the mannequins may not look good on you. Also, what looks good on someone may not look good on another. The clothes desired by westerners may be unpopular among the Chinese. Thus, the hardest thing about design isn't creating new things but to produce design that fits all.

'Fit design' also has another layer of meaning: moderate design. Designers tend to be sentimental and overdosed on design, for instance, designers always put their focus on the design concept and visual language which made them failed to pass on messages to audience most of the times and would result in a bigger budget.

Some of your works, such as '1937,' has a nostalgic feel to it. Would you say that your designs blend the new with the old?

Yes. I always look for dichotomies and consistency. I love visual stimulus, which is multi-faceted and comprise more than the old and new. I create different kinds of visual stimulus according to each project's need and uniqueness. The right amount of visual stimulus can be powerful.

The work '肆' is a nod to the traditional Chinese characters. What are the inspirational behind this piece? What other design elements best represent Chinese culture besides this?

The traditional Chinese characters have been around for ages. It is a unique cultural gem and the only traditional element that is still in use among the public. Each of them is a priceless artwork with perfect structure. We need to appreciate, protect, pass on, and study it so that more people can understand why it is one-of-its-kind.

Each traditional Chinese character has a very distinguishable frame. For most of them, we can still tell which is which even if we fill up the centre with other content. This is a very interesting characteristic and it is the inspiration for '肆'.

What traditional Chinese culture left behind is a long sigh, excruciating history... it isn't a pillar in a palace, a relics from a grave, or an ornament, which can only serve as entertaining 'cultural fast food.' I couldn't find another single element that can represent Chinese traditional culture. Tai Chi is very Chinese but it can't represent our country since South Korea has already used its graphics for her national flag. Stamp is very Chinese too, but when it is pited against calligraphy, it is not as representative. It's like asking which dish could epitomise a Chinese banquet...

Typography is a prominent feature in your design. Tell us how you got interested in it in the first place and which typography project are you the most proud of so far?

As a graphic designer, neglecting typography is unforgivable since it's versatile. I'm interested in typography since there isn't a reason not to be interested in it.

If budget allows, typography is my no. 1 priority, which involves post-production work and paper. Up till now, I'm pleased with all my typographic works.

You have been working on your designs, planning on exhibitions, as well as lecturing in university, which field do you enjoy the most?

It's all hard work but I feel pleased after each project. I'm curious about unventured territories and am willing to try new things when the opportunity comes along, not particularly aiming for more achievements but instead, I want to understand what I can and cannot do.

Please tell us about the concept of your recent exhibition 'China Design Now.'

'China Design Now,' held by the UK at the Victoria and Albert Museum from March 15 to July 13, 2008, was the first exhibition about contemporary Chinese design. It aimed to show how China's burgeoning economy is influencing its architecture and design.

Have you always been conscious of your own cultural roots and historical context?

When I am conscious of my cultural roots, I couldn't help but I need to look at the issue from a westerners' perspective, which makes me very western in a way too. However I always try to use my own cultural perspective to think and solve problems.

How do you feel about your motherland, China? And how does it influence your design sense?

The rock and roll scene in China isn't as angry as before and I didn't and couldn't foresee such great economic progress more than 10 years ago, but I'm very pleased with what we have now. My country influences my designs in 3 ways: its culture, political state and economic level. I use the language to think and

present myself. I also need to connect with my works to local audience hence I have to include cultural elements. Politics plays a big role in deciding how important design is in its place. The country is like a massive fish tank where the economy is like the water while designers are like fishes swimming inside. The state of the economy has a huge impact on the design scene too. Look no further than cities of various economic levels and you'll see what I mean.

What project/work of yours you find the most unforgettable? Why?

My most unforgettable project is my first name card I designed. It is so ugly!

What are your plans in the near future?

I'm designing my new office located at a spacious loft art space with a good vibe. We make part of it as our own exhibition venue and hence it becomes a platform for regular exhibitions for my friends and I. We'll continue to promote the '7080' exhibition so that the public can get to know more about the top local designers and their work.

Who do you admire the most in the same field as yours in Asia??

Chinese writer Lu Xun who is famed for his achievements in the field of literature. He is not only a thinker and writer, he is an artist with excellent taste also. I collect books designed by him. His book design has an eye for details and is modern-looking, which still stands out from the crowd even nowadays.

How do you feel about Asia's design industry and what are your expectations towards it?

Asia is a complicated economy comprising super-rich Japan, developing countries like China and India, and many small and yet to be developed countries. It shows a close relationship between the level of economic development and that of its design industry.

The Japanese design industry is the first to take off in Asia. They have the most outstanding designers and design research centres. In an Asian context, the Chinese design industry is far behind it. In Japan, design is not just an industry, it is also a national ideology. It is a shame that the creative industry was once omitted from our country's ideology. But China has many patriots, and dedicated and estab-

CHENMAN

lished designers that made our design scene happen. More than 10 years ago, designers in Mainland China can only learn from that in Taiwan and Hong Kong. But I believe China's design power today has surpassed that of Taiwan and equals to Hong Kong's.

Chinese designers are getting more and more international attention and recognition over the past few years, how do you find the design industry in today's China? In what ways can it be even better?

Graphic designers in China have just made their mark on the international stage. You can spot a lot of Chinese designers in international competitions. But not many Chinese designers have yet taken part in international design projects. Winning an award only means gaining recognition for one or two works of an individual designer or firm. If Chinese designers can have a slice of international design projects, they could have earned critical acclaims and this is what I dearly hope for. Chinese artists and architects have made achievements on the international stage in the past few years and I believe designers are getting there soon.

At this stage, China only has design profession but not a design industry yet. Design industry is a system involving vast capital and capabilities, like Hollywood, which has the whole package include creatives, investors, management, advertising, research centres and education. This system can't be segregated and all the elements must be combined together. I think that for China to have its own design industry, Chinese designers should seize the chance to participate in international projects and make the most of it. A design nation is not just about churning out outstanding designers, it needs systems and companies to bring out the best in its designers.

If you were not a designer, what would you like to be?

If I weren't a designer, I would still be doing design because it's the only thing that I can do.

There are many aspiring designers, before we wrap it up for the interview, do you have any advice for them, including your students?

Perform all your tasks well then you can become huge. This advice is for myself too.

...

Profile:

...

Chenman first made a name for herself with the covers for the Chinese publication 'Vision' magazine. Man's talent is her ability to marry her quirky photographic eye with technical wizardry. She has a strong aesthetic that is captured in her images. Though a relatively young talent on the photography scene, she has shot numerous fashion editorials and portraits, not only of Chinese celebrities, but also international style icons. Man enjoys bringing her home, Beijing, to the world of fashion, incorporating scenes of the Great Wall or hutong alley ways, creating an eastern style that rivals the west.

...

First of all, congratulation to your new-born baby! How do you feel? A boy or a girl?

It's a girl. I believe all women have to bear a child and I'm no exception.

When and how did you find your talent in visual aesthetic as well as the sense of artistry especially in photography?

Thanks to my capable mother and the mouse I drew on a broken piece of paper, I started to learn drawing when I was just 2 years old. I studied photography at China Central Academy of Fine Arts for 4 years, and that's also where I learnt drawing, graphic design, architecture, art direction, photography, etc. This formed the foundation of my work, and by foundation I don't mean style. Photography is what I do everyday but I won't pigeonhole myself as a photographer, I am still involved with painting, multimedia art, fashion, script writing, and film. I just do what I love and love what I do. I got into photography because of my interest in visuals and people and my grasp of fashion. So I am in the visual art industry, and I don't categorise myself.

What made you pursue photography as your profession? Please tell us about your educational background and your inspirations.

When a person's spiritual world is developed to a certain point, he/she will find his/her signature style. From scientists to villagers, everyone has their own signature style, just like Chairman Mao's hairstyle, Stephen Hawking's wide-rimmed glasses...all these people have found their signature style. You'll find yours when you have attained the highest level in your inner world. My signature style is a cocktail of technique, patriotism, fashion and love.

The women featured in your work have an otherworldly quality. Is there a special reason?

I love their voluptuousness.

VISION is your frequent collaborator. What do you and VISION share in common, stylistically speaking? Which of your work for VISION is the most memorable?

I have stopped collaborating with them. I began freelancing for them by the end of year 2003 and I was with them for 4 years. It

brought my strengths to the fore, be it my philosophy or technique. At the beginning, I was flaunting my skills a bit, from the first issue to the collaborations with certain Brazilian models. There's always something memorable in each issue. The space trooper shoot was the most unforgettable since I was sick and I polished it in bed at home.

In addition to photography you have also made your mark in film. Tell us a bit about your short and experimental film for the Wave Chinese Media Art exhibition.

It was a college collaboration between my ex-boyfriend and I. I shot him, made the motion graphics and he edited the film. It was a short one. In those days, I wanted to flaunt my obsession towards visual arts and techniques, which is the most prominent feature of my early works. Flaunting has its negative connotations but when things reach their limits, the shortcomings could be hidden as a result.

Beijing is a motif in your work. How does the city's transformation influence your work? Besides Beijing, what other oriental elements do you use to create a far-east style that rivals the west?

There are too many. I was brought up in Beijing's Hutong and am emotionally attached to the place. What makes Beijing as it is are things like cab drivers producing fading photos, women's scarves, palm trees, jade and red nail enamel. The way I create my work is like a slice of onion spicing up a bowl of noodle with soy bean paste.

Are you always so aware of your own cultural roots and historical context? Or you learned about them later on?

Babies are not born to know how to love, and not everyone can realise such when they grow. I am lucky since I know how and what to love by the time I should. Everyone in the country immersed themselves in the martial Cultural Revolution in the post-80s when I was still a kid. And when economic reform began, people strived to emulate the success of Hong Kong and Taiwan, and later the States, Europe, South Korea and Japan. By experiencing the transformation of China, from a hermetic country into a comparatively liberal land, from abject poverty to the growing disparity between rich

and poor, we became aware of milk products besides the China-made yogurt and White Rabbit creamy candies, but also the taste of Häagen-Dazs ice-cream, Coca-cola, and even the air outside Beijing. I realised what kind of impact my country has made on me. It was such a lengthy and gradual process that I cannot conclude in a 2-hour movie, and a storyteller needs her audience.

Do you see yourself as a mover and shaker in the Chinese design/photography industry? How so?

It seems inappropriate for me to comment on this. But I see myself a climber who consistently keeps my head down focusing on the steps that I am making at the present. I do not look forward or backward.

What was/is your biggest challenge to date and why? How did you overcome it?

I have not come across significant challenges in such peaceful times. These challenges often relate to my daily living and these big issues need to be chewed on.

Do you have any special preference in cameras?

I use all sorts of cameras, including Hasselblad cameras, digital cameras and those that work with plastic film rolls. Cameras are tools and possessions. I shoot what I want to shoot. What matters is your way of thinking and how it interacts with your experience to generate new ideas. Hence you can produce strong pictures in different styles with the same camera. I don't have special preferences when it comes to cameras but I do have my criterias in choosing a boyfriend.

What project/work of yours you find the most memorable? Why?

I don't have one since I don't look back.

We are bombarded with images of celebrities. How do you make us see celebrities with fresh eyes through your portraits of them?

Passion! Love what you do! When I was a kid I wasn't articulate. I remember adults around me always asked for my name, age, and about other general questions. Sometimes they asked me what I wanted to do in the future. I didn't think through my answers and said premier, scientist, astronaut, etc.

Based on my 'I like' principle and the intuition I inherited from my mother, I'm a creative till this very day.

What are your plans for the near future?

Action speaks louder than words, that's why I rarely plan ahead. Philosophers often think too much and end up giving up their lives. So why keep your brain busy?

What is the most exciting/impressive work of others you find lately? Why?

There are too many. But I can only tell 'which' I like but not 'whose' since I don't even know who designed it! Like at the time when I was still in high school (with unlimited wants for fashion but limited cash in pocket), riding a bike through hutongs in Beijing, I just braked and dashed towards the perfect-coloured second-hand clothing that caught my eyes. It was too lovely for just 8 dollars! Who cares about the designer? I was just thrilled!

How do you feel about Asia's design industry and what are your expectations towards it?

Play by your own rules. But I also hope that more and more creatives who understand themselves will approach work from a refreshing perspective.

How do you feel about your motherland, China? And how does it influence your design sense?

It is similar to how I feel towards my mother, so as the influence that my mother has on me.

Chinese designers are getting more and more international attention and recognition over the past few years, how do you find the design industry in today's China? In what ways can it be even better?

The industry is founded on the country's prosperity, and the world's recognition will grow when China has a stronger economy. How I feel does not really matter on this issue.

If you were not a photographer, what would you like to be?

A chef. I love eating and enjoy watching people eating even more.

JOEL CHU
COMMUNION W LTD.

Profile:

Joel Chu is the creative director of the award-winning firm, Communion W. Established in 1998, it is a leader on the creative and graphic design front and has churned out numerous memorable advertising campaigns and music packaging over the years. Their secret to success is their profound understanding of the youth market. Chu has collaborated with Hong Kong local well-known singers like Eason Chan and Edison Chen and multinational companies such as Levi Strauss, Nike, CitiBank and Columbia Pictures.

Please tell us about your educational background.

I started studying design since primary school without knowing why my application was accepted. I got into Hong Kong's Design First at age 14 to study graphic design even though the minimum admission age was 18. I studied traditional Chinese painting on the side.

What made you pursue design as your profession?

I see myself as a creative. Apart from graphic design, I'm involved with advertising and marketing too.

However, there are many graphic design graduates each year and that leads to greater competition. Also, people claim themselves a graphic designer as long as they have a computer. Thus, the public has less respect for this creative discipline and thinks that it is no longer a profession.

I believe, we shouldn't pigeonhole ourselves. The line between, say, graphic design and advertising, is blurred. I am also involved with interior design these days. Advertising hones my business thinking as most designs have commercial values and clients behind.

We are labelled as a graphic design house, an agency, or even a book publisher, but we only publish books when a suitable subject arises. Most of our works are commercial but we do book design for interest.

Where do you get your inspirations?

I get inspired by everything and anything. But it also depends on our project's target audience. For instance, after I came up with a subject for a book, I'll think about the type of people who would be amused by it. So it all boils down to whom I'm designing for.

Another example is a commercial for a camera. I'll consider its price range and quality. I don't wait to be inspired. People who believes in that are over-the-top. If your deadline is tomorrow or a few hours later, waiting for inspirations is a luxury.

I think, graphic designers shouldn't only read books about graphic design. No matter which creative discipline you're from, the public is your target audience. If you want to strike a chord with people, you have to be social-con-scious too. If you get inspirations from your favourite creatives, chances are that you won't have something new to say and soon be followed their footsteps.

You have the ability to capture the essence of local celebrities. Does it come naturally to you?

Everyone is unique. We can't imitate each other. We can choose to see from the good side or bad side. Sure it takes time to know a person as everyone carries a certain quality. For example, I would collaborate with a singer because I get inspired by his or her songs. Some artists may not be armed with a strong identity or character, but as an outsider of the entertainment business, I listen to what they have to say with his new product and offer them alternative ways to re-package himself/herself. Maybe that's why I've earned trust from them.

The artwork of Edison's CD album is among your most eye-catching work. What inspired this piece?

When Edison first got into showbiz, he sang canto pop that he didn't like. He didn't like singing cheesy love songs. His record company wanted him to become a heartthrob yet that is not who he really is. He loves hip hop and he knows exactly what he wants. He wanted to sell records with his messages, not his good looking face. So he fought for this album on both the artwork and music fronts.

The artwork on this album sleeves were done by 8 illustrators and it looked pretty good. This proves that he did what he had always wanted to do.

Which singer would you like to design a record sleeve for that you haven't yet? Why?

I'm not very interested in designing record sleeves. Record sleeves held the key to our understanding to singers 10 years ago, but things have changed and record sales are going downhill. Nowadays, people tends to download music instead of buying CDs. The quality of music doesn't really matter and we're settling with MP3s. And to be honest with you, I'm not a fan of MP3s.

Making a record sleeve that conveys a certain message is much more important than featuring nice pictures of the artist. There isn't any particular singer I want to design a record sleeve for. I'm more interested in collaborating with musicians who have a message to convey for the public.

Fashion and music have been dominating your work. Are there plans to branch out into other parts of the design scene?

I always want to do a book revealing how fashion and fine art bounce ideas off each other for the past 20 years.

Practically speaking, fine art can be transformed into a product. Artist Richard Prince's collaboration with Louis Vuitton epitomises this. Creative disciplines influence each other and I don't bother to categorise them. Graphic design can have a music touch while fashion can inspire movies. I'll keep on designing books and do stage design if the right project arises. Every drama features lighting, music and props has a different audience group, and it amuses me.

What is/was your biggest challenge to date? Why and how did you overcome it?

Every project is a challenge. Even though each of my work carries signature style, I don't want to repeat what I've already done. The work process is tough but the end result is sweet. When we design for clients, there are things that we can and can't do. The question is how to make our work interesting within these limitations.

When it comes to designing record sleeves for an artist who sings more attractively than s/he looks, the challenge is to convince his or her record company to focus on his or her voice, instead of selling records with his or her face.

What project/work of yours you find the most memorable? Why?

This is a hard question. I lose interest in my previous works easily and tend to focus on my current projects. I didn't keep a portfolio back then and I threw my work away upon completion. My colleague keeps my portfolio, not for my reminiscence, but for clients reference.

Who do you admire the most in the same field as yours in Asia?

M/M (Paris), Japanese artist Shinro Ohtake and Japanese art director Inoue Tsuguya who hates interviews and refuses to date his work. I really like his self-titled book. I admire Shinro Ohtake because of his passion. He released a massive book which comprises his work over the years. I came across his work at an early age. I saw his exhibition held in Tokyo a few years ago. I was surprised by his abiding passion towards art for so many years. I am also impressed by many European artists.

What is the most exciting/impressive work of others you find lately? Why?

I'm really impressed by Tokyo's 21_21 Design Sight's exhibition 'XXIst Century Man,' directed by Issey Miyake. These guys are real pioneers.

How do you feel about the design industry in Asia and what are your expectations towards it?

We need to change the status quo. Japan is leading Asia's design industry since they give respect to their own traditions and are aesthetics-conscious. China is like a bubble on both the economic and creative fronts. Even though its art scene is burgeoning, many of them are imitative and could hardly show originity in their work. Thanks to the Cultural Revolution, many Chinese were discouraged from being expressive and have hence lost their creative drive. But finally, contemporary artists tend to voice out the sad phenomenon with their works now.

Mainland China has a huge population, so it is easier to spot good artists there than in Hong Kong, which concerns more about economics than art in contrary to many other mainland cities like Beijing. I think China's creative achievements will soon surpass Hong Kong's; Taiwan's book design and music videos are as well more impressive than Hong Kong's.

How do you feel about Hong Kong? And how does it influence your design sense?

People in Hong Kong tend to be lack of vision. There are too many tall buildings exaggerating the pollution problems in the city, real thanks to our property developers. Even though the government attempts to develop the creative industry, no sustainable plans have ever been seen. Look at our public library, which it is pretty ugly; and the shrinking Victoria Harbour because of the reclamation with tall buildings, Cultural development is low on the government's priority list. So I've resolved to try my best at what I do.

However I have always loved Hong Kong. I complain since I love the place. It's the land of opportunities and freedom of speech. If my client wants me to factor his/her dissatisfaction with Hong Kong into pieces, then I would. Otherwise, I won't do that deliberately. However, our Canon advertisement has a political undertone and is a nod at our objection to the dismantling of the Star Ferry. The pier is an integral part of Hong Kong's collective memory.

If you were not a designer, what would you like to be?

An architect or a painter. Hong Kong's architecture is ugly. I don't like skyscrapers and I want to develop petite architecture.

FAN DAI
RESONANCE DESIGN GROUP

Profile:

Dai Fan was born in 1983 and set up Resonance Design Group in 2005. The award-winning designer's work has been featured in the bestseller '3030: New Graphic Design in China,' which sheds light on the rise of graphic design in the country, and design publications from around the world. Resonance radiates energy since they never-stop questioning, researching, and above all, creating. The design firm believes that designs pushing the envelope are underrated in China yet there are creatives out there who are challenging the system.

Please tell us about your educational background.

To a certain extent, I think it's a failure if education doesn't give students spiritual freedom. I'm not a good student and I was disappointed by my design education at college. I didn't like the way they defined design. And I didn't want to be educated as what others received, so I just follow my heart. You can call it an escape from the confines of my design education.

Even though students do pay for their education, they don't have the right to choose what they favour. But what's also true is, education is just a process, it's not the end; you need to observe and immerse yourself in design to be success. Having a mind of your own is much more important than being spoonfed.

What made you pursue design as your profession?

Design always allows you to create something new everyday. It lets us realise our dreams. It's an interesting and complicated matter.

Did you start Resonance Design Group upon your graduation?

Yes. Firstly, I believe in the power of design. I planned to join a design firm upon my graduation, but I realised that Beijing is deprived of a studio merges commercial with creative. Being amazed by the way my country disregard the most fierce and unconventional local designs, I established Resonance Design Group for Chinese designers to realise our ambition and fantasy. By indulging our passion for the epoch, and branching out our designs disciplines, we look forward to creating a whole new commercial world with new forces and energy.

Where do you get your inspiration?

Inspiration is all about discovery. It is very personal, yet ironic, because design isn't art. Initially, what an assignment requires is the No.1 concern, while at the same time, how the message can be perceived by the maximum audience. For sure, I would follow my instinct sometimes. I might pay attention to things that others do not often care. Just like I am sometimes amused by supermarket flyers, which you might have thrown it away without looking at it for once. Those are the beautiful but transient moments and memories that keep influencing me from time to time.

Your design is characterized by simplicity. Has it always been like that?

Perhaps my style will become complicated. I hope to transcend myself and push the envelope since you never know what your work will be like until you've completed it. Also, style is defined by others.

As a creative consultant with a focus on branding, do you see any problems of the field in China? What is it and how could it be improved?

First, successful brands must possess distinguished features, which connote the powerful energy and ideology of the name, forming an ideal foundation for the brand. However, China doesn't have a lot of unique brands and it's hard for ordinary brands to become established. Secondly, most local enterprises in China do not seem to understand what good reputation and qualities could bring further than just having a big name. The composition of spiritual and cultural elements, plus creativity, would definitely be the key to successful brand names. Thirdly, a brand's success also lies in the ability to strike the consumers, as consumption behaviour often has a close link to consumers' emotions.

What was/is your biggest challenge to date and why? How did you overcome it?

I think my biggest challenge is how I could make an impact with my designs. I usually ponder on my work when I feel troubled.

What project/work of yours you find the most memorable? Why?

Every piece is unique and memorable to me. .

What's your future plan?

We have been started out as a graphic design firm, but not limited to the field. We have recently branched out into fields like business spacing, TVCs and website designs. We hope that one day, with our joint effort, Resonance could become one of the best design workshops in the world.

Who do you admire the most in the same field as yours in Asia?

Kashiwa Sato. The projects he accomplished were supremely impressive!

FLEECIRCUS

How do you feel about Asia's design industry and what are your expectations towards it?

Asia is not much of a place with strong design background, but today's Asian designers do share the same vision for beauty. It has somehow resulted in the signature style of Asian designs, which could be a good thing for the industry. But perhaps we will be more versatile if we ditch this similarity.

How do you feel about your motherland, China? And how does it influence your design sense?

I was born in China amidst the time of reform and opening up. The revolutionary policies had brought chaos to the country, as well as passions, dreams and opportunities to the people. In just 20 years' time, China has undergone a metamorphosis, and the process has continuously brought conflicts and anxiety to my mind, affecting my designs. Chinese traditions greatly influence us, but I hope we are inheriting traditional ideologies and national spirit rather than the form and style. I object to internationalism too, and wish to rethink the existing values and content.

Chinese designers are getting more and more attention and recognition over the past few years, how do you find the design industry in today's China?

China's design industry is burgeoning, yet only a few top-notch design firms have emerged. In general, design firms tend to focus on profit margins rather than creativity, limiting the real enthusiastic designers in the country to flaunt their talents on the creative stage. But this is a progress that China must go through. Young designers should hold on to their believes and create a new world for the industry together.

Do you have any suggestions for young designers including your students?

Don't be influenced by others, otherwise, it's how you begin to make mistakes.

If you were not a designer, what would you like to be?

I would run a Chinese restaurant.

Profile:

Fleecircus is an illustration unit based in Singapore. Its illustrations combine detailed vector-based drawings and back-to-basics pencil sketches. Between 2000 to 2007, Fleecircus' illustrations had been commissioned by MTV Asia, Chanel, Zouk(Singapore), Funkstörung (Germany), Anna Sui, etc. Fleecircus' latest collaboration includes Singapore Design Festival's 20/20 and My Favourite Moleskine Exhibition, which toured Hong Kong, Singapore and China.

Please tell us about your educational background.

I studied and graduated from LaSalle College of the Arts, where I majored in Graphic Design.

What made you pursue design as your profession?

I worked on graphic design for 3 years before switching to illustration full time. During the 3 years I spent on design, I subconsciously sneaked in illustration in projects I handled. It was an evident that I had more passion for the latter.

What are your inspirations?

My childhood, the nature and loads of books. I read Wildlife Encyclopedia over and over again to get inspirations.

What's your biggest challenge to date? Why and how did you overcome it?

I see every project as a challenge and try to learn new skills with the given opportunity.

What project/work of yours you find the most memorable? Why?

Every project of mine has its significance. So I try not to make one more special than the other.

Why the name 'Fleecircus?'

When I was still doing graphic design, I had taken on freelance illustration jobs on the side. There was one project, which I wanted to design a series of 42 characters and I needed a place to house them. The initial concept was they were a bunch of sideshow characters for a circus. So the idea 'Fleacircus' came to mind, and I personalised it to 'Flee' because of my last name.

How does your attention to details translate into your work?

Paying attention to details has always been very important to me. I believe the extra detail touch defines your style among other illustrators.

Please tell us about your latest piece Fleecircus x Hooked Clothings. What led to this collaboration, what inspired this piece, etc.

I got a call from Alex of Hooked Clothings who gets to know me through Arnault from Kapok in Hong Kong. The project was under a pretty tight deadline, and I didn't want to reuse

RISA FUKUI

any of my old drawings on this project, so I scanned a couple of lace patterns and maximised the contrast to give it a very raw half tone effect. It was an interesting experiment.

Your work often features children. Is there a special reason for that?

It's always my preference to depict innocence, children by what I mean, and the nature in my work.

Please tell us about your Moleskin project. What's special about it?

It was a really fun project. At that time I was really swamped with work, and the only time I had for the Moleskine project was the 1-hour bus ride to and from my office. The sketches were made of people I observed during the bus ride.

What are your views of the Asia's design scene? What are your expectations for it?

The Asian design scene is a young and thriving one. More and more up-and-coming Asian designers and illustrators incorporate their rich culture and history in their works, establishing themselves in the international creative arena.

How do you feel about your motherland? And how does it influence your design sense/style?

I was born and raised on an island near Singapore. The island has no electricity supply and running water. In a way that encouraged me to have a sense of wonder, and appreciation for the nature. Instead of growing up with battery-operated toys, I was surrounded by plants and animals. I wish to make record on what I saw and learnt everyday, the fastest way is to pick up a pencil and draw everything down on paper.

Which creative catches your attention the most recently? Why?

Meticulous doll makers like Ryo Yoshida whose attention to details is just so amazing. Royal de Luxe's surreal performances of The Sultan's Elephant is also great too. These are the constant reminder of why ideas and skills are more important than just creating art in front of the computer.

What is the most exciting/impressive work of others you find lately? Why?

Artists who have amazing skills with natural media constantly inspire me. For instance, Aaron Horkey's illustrations and Naoshi Yoshida's sculptures.

What are your future plans?

To apply my illustration on different platforms, such as fashion and lifestyle products.

If you weren't a designer, what would you be? Why?

I will be a musician, for the ability to create and inspire.

. .

Profile:

. .

Risa Fukui is working extensively as a Japanese paper cutout / Kirie artist. She is famed for the pinpoint precision of the depictions in her work. A leading lady in the Japanese paper cutout field with her free style of broad activities including the sneakers design in collaboration with Reebok, the jacket design for a Japanese musician, Mika Nakashima, fashion brands, stage decorations, original film production, advertisement, etc. Her first book 'KI RI GA' was released in 2007. She is inspired by plants, animals, smoke and invisible things that fuel her imagination.

. .

What made you pursue design as your profession?

I'm not sure if I call it 'design,' but I started when I went to Tama Art University. I was studying graphic design at the University, and personally making Kirie at the same time. It became my profession somewhere along the line.

What's your educational background?

I had been good at sports since I was a kid, and I played a lot of basketball games at school. But I liked to draw at the same time, and was a member of the Kirie club in high school. I was interested in Japanese painting, but I chose graphic design at the Tama Art University because they provide good career prospects.

Where do you get your inspirations?

All the time from various places.

Why is nature your favourite motif?

I don't like drawing artificial things because they don't have the energy of life. People, animals and plants look similar, but none of them is the same. They are full of energy, and that's why I am fascinated.

You like to obscure the faces of your subjects. Is there a special reason why?

I wanted to express the crease on people's face because it shows the background, race, profession, age and the person's life. Therefore, I chose to draw old people at the beginning most of the times. But I am also capable to draw people at different age.

How do you inject modern energy into the traditional Japanese paper art of Kirie?

Maybe because of my graphic design training, I got into Kirie simply because of my fascination towards its visual. For me, it looked good graphically. I was self-taught. I think the energy came from my curiosity to do what I wanted and on the power of the simple material, paper.

Have you always been conscious of your own cultural roots and historical context?

I am not conscious of it, but I think my works naturally show those things.

Over these years, what is the most important thing you have learnt from Kirie?

The more I know about Kirie, the more I feel the depth and possibilities in its expression. Also, I feel that the simple process with paper can be what most people enjoy irrespective of their age and gender.

Please tell us about your collaboration with Reebok, your first shot at product design. What challenges have you faced and how did you overcome them?

It was hard to translate a flat expression into a 3-dimensional figure, i.e. a product. I wanted to make good use of the shoe's shape. There are many designers' shoes in the world, but I wanted to make something we've never seen before.

'KI RI GA' (2007) is the name of your first book, what does it mean?

The word 'Kirie' has a soft impression, but I felt my works were a bit different from it. My works are more like paintings (painting in Japanese is 'KA I GA'). That's why I named it 'KI RI GA.'

Your work is dubbed 'KI RI GA,' do you feel comfortable about it?

Originally, the word 'Kirie' doesn't have such a long history. I heard that it was created when people presented Mr. Jiro Takiidaira's paper cutout work. I really respect the word 'Kirie' but I also wished to create a new word in the same way. It would be great to use both words in different situations and occasions.

What is the most exciting/impressive work of others you find lately? Why?

I'm interested in things in large scale or size in contemporary art. I get very excited when I see art that catches me off guard.

What project/work of yours you find the most memorable? Why?

It's a workshop. Usually I do all the work production by myself, but I can discover many things by communicating with others. I have done 2 workshops for adults and 1 for kids so far, and I learnt a lot from the workshops because I needed to know well about it and to teach others the art of Kirie.

What are your future plans?

To work on the things in front of me one by one, step by step, and in my own way.

How do you feel about Asia's design industry and what are your expectations towards it?

There are expressions that we can do in Asia only. For instance, with colours that coming from the Japanese nature, and there are beautiful colours and patterns in ethnic clothes in Asia. Most people tend to follow the European and American styles, but we have a very proud and solid culture here.

How do you feel about your motherland, Japan? And how does it influence your design sense?

I like Japan. I get inspirations from its people, history, nature, culture and everything.

If you were not a designer, what would you be?

I don't know, but I wanted to work for something related to art, or something to support handicapped children.

YU GUANG, JUN HE AND ZHIZHI LIU

MEWE DESIGN ALLIANCE

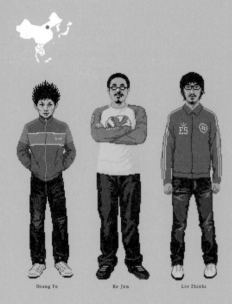

Guang Yu He Jun Liu Zhizhi

Profile:

MEWE design alliance combines the individuality of 'Me' and the power of 'We;' comprising Yu Guang, Jun He and Zhi-zhi Liu, all graduated from the China Central Academy of Fine Arts. The studio's work stretches across the medium of graphic design. The team got together because of their passion for design and they are famed for their award-winning book design.

Why the name 'MEWE?' Does it stand for anything?

We knew each other since we all studied at China Central Academy of Fine Arts. After graduation, we always got together to discuss design-related issues due to our common interest in design. The name 'MEWE' is a reflection of our state of mind where we believe a group, i.e. 'we' is formed by several individuals, i.e. 'me.' 'Me' is about independence while 'we' means power.

What made you pursue design as your profession?

G: I started to learn drawing at a very young age hoping to become an artist after I grew up. In high school, I couldn't get into the course I wanted because of the education structure, so I had no other choice but to study design. I believe it happened to others too. As when I studied design, I got to understand more about it and totally fall into it. Gaining more and more encouragement and recognition, I finally decided to become a designer.

H: I started to draw at a tender age. I didn't understand what design is about when I tried to gain admission to college. At that time, design meant decoration. So I think it was the fate that got me into the profession. In short, I studied design, worked as a designer, taught design, and now I work as a designer again.

L: I like drawing since I was a kid. I learnt to do illustration before graphic design and got more intrigued by the latter. That's how I became a designer.

What made up the team of you three (Yu Guang, Yun He and Zhizhi Liu)?

We share the same education background and passion for design. We also got together since we are affable: we always talk and never run out of conversational topics.

Where do you get your inspirations?

G: I don't have a specific source of inspiration since it is all around me. It's important for a designer to be sensitive to his/her surroundings.

H: Any little things in life can be inspiring.

L: I take back what I said in early years, that we don't need inspirations. But I don't hunt for it and don't rely on it especially when I design. If obstacles arise during my way, I usually analyse it carefully and inspirations may emerge somewhere in the process.

You once mentioned that you want to do packaging for cigarettes and alcohol. Why?

G: This was a joke by Zhi-zhi Liu. We hope that we can collaborate with clients from all walks of life and this hope isn't geared towards alcohol and cigarettes, which epitomise poor design in China. The design of daily consumer goods illustrates and reflects our country's economy and education level. Even though the market is the king and the power of design is limited, we still hope that we can try our best to make a difference.

L: Packaging of products in China tends to look the same, whether they are by big or small brands. Let's look at mainland China's packaging for cigarettes and alcohol as examples. To be honest, all design jobs are the same to me. I am not particularly drawn into designing packaging for cigarettes and alcohol.

Book design dominates your work. Is there a special reason why?

G: Many people have asked us this question and many of them have pigeonholed us as book designers. This is not the case though. It's coincidental that our first design project was about book design and we scooped an award for it. It's also coincidental that clients approach us because of the recognition of this project. We eventually receive more and more book design projects. I wonder what it would be like if our first job wasn't about book design and we didn't get an award for it. I wonder if our clients didn't approach us because of our first work too. Who knows what would have happened! I treat projects and all clients the same. I give my best shot at each work, no matter what medium it needs.

L: Maybe it's because we have connotation with a lot of artists and writers, whose works are usually novels or comic books. We find them easy to communicate, hence designing more books.

If there is a style in your design, how would you describe it?

G: Everyone has his/her own style because everyone has a unique personality, admit it or not. I'm no exception. I believe my works have my personal stamp on it. I'm lucky since I can't see my style and I don't want to see it too. I don't mind its presence but I don't want to think about it for myself.

H: I don't think I have a specific style since the time hasn't come for us to talk about our own style. I think that we shouldn't be different for the sake of it. Instead, we should be ourselves since we are unique. It's dangerous for young designers to blindly pursue style.

L: We don't just stick on one specific style, but we may have unique approach while pondering problems. We are curious about how our peers handle their self-promotional works because of the interesting things that lay beneath.

What was/is your biggest challenge to date and why? How did you overcome it?

G: Every job comes with pressure, pressure from comparing with the other good works out there, and also self-imposed pressure. I try to reduce my pressure by creating good works at my best.

H: My biggest challenge to date is myself since I'm an introvert. My problem is to complicate simple matters. Thus I always struggle to make my design simpler.

L: Laziness is my worst enemy. I love day-dreaming. But it doesn't matter since, if I become hardworking someday, I may not be able to create good designs anymore.

How does the Beijing's transformation influencing your work? What other oriental elements do you use to create a far-east style that rivals the west?

Due to several historical circumstances, design in Greece is not as developed as in other European countries. However, the current design practice proves that new standards have been set up for further development. Athens 2004 Olympic Games was the reason for Greek design to become the talk ronment that formed the basis of new ideas.

What project/work of yours you find the most unforgettable? Why?

H: '乃正書昌耀詩' (2002), a poetry and calligraphy book. Though, books on these subjects are not popular in the market. We needed sponsorship from our publisher and printer to get the 2000 copies produced. We spent a lot of time on the book design and we used special paper for it. In the end, the book's sales was a pleasant surprise. It was sold out in no time! Even though the book wasn't popular simply because of its design, the result is a great encouragement for me and it made me want to keep doing what I'm doing.

You have won many important awards in and out of China. Which are the most significant to you? Why?

G: Tokyo TDC since it's my first award.

H: Winning 'The World's Most Beautiful Book' category in Germany's Leipzig Book Design Awards for the book '朱葉青雜説系列' (2005). I was oblivious to the book's nomination by the judge panel who found the book in a book store. This made me much happier than entering and winning a competition. This competition is one of the most important international competitions to me, ever since my college days.

You are quickly established in China, what's your future plan?

G: I'm very happy to be dubbed as 'quickly established.' I hope I can work hard to live up to this title.

H: I don't like to think too much. I perceive design as a form of self-entertainment and I would like to continue teaching well and designing well.

L; I never have plans. I love to let things happen in a natural way. Fame is volatile in China, it makes people fragile.

What is the most exciting/impressive work of others you find lately? Why?

G: Tons around the world.

Who do you admire most in the same field as yours in Asia?

G: There are many, for example wx-design, Les Suen, Masayoshi Nakajo, Kaoru Kasai, Eiji Yamada, Fumio Tachibana, Theseus Chan, etc.

H: I'm afraid there is more than one. There are too many brilliant designers in Asia (e.g. Japan, Hong Kong). But I am more concerned about the works than whom made them.

L: There are graphic designers, fashion designers and architects that I admire.

How do you feel about Asia's design industry and what are your expectations towards it?

G: Asia has a strong design scene armed with its unique regional design philosophy. I hope it could gain more recognition in the future.

H: The biggest issue is how to handle the impact brought by globalisation. International and adaptive designs are everywhere in Asia.

It's hard to tell where they are from. Design-wise, this lack of identity makes the works monotonous, Asian designers should be more conscious of their characters and cultural uniqueness.

L: The Asian design scene is getting better and better. We should cherish what we have now and work hard.

How do you feel about your motherland, China? And how does it influence your design sense?

G: I don't have feelings about China and my views can't change anything in there. Any influence has its good and bad.

H: I feel quite good about China. I was brought up here and I shall continue to work and live here. She has lots of influence on my works.

L: The topic 'motherland' is too big so I don't want to talk about it. I was brought up here and I speak Mandarin, I think and solve problems in a Chinese way most of the time. Needless to say, everything about this place influence my works.

Chinese designers are getting more and more attention and recognition over the past few years. How do you find the design industry in today's China? In what ways can it be even better?

G: Objectively speaking, Chinese design is getting better gradually, but there's still a big room for improvement in general. We are getting more recognition from the world because of our rising economic prowess. Put it this way, do you think we should be proud of the fact that we don't have a lot of top-notch designers in a country with 1/6 of the world's population? Imagine how people spend their money on products with ugly packaging in the supermarkets everyday, does it matter when we have a few more capable designers who could garner all the international awards? I believe if we try our best at what we do and don't cause troubles to others, then the world will become a better place.

H: This is a general question. Indeed, Chinese designs got into the list of major international awards in the past 2 years, but they only constitute the minority. It is in general not in a very high standard. We still have a long way to go. I don't have much to say except for that we should try our best to make it success.

HANSON HO

H55

L: Although China's economy is burgeoning and our design industry is also developing rapidly, the Chinese design scene is still at an infantile state on the international stage. I hope that we can perceive issues objectively, then reflect and improve. Fast development isn't necessarily good: 'fast' and 'new' are neutral advantages so we can't afford to be proud like a child, maybe this is how we can get better.

Many young people wants to become designers now, do you have any advice for them including your students?

G: When it comes to hobbies, you should choose to do what you like the most. But when it comes to work, do what you excel at.

H: Keep yourself cool and continue to produce good works. Gain more experiences and be patient.

L: Be careful. Design is a profession where you have to give your mind, body and soul. Haha.

If you were not a designer, what would you like to be?

G: A musician.

H: A chef.

L: A writer.

..

Profile:

..

Hanson Ho is the award-winning design director and owner of H55, a graphic design platform started in 1999. His portfolio of projects include the much publicised redesign of the iconic 'Funpack' for Singapore's National Day Parade 2007, identity design for the upcoming 'Design Difference' ICSID and IFI World Design Congresses 2009, and his ongoing personal project, Rabbit: wearables which are available at London's Dover Street Market by Comme des Garçons, amongst other design stores around the world.

..

Please tell us about your educational background.

I graduated from Temasek Polytechnic's School of Design in Singapore in 1998, specialising in Graphic Design. After working at 2 design houses in about 2 months time, I decided to embark on the most important design education experience of my life and run a design studio called H55 in the real world.

What made you pursue design as your profession?

I increasingly enjoyed reasoning and analysing life in my teenage years. This, combined with my interest in visual pop culture and the desire to communicate ideas to the mass, naturally led me to graphic design. I needed to turn thoughts into form.

What are your inspirations?

I am particularly inspired by ideas and things, which have always been so close and familiar to me that I was previously unaware of.

What's your biggest challenge to date? Why and how did you overcome it?

I found it very difficult to separate design work from life for many years. It seemed that I was doing the right thing at first (breathing design), until it became an unhealthy addiction that distracted me from everything else. A better understanding of how life is made up of the significant relationships we have with others has helped me to compartmentalise my life and working hours.

I believe that if we are passionate about something, we have to love it so much till we are able to detach ourselves totally from it and let it exist independently in the world eventually; be it a person, a hobby or a profession. It is then that we have fully mastered and taken control of our craft.

What project/work of yours you find the most memorable? Why?

I try not to be sentimental about any piece of work because I believe it limits one from moving on to new things.

Why the name 'H55?'

'H' stands for my name, and '55' is used because I wanted a name that is short, memorable, with a beautiful form, neutral in its meaning, timeless, with no language barrier while being able to reflect my hard-edge modernist

roots. It also reflects the process of registering a business name, where each company will be given a business registration number.

Please tell us about your talk-of-the-town redesign of 'Funpack' for Singapore's National Day Parade 2007. Any fun stories to share?

It had to be conceptualised and designed in 2 weeks over the Chinese New Year holidays, due to the time constraint.

Please tell us about your ongoing personal project, Rabbit. What is its style, and whom is it designed for?

Rabbit has no particular style or definition. It is a platform created to encourage personal exploration and discovery of new ideas and happy mistakes. Everyone has his or her own interpretation of what Rabbit represents. Currently, Rabbit means love that is life-giving for me.

You once mentioned that Rabbit is a concept that exists in all of your characters. What exactly is the Rabbit attitude?

It is the desire to love something or someone completely and absolutely.

Please tell us about your character RedFox. What does it symbolise, etc.?

Rabbit is holding RedFox's hand in one of our posters, although he knows that his red friend is tempted to eat him. RedFox in return, is in a constant struggle between fulfilling his desire of accompanying Rabbit and his hungry stomach, between selflessness and selfishness.

What are your views of Asia's design scene? What are your expectations for it?

There are more and more interesting brands, innovative ideas and award-winning designers coming out of Asia every year. The world will be looking more towards the fascinating and growing East as they get more frustrated by the system in the West.

How do you feel about your motherland? And how does it influence your design sense/style?

Singapore is safe, systematic, neutral, orderly, organised, global, modern, functional, objective, efficient, positive and reliable. Just like Swiss typography and Helvetica.

Which creative catches your attention the most recently? Why?

Naoto Fukusawa and C.S Lewis for their introspective approach to their work, which helps us to be more aware of our human selves.

What is the most exciting/impressive work of others you find lately? Why?

A magazine called Fantastic Man, which challenges and conforms to the traditional definition of a magazine at the same time.

Please tell us one thing about yourself that people don't know yet.

I spent all my energy playing competitive squash before design came into my life.

What are your future plans?

The future is now.

If you weren't a designer, what would you be?

A full time husband and father.

HIDEKI INABA

Profile:

Born in 1971, designer and graphic artist Hideki Inaba founded HIDEKI INABA Design in 2004. He was the art director of Japanese magazines '+81' and 'gas.' He joined forces with NIKE Women and Shu Uemura when 'Newline,' featuring Inaba's works, was released in 2006. He is famed for his experimental and unconventional design.

You majored in Science and Engineering in college, tell us about your first job after graduation.

I worked at a stationary company after graduation and I joined a computer software company afterwards.

Your first job was not design-oriented, how did you get into design?

I made original typefaces and drawings for interest and part of my previous jobs was to make graphics and logos. Then I had an opportunity to show my portfolio to +81 magazine, and they asked me to work for them. This was the time when I started my career as a designer.

You were a freelance graphic designer based in Tokyo back in 1997, was it difficult to freelance in Japan?

In retrospect, it was very hard for me since I didn't know anything about design.

Please tell us about your personal project Newline. What's the concept behind it?

Newline is a personal project. In which, I created the graphics I wanted.

How do you describe/interpret the style of the visuals that you create for Newline?

It's in complete free style. Graphic design is commercial and I have to design something within certain constraints. But there is no restrictions in Newline.

What project/work of yours you find the most unforgettable? Why?

Every work.

HIDEKI INABA Design was founded in 2004, how many staff members do you have now?

5, and the team won't be bigger from now on.

You have achieved critical acclaim, what is your future plan?

I hope to design things that I like.

Who do you admire the most in the same field as yours in Asia?

I don't know.

What is the most exciting/impressive work of others you find lately? Why?

I went to South Africa on a business trip the other day. The landscape and people there are still in my mind.

How do you feel about the design industry in Asia and what are your expectations towards it?

I don't know.

How do you feel about your motherland, Japan? And how does it influence your design sense?

Many people including me can't understand English, but they listen to English songs and read English books. I think that brings influence on Japanese design.

If you were not a designer, what would you like to be?

I don't know.

SINGH INTRACHOOTO

OSISU

Profile:

OSISU produces functional art that integrates local crafts and skilled carpentry with contemporary aesthetics. Each model of OSISU is pure passion, hand-crafted from materials left to waste at construction sites or discarded from manufacturing processes. OSISU's creations exemplify a commitment to environmentally responsible design while meeting functional requirements. Their design innovation adds value to overlooked resources and extends the life cycle of natural materials.

You have a strong educational background, when did you find out your potential and interest in design?

I actually like design since I was a kid. My interest was originally in architecture, not product design. I found my new enjoyment with product design in 2006 when I started designing with scraps.

What made you pursue design as your profession?

I was specialised in architecture so design has been my profession from the very beginning. When I was a kid, I always wonder why my friends had a hard time choosing a field of study. I didn't understand why, I thought everybody would certainly know what they want to do.

What are your inspirations?

Scraps, animals, insects, and crafts.

What's your biggest challenge to date? Why and how did you overcome it?

Earning a Ph.D. from MIT was the biggest challenge! I overcame the difficulty by finding my own niche, my own area of interest to pursue.

What project/work of yours you find the most memorable? Why?

Having established OSISU was the most memorable project because it was so unexpected that we would be pioneering a design movement in the country. Now, we are the face of eco-design for Thailand.

You have been described as a designer and an inventor. Which cap do you face more comfortable with?

An innovative designer would be my preference. I am honoured to be considered as an inventor, but I also feel that many others have contributed to the success of our new materials. It's teamwork, I didn't do it singlehandedly.

How are your designs inspired by environmental concerns, besides the fact that you use waste as a material?

Aside from using scraps and wastes in my design, I also get inspirations from animal and plant forms. I also create eco-products because I want to be part of the solution that helps to mitigate environmental problems that we're facing now.

What are the challenges you face in breathing new life into trash and how do you overcome them? Illustrate this with one of your submitted work.

There are many challenges making products from wastes:

1/ Scraps are so inconsistent both in terms of shape and amount;

2/ It is hard to find workers who are willing to work with scraps;

3/ We often meet difficult suppliers of wastes from time to time. Recently, we have found pen-fillers with dried up ink which does not get recycled in the factory since it takes too much time and labour force to remove the dried ink and to separate ballpoint tip from the tube. We have designed 2 products from these pen-fillers. After we spent a month designing and producing the product, the manufacturer wanted to sell these wastes piece by piece at regular price! I was saddened by this actually because we are all so efficient at making wastes. So I move on to new scraps.

You have used many kinds of trash for your designs. What kind of trash would you like to experiment with that you haven't yet and why?

It is a tough question since there are so many kinds of scraps and I find new types of scraps everyday. I conduct experiments and design with them daily. There are so many kinds of scraps out there that I have no idea of their existance.

Are your carpenters surprised to see your finished work? Is it likely that they didn't know industrial waste could be used as a design material?

Oh, our team including me are always surprised when works are finished. I actually anticipate with excitement when my workers bring new prototypes to my studio. When you design with wastes and scraps, you can be quite sure that no one knows what the final outcome would be like. It's always exciting.

Do you think that limited edition furniture will become high-end products eventually? Why or why not?

I guess so, maybe that's why designers like to do limited editions when they want to jack up the price. I guess it is a marketing ploy that toys with people's desire for the unique piece.

MINSEUNG JANG

What are your views of the Asia's design scene? What are your expectations for it?

The Asian design scene is getting better and better. I think if we can change the misconception that products from Asia are cheap, we can be a lot more innovative.

How do you feel about your motherland? And how does it influence your design sense/style?

I think Thailand is a great place to do experimental design. I am not sure how it has influenced my design but I use scrap materials that are available here, so my works should be quite grounded to this context.

What is the most exciting/impressive work of others you find lately? Why?

Water Cube, the Beijing Olympics swimming stadium, it is just so amazing technologically and aesthetically.

What are your future plans?

To diversify OSISU into other businesses beyond product design. Our future projects may include real estate developments, boutique hotels, design schools, etc. The brand OSISU should represent eco-friendliness. I want to show others that being environmentally conscious can also be successful financially. I hope it would inspire others to make a more balanced decision. Not only focusing on the economic aspect in business, but also taking the environmental and social aspects into consideration at the same time.

If you weren't a designer, what would you be? Why?

A researcher, I love experiments!

Profile:

Majored in Sculpture at Chung-Ang University, multi-talented young furniture designer Minseung Jang opened a design studio in his own name at the age of 29. Jang has directed the Pusan International Film Festival exhibitions for 2005-2006, and produced over 20 soundtracks when he was a member in a rock band. He is also devoted to photography and music production besides furniture design.

What made you pursue design as your profession?

Not only to make people's lives easier but also to make them happy.

What are your inspirations?

In most cases, I get inspired by the material itself. Just like cooking, I think good design means having a firm grasp of material. I get into traditional materials such as iron and wood and I think this comes from my academic background, sculpture.

This tendency naturally enhances my passion for architecture. But building a house requires more conditions and responsibilities. Basically my furniture craft works are inspired by the traditions of architecture too.

What made you turn into furniture design and photography from the music scene?

Basically my profession has changed. But among different art forms such as literature, painting, music, and film, the one that inspires me the most is music. My attitude towards design is influenced a lot by music.

I actually got into music for fun, but it became the business itself soon, and I realised that I went too far from my own craft which I've been doing since I was a teenager.

So as a comeback, I began to make furniture I needed, and do photography by myself. I believe I understand my furniture design the best. And now, I have more opportunities to work as a professional photographer.

How does your passion for music translate onto your design?

Music is the most powerful and direct medium and its influences vary depending on the listener's status such as educational level, religion, nationality, and economical ability.

This type of attitude to music influences my creative process. If someone wants to understand the mentalities of various countries, I'd recommend him to listen to the music there.

Your work has adopted a minimalist feel to it and striped down objects to their essence. What were you trying to convey through this?

I definitely agree on it. The principle of my work is not having too much artificial process. Fine materials and valid method should be guaranteed. I used to deny humanities in my work. To embody this notion, I focus on surface and colours.

Nowadays, people seems to have lost their cultural-ecological features and class distinction is strengthened through education and upbringing. This tendency is shown through artists' work also. Above all, I think this is stupid anyway. But ironically, it made me realise that simple-looking work requires much more effort and perseverance.

What's your biggest challenge to date? Why and how did you overcome it?

In terms of design, sculpture means making a useless thing.

In the past several years, I have been trying to make things practical. But there was no difference between these works because they were made of the same materials, with same methods, and even its 'exhibition' nature. Recently, I'm planning to make a very practical large table through a very impractical method in terms of its costs, materials, and distribution. We'll be able to see that in the next year.

What project/work of yours you find the most memorable? Why?

Probably Table 1 (T1) that I made in 2005. This is because it gave me important lessons like 'what role do designers play in Korea and what their responsibilities are.' Also, I get the chance to meet many nice people during the working process.

What are your views of the Asia's design scene? What are your expectations for it?

I don't know much about it as Asia is a huge concept in terms of geography, dialect, lineage, and cultural aspects. To me, the Korean design scene is led by the people educated in the West. Nowadays, many designers are trying to seek inspirations from indigenous traditional folk crafts. But I think we need more time to gain deep understanding on this matter. In the past, the design field of Asia was inevitably westernised. But I guess in the future, designs with oriental philosophical attitude shall dominate on the Asian design front.

How do you feel about your motherland? And how does it influence your design sense/style?

The answer to the previous question could also apply to this one. Korea is still in the midst of modernisation. We claim to live like Americans in the 80's and nowadays they seem to claim living like Europeans, especially the Scandinavians.

I don't want to judge whether this is a good or bad thing. This is only a procedure and this process has created many unique and prevailing streams of art work.

I do not try to forecast a potential trend too. I just try to work as a non-national technical craftsman because I think technology itself could be the most common and universal language.

Which creative catches your attention the most recently? Why?

Gustave Eiffel who made Tower Eiffel. Even though the tower is the most impractical thing with iron he had made, its complicated mechanism still impresses me. I am planning to make a furniture which adopts such structure.

What is the most exciting/impressive work of others you find lately? Why?

The albums of Nordic pianist Ketil Bjørnstad. I have always wished to visit Northern Europe but I couldn't. I felt I was visiting the place when I listen to his music. Those feelings formed an exciting and fascinating experience for me.

What are your future plans?

To make something that is able to cheer people up and that embodies both primitivism and futurism.

If you weren't a designer, what would you be?

Actually, I don't see myself a designer. The definition of designer could be different in the contexts of course. But in my case I just think that I'm making something. I think that there isn't any significant distinction between making a useful furniture or making a useless sculpture. It just depends on the context of the situation.

JIAN JIANG, XINGYU WEI & YONG ZHU

JOYN:VISCOM

Profile:

JOYN:VISCOM is a Beijing-based design studio specialising in digital media and visual communications. It aims to create experiences, whether they are commissioned client-work or self-initiated projects. Their clients include Nike, Motorola, Absolute Vodka, Coca-Cola, JW Marriott, etc. Their work has been featured in several design festivals such as Sydney Esquiess, Curvy Exhibition, Semi-Permanent 04, 'Beijing Case' ZKM (Museum of Contemporary Art) Karlsruhe Germany, 'China Design Now' V&A Museum UK, etc.

Please tell us about your educational background.

We all studied graphic design and visual communication at college; Jian Jiang at UTS, Sydney, Xingyu Wei (Weestar) at Hebei University of Technology, Tianjin, and Yong Zhu at Henan Arts Crafts College, Zhengzhou.

What made you pursue design as your profession?

The passion of creating ideas, reorganising information, and playing with texts and images.

Founded in Sydney Australia in 2003, what made JOYN:VISCOM relocate to Beijing? What can the design scene in China give you that the scene in Australia can't?

We realise that we can make our own standpoint here. Also, it is quite important for us to support our own design philosophy and point of view.

How do you find the experience working in Sydney from 2003 to 2006 when JOYN:VISCOM decided to move to Beijing?

To keep an open mind. That's what we've learnt from the cultural diverse country.

Tell us a bit about your limited edition design magazine, Plugzine.

Plugzine comes out once a year. It keens on digging up hidden talents as well as providing them with a platform to express their creativity. Plugzine is a diverse but coherent piece of work, an experimental project that involves different people and reveals different subject matters in each issue.

You did a catalogue entitled 'Unmask' in 2006. How did you translate such an abstract theme into the catalogue?

It just came from a simple idea of 'taking the mask off' which is what the artists wanted exactly.

How would you describe your design style?

Non-style is our style, we don't really have an established design style or philosophy so far.

What was/is your biggest challenge to date and why? How did you overcome it?

The hardest time is actually everytime when we get a new design started. The simplest way to deal with this is to keep thinking and working hard.

What project/work of yours you find the most memorable? Why?

Plugzine, our first independent publication that oozes passion and intelligence.

Who do you admire in the same field as yours in Asia?

M/M, Jop Van Bennekom, Hattori Kazunari, Albert Folch, Spin, etc. It's just too many of them to count. Their unique style always intrigues us.

How do you feel about Asia's design industry and what are your expectations towards it?

It's growing faster than ever before. We're expecting more opportunities to travel around and get involved in high quality communication activities in Asia.

How do you feel about your motherland, China? And how does it influence your design sense?

China is growing fast but lacks of diversity and originality. However, we have rich cultural inspirations. Hopefully more and more young and talented people would get emerged and so the local design scene could be pushed towards a whole new stage.

Chinese designers are getting more attention and recognition over the past few years, how do you find the design industry in today's China? In what ways can it be even better?

As you can see, China's design industry is rising with her strong economy but there's still a big gap between the marketing and cultural demands and the current situation of the local creative industry. To make this relationship better, we have to keep thinking, working and communicating hard.

If you were not a designer, what would you like to be?

J: A hair stylist.

W: A professional soccer player.

Z: A snooker master.

FANNY KHOO & TOM MERCKX

ME & MISTER JONES

Profile:

The design and art direction duo comprises Fanny Khoo (Me) and Tom Merckx (Mister Jones). Since joining Flink in 2002, Merckx was highly instrumental in establishing it as a creative agency with work widely published in design annuals and publications. A year ago, he decided to relocate to Singapore with his family as a design director for the award-winning design agency while Khoo is the creative director there. She not only conceptualises ideas but also wields a deft writing sword.

Please tell us about your educational background. What made you pursue design as your profession?

M: I've always wanted to go to art school due to my love for drawing and putting together typo stuff. Advertising to me seemed like the easiest route to landing a job after graduating but couldn't get away from the fact that it was more about selling than anything else. I ended up doing more graphic design in my advertising classes as it's more interesting to create beautiful aesthetics, rather than marketing.

In restrospect, I wouldn't choose it again. The good thing to come out of it was getting a degree in photography – it's always good to know a thing or 2 about photography for a designer. I started to learn production after I left school and got more and more true opportunites to prove myself creativity. It was clear rightaway that this line was something for me and I've been obsessed with it since then.

K: I think most designers who ended up in the creative industry have always been passionate about the craft. I mean no one would actually work in such a tough, at times undervalued industry unless they are truly passionate about it. I've loved art since I was a child. At 12, I won an art scholarship but wasn't able to do so till I enrolled myself in LaSalle-SIA (Singapore).

Design to me is not just about solving communication problems, it's also about creating desire and has an impact in everyday life. I guess to me, it's hard to differentiate between life and design. Can't you tell that Mother Nature is the greatest designer?

What are your inspirations?

M: Frankly, there are too many to mention. It's a very cross-platform thing, basically everything I see can inspire me, new stuff and retro stuff, all fields of art and design, the nature, and of course things surrounding me that contain great beauty.

K: Yes, how much space do you have? I share most of Tom's influences but life is a very inspiring teacher. I really admire people who are not afraid to challenge the norm and make a difference. Tibor Kalman, Christopher Bailey, Marc Jacobs, Satoshi Minakawa, Wink Media, Nadav Kander, Johnson Banks, Mary Lewis... The list is endless.

What's your biggest challenge to date? Why and how did you overcome it?

M: We're trying to rebrand Equus now. I think it's a lot harder than when we had to change Bizart into Flink.

K: Equus has had a longer legacy, that was established 14 years ago and there's more 'heritage' to consider. As a rule, it's always more difficult to change old perceptions than to make new ones. We've been working with Equus for less than a year but a new identity and website have already been built. There has been a slow but gradual infusion of a different clientiele, a more cosmopolitan team and more plans to be unveiled hopefully by the end of 2008.

What project/work of yours you find the most memorable? Why?

M: I have vivid memories of the UseAgain exhibition, where we invited about 60 image-makers worldwide to submit unused or rejected artwork, so we could give them a second life (use again). With the thousands of pieces we received, we created huge compositions that was then made into an exhibition in our ex-office in Antwerp, Belgium.

K: For me, there is not much about a specific project but the experience of working on 2 very different continents. The mindsets in Singapore and Belgium are also different in terms of client expectations and consumer landscapes. It's pushed a lot of my buttons and certainly made us more borderless in that sense.

Why the name 'Me and Mister Jones?'

Me and Mister Jones (MAMJ) was set up as a creative platform and mostly to showcase our collective portfolios. We worked together on so many projects so it just made sense to come together as one.

Besides, it's a good creative outlet, personally and professionally speaking, to vary our project types. MAMJ was actually set up as a company in Belgium for a few months, but we closed for tax reasons. Jones is Merckx's nickname since his age of 10 in his local hometown. They used to call him 'Hey Jones.' The name was conceived long before the Amy Winehouse song, but it's a nice coincidence.

What led to Fanny Khoo and Tom Merckx joining forces?

M: I started working for Bizart (later renamed to Flink) seven years ago and Fanny came by the studio one day and got to talking with the management. She joined us a year later and we've been working together ever since. Fanny is good at starting projects with new directions and the way we work together is not an equation of 1+1=2. It's more like 1+1=10 because we constantly bounce ideas off each other.

K: Tom is a very, very good designer. And believe me, I've seen enough to know that brilliant designers don't come about every day. I was probably half of me before working with Tom. It's a strange dynamic since we're married and have a child, and yet work so well together. I'm not saying we don't fight but if we do, we're still speaking the same language.

Your works contain various styles. Which style is the most you?

M: For my personal work, I'd say it's elaborate, eclectic, occasionally dark and gloomy. I am also inspired by politics but in any case, I will try to stay away from a style or a trend.

For my commercial work, being versatile always helps. It's important for me to find a solution that I can be proud of and at the same time, works for the client too - something not always obvious in the corporate world, but we will try. It's a struggle sometimes but I'm keen to try new things and create within constraints. An interesting combination to keep me interested.

K: I don't think we have a style because our work is not very style-led nor trendy. The combination of ideas and art direction may take us to different places but we're more like a chameleon in that aspect. It's nice to hear good vibes from our peers though a colleague of ours described it as walking into a nice room, taking time to discover everything and not wanting to leave.

Anyway, I'm such a restless person so it's difficult to pin anything down to a style.

Tom and Fanny, both of you worked in Flink before the formation of Me and Mister Jones, what does it have in common with Flink in terms of style?

We had creative freedom at Flink, which gave us more control over our creative output so there was a real ownership when it came to our work. Our personal work is infinitely less corporate, also due to the different clientele in fashion, music, culture, etc.

You collaborated with Absolut Vodka on the Find Your Flavour campaign. Which Absolut Vodka flavour suits you the most and why?

M: Absolut Vodka, neat, no rocks, thank you. I'm a purist by nature, so pure and simple work the best for me. To be honest, I'd rather have an authentic vodka that doesn't sell by the millions, but that might not go down too well at Absolut!

K: Well, according to the Absolut Find Your Flavour site, I'm Ruby Red? They rationalise that I'm into the good life and am not afraid to live it.

What are your views of the Asia's design scene? What are your expectations for it?

It's evolving fast. There seems to be real potential although we hope there's less quantity and more quality. Being in Singapore can sometimes feel like growing in a vacuum.

On a positive note, the Singapore government is also investing more into the arts and culture so that helps to get things going. But creativity is a difficult thing to predict. It comes and goes. Although we see some form of change catalysing, the culture is still not quite there yet. We think the Japanese are still masters of design in Asia. Hong Kong is not bad either. We hear Thailand's gearing up as well. So some exciting developments is ahead.

How do you feel about your motherland? And how does it influence your design sense/style?

M: I get inspired by the local street art scene in Antwerp and the minimalist architecture and interior designers, even though they are essentially different - in fact, polar opposites.

I guess a certain European aesthetic can be found in some of my work. I have quite a few friends in Belgium that share the same passion for all things and design, but overall there doesn't seem to be much interest in graphic design, unlike places such as the Netherlands, the UK or Scandinavian countries.

K: I have very mixed feelings about Singapore but when I was working in Belgium initially, I was told that I had an Asian style. You know, in terms of using bright colours (Belgians use very little colour, and if they did, only accents of it) and the use of visual and verbal language. Belgians are notoriously subtle, from the way they communicate and express themselves. It is almost like they are afraid of drawing too much attention to themselves.

In a way, I learn how to hone my skills with a balance from both cultures. I like the vivacity of a strong Asian spirit, but only when you can embellish it within the right context. The European subtlety and its refinement also became part of my aesthetic and most certainly my palette. Our colleagues often make fun of our 'winter hues,' so I make a conscious effort to dress brighter here.

Which creative catches your attention the most recently? Why? What is the most exciting/impressive work of others you find lately? Why?

M: So many influences everyday, where to start? The breathtaking motion work of Encyclopedia Pictura recently.

K: I have the attention span of a fly so at this very moment, it's Santos&Karlovich and Shun Kawakami. I also love the visual blog www.fff-found.com.

Please tell us one thing about yourself that people don't know yet.

M: I snore like a pig at night. ZZZZZ.

K: Apparently, I'm a kitchen goddess, haha.

What are your future plans?

M: For now, we are working hard to wow Singapore with some amazing projects. In the long run, we hope to eventually head back to Belgium and set up our own design outfit.

REX KOO

F: Yes, It's been a lifelong dream but the future is now. We're excited about some of our new projects and the opportunity to expand our ideas here. I've always loved collaborations, so there's a fair bit of that in the near future.

If you weren't a designer, what would you be? Why?

T: I'm not really sure. Most likely to stick with something creative. I like music and was involved with several bands before moving here. If not with music, I'd like to do something with plants.

F: When I was young, I thought of being a psychologist. Maybe I have far too many interests but like Tom, find it diffcult to get away from the creative circle. The juncture of fashion and interiors has always fascinated me. A stylist? I've also done quite a bit of professional writing. Perhaps the editorial life is a missed calling? Whatever it is, I'm lucky to be able to combine everything I love at my job.

..

Profile:

..

Rex Koo is a graphic designer extremely passionate about Chinese and English typography. Before going freelance with his personal website rexair.net in 2001, he has worked for Shya-la-la workshop, Communion W, and participated in the design of the poster and original soundtrack of the renowned film director Wong Kar-wai's movie, 'In the Mood for Love.' His work has been featured in many publications, including Colors, CREAM, Plugzine and City magazine.

..

Please tell us about your educational background.

I graduated from the University of Salford with a graphic design degree in 1999.

What made you pursue design as your profession?

I don't know a lot but design is the only thing I am confident that I can excel at. In addition to that, I can't stand the monotonous office life. Even though design isn't always interesting but it is what I like after all.

Where do you get your inspirations?

Almost everything. What matters is what I am thinking at that moment.

How do you find your previous work experience in Shya-la-la Workshop and Communion W, as well as the original soundtrack for 'In the Mood for Love?'

Both of them are outstanding design units and I have learnt so much from them. I learnt design techniques from Shya-la-la, especially typography, while Communion W taught me creative thinking.

As for the soundtrack for 'In the Mood for Love,' it's one of the projects I was involved in when I was with Shya-la-la. To be honest with you, I was under a lot of pressure since Wing Shya, the founder of Shya-la-la and Wong Kar-wai are both demanding persons. Besides, I was a fresh graduate back then and had the 'do my best' mentality when given such a great opportunity. Thus I was so stressed that I couldn't stop pondering the project even when I was on holiday. It was tough yet very precious work experience.

Do you work on your own now? Have you encountered any difficulties working alone/freelancing?

Yes. When I first started freelancing I sometimes felt lonely since I used to work in a very lively atmosphere with talkative colleagues. But I think I did it okay. I think I am one of those designers who finds it hard to adjust to team work.

Why the name 'Rexair?'

I decided to set up my own website after I left Shya-la-la in 2000. The design style is reminiscent of informative graphics because I've always loved informative graphics such as plane survival guide. And then, I realised I

needed a fake airline logo to make my website look like a survival guide. Thus I dubbed my site Rexair. Rexair isn't my alter ego though, and I still use my name in my works.

You acclaimed that you are extremely passionate about Chinese and English typography. Why does it appeal to you?

We are exposed to words since we first started studying. But our language, which we are familiar with, has a lot of possibilities when it comes to styling and transformation. This is why I am drawn to Chinese and English typography.

What belies the whimsical images in your Colours notebook project?

Almost all the materials I used for the notebook were waste such as shopping bags, fax paper, wrapping paper and old mags. I wanted to transform these waste and lace it with another layer of meaning.

How does the theme trash appeal to you?

Thanks to Macintosh. I think that nothing is truly trash. Things just live on in another format.

What made you decide to ditch vector graphics for handmade artwork?

I have always loved to draw. I created vector when I used computers for work for a few years. I don't reject vector but I get tired of it. Thus I started to do handmade artwork. To me, handmade stuff is more alive than vector works.

What is/was your biggest challenge to date? Why and how did you overcome it?

Although freelancing gave me freedom but it was hard for me to get a big break. I am at my 30s and has been facing a lot of problems especially work-wise. I always think about how I can get better at my game, and I hoped to have a big break in half a year's time. There's nothing more important than sticking to your beliefs.

What project/work of yours you find the most memorable? Why?

Pop Parade (流行示威), a local book. It was a project I did 7 years ago, I singlehandedly made the 150-page book. Almost every page has a different layout since the author wanted to do a book that resembles a magazine.

The book has a lot of design elements, perhaps too many of them and the project took me 5 months to complete. Looking back, this book was of a poor quality, the design was amateur and its style is outrageous. It's impossible for me to create the same work now. Thus it's the most memorable project for me.

6 months after the book's release, I stumbled upon the website of an American typographer who had included the book in his top 10 favourite books, which also boast Damien Hirst and Ryan McGuninness' works! I emailed him to ask him why he likes this Chinese book and his answer was 'I have never read such a book.'

What are your future plans?

I just set up ReStart Associates with my partner. I have been yearning for this.

Who do you admire in the same field as yours in Asia?

Les Suen. His work is of international standard. He has his own view of the medium of books and continues to explore its endless possibilities. This is what I admire about him.

What is the most exciting/impressive work of others you find lately? Why?

Cloud by Troika for London Heathrow. I love its facade.

How do you feel about the design industry in Asia and what are your expectations towards it?

There are lots of interesting works in China over the past few years. What is most striking is that they can realise the craziest ideas, which may be due to their low budgets. I hope that I can collaborate more with designers from the Mainland.

How do you feel about Hong Kong? And how does it influence your design sense?

I have mixed feelings about Hong Kong. On one hand it is my home, on the other hand its creative industry can be improved in many ways. The fact that design isn't widely perceived as a profession is frustrating to me but it is also easy to get into the design industry here. You only need to know how to use the relevant softwares. The government has been talking

about promoting the creative industry but their proposals and policies aren't of help. Local designers need determination and patience to produce good works.

I'm caught between two very different cultures since I was born in the colonial times, but I am not greatly influenced by that. Take finding our identity after the hand over, terms like patriotism don't really strike a chord with us. And at work, our peers in the Mainland tend to see us as outsiders. Thus it's hard to say how Hong Kong influences my works and way of thinking. I think I must be influenced by it to a certain extent but it's hard to say.

If you were not a designer, what would you like to be?

A rock star or a farmer.

SHINSUKE KOSHIO

SUNDAY VISION

Profile:

Sunday Vision's work varies from graphic design to motion graphics, web design to apparel design. Shinsuke Koshio has been using Sunday Vision as his design name since 2001. He also creatively helms Switch Stance, an apparel label by Sunday Vision. His clients include Fuji Television, Drella, Laforet, Selfish Magazine and Victor Entertainment.

Why the name 'Sunday Vision?'

When I was a student at the University of Arts, we had a daily learning program. Our main production time was Sundays and evenings. Our schedule was lined up on Sundays and was completed on the same day. Therefore we took the word 'Sunday' for our company's name. My partner suggested using the word 'vision.'

Please tell us about your education background.

I graduated from Musashino Art University, Tokyo with a graphic design degree. However, it was skateboarding, BMX and music that have taught me the pleasure of graphic design.

What made you pursue design as your profession?

I enjoyed graphic design just like the way I enjoyed music and skateboarding. Daily life consists of loads of ideas so it's necessary for me to jot them down. And I take it from there when necessary.

Nature is a popular subject on the design front. How do you make it special?

In the course of history, nature has been expressed in various manners. I think about what kind of expression I use every time I deal with the subject of nature. It is important for me to choose adapting my style to fashion, and to my personality also.

You have a diverse portfolio among graphic design, illustration, animation, web to wear design, in what field that you find more fun in it? Why?

I use a different approach for each field. For instance, there is a time line for films but interactive elements in web.

We know your style is still evolving, but what is the best way to describe your style?

It is very important for me to achieve a balance so that my style can evolve.

What was/is the most challenging for you so far? What is/was your biggest challenge to date? Why and how did you overcome it?

I was in charge of the advertisements and commercial films of a department store in 2006. I needed to create commercial films and advertisements for each season in a year.

Who on the creative front in the same field in Asia catches your attention the most recently?

There are a lot of interesting designers in Asia. I rarely check out others' work beause I want to concentrate on my own and explore my style.

What is the most exciting/impressive work of others you find lately? Why?

I always get impressed by work made outside the design field, such as movies and dance perfomance.

How do you feel for (about) the design industry in Asia and what are your expectations for it?

Thanks to the Internet, Asian designers can be even more active. It's important to understand each other's culture.

How do you feel about your motherland? And how does it influence your design sense?

Japanese traditional prints and compositions have a great influence on me. I produced the original skateboard using the Japanese traditional ink URUSHI.

As a design unit based in Tokyo, what is unique about the city?

Each area has a different character. The new and the old coexist and I'm stimulated by both.

What would you like to do the most if not designing?

A football player.

CHRIS LEE
ASYLUM

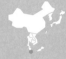

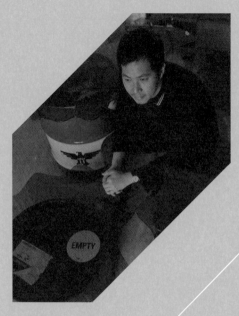

.......................................

Profile:
.......................................

Asylum is a multi-disciplinary creative company, comprising design studio, retail store, workshop and record label. Their projects cover branding, corporate identity and literature, retail design, environmental design, experiential design and interactive design. Asylum's work in the creative industry is recognised with international awards including The One Show, D&AD, Creative Circle Awards, NY Art Director's Club, NY Type Director's Club, Graphics, Communication Arts and IdN Awards.

.......................................

What made you pursue design as your profession?

I was inspired by record covers when I was a teenager. 4AD records was a particular influence. I tried electronic engineering but I couldn't make it.

What are your inspirations?

I am inspired by so many things! Contemporary architecture, modern art, experimental music, fashion, good cuisine, big cities, chaos, parties, spontaneous energy, urban living, passionate people, craftsmanship that's unfazed by commercialism, Japanese perfectionism, old things, rough streets, courage, etc.

What's your biggest challenge to date? Why and how did you overcome it?

The biggest challenge is to base in Singapore and yet remain focused to do creative commercial work. Singapore is a very commercial city, there is not much entertainment, arts, music or film industry for design companies to show their talent. Most of the clients here are in banking, finance, telecommunications, IT, hospitality, etc.

We are very focused in choosing our direction and the type of work that we like to do, building a portfolio that shows what we do best. All our works are now very diverse. We are doing graphic design, interactive design, branding and interior design for retail, boutique hotels, restaurants, bars, developers, fashion brands, etc. We are even doing retail consulting and planning for some property developers.

What project/work of yours you find the most memorable? Why?

I'm sorry but I really can't pick one because every project has a good story behind it. I think the meaningful ones are our self-initiated projects because there is a social statement in them. We are publishing a book called Moonlighting that features people who do interesting stuff outside their day job. I hope the book will inspire young creatives to be more passionate and do more.

What are your views of the Asia's design scene? What are your expectations for it?

Asia has never been more exciting for creativity. There are so many different people doing interesting stuff and there is a sense of optimism and a 'can do' attitude. For once, there is a shift in creative energy from the West to the East. We used to look towards London or New York for inspiration but I think the attitude is changing. There is also more dialogue and exchange of ideas among designers in Asia.

How do you feel about your motherland, Singapore? And how does it influence your design sense/style?

I think Singapore is a dynamic country that has its priorities on economic growth from the beginning. Being so influenced by many different cultures, we are now trying to define our own. The great thing is that we have a more acute sense of what's happening in the world and the bad thing is we've lost our own voice.

I also feel that people in Singapore are very complacent and comfortable, so there isn't a hunger for success. Compared to what I've seen in other parts of Asia I think it's worrying.

My early aesthetic was influenced by British design, now it's more by Japanese culture with a dose of Chinese. I try to find our own personality in our work and as we approach our 10th year, we are becoming more defined than ever. Humour, wit and irreverence amount to the Asylum personality.

Which creative catches your attention the most recently? Why?

I find that the things that excite me these days are mostly in architecture, art or music. Graphic design on its own is void of content and relevance in the world today. I feel that creativity is exciting only if it is able to affect people's lives and add something to the cultural fabric of that society.

What is the most exciting/impressive work of others you find lately? Why?

I like what I see in Thomas Heatherwick's studio, he's one of the most exciting architects in the world today. I like his larger-than-life ideas for small and seemingly mundane projects. Wonderwall in Tokyo is also doing some really simple but stunning works in interior design. For music, I'm really impressed by Morr Music based in Berlin, they have a diverse and really exciting group of musicians under the label. I hope I could also do a book about them sometime this year.

SEOUL, KOREA

HYUKHWAN LEE
MOSS CREATIVE INC.

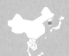

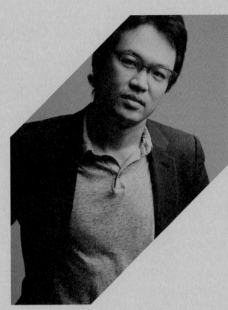

As a multi-disciplinary design company, what are your future plans?

I certainly hope to do more unusual projects like making a sculpture in a public place, working on a mobile phone design, or perhaps hosting a travelling art show, projects that can affect people's lives more profoundly. I am happy about the direction the company is heading to and I will continue to work on more self-initiated projects to feed our soul.

If you weren't a designer, what would you be?

A chef, wine sommelier, architect, artist, publisher, travel writer, curator...oh no, too many choices. I better stick to design!

Profile:

Founded by Hyuckhwan Lee in 1999 in New York and Seoul, Moss Creative INC. has built a reputation for breakthrough advertising campaigns that deliver valuable results to their clients, mostly prestigious fashion companies. The depth of experiences over many years in the advertising industry allows the company to provide design, visual attitude, advertising colour as well as strategic marketing and consumer maxims.

What made you pursue design as your profession?

I had an ambiguous dream to do something extraordinary. Even though I do not remember where the exact starting point was, I have long felt an uncontrolled desire to create product designs, which could move one's soul.

What are your inspirations?

Unlike other designers who are usually inspired by the past, especially by the affluent times of the 1960s in the USA, I am more inspired by contemporary designs. It is much more fun to predict the future by looking at the present.

In my opinion, today's 'modern' fashion is a reinterpretation of the past and it will become the past designs of the future. For that reason, I am always interested in modern architecture, automobiles, and many other product designs, in addition to fashion design.

What's your biggest challenge to date? Why and how did you overcome it?

Setting a goal is always a big concern for me. My standards are way too high and my expectations are far from reality. I always feel something missing everytime I finish a project, which is probably due to my high expectations. However, this discontent keeps me moving forward. In fact, there is no 100% perfection when it comes to design.

What project/work of yours you find the most memorable? Why?

It is the young casual 'THERES'S that I worked on in the summer of 2002. It was a new provocative brand mixing multiple ideas with vintage concepts. I did every task by myself from conception to tentative plans through photographing in Brooklyn, NYC.

Initially, I had a photographer but he could not deliver what I wanted, so I decided to keep snapping my own photos which were taken next to the photographer for the advertising campaign. Fortunately, the ad received a good response. I remember this project well, because of the photos I took. Since then, I have photographed several seasons of advertising campaigns.

What crazy things have you done with your designs over the years?

I do not intend to do crazy things. I rather try to be curious about new things I observe. Observation is part of my daily life, I wouldn't feel bored as I keep looking for new things.

Moss's No. 1 concern is how to express an edgy, trendy and uneasy attitude. Illustrate this with one of your submitted works.

The top topic of Moss, which delivers an edgy, trendy and complicated attitude, is always something 'new.' I believe that there should be a few things more powerful than new products and they impart an 'edgy' impact.

Of all the fashion advertisements you have created since 1999, which one are you the most proud of and why?

The 'A6' project, a fashion advertisement I'm most proud of. I have worked on the project since F/W 2000. Even though it has lost some of its originality over time, it had a strong beginning, and its early times typography never falls behind in comparison with modern advertisements. We worked with Swedish photographer Sesse Lind and upcoming Swedish young models in Puerto Rico. This was for S/S 2002. I took the photos of waves and oceanic scenes myself. Furthermore, the A6 logo above the image was well-received. I believe it is the best of typography.

Which fashion house would you like to collaborate with that you haven't yet and why?

I would like to collaborate with Louis Vuitton. I've always admired their imagination, which frequently engaged with fairy tales and fantasy. I would like to mix our creativity with these themes.

You said that your creativity will not be compromised. How do you balance the commercial demands from the fashion industry with your creativity?

Our work is based on art. However, the work would not exist without clients. Basically, we would try to listen to our client, understand their needs before we propose our initial plans with our creative input. This is very important to us. No one would against creativity and originality, especially in the fashion field.

You work mostly with fashion houses. Are there plans to explore other design niches?

I believe that everyone can be our clients if they are looking for the spontaneous, private and abstract beauty that fashion should have. At present, we are working with clients in the cosmetic area.

What are your views of Asia's design scene? What are your expectations for it?

Actually, the Asian design world is not as liberal as western design culture. But the emerging market amazingly offers us unlimited opportunities.

How do you feel about your motherland? And how does it influence your design sense/style?

Korea is well-known for Confucian and conservative ideas till tody. I always appreciate that I have grown up with my country's conservative emotions and philosophy.

As a Korean, I have a delicate and sensitive touch on designs that is totally different from Western designs. It's easy to find each designer's own culture through their respective designs. It is so natural! However, sometimes I think I prefer being more liberal.

Which creative catches your attention the most recently? Why?

I worked on the advertising project for the fashion brand 'Polham' for F/W 2005. In the studio, we photographed a white tiger, an icon of Korea. Even though we had to photograph the model and the tiger separately (because the model was afraid of it), it was an interesting project.

What is the most exciting/impressive work of others you find lately? Why?

I am impressed by the Time Square in the New York series of the Korean photographer Kim Atta. It was amazingly dramatic! I am so proud that he is Korean.

Tell us one thing about yourself that people don't know yet.

Even though I try to appear as a grown-up, I still feel like a child and immature. Sometimes I feel so immature even when I am not intented.

If you weren't a designer, what would you be?

If I am not a designer in fashion, I would design automobiles. I am not a speed maniac but a design maniac. An automobile's design really inspires me. It's like bags or shoes for women. I love automobile's designs just as much as I love fashion advertisements.

LIN LIN & SAM JACOBS
JMGS/JELLYMON

Profile:

Set up by Lin Lin and Sam Jacobs, JMGS/ JELLYMON is a multi-disciplinary design studio who specialises in artwork, toys, fashion, lifestyle products, branding, photography and creative direction. The pair met at Chelsea School of Art in 2002 and have been working together ever since. They are primarily based in Shanghai and London and have coped with clients from the UK, USA, Europe, China, Japan and Australia. They have worked on projects for independent regional companies and multinational's such as Nike, Adidas, eno, Wieden & Kennedy, K-Swiss, and many more.

Why is your company named JMGS/ JELLYMON?

Haha, it's a silly name, at least we kind of think it's silly now! That's how 'JMGS' came about, it sounds professional and serious, and people can guess what it stands for or make up their own: Jellymon Get Serious, Jellymon Graphic Studio, or Just Mix Great Saliva... what ever you want.

The name 'Jellymon' came about because at the time we were deeply obsessed with the consumption of gelatinous products and the strange gurgling feeling you get when you choke them down. We love everything with jelly and ice cream and our favourite is Cheung Fun (Cantonese lasagne made of rice filling with shrimp or meat usually). Most great cultures have jellied food. We put it together with 'mon' which is short for monster just like when Pokemon were the biggest trend. We thought it sounded like a rejected Pokemon. We later found out that there is a Digimon character called Jellymon so we were sort of right. Digimon tried to sue us over the use of the name but we had registered it years before them and Yamato Matt Ishida was well pissed off.

Please tell us about your educational background.

We met at Chelsea School of Art, UK. We were studying spatial design and both realised around the same time that we wanted to study something else.

J: I changed course at Chelsea to study Communication design. It was a really great course, you could pick and choose what you wanted to do, from graphics, animation, film, photography, interactive, etc.

L: I finished my BA in Spatial design at Chelsea, as most of my college friends went on to pursue further architecture studies, I did an MA at London College of Communication in Typo/Graphic Design. Most of my research for my MA was on youth culture and fashion.

What made you pursue design as your profession?

J: It was predestined, I have kept drawing and doodling from the second I could pick up a pen. If I see a blank surface, I will have it filled or covered real soon. It can be a problem which varies with obsession. Design solved this for me really. It's a fun and challenging thing to do with your life.

L: Unlike Sam, I am not very good at drawing, but it doesn't stop me from solving problems and being surrounded by beautiful things.

Where do you get your inspirations?

J: Everywhere really, but I'd say the biggest inspirations for me are work and music by other designers and artists. I find it hard to work without music. When you are listening to a great melody, you can just close your eyes for a few seconds and let your thoughts flow and get lost in the music and lyrics; and when you open your eyes again, your head is full of interesting stuff!

L: Mainly from the cities I have lived in and visited to. People are my inspiration, and no matter how cliché as it sounds, Sam is a big part of my inspiration.

What made you decide to leave London for Shanghai?

J: Lin Lin is a Cantonese so we plan on travelling China few times a year to look at the development. It's amazing how things happened here.

L: We'd visited Hong Kong, Guangzhou, Beijing and loads of other small cities... Fascinating culture and people.

J: It wasn't till we visited Shanghai that it really clicked me. I just didn't want to leave. It's such a vibrant place, so happening. You can basically feel the electricity of change and opportunities in the air.

L: It feels like we have already lived in London for most of our lives, growing up there and loving the street culture. But in China, it feels like it's just starting. Youth culture is developing so fast with China's very own music, style and vocab, we just want to play a part in this.

How did you start teaming up to establish JMGS/JELLYMON?

J: We were already friends. After leaving university, we really wanted to try doing what we wanted to do in design-wise. I guess we were lucky and some people liked it!

L: It turned out we found the missing puzzle in each other. We fight a lot at work but always manage to get the most out of it at the end.

Have you encountered any difficulties when you first started your business in China?

J: I guess for me it was a bit of a cultural shock, and the language barrier that I'm trying very hard to overcome! It was fine after a few months. People work really hard here and are professional, motivated and in general good at what they do, so that all really helps.

L: For me it's more like struggling with my own identity sometimes. I am a foreigner in my own country but then soon I realise it doesn't really matter. People in China are open-minded and curious. Boundary pushing is never easy but it is a great feeling once you manage to get away with it.

How would you describe your design style?

L: Our style is fun, pretty bold and flat. I don't want to pigeon-hole our style but most of our work are pretty cute and young. Though underneath, we are trying to make sure that there would be something weird or unexpected that reflects what's happening in the world right now.

We try to look into the East through the western eyes and the West through the eastern eyes to give us a fresh perspective.

Your projects mainly targets the youth market. Why so?

J: We are young and it's what we know best. Also I think that the youth market in China is so varied, from people who are into Beijing indie rock to luxury brand aficionados. You can never get bored or stuck with the same thing every time. I guess I like working on sportswear and streetwear brands because that's what I like. I'm a sneaker addict so if I can get some free shoes from the projects, I will be so happy.. wink wink!

L: Youth market suits my personality. It's complicated yet full of energy, confused at all times yet with logics.

Describe the kind of youth you design for.

L: I don't think there is a particular demography for us, perhaps for some of the brands we work with. We are picky about whom to work with. Design may not change the world, but we hope we can bring a bit of happiness to everyone who have a piece of our work in their lives.

Your projects have a heavy dose of fun. What belies this sweet surface?

L: We often explain this using that famous quote from Mary Poppins. Our work is 'like a spoonful of sugar to help the medicine go down.'

We work in a commercial industry dealing with huge multinational companies with high expectation and strong corporate cultures. What we do is to bridge the gap between the target audience and the client. Whether you are selling life insurance or the freshest pair of sneakers, you need to put a twist on it so your audience can connect with it. We just try and sprinkle whatever we do with a bit of Jellymon-love!

'The Secret Life of Pagodas and Other Assorted Structures' is a work-in-progress piece. Why did you merge buildings with characters?

J: I feel such a strong connection to where we live. At the moment it's Shanghai, but it's more about the feeling of 'city life.' I'm addicted to city life which comprises of the fast pace, concrete, neon lights, over crowding, traffic, noise and smell. Cities are living breathing microcosms so it's a natural progression to feel attached to the buildings around you.

I think the series 'The Secret Life of Pagodas and Other Assorted Structures' really grew out of our fascination with the Pudong (downtown Shanghai) skyline. It's ridiculous, fantastical, beautiful and pretty funny. The building being most capable of summing this up is the Pearl Oriental TV Tower. It looks like a space rocket from TV shows I watched when I was a kid, Button Moon or The Jetsons. It feels alive and full of personality and in a strange way, it's a major factor of why I moved here. It represents a lot to me and feels a bit like an old friend.

The series is our reaction to the feelings we have and a reflection of how we see these buildings when we stare at them from our windows. The Pagoda part came about because it feels like a natural starting point when we are trying to examine Chinese buildings. They exist in China Towns around the world and are probably one of the first things people can think of when they think about China. When I see a really old beautiful Pagoda somewhere like Guilin, I get the same feeling I have with the TV tower, I think that one is the natural successor of the other.

What is/was your biggest challenge to date? Why and how did you overcome it?

L: The biggest challenge in our field is to convince our clients to let us push beyond boundaries. It might take longer time to settle an agreement, but if it is worthy we will go as far as it takes. Just like everyone, we have had ups and downs in life, but we try and keep happy and get passed bumps on the road.

What project/work of yours you find the most memorable? Why?

J: I just feel lucky and pleased with all the commercial works we have done. I don't feel 100% satisfied with anything I have done in the past, so I guess the most memorable project will be the next one we do. Hopefully we can learn something new and do something better than before. If I have to name something outstanding, the one we worked with eno is really fun and open. We worked really closely with them to develop a Chinese brand which has integrity and real drive to push forward the Chinese creative scene.

L: I still love the Choking Hazard toys we developed about 3 years ago. They were a bit ambitious but failed to get passed the sampling stage. I haven't got any kids so they were like my kids! It was amazing to see them come to life from an idea to illustrations. We just got them back from Europe from an exhibition and they were all broken but we'll fix them up and they will be as good as new!

What is your company scale now? Any plans to grow bigger?

J: Right now we have 5 people; Lin Lin, Sam, Pop, Lulu and Evan. It's a good balance and we have been so lucky to find these 3! We don't have a target or a 5-year plan or anything. We just want to keep doing what we love and grow organically. If in the future we need more people we will wait till we meet people we really click with.

Your work stretches from toys to fashion, products to branding. What's your future plan?

L: To keep doing the same thing, working on projects we love, with people we like and try to find the secret of everlasting youth.

Who do you admire in the same field as yours in Asia?

Japan: The Wonderful! design works, Nagi Noda, Devilrobots, GROOVISIONS, Hiroshi Fujiwara, Hiroki Nakamura, Junya Watanabe, and Ninagawa Mika.

China/HK: 223, WZL, Popil, Rubber Pixy, JOYN: VISCOM, Tony Law, Eric So, Michael Lau, Tim Tsui, and Edison Chen (haha only joking).

What is the most exciting/impressive work of others you find lately? Why?

Anything and everything by Geoff McFetridge and artists we have mentioned above. An album by the group Hedgehog from Beijing called Noise Hit World. Loads of clothes and sneakers from PEGLEG NYC, Mishka NYC, Kidrobot, Nike, adidas, VISVIM, UBIQ, Raf Simons, Dr Romanelli... the list goes on... it's an addiction!

How do you feel about Asia's design industry and what are your expectations towards it?

J: I feel that each country in Asia has its own scene and level of development. Japan in particular Tokyo, is the world leader. China on the other hand is developing fast but still has a long way to go. I feel very positive about the design, art and music scenes in China. I can't wait to see any fun and original things come out of them.

Would you like to carry on your stay in Asia? If so, how long would it be and why?

J: I'm definitely not considering of leaving here at the moment. I think we'll be here for the foreseeable future. The whole world is tilting towards the East at the moment and I believe that will continue to happen. I can't think of anywhere I would rather be right now than Shanghai.

Do you find any benefits/advantages to work as a foreigner in Asia?

J: There are benefits for sure, you are an outsider from a different culture bringing in different ideas and insights with them. The thing is that I come from a culturally mixed up place like London, I feel like someone who comes from Shanghai or Tokyo would become a designer in London if s/he lives and works there, so I hope the same would as well happen on me when I'm living in another country. I want to make up a cultural mix but at the same time I want to fit in.

Which part of Chinese culture/tradition do you find the most interesting? And why?

L: Chinese Minority tribal culture....A recently study on the minority tribes in China. It is absolutely fascinating! They are all Chinese but they look like Turkish, Thai, Russian... they live in their own way, with beautiful personalities and amazing visual culture and music. A lot of them came to work in metropolitan cities like Shanghai, sadly often get discriminated. But they are survivors. We also designed a line of streetwear based on the study, called 'A Tribe Called...,' which is now in production.

We understand that you had a trip to Beijing lately, any discoveries or fun stories to share with our readers?

L: I see Shanghai as a glamorous sexy lady. Beijing is a little rougher around the edges, but the people are so nice. Really cool, Really 'Niu B!' ('Niu B' is a beijing expression for super dope!). It is a huge place, much bigger than Shanghai and you would have to spend a long time in traffic. But the more you visit to Beijing, the longer you would stay there. And the more you explore little areas and secret spots there, the more you love it!

If you were not a designer, what would you like to be?

J: I guess it's cliched, but if I wasn't a designer I'd love to be a music star. It seems like fun... to travel around the world, meet cool people, do something you love... sounds familiar!

L: I would like to be a cultural ambassador, to travel around the world, meet different people, master all languages.

MARC & CHANTAL DESIGN

MARC BRULHART, MARC CANSIER & CHANTAL RÉCHAUSSAT

Profile:

The studio was founded in 1993 by Marc Brulhart, Marc Cansier and Chantal Réchaussat. The partners were guided by their design education in Paris and Milan to develop an open environment, one in which lateral thinking and creative interaction are encouraged throughout the company. Today, the team is harnessing this accumulated know-how, crafting these unique experiences and creating precious emotional links between their clients and the public. They combine strategic thinking, graphics, multimedia and interior design as part of a global and holistic vision.

Before Marc & Chantal was established back in 1993, Marc Brulhart studied several different kinds of designs like jewellery design, interior design and industrial design, what made you pursue design as your profession?

MB: I've always liked building things like toys, treehouses, etc. I ended up studying furniture making. Then one day, I won a competition presided by a British designer. My prize was a trip to London, touring studios, museums, schools, etc. I discovered my profession during the vocation.

Chantal Rechaussat and Marc Cansier, tell us about your educational background. And what work experience did you have before the formation of Marc & Chantal?

CR & MC: We studied fine arts and graphic design at the Ecole Supérieure d'Art Graphique (Atelier Met de Penninghen) in Paris and both graduated in 1991.

This school's heritage is quite unique. Also known as Académie Julian, it was founded in 1868 and was attended by such artists as Matisse, Leger or Derain, to name a few.

Its approach to teaching design is, as a result, very much anchored in tradition. We were given a 2-year solid, classical drawing foundation requiring rigorous discipline before being taught design per say.

The remaining 3-year design course had introduced us to a broad range of disciplines, from calligraphy and typography to illustration, photography, graphic design, corporate identity and art direction as well as continuous life drawing training.

This is where we've learnt the virtues of a holistic approach to design. Marc Cansier's final school project was to design a Museum for Angkor Wat in collaboration with an interior designer and Chantal created a collection of hair jewellery.

Chantal worked for a year with a design firm named Dragon Rouge ('Red Dragon') before moving to Hong Kong at the end of 1992 while Marc Cansier worked freelance over that period.

What led to the collaboration between Marc Brulhart, Chantal Rechaussat and Marc Cansier?

We were subletting Marc Brulhart's flat when we first arrived. We were therefore his tenants before becoming his friends and later his business partners. We were working freelance at the time and were asked one day if we could design and produce shop displays. Back then, we always enthusiastically said YES to anything and then figured a way to deliver the promise.

Marc Brulhart was a product and interior designer and we began our collaboration in the kitchen, bending metal bars on the stove. The experience proved successful, the client was satisfied and within a few months Marc Brulhart resigned his day job as a watch designer and we were then in business together.

What made/motivated you to come and work in Asia? Why does Hong Kong appeal to you?

MC: I had passed through Hong Kong once and was struck by the city's energy and vibrant cosmopolitan feel. France was economically depressed in the early 90s and our industry seemed to have limited perspective for young designers in search of creative challenges. So, we left. Hong Kong offered us the environment we craved for, which were exotic, dynamic, spontaneous and as far as our industry was concerned, plenty of room for innovation!

Driven both by conviction and necessity at the time, we saw an opportunity to make use of our broad design education and from the start, promoted a cross-disciplinary approach towards our clients.

Where do you get your inspirations?

Anywhere, the beauty of working across disciplines and with clients from very diverse industries is where you may 'pollinate' ideas from one field to another!

Please tell us about your graphic design for Mandarin Oriental. How do you inject new energy into this hotel, which is steeped in history?

As with every project, we designed objects that would be an integral part of the interior as well as for the Mandarin Oriental brand where each

needed to tell a story and feel right. We reinterpreted the sumptuousness of this institution through carefully researched themes and visual inspirations but we shed the old stuffiness. The rejuvenated interior scheme served as a guide for colours, textures and finishes. The chocolate browns and creamy tones are still there but the overall scheme was jazzed up with accents of more vibrant colours such as fuchsia, chartreuse green or vermillion.

Graphic inspiration came from the research. For instance, the name of the all day café Causette, meaning 'chat' in French inspired the use of poems in English, French and Chinese to adorn typographically for the café's menu covers.

You have collaborated with many brands over the years. What project/work of yours you find the most memorable and proud of? Why?

It's hard to pick one but our design for the Central Time exhibition for Hongkong Land is definitely one milestone. The elegance and simplicity of the solution made it a very engaging and fluid experience for the visitors, which was what we were striving for.

Your work is mostly commercial. Are there plans to be more involved with Hong Kong's art scene?

Actually we have been quite involved in the past, working with the Youth Arts Festival, the French May Festival and recently the identity for the BODW (Business of Design Week).

We still plan to be involved in collaborative work with the art scene, but we think that when it comes to the communication of local art-related events, it is better to leave it to the new generation of upcoming designers since it is a great showcase for them.

Branding was once the hottest topic in town among designers, however the boom was spoiled quickly in just a few years and much less people talk about it now. How do you find this phenomenon? How does it influence you?

We don't really feel it that way. Actually it's only recently that we've started being really interested in branding and this is a major focus for us now. I think it's a key thing for the

future of the Hong Kong's design industry, but branding is not just about designing logos, it's about telling stories also.

As a creative consultant expert in creating inspired, multidimensional brand experiences, do you see any problems of the field in Asia, especially in Hong Kong? What is it and how could it be improved?

Brand establishment is a complicated thing, like a living organism which embraces deep layers of history and emotions. If you don't have 150 years of history, like Louis Vuitton or Hermès, you will need to create that 'mystical quality' overnight, like what A Bathing Ape did for example. Their shops and products are a multidimensional brand experience, hence the success.

I think we will see more successful global brands coming out of Asia in the near future. Hong Kong has fantastic opportunities where none should be missed!

What is/was your biggest challenge to date? Why and how did you overcome it?

We went through many crises, the 1997 Asian financial meltdown, 2000/2001 Internet bubble and 9/11 attacks, and 2003 SARS in Hong Kong. We suffered, adapted, learnt and survived. When time was rough, it helped greatly to have a real culture and identity within our company-something to hang on to.

Your company is now a diverse group of 30 professionals coming from around the world, what are your future plans?

We want to stay around that size and keep growing and nurturing the quality of our team. We have great talents here, and many offsprings that started their own companies. We are in touch with them and starting to build a network of partners we can work with.

Who do you admire in the same field as yours in Asia?

We love the collaborative work of Japanese architect Kengo Kuma and graphic designer Kenya Hara. We are extremely proud to work on the identity of The Opposite House, the hotel that Kengo Kuma designed in Beijing for Swire Hotels.

What is the most exciting/impressive work of others you find lately? Why?

'No Country for Old Men' by the Cohen's Brothers!

How do you feel about the design industry in Asia and what are your expectations towards it?

We are excited to see how China gets mature into a powerful source of strong design. There are incredible talents out there, who need to overcome a lot of challenges.

Would you like to carry on your stay in Asia? If so, how long would it be and why?

In a way we feel like we are only starting now. It has never been so exciting and we are looking forward to participating in the development of the industry for the next 10 years.

Do you find any advantages to work as a foreigner in Asia?

We have been asked about this question for many times. Being European allows us to act as a bridge between the East and the West more easily. After 15 years staying here in Asia, it's easier for us not to get 'lost in translation.'

Which part(s) of Chinese culture/tradition do you find the most interesting? Why?

The food! Being French, we can easily appreciate the complexity, diversity and subtlety of all kinds of Chinese cuisines. It tells a lot about how strong the culture is.

Do you have any advice for your students and youths in general, especially to aspiring artists and designers?

Open your mind, be curious, look beyond Hong Kong, go to China, learn English and Mandarin (and French in your spare time) and stop reading those gossip magazines!!!

If you were not a designer, what would you like to be?

MC: A rock star, but I am really suck at music.
CR: A mad scientist.
MB: Curator of an erotic art museum.

JAVIN MO
MILKXHAKE

Profile:

Milkxhake is a young Hong Kong-based design unit co-founded by graphic designer Javin Mo and interactive designer Wilson Tang in 2002. It mainly focuses on graphic and interactive mixtures. In 2004, Javin Mo from Milkxhake was invited to join FABRICA, the Benetton Research and Communication Center in Italy. In 2005, he re-initiated Milkxhake with Tang to form one of the most energetic design collective in Hong Kong. Their works have been selected for numerous international design awards including the Tokyo Type Directors Club Awards and Hong Kong Designers Association Awards.

Please tell us about your educational background.

We both graduated with a degree in Digital Graphic Communication from Hong Kong Baptist University in 1998. After graduation, I worked as a graphic designer while co-founder Wilson worked as an interactive designer.

What made you pursue design as your profession?

Design brings happiness and satisfaction to me.

Why the name 'Milkxhake?'

To be honest, 'Milkxhake' was just a final-year project. We came up with the name 'Milkxhake' at that time while we changed to 'Milkxhake' in 2002 to embody the meaning of 'mix'. We think it's a good name as we believe design should mix up ideas apart from physical appearance.

What led to the collaboration between interactive designer Wilson Tang and youself as a graphic designer?

We studied in the same university and worked on some projects together. After graduation, though we worked in different fields, we kept initiating projects together after office hours and we began to start our first website as our creative platform. After returning to Hong Kong in 2005, we decided to set up our own studio.

Milkxhake's design motto is 'Mix it a better world,' how do you illustrate in your work?

'Mix it a better world' is our design belief. Design can bring happiness to our life and surroundings. In a commercial city like Hong Kong, the role of design culture is not as strong as that in other cities like Tokyo. We hope we could do something more for our city and we believe that good design can create a better world.

Do you see yourself as a mover and shaker on the creative front? How so?

A mover is some talent that can create influence in his/her profession, I would say we are just 'milkshakers' who are mixing up ideas in design.

Have you always been conscious of your own cultural roots?

Even though we are Chinese, we had grown up under the strong influence of both Eastern and Western cultures. 'Mix' is always our culture and so is our design. We don't care too much about the East nor the West since we belong to neither side.

Any fun stories to tell about your Moleskine project?

Moleskine invited me to create my own notebook for an exhibition held in Hong Kong and Taipei. My idea was very simple - to mix different images taken in different cities in Europe during my 1-year stay and to generate a very interesting editorial mixture.

'Wannabee Chinese!' is one of your most provocative works to date. What belies these ironic images?

Initiated by FABRICA, 'Wannabee Chinese!' was a collaborative project with Ben Tseng. A series of provocative images was created which paradoxically reflects the lust of westerners towards modern China. The most interesting idea was to invite different FABRICA young artists to be our guest models, who worked hard to be 'real Chinese.'

As China is quickly becoming a new growth engine for the world, the 'Wannabee Chinese!' series has a special meaning to us Chinese. Among the images, the Spanish-Romanian guy dressing up in Cultural Revolution style holding a recent Chinese economic magazine is the most ironic one. It was also selected and published in Colors magazine's 'Lust' issue to match with the theme of the FABRICA 'Wanted Creativity' campaign.

Javin, how do you find your experience as an art director for FAB first 3 issues, quarterly magazine of FABRICA, Italy, between 2004 and 2005?

FAB Magazine was the most challenging project at FABRICA. During my second week there I was immediately appointed as the art director of the magazine. Before, it was only an A2 poster featuring FABRICA news and activities. My brief was to create a totally new quarterly magazine including logo, cover and editorial art direction. The most interesting part was to collaborate with different young people in FABRICA, from editors to photographers.

What project/work of yours you find the most memorable? Why?

In 2008, apart from being a designer, I also donned my editor cap and launched my first title '3030: New Graphic Design in China' published by 3030 Press in Shanghai. The project

HIDEKI NAKAJIMA

NAKAJIMA DESIGN LTD.

is a showcase of the new graphic art, illustration, poster and print design in China today. With over half year research, I selected 30 studios and young designers around their 30s from 13 different cities in China. I also worked as a guest art director for the book.

Milkxhake is well-established in Hong Kong, what are your future plans?

It's a shame to say it is well-established now. I just want to concentrate on producing more 'mixtures' with good quality here. Sometimes it is not easy.

Who do you admire in the same field as yours in Asia?

This is a difficult question to answer. In Asia, Japan is always the leading design country. There are too many good designers whom inspire me a lot.

How do you feel about the design industry in Asia and what are your expectations towards it?

There are many young up-and-coming talents in Asia especially in China. After editing the book project about China, I can really feel the passion, freshness and energy of those young designers and I believe many more people will focus on Chinese designs in the near future.

How do you feel about Hong Kong? And how does it influence your design sense?

Hong Kong is a total 'mix.' The young generation has no unique style while they have no sense to integrate local culture into design. As a result, it's hard to say that there's a unique Hong Kong design style right now. However, because of the emergence of the Internet and globalisation, a lot of local independent young designers, including me, are trying to set up their own studios, which marks a new design force in Hong Kong.

If you were not a designer, what would you like to be?

Be a teacher, or to open a small bookstore somewhere.

..

Profile:

..

The Art Director founded Nakajima Design 13 years ago. Since 1999 Nakajima has been a member of the unit 'code,' which comprises Ryuichi Sakamoto, Shigeo Goto and Rika Sora. He has published many books, including 'Artist, Designer and Director SCAN: Hideki Nakajima' (2001) and 'S/N,' a collaboration with Sakamoto. He has scooped numerous awards over the years, including the New York ADC Gold and Silver Prizes, the Tokyo ADC Award, the Chicago Athenaeum Good Design Award and the Kodansha Publishing Cultural Award.

..

What made you pursue design as your profession?

An album jacket designed by Peter Saville. Originally I wanted to be an illustrator, but my life completely changed the moment I saw it.

Where do you get your inspiration?

From my dreams. I think the turning point in my designs always comes when I try to create something I saw in dreams. Also, having conversations with other creators and listening to their future projects are inspiring to me.

You got into design in 1994. How has your style evolved since?

Actually I started working as a designer in 1980. I decided to be an art director initially after working as an assistant for 10 years. Then when I turned 30, the dream came true. I was invited to the publishing company 'Rockin' on' and started the art direction of their magazines like 'CUT' and other books.

In 1995, I set up my company NAKAJIMA DESIGN, and it gave me a chance to work on a wider range of design. However, doing design as a job couldn't cover everything I wanted to do, so I started creating my personal works, and showed them at my solo/group exhibitions. Those personal works satisfied me and have led me to the next step. In other words, they made me create a new direction of design. Overall, I think I've changed slowly but steadily.

What is the most exciting/impressive work of others you find lately? Why?

When my friend John Warwicker from TOMATO showed me the design for his upcoming book 'The Floating World,' I was impressed not only by the design, but also his view of the world. Another one is the book 'Inoue Tsuguya, Graphic Works 1981 - 2007.' It surprised me and made me realise that the designs of Mr. Inoue have established the new history of design in Japan.

We find your personal work is abstract and free flowing, what do you want to express through it?

In fact, I haven't understood what design is at all. However, one thing I'm sure about is the effort to keep searching for a completely new design form is my attitude towards design. I haven't achieved it yet but I believe I will someday.

Your personal work 'Unfinished' is housed by many museums. What is so special about it?

It is my great honor. I think the reason why they house my work is because it looks simple, though it's actually packed with details, using various printing techniques. For example, using ink which becomes transparent at body temperature; paper that would change colour after embossing; as well as doing some polychrome printing in customised ink. What's more, you won't know what's hidden in the work until you actually face it. That would be another reason.

What was/is the most challenging for you so far? What is your biggest challenge to date? Why and how did you overcome it?

Holding an exhibition 'Clear in the Fog' and publishing the book 2 years ago.

It's my personal exhibition at ggg (ginza graphic gallery), a sanctuary space for designers. So I did my best. It took a year to make it happen, and I overcame it by breaking my back.

What project/work of yours you find the most unforgettable? Why?

'Sampled Life,' an art box made for the opera 'Life' by Ryuichi Sakamoto.

Though we didn't have enough time for production, we experimented as much as we could. People who know about design would say it's something inexplicable. We collaborated and worked like a unit. It was a miraculous experience. Afterwards, 'code' started with the same members.

You have won many important awards in and out of Japan. Which are the most significant ones for you?

The very first awards I received. It was the 'Art Directors Award' in New York.

I received a Gold and 2 Silver awards, and even the people in New York seemed surprised as that's rare. It encouraged me as I felt I'd done the right thing. It was not Japan but a foreign country that noticed and appreciated me first. Thanks to the awards, people in Japan started recognising my works as well.

Your work has covered various fields yet apparently more active in editorial, CD jacket and fashion, what is your future plan?

I've never promoted myself actively to get a job. Fortunately, people offered me jobs so I could experience a wide range of works. This means I can't predict which direction I will go in the future. All I can do is to do my best on each job. Otherwise, people will get bored of my work and no one will offer me any jobs.

This autumn, I'll hold a group exhibition in Los Angeles, and a small personal exhibition at an art gallery in Tokyo. Also I'll work on my personal projects for which I've already decided the concept. After finishing that project, I'll work on the new phase of my personal work. I will try my best, though I haven't fixed the details yet.

Are you still a member of the unit called 'code' with Ryuichi Sakamoto, Shigeo Goto and Norika Sora? What does it do?

We've gone silent for a while. The original theme of our activity was to produce things that reduce harm to the environment. However, we think a part of the mission of 'code' has completed because people are getting more and more environmentally-conscious. We still have the plan to do something together in a different way.

Who in the field, among Asia, catches your attention the most recently?

There are many, so I can't only pick one. For example, Benny Au, Stanley Wong, Les Suen from Hong Kong; Wang Xe, Lu Tingren from China; Ahn Sang-Soo from South Korea, and many more. They don't look to the past, and always keep challenging. I respect them from the bottom of my heart, and I'm glad I live in the same time period with them.

How do you feel about the design industry in Asia and what do you expect from it?

There are lots of up-and-coming designers in Asia. They're really talented, and I feel stressed in some way. I hope we could move forward in peace and stimulate each other.

How do you feel about your motherland, Japan? And how does it influence your design sense?

My family business was Japanese kimono tailoring/dressmaking. My grandfather was very skilled among other family members. He made kimonos for the nobles. His job was to make a kimono out of one fabric, but his special technique also enabled people to run wearing the tight kimono. His way of sewing was not mechanical, but customised and nimble. The way he sewed has engraved in my mind. Because kimono is all about minimalism, that's why it's ingrained in my mind.

You are very well-established in Japan, do you see yourself as a mover or shaker in the design industry? How so?

I'm not good at being a 'mover,' so I think I'm more like a 'shaker.' It links to my starting point as a designer; as you know, I was shaken by the design of Peter Saville.

If you were not a designer, what would you like to be?

A musician. Now I have no talent for it, but that's the world I long for.

JONATHAN NG

IDN

Profile:

Jonathan Ng is the art director of IdN magazine, an international publication for creatives on a mission to amplify and unify the design community in Asia-Pacific and other parts of the world. It has held many exhibitions and conferences over the years. It dedicates itself to bringing designers from around the globe together to communicate with, learn from and inspire one another. It has truly become what its title proclaims it to be: an international designers' network.

Please tell us about your educational background.

I studied Architecture at the University of NSW in Australia.

What made you pursue design as your profession?

My father showed me the first issue of IdN 15 years ago. I remember there was an article about using Photoshop 1.0. That was when I was first introduced to computers. I had also grown up surrounded by cameras and dark rooms, negatives and the films from developers. Funny enough, I did not pick up a camera until I was 13 (I think it was a Pentax K1000), and from then on in high school, friends could only find me either in the art department or in the dark room. It was fascinating to see all the details, things you would not normally see, until they are revealed to you in the developing tray.

Where do you get your inspirations?

The minute details of things- inspirations really do come from almost everywhere, only if you study them closely. Everything is made up of smaller things, and smaller things comprise miniature elements.

Cities are very interesting things to look at. They comprise many levels and layers. On one hand, you can study or appreciate a particular building or interior space, understanding how space is used. On the other hand, you can study why certain districts are more popular or populated. Inspirations come from understanding complex systems are hence revealed in details to you.

What did you do before joining IdN? How did you find the experience?

Before I joined IdN, I had worked as a printer, and then as a design architect. I think both jobs require a high level of sensitivity to details, which is why I enjoyed them so much.

Please tell us about your new column 'Top Talent.'

The new column 'Top Talent' tries to reach out to students who are interested in design and eager to gain some exposure. We believe good works do not only come from designers who are at work already. Those who are still experiencing the fun of design and finding their way in school can come up with many innovative and inspirational designs. Thus, we encourage every students, who are interested in design, from graphics to fashion and photography, or any other design-related field, to submit their works to us. They may just find himself/herself the next featured creative in our coming issue's column.

How is IdN an international designers' network?

Our previous column '15 Degrees' aptly demonstrates how the designer network starts from us and grows by itself. In each IdN issue, through our columns, topics, competitions and our books also, we gather creatives in all design fields from around the world and people can get to know them better.

Thus, IdN is a design platform/network for us to reach out to other creatives and let them know what's going on in the design world in return. We are happy and proud of our inspirational network, having 15 years of creative publication as its backdrop. And we are always looking forward to meeting new creatives and continue to expanding our international designers' network.

This year is IdN's 15th anniversary. How has it morphed over the past 15 years? And how do you see it in 15 years' time?

15 years is a long time for a magazine. I do not think the magazine had morphed a great deal. The only possible reason is that the industry had changed/matured with time.

Seeing the industry mature is like watching a kid growing up. In the past 15 years, even the term graphic design had travelled from one spectrum to another. No one seems to remember that graphic design used to be a very mundane 'job' involving typesetting and separation. Then this kid has grew up a little, s/he rebelled and started to think that 'design is cool, design is hip.' In the past few years, the kid had really matured and began to understand its roots. You can tell by the industry being more appreciative of the arts. And IdN has been there all the time.

Which theme that you have featured over the past few years best represents IdN and why?

The standard answer might be the '15 Degrees' column that best represents IdN. The column is about interviewing 15 interconnecting artists/designers, aiming to show readers that

designers are all connected somehow, and that IdN is truly a network.

Personally I hold the view that IdN is still like a kid who refuses to grow up while constantly looking for the next toy. Volume12 Number6 'It's Playtime' best fits this analogy.

What is/was your biggest challenge to date? Why and how did you overcome it?

I remember an art teacher used to tell me that I just don't know when to stop, and I think that is true to many artists and designers. The more you look at a piece of work, the more you notice things, you would like to change, improve, modify, or even start again from scratch. Fortunately, there is this thing called the schedule, or otherwise I'll get nothing done.

What project/work of yours you find the most memorable? Why?

I would say our next project/issue would always be my most memorable work. It's always fun to develop something from scratch.

IdN is well-established, what is your future plan for both IdN and yourself?

IdN has done a lot for the international design community. It is constantly keeping up-to-date with the latest in this fast-paced industry. There are plans to consolidate this network with more than just a print medium. Personally I would also like to contribute a little bit to the education sector of this industry as well.

Who do you admire the most in the same field as yours in Asia?

I admire the work of Theseus Chan (WERK).

What is the most exciting/impressive work of others you find lately? Why?

I'm always exited in work that can successfully engage in multiple disciplines or challenge how you look at a particular field. Lately the work of UVA pops into mind. Reaching further back, Yusuke Obuchi's Wave Garden project does not only imply the involvement of multiple disciplines, but also help raises issues surrounding us.

How do you feel about the design industry in Asia and what are your expectations towards it?

The design industry (as opposed to the art sector) has always been governed by the commercial world. If one is to talk about this industry in Asia, it is impossible not to mention about money and link to words such as commercialism and profitability. However, the commercial world is in turn driven by the market demand. One of the biggest differences between Eastern and Western cultures (and even civilisation as a whole) lies in the way how businessmen from two sides value design and art as an asset.

I am expecting that this demand for quality design will only increase with time in Asia. This is also evident by the way that the art industry has become more and more a part of the design industry. (IdN, to many readers, is synonymous with adjectives like 'artsey.' Where do you draw the line between art and design? And is this line getting increasingly blurred?) This, however, is yet another issue.

How do you feel about Hong Kong? And how does it influence your design sense?

I love Hong Kong and Southeast Asia in general. These are cities of the senses. Taste, smell, touch... Then perhaps European cities are cities of vision. This I think influences designers in the east (particularly graphic designers) to think beyond the limits of the page.

If you were not a designer, what would you like to be?

If I am not in the design industry, I might have become an archaeologist.

NAGI NODA
UCHU-COUNTRY / PARTIZAN

Profile:

Nagi Noda appeals to the world in different ways: most of the time as a director, other times as an art director or artist, or a fashion designer more recently. She has created numerous campaigns for Japanese department store Laforet. She has shot several critically acclaimed and inventive films including a video for Yuki, TIGA, Cut Copy, and projects for Nike, Paris' Monoprix, etc. She has also shot a hugely anticipated Coca-Cola spot for 2006 World Cup World campaign, featuring a track recorded by Jack White.

What made you pursue design as your profession?

The occupation of my parents. Both of them are artists, and I've been familiar with this creative world since childhood.

Where do you get your inspiration?

Daily life.

What were the highlights of your New York days? Did you like it there?

Actually I'm staying in New York right now for business. I won't pick up any highlights. Rather I just love the atmosphere in this city.

You were a model for Uniqlo. Did you enjoy it? Do you still model?

That also happened in New York. I enjoyed the shoot as I'm not the subject but usually the director.

Please tell us about your short film 'Being Appraised as an Ex-Fat Girl.' What's special about it?

When I saw groomed poodles, I always thought they looked like massive muscles. That's where the idea of this film comes from. Animals resemble their owners.

It means if the owner is fat, so would the animal. So I decided to make a fitness video for men and their animals.

What's it like collaborating with Scissor Sisters? What do you and the band have in common?

I enjoyed working with Scissor Sisters a lot. They had rehearsals repeated for 2 weeks in advance, though they learned everything within 1 day since they had an overwhelming sense of self-expression. Common point? I think both the band and I are creative kidults.

Your recent fashion label 'Broken Label' is a collaboration with famous fine art painter Mark Ryden. What made you choose him as your collaborator?

Because I'm a big fan. I bought his 2 original drawings 6 years ago, before I even met him face-to-face.

Your work has a surreal quality to it. Is there a special reason why?

I can't judge myself. I'm just attracted to something cute, beautiful or cool.

What's your biggest challenge to date? Why and how did you overcome it?

I don't have any big challenges in the business field, compared with the field of love.

What project/work of yours you find the most memorable? Why?

I would say it's HANPANDA. All I can say is that I love this project. I'm planning to make the sequel. HANPANDA has a magical charm, and I never get bored of looking at it.

What are your plans for 'Broken Label'?

I'll launch a new brand called 'NAGI NODA' and make the announcement in Paris.

What is the most exciting/impressive work of others you find lately? Why?

'PINK,' one of the adicolour films directed by Charlie White. It was perfect.

How do you feel about your motherland, Japan? And how does it influence your design sense?

I think Tokyo is a unique city in where its culture has been shifting continuously and rapidly. It is full of inspirations, but not living at ease.

If you were not a designer, what would you like to be?

Now I work more as a director, not as a designer. So I'd like to make a film. If I were not a designer nor director, then I would like to be a voice actress.

TAKASHI OKADA

Profile:

Based in Tokyo, Okada started freelancing as a graphic and web designer in 1999. He mainly designs Flash-based websites as well as collage-style motion graphics and interactive work of illustrated handwritten typography. In 2007, he won an Adobe Motion award in the flash animation category with the work 'What Scary Strange Amazing Complexity.'

When and how did you realise that you are interested in design?

I liked drawing when I was a child, but it was only sensuously. After I became interested in contemporary art when I was a college student, I learnt to draw on a conceptual basis.

Please tell us about your educational background.

I majored in furniture design at Hokkaido Tokai University, School of Art and Technology, Department of Design and Architecture. As for graphics and web design, I taught myself.

Where do you get your inspiration?

Non-commercially produced fine arts, and good music.

Is it difficult to freelance in Japan? How did you start your business?

Most of the designers work full-time since freelancing in Japan is financially insecure. I also worked at a design company, but I quited after I figured out that it'd be easier to work by myself. People around me introduced agencies and clients to me, and the business started before I knew it.

You use the name 'hybrid graphic' for your website. Is there a special reason why?

It's because I use 2 domain addresses to divide my personal works (www.okadada.com) and client works (www.hybridgraphic.com). When I collaborate with other people on client works, I use the word 'hybrid.'

Any reason why your work is packed with details?

Lately, I am drawing traditional motifs with pencil. Then I scan it and multiply the image. Though it looks complicated and detailed as I reduce the size of some parts as much as possible, it's made with one simple idea; one pattern constitutes another pattern.

You won an Adobe Motion Award for Flash Animation in 2006. Tell us what is special about your work.

I don't know. Though I can say that it has become more difficult and complicated to express design ideas, because Flash is constantly adding new technologies. At least, I always try to use a simple approach even with complicate programs.

Your work is clouded in mystery. Is mythology one of your inspirations?

I can be inspired by a single word and start designing. Since mythology is the origin of words, this proves that it is one of my inspirations. Also I get more inspirations from something eccentric in the punk and noisy music from the 80s and 90s. I often listen to that while I'm working.

What was/is the biggest challenge to date? Why and how did you overcome it?

The challenge comes to me when I'm offered a job, for which I don't find any motivation, nor a single idea comes up to me. Then I need to take time, to try out this and that.

What project/work of yours you find the most unforgettable? Why?

Lately it is a mobile website called Amadana because of the creative freedom I was able to design it using my personal works.

What are your future plans?

Keep working at my own pace.

Who on the design front in Asia catches your attention the most recently?

Kenya Hara. His design is completely authentic and filled with dignity. Also I can learn a lot from his typography.

What is the most exciting/impressive work of others you find lately? Why?

I've been interested in the works of Sarah Sze. Her spatial composition and details are thought-provoking.

How do you feel about the design industry in Asia and what do you expect from it?

I don't know much about the so-called Asian design industry, but what is unique in Asia is the usage of minority languages. It'd be so useful if someone made a translation software that would enable us to communicate with each other using our native languages.

How do you feel about your motherland, Japan? And how does it influence your design sense?

I live in Tokyo but originated from Hokkaido. Tokyo has this typical Asian chaotic commercial culture while Hokkaido has a long winter.

ZINOO PARK

ZNP CREATIVE

It is snowing for about half of the year. That's why the town becomes monochrome. It's so beautiful. I think it affects me a lot.

Actually I think that snow is interesting. It's simply white but has a complex structure consisting of crystals. In the air, it's variable and floating, showing us unexpected motions. I think you can see these snow characteristics anywhere in my design.

If you were not a designer, what would you like to be?

I'd like to be the son of a celebrity because he doesn't need to work.

Profile:

Zinoo Park is that rare kind of designer, who uses both products and graphics to express his design concept that is well-paced with pop culture. The Coca-Cola Project (1999-) epitomises this, where he has transformed an old-fashioned coke bottle to an art item. While he continues to work with Coke bottles, his interest in pop culture expands to projects such as the 'FAKE Bag (2006)' and 'Re-masterpiece (2007).' Park also uses his work to explore the relationship between functionality and design.

What made you pursue design as your profession?

I think my family has influenced me to pursue design as my profession. I used to go through my sisters' art books, who also majored in art. My parents worked in the fashion industry and I also pursued design because I like to observe things and create things.

What are your inspirations?

Movies. As I still crossover between art and design, I don't think I like to be influenced by one single thing, but rather by a mixture of these phenomenon.

What's your biggest challenge to date? Why and how did you overcome it?

I think there were 2 turning points until now. First was the military service that I had attend. Duty as an officer was a burden to me as I grew up as a student, who was so unfamiliar to the environment of the military life and the warfield. I was able to overcome the 30-month military life by researching and reading art-related book during my spare time.

Second was just before I attended the Royal College of Art. I almost failed to pursue the masters program in London due to lack of preparation and over pushing myself to get admitted. However, I was able to get an opportunity to re-apply with the help of the world-renowned designer Ron Arad. Luckily, Ron believed in my potential as a designer after looking at my Coca-Cola project.

What project/work of yours you find the most memorable? Why?

The Coca-Cola Classic (1996): I designed and made a classical silver kettle, decorating the typical Coca-Cola bottle with baroque style handles during my degree majoring in metal craft. It was a union between Pop and Classic Art. This project enabled me to seriously consider myself as an artist.

You worked for Tord Boontje. How does this experience influence your current design?

It was a short experience, but I think I worked with Tord at a very important time. It was the time when Tord gained fame throughout the world, and just when I graduated from RCA. It was a great opportunity for me to develop my vision and dream as a product designer.

You are engaged with pop culture. Which aspect of it fascinates you the most?

I think the latter half of the 20th century was culturally governed by pop culture. Also the local pop culture of vivid colours, expressions, and strong symbolic figures that Seoul provides has always been deeply embedded in the 'television' inside my brains.

What symbol of pop culture would you like to explore with your design that you haven't yet and why?

Louis Vuitton monogram is one of the symbols that I have fun working with, and I think I can still have fun playing with it.

You started the Coca-Cola project in 1999. How has it morphed over the years?

The Coca-Cola bottle and its logo that I have worked with for more than 15 years were the best tools to express my core design issue of 'communication.'

However, the methods and the media used were changed from time to time, from the original metal crafted silver to photography and installation, then to grotesque objects made from latex rubber that moved with sound, and eventually back to graphics.

The 'Secret Digital Woods' is a futuristic scenery, mixing real pictures with 'digimal' (digital and animal) graphics.

The Coca-Cola project presents me with ongoing artistic inspirations as time passes by.

What statement would you like to make with 'The Perfect Fake Bag' project?

This project was proposed by a gallery in Seoul to commemorate Andy Warhol, and was a part of another project called 'Truth & Irony.' 'The Perfect Fake Bag' series intends to visualise and satirise the current era by combining the Louis Vuitton brand and the graphic image of FAKE.

Through this project, I tried to reveal the social phenomenon of people preferring fake products over genuine ones, and also stating that once the word 'FAKE' is printed, that bag becomes original as an artwork. It also delivers a message that we should be the one valuable, not by what we wear or carry.

What are your views of the Asia's design scene? What are your expectations for it?

Asian design has been based on its unique culture and history, and changed rapidly since the late 20th century. I believe these changes will influence the design industry with greater force in the near future.

How do you feel about your motherland? And how does it influence your design sense/style?

Overall, I think Koreans are very intelligent and passionate which is one of the main reasons why Korea has not remained still but changing endlessly. Sometimes fast-paced cultural movements has put a lot of pressure on the designers in Korea. Without great passion and energy it is hard to survive as a designer here. Jesus!

Which creative catches your attention the most recently? Why?

DJing+Performance: I would like to work on a complete art project that includes visual and sound.

What is the most exciting/impressive work of others you find lately? Why?

Japanese artist Murakami Takashi. He is currently working with Louis Vuitton and I think he is having a great time doing it, and that is also the path that I would like to take. I think Takashi is probably having the most fun because of Andy Warhol.

Please tell us one thing about yourself that people don't know yet.

I am still single.

What are your plans for the future?

I plan to open my shop in the very near future, and in the long run, I would like to start a business that combines art/design and charity.

If you weren't a designer, what would you be?

Film/commercial director or a fashion photographer.

POORONI RHEE

Profile:

Pooroni Rhee was born in Seoul and graduated from Rhode Island School of Design with a BFA in Painting in the USA. She has always been curious about the variations between images and words. Rhee has always wanted to become a visual storyteller. She works as a freelance graphic designer, illustrator and researcher in Seoul. She teaches visual narratives at Ewha Women's University, Hanyang University and Chungju University in Korea.

What made you pursue design as your profession?

It gradually happened. I studied art since I was very young and I studied painting for my degree. After college I started working at a very big broadcasting company. I realised I loved working with people, which I wasn't aware of before. I think I was seeking for a niche where I could mingle with people and do this and that of the visual stuff outside the white cube.

What are your inspirations?

A lot of things. I was obsessed with biology and supernatural phenomenons as a kid, and those impressions are still vivid and keep coming back to me. Art, exhibitions, movies, stories and everyday oddities also stimulate me a lot.

What's your biggest challenge to date? Why and how did you overcome it?

My biggest challenge is to wake up early in the morning. I am a night owl. I have been working on it with many alarms to train my willpower.

What project/work of yours you find the most memorable? Why?

Every project is memorable and special but the most memorable would be the most recent work. Since last year, I worked on the new Korean passport design for the designated competition under my professor, Suzung Kim's direction. We were a perfect team, and we ended up winning the competition.

It meant a lot as it is a very open project to the general public. We had to do a lot of visual researches, from the visual history of Korea to museum studies and even various printing techniques. Due to the nature of the project, the conceptual decision making process required a lot of careful considerations and critical thinking.

You switched from journalism to design. Why was the transition?

I guess both my work at Korean Broadcasting Systems and as a guest reporter for a design magazine can be loosely categorised as journalism. The first job was a side thing to make money while I was doing studio work on my own. The magazine job was interesting because I didn't know much about the design world, and I got to learn a lot from getting in touch with a lot of information. They were all very meaningful, but my real pursuit has always been creating visuals.

When and how did you realise that visual storytelling is your niche?

I am linguistically challenged. No matter how much I love reading stories, I was never good at story-telling. I tried to write different stories as well, they were horrid. But visually I think I do it a little bit better. I think there are different ways to go about for communicating. My methodology is storytelling. I work better when I reflect the project on fictional stories and apply narrative approaches because it makes everything more concrete, clear and magical for me.

What story would you like to tell us through your works that you haven't yet?

I am working on stories on cities as natural habitats, and colours also. For my personal amusement, I would like to make works on geology. But for design projects, I am open to anything.

You explored the relationship between design and art. Please tell us more about it.

Well just because art and design seem so divided especially in Korea. They are clearly very different but with a lot of similarities. Because I am kind of in the twilight zone, I am interested in observing the interactions of both. I think you grow up thinking they are not that different and you are educated that they are very different, but maybe it should be the other way around, I feel that there are often many over simplifications surrounding the subject, with institutional, bureaucratic and political motives, I like flexibility in divisions and categories.

What are your views of the Asia's design scene? What are your expectations for it?

I don't have that big of a clear perspective, but I think there is a high level of energy going on right now. I feel like it is an exciting time for young designers in Korea and it is going through the post-industrial transit period. The general public are more appreciative of art and design, they are forced in a way, so there are many opportunities if you seek out, and I feel like just a lot could happen, but it is happening at a cut-throat pace.

JONATHAN SEOW
WOODS & WOODS

How do you feel about your motherland? And how does it influence your design sense/style?

I grew up and lived in the Middle East and the US, and I am a mixture of different cultures and habits. People in Korea say the things I make are atypical of Korean designs, but I think from my mannerisms there is Koreanness there definitely, but it is a hard thing to pinpoint. From decision makings to the surroundings, it is all Korean. I think my adoption of the Western approach mixed with the Korean folkness (erratic, rough, eerily canonical and flashy) is essentially reflective of contemporary Korea.

Which creative catches your attention the most recently? why? what is the most exciting/impressive work of others you find lately? Why?

Recently I encountered a book on Saul Steinberg at a friend's studio and a lot of his works are so complete and elegant, I was mesmerised. Also I read Calvino's 'Baron on the Tree' recently and I felt like that was the written version of the works I would like to make.

Please tell us one thing about yourself that people don't know yet.

I don't know. People think I am very chaotic but I am much more organised and I am like a librarian in my heart.

What are your future plans?

Work, gather, make, write, present and teach. I had an exhibition in Switzerland in May. I have plans on writing a few papers and presenting them. I am also a part of a small group of people that gather, make T-shirts, exhibit and party. I would like to contribute more and create a meeting point and a web-journal/blog that share knowledge and insights available in English among designers and the public. I would also like to finish my doctoral thesis.

If you weren't a designer, what would you be?

I was always into biology and ecology, so I often fantasise about becoming a scientist even to this date but I never liked doing experiments and recording data. I think I would still be making visual things, maybe paintings or textiles.

...

Profile:

...

Born in 1977, Singapore, Jonathan Seow established WOODS & WOODS in 2001. He has been presenting his collections on the official calendar of the Paris Fashion Week since Spring/Summer 2005. During the recent years, he was 1 of the 5 winners for the 'Who's Next Concour Jeune Createur' in Paris and 2nd Best Collection and Best Menswear at '12th MittelModa Fashion Awards' organised by Camera Moda Nazionale Italiano.

...

What made you pursue design as your profession?

I started designing my own collections because I needed somewhere to input my ideas and thoughts about fashion back here at a time where 'thought-fashion' does not exist.

What are your inspirations?

I do not like to interpret fashion as in only reflecting trends. Sometimes I also like to think of it as a tool to reflect my discomfort about the development of humanity. That is probably why I always think of a person and his surrounding, rather than clothes that merely look like a by-product of a design work. I design clothes that revolve around a human form and his/her social activities, this is my visual language.

Thus the end result is a collection based on generic clothing worn by people daily. I cannot deny my first encounter with fashion is in the making. During college, I am always bothering on tailoring and different ways to cut the same piece of garment. Therefore I have earned a keen eye in construction and finishing a garment... something that I am still learning everyday. I see fashion as clothes that reflect a certain attitude, a current state of mind, armed with historical context, a crafty introspection, novelty and above all, it is sustained by a body of works that is progressive.

What's your biggest challenge to date? Why and how did you overcome it?

The biggest challenge is to pursue fashion design as a sustainable career in Singapore. Fashion is not a natural profession here, due to its non-existence. To be in the creative circle in Singapore, one feels the constant duty to fight and uphold its belief and ethics, thus it's a far cry from building a profitable career. The reason being, you always have to constantly justify what you are doing. Singapore has a lack of skillful manufacturers and public funding for fashion designers is low, especially it is not accepted as part of the arts and cultural development.

The way we understood fashion is still quite in the 80s, though the facet changes constantly, the lack of good content is evident. Simply Singapore does not have the kind of infrastructure to sustain and build a good fashion label, it is more of a market place. This is something that I am still and will constantly be fighting with.

What project/work of yours you find the most memorable? Why?

We see WOODS & WOODS as a project in itself. It's enriching as we are given the freedom to build a body of work based on our beliefs that may have inspired a few.

Why did you drop out of Fashion College in Singapore?

Back in 1995, the fact that fashion studies in Singapore was at its infancy stage and from a personal viewpoint, I constantly felt they were imparting wrong values in fashion designers. I couldn't put into words why, but at that time I knew it's not what I want to pursue.

Why the name WOODS & WOODS?

We like how it looks on the back of a garment. The classic connotation and its anti-design sounding bring out a certain sense of modesty.

Monochrome colours and details drive WOODS & WOODS. Is there a special reason why?

There isn't any particular reason why, but I guess unconsciously the monochrome colours may have helped me to pave out a more contemporary approach that I feel natural with.

Please tell us about your 'Studio Prive' co-project supported by the DesignSingapore council. How did it come about, etc.

The 'Studio Privé' project is a 15-month long support program for new designers who wish to refine their signature style for the development of their own fashion label. The project started together with the opening of the Studio Privé Showroom at No.2a Haji Lane, where it housed and launched 10 new designers to the industry.

During the 15 months, each designer presented a S/S 07 and A/W 07-08 collection in conjunction with 2 major design events in Singapore: SuperStyle-Mix by Motorola and The 2nd Singapore Design Biennale.

A production-line project consisting of 7 styles of knit-garment is also being produced under a collective label – 'NUMBER 1,' which was also launched during the Singapore Design Biennale at the UTTERUBBISH show.

Currently 'Studio Privé' is an independent project founded by WOODS & WOODS, co-supported by DesignSingapore Council, with project partners include Por Avion Studio and 2Manydesigners & Publicist – SinKid PR.

If you can change one thing about the Singaporean fashion scene, what would it be and why?

I hope to get rid of the narrow-mindedness and inject a broad-based mentality for the scene. Given this, the other pieces will fall into place.

What are your views of the Asia's design scene? What are your expectations for it?

I feel that Asia's design scene is evolving very fast, which in itself is both its strength and weakness. The fast pace made fashion so disposable that consumers are less willing to pay for an exclusively-made product.

Asia is known to be more of a market place and a manufacturing hub as opposed to producing original design concepts and ideas behind those finished works. We must be able to ride on technology and manpower, not only using it in favour for the growth of the economy but also for constant creation.

How do you feel about your motherland, Singapore? And how does it influence your design sense/style?

I feel close to Singapore since my family and friends are residing here. It is mainly sentimental values as opposed to others. It hardly influences my design sense or style. Like I've mentioned fashion is non-existent here, at least not what I think fashion should be, which sometimes makes myself feel what we are doing is unreal or redundant.

Which creative catches your attention the most recently? Why?

I'm really fascinated by the world of Daniel Johnston, a manic American song-writer and artist. He's great! In his world, there's only his music and drawings! For he's always keeping it real and sincere too.

Please tell us one thing about yourself that people don't know yet.

I need to take long walks in the night to unwind before falling asleep.

What are your future plans?

I don't know where this will take me, but I hope I can continue to find joy in whatever I'm doing for as long as I'm alive and kicking. For this year, we are going to create a new work for a contemporary art space/gallery, 72-13, as part of a residency scheme. We are rather grateful, as we are given the freedom to create works out of our usual context, therefore we are producing a new work installment titled 'WHERE WE AT.'

Aside from producing collections, we are also taking a role as a curator to posit fashion at various different contexts to suggest new perspectives and possibilities. It redefines the idea of a fashion show and what fashion represents today, hence 'WHERE WE AT.'

As a guest lecturer of Fashion Institute of Singapore, do you have any suggestion for your students and the overall young people, especially to those who would like to be a designer or an artist?

I guess to be constructive, I will have to advise one to go beyond making clothes. As a contemporary designer now, one needs to understand how to promote his/her works. One simply needs to deploy greater skills for the development of a label or body of works.

If you weren't a designer, what would you be? Why?

I will opt for full-time DJ/producer of electronic/tech-music, while being a part-time curator for a good cause. Why? I am a big fan of music and collector of new, used and trash vinyls.

SHING
ARGENTUM

Profile:

Argentum is a jewellery brand creatively helmed by Shing, who ardently believes in the merit of working with one's hands. She started her label, Argentum (silver in Latin), in 1994 when she quited from a jewellery firm after 3 days of deskbound drawing. The Central Saint Martins-trained artisan makes bodily adornments as extensions of one's self. She challenges the boundaries of jewellery through her constant questioning of the very medium she works in. Argentum transcends adornment, the division between the material and spiritual realms seems to fade in these ethereal collections.

Please tell us about your educational background.

I was trained in jewellery design at Central Saint Martins in London.

What made you pursue design as your profession?

I have always liked to use my hands to make things since I was a kid. So I guess it was a very natural call.

What are your inspirations?

Inspiration is a very complicated thing. I do not have specific sources of inspiration, but I am very specific about my tastes, inclinations and ideas of beauty, which give rise to my work. If I really have to put it down to something, it will probably be death, decay and the impermanence of life. I find a lot of beauty in the processes of decaying and aging. A wilted flower that is shriveled and dessicated presents to me a beauty far more intriguing than a fresh bud.

What's your biggest challenge to date? Why? And how did you overcome it?

My biggest challenge will always be the next one to come, which I am about to overcome.

Why the name 'Argentum?'

It literally means silver, in Latin, which is also my staple material.

You see jewellery as an extension of one's self. How is that so?

Jewellery brings out one's individuality more than clothes I think. You can tell a person from the kind of jewellery one chooses to wear. The details of the plot, in other words.

You said your design isn't about flaunting the size of that stone. Would you say that your design is minimal?

The philosophy behind it is minimal but the look is not. I love the play of materials, textures and patinas.

Your design oozes mystery. Is there a special reason for that?

Maybe it's because I'm a very private person?

Why are you still coming to terms with mankind's need for jewellery in the first place?

I have always held in high respect an ascetic existence. Therefore I always have questions about needs versus wants and jewellery is one of those.

What are your views of Asia's design scene? What are your expectations for it?

The design scene in Asia is definitely burgeoning and becoming more sophisticated as we get more affluent and developed, with the Japanese paving the way, in my opinion. Given enough education, exposure and exchange of ideas, Asia's design scene will be as good as any other, I'm sure.

How do you feel about your motherland? And how does it influence your design sense/style?

Singapore has been putting in great effort to foster design in the recent years, which creates wonderful opportunities for budding and veteran designers in the country. I think my design sense is still very much the same as before, but I do hope for a future of design-conscious people who appreciate the value of beautiful things.

Which creative catches your attention the most recently? Why?

Carol Christian Poell, always. She is not a fashion designer but a fashion artist whose conceptual ideas never fail to surprise or amuse me.

What is the most exciting/impressive work of others you find lately? Why?

The most impressive work to me has always been that which contributes to the society in a big way. For example, the work of His Holiness the Dalai Lama is one of the most awe-inspiring efforts of humanity.

Tell us one thing about yourself that people don't know yet.

I have a phobia for butterflies and moths.

If you weren't a designer, what would you be? Why?

A taxidermist. Death, decay and the impermanence of life.

JO SOH
HANSEL

Profile:

Designer Jo Soh's womenswear label, hansel, blends playfulness and minimalism in her unique take on retro-inspired styles. Her signature love for juxtaposing strong and subtle shades has garnered accolades since hansel's impressive debut at Mercedes Australian Fashion Week in November 2003. The Sydney Morning Herald praised the label for being 'ultra modern and fresh' and influential design magazine, Wallpaper, endorsed hansel as a hot brand to know on their annual 'The Secret Elite' label directory in 2007.

Please tell us about your educational background.

I graduated from Central Saint Martins College in London in 1999 with first-class BA Hons in Fashion Design with Marketing.

What made you pursue design as your profession?

I was artistically inclined since I was really really young. But when I was 12 years old, I made a conscious decision to choose pursuing design as my career direction over fine art because I strongly believed that my talents could make a positive impact on society and I felt that I could accomplish this through the design of the things that we use in our daily lives.

What are your inspirations?

I get inspirations from anything and everything around me. My imagination is very active. I don't have to physically travel for inspirations. I travel in my head.

What's your biggest challenge to date? Why? And how did you overcome it?

It has to be running a small business. I am not trained in topics such as bookeeping and accounts, but I am learning now!

What project/work of yours you find the most memorable? Why?

I recently designed the official team outfit for the disabled athletes in the Singapore contingent who competed at the ASEAN ParaGames in Korat, Thailand, in January 2008. The project was a great example showing how design can be used to create positive emotional and practical values in our lives.

You sewed haute couture garments for Tristan Webber in London. How does this experience influence your current design?

There was not any one of the experiences that influences my work today. I would say that all my experiences teach me something that would later influence me in the way I work. The experience working with Tristan exposed me to pattern drafting and sewing techniques used in couture and the organisation of fashion shows for London Fashion Week was all very exciting.

You always pull together unexpected elements. Could you give us some examples please?

For example the Spring/Summer 2007/2008 collection, I combined fashion with animation with the character Captain Cheese which appeared as a t-shirt print as well as in a short animation. The character was specially created by my New York-based artist friend Luis Cantillo and Singaporean DJ Adrian Wee. It is a super cheerful little superhero who can put smiles on people's faces!

hansel blends modernity with retro. Which of them are more inspiring and why?

I am inspired by all periods from the history of fashion, but am particularly impressed with the 1940s because they mixed bold detailing with conservative silhouettes and garment styles. I like the contrast.

You really enjoyed your one time stint as a pre-school art teacher. Would you like to share with us?

It was an eye-opening experience to work with young children. I taught children from the ages of 2 all the way to 12. Children are certainly very inspirational and they can teach adults a lot about human behaviour if adults are open enough to learn from them!

If you can change one thing about the Singaporean fashion scene, what would that be, and why?

Promote self-confidence and individualism. That would lead to a more interesting dressing style among the average person on the street and thus lead to more vibrant street style in Singapore. Singaporeans tend to move in herds.

What are your views of the Asia's design scene? What are your expectations for it?

Asia is really stepping up in the design world! There is a proliferation of amazing talents.

How do you feel about your motherland? And how does it influence your design sense/style?

My motherland? Sounds vaguely communistic! Singapore is my homeland. Singapore is a nation built on immigrants. I have been

SANGYOUNG SUH

living in both Singapore and London and I am a contemporary blend of Eastern and Western cultures. I believe this influences my work on a subtle level.

Which creative catches your attention the most recently? Why?

Andrew Holder's artwork.

What is the most exciting/impressive work of others you find lately? Why?

Also Andrew Holder's.

What are your future plans?

My plans for hansel include setting up our own online shop, plus bringing hansel to other markets such as the USA. etc.

If you weren't a designer, what would you be? Why?

A pilot! It's my childhood ambition.

Profile:

Educated and trained in Paris, fashion designer Suh Sangyoung is known as the maverick in the Korean fashion world. The technology-savvy Suh presented his 'Field & Air' collection online, which was the talk of the town. He thinks that graphics is very effective in conveying the concept of his clothes to people. To him, models should be shown as objects in collections just like any other elements, such as accessories.

What made you pursue design as your profession?

As a child, I always thought that making something on my own would bring a great deal of happiness. I've had a lot of interests in a lot of things, but the only thing I have actually felt like making is clothes.

What are your inspirations?

People.

What's your biggest challenge to date? Why and how did you overcome it?

Probably the time I spent in Paris. While studying and working in Paris, I've met a lot of people who gave me a great deal of help and support.

What project/work of yours you find the most memorable? Why?

I always tend to have the greatest attachment to my latest collection. There's no specific reason. It's just that I feel like my latest work best depicts the 'latest me.'

Your design has morphed from wearable to avant-garde over the past few years. What caused this transition?

I can't agree with the statement that my works have morphed. I have to say that I was just being true to the senses I felt and the circumstances that were surrounding me during each particular moment.

Tell us about your 08 Spring/Summer collection. Is it a continuation of Framed (07/08 Autumn/Winter)? If so, how?

It isn't necessarily the continuation of Framed (07/08 Autumn/Winter) collection. When I first began preparing for 08 S/S 'Ornament,' I wanted to express minimalism to a great extent in this particular collection. It can differ a lot from the very definition of 'Ornament' or what the dictionary says about it, but I wanted to make things that were 'ornamental' with the least things as possible.

KEIICHI TANAAMI

Your fashion collection is often embellished with graphics. Does it worry you that the viewers' attention will be drawn to the graphics more than the clothes?

In some cases, graphical factors can be used very effectively in conveying the concept directly to the public. It's true that I've been interested in that particular area during my few recent collections.

The faces of your models are often obscured. Is there a special reason why?

Generally, I think models should be shown as objects in collections just like any other items, such as clothing, accessories, etc.

What are your views of the Asia's design scene? What are your expectations for it?

I think it's time for more exchanges. In fact, I know very little about this category, though I'm talking about it at the same time. It may sound a little obscure, but I wish we could have more opportunities, such as this project, where we can communicate with each other.

How do you feel about your motherland? And how does it influence your design sense/style?

Whether I accept it or not, the background that surrounds me will have a significant impact on my work.

What are your future plans?

To live happily with my family and friends.

If you weren't a designer, what would you be?

Not sure.

..
Profile:
..

Born in 1936, Keiichi Tanaami's paintings, illustrations and graphic designs have been taking people into psychedelic ecstasy since the 60s. His work is characterised by a vibrant use of colours and his favourite subjects like goldfish, pine trees and waves. Recently, he has collaborated with an Indian fashion designer, Manish Arora.

..

Would you call yourself an artist or a designer or both? Why?

I need to release myself from all the constraints and express freely. On the other hand, I also like working hard to the utmost limit within constraints. An artist or a designer, I have no preference, though lately people often call me an artist.

Are you comfortable with the title 'psychedelic master'?

I don't care about the title.

When and how did you find your interest and potential in art/design?

I started thinking about design after I was inspired by the subculture such as the comics by Osamu Tezuka which I read in my childhood; the short animation films by Disney and Fleischer Brothers; American western or marine swashbuckler B-movies; and illustrations from boys' magazines. I can't forget how much I was affected by films when I was a teenager, especially those by Fellini, Godard, Visconti, Chaplin, and Howard Hawks.

What inspires you to create?

Very trivial things. For example, a murder scene photograph of a crime case in a newspaper, some graffiti on the wall, one line in a novel, or one frame of a comic. Lately, I got inspirations from a bakery showcase.

You broke into the design scene in the 60s. Do you find it affects your style of work and how has your style evolved since?

The 60s was a special period for me. It was the time when lots of people with strong characters blossomed simultaneously, such as Shuji Terayama, Tatsumi Hijikata (dancer), and Nagisa Oshima (director). I was young and immersed myself in the 60s. Things changed too rapidly to stand still at that time. I should say it was really 'the physical period.' I think most of my works burgeoned at that time.

Did your early work experience at Hakuhodo affect the development of your design career and motto? How?

I worked there only for 2 years after graduating from art college, so I don't remember very much. I think I focused on learning the business rules.

Goldfish and pine trees feature prominently in your works. Is there a special reason why?

I grew up watching goldfish and roundfish swimming in the fishtank and aquarium everyday as my grandfather liked fish. During the wartime, the light of a flare bomb dropped by an American plane shone in the reflection of a goldfish in the aquarium. I can't forget that image. I took the drowned fish out of the fishtank, and crushed it in my hand. I still remember that feeling clearly.

When I was in the hospital because of peritonitis, the medicine I took produced side effects and I was delirious with high fever. During the hospital stay, the pine trees out of the window left a strong impression on me. The shape of the trees was crooked like Dali's clock. I think the strange shapes of trees became my design motif later.

Over these years, what project/work of yours you find the most unforgettable? Why?

Nothing particular, but each upcoming project is always the most important.

Your work has covered various fields including graphic design, editorial design, animation, experimental film, painting, printing, dimensions, etc., and you have been especially active in the field of animation and film; do you find it better to present the concept of your work? Why?

The most important thing among my design fields is to 'move.' Even on a canvas, I try to draw one moment of movement like a still image. It's like I select one frame from a motion picture, and see it as a stop motion. I can use music and time freely on animation, so it may be the perfect tool to draw movement, which is what I want to achieve.

Please tell us about your frequent collaborations with Naohiro Ukawa. Any fun stories to share?

When we held an exhibition together at Kirin Plaza in Osaka, we made a dummy of Tanaami doing DJ suggested by Ukawa. It was fun. The process was, first I needed to put my face

into the thick green liquid with my eyes wide open for more than a minute, and the liquid slowly came to set. Then we encased it in plaster. However, it was not easy to keep my eyes opened in the liquid. Besides, 1 minute was longer than I expected and it was painful. At length, Ukawa held my head tight and the dummy was successfully made at the end. I think it's still displayed in Ukawa's house.

Please tell us about your recent collaboration with six fashion designers including GUCCI and MIU MIU for Wallpaper.

It was one of the most exciting artworks I've done recently. Wallpaper left it entirely up to me, such as selecting designers and costumes, layout, and using graphics only instead of pictures. They gave attention to details, about how to show the costumes and texture, so I'm happy with the results. That job then led me to design the cover of their special issue. I'm content with what I've done.

Do you find the increase of international collaborations, exhibitions and broadcast in any ways affect your work? How?

When I look at the artworks, I've never thought about where the artist is from, or whether the artist is a man or woman. Rather, I'm comfortable to show my works in foreign countries as people see my works keeping an open mind.

What's your future plan?

I will hold several personal exhibitions, one in Shanghai (8–14 September) titled 'Large Flat Surface and Solid' and other two in Rahman Gallery Berlin and Nanzuka Underground Tokyo by the end of 2008. On the editorial front, I'm preparing an art book that collects all my works. It'll be published by PictureBox Inc. in New York.

Who on the creative scene in Asia catches your attention the most recently? Why?

The Indian designer Manish Arora whom I collaborated with for the Paris Collection. Though I don't look into women's apparel much, his clothes are something you cannot forget once you see them. It's more art than fashion.

What is the most exciting/impressive work of others you find lately? Why?

Works by the German painter, Neo Rauch. It's like a picture from a crime novel. The drama which involves complex characters and landscapes never makes me tired. Looking at his works, I realise what power great artwork has.

How do you feel about your motherland, Japan? And how does it influence your design sense?

There are lots of excellent artists around the world. However my most favorite artists are those from the Edo period like Shohaku Soga and Jakuchu Ito. They're painters of marked individuality, and known for their bizarre and unique drawings. Unfortunately, they haven't really established much of a name or public recognition, but I'm sure they will sooner or later. I'm not conscious of being born in Japan, but I'm glad to be so close to such excellent forerunners.

You are internationally renowned; do you see yourself as a mover or a shaker on the Japanese creative front? How so?

If anything, I think I'm a shaker. It's rather healthy as an artist, isn't it? Though I'm not confident whether I can play the role well.

What would you like to do most if not working on the graphic arts scene?

Something related to music, like a composer.

As a professor of Kyoto University of Art and Design, do you have any advice for your students and the overall young people, especially to those who would like to be designers or an artists?

You should assess what you want to do and which direction you want to go. Otherwise, you can't get good results, no matter how hard you try to do your best.

PAKKANAT TANPRAYOON

2MAGZINE

What made you pursue design as your profession?

Design makes me happy. It always does, ever since I was very young.

What are your inspirations?

I draw inspiration from everything.

What's your biggest challenge to date? Why and how did you overcome it?

Every new project presents its own challenges. It's a never ending process of learning and growth and there's still a long way to go.

What project/work of yours you find the most memorable? Why?

I found doing the astrology calendar for LYN shoes where we created astrological symbols by digital manipulation of the stock pictures was interesting. It was a big challenge to try and recombine the shapes in ways that were creative and true to both the product and the symbol I was trying to create.

How does 2magazine distinguish itself from other international men's fashion mags?

We have a very edgy aesthetic. I think we have more artistic and creative license than other international magazines which have to conform to a set standard.

How has the mag evolved since its first issue?

The magazine is mature, it has grown in a great deal. We've become bigger, our content has increased and the magazine has also become more disciplined in its focus.

Thai men's fashion is colourful and has an eye for details. What's your dressing style then?

T-shirts, jeans and sneakers.

If you can change one thing about the Thai fashion design scene, what would it be?

There are too many impostors around.

What are your views of the Asia's design scene? What are your expectations for it?

I'm not sure if there is an 'Asian design scene.' I think every designer, whether Asian, European or American, has their own style regardless of nationality.

How do you feel about your motherland? And how does it influence your design sense/style?

Thailand is a country with strong traditions and cultures, but I'm not sure if it affects my work. As a commercial designer, I work from a brief and the most important thing is to follow the brief.

Which creative catches your attention the most recently? Why?

Steven Klein's photography. Go and look at some of his pictures and you'll see why.

What is the most exciting/impressive work of others you find lately? Why?

There are so many good designers I've collaborated with and what I like about them is that they all have their own style.

What are your future plans?

To set up my own design company.

Profile:

Tanprayoon is the art director of 2magazine. Established in 2005, 2magazine provides their readers a lifestyle and fashion magazine in English with an international outlook. It focuses on the interests of modern man with a vast range of contents including witty and sharp reportage. Featured topics stretch from dining to technology, books to travel.

ASAO TOKOLO

Would you call yourself an artist or a designer or both? Why?

Both, though I don't want to define myself at this moment.

We understand you first studied at Tokyo Zokei University in Japan. What made you choose Architectural Association – AA School in London in the mid-way for your design education?

Actually I studied architecture at Tokyo Zokei University as well. Also because my father who is an architect, I was interested in architecture since my childhood. When I was a university student, I read a book of AA publications for the first time and found a drawing by Shin Egashira which had a huge impact on me. That's why I wanted to learn at AA School.

What did you study in AA?

The potential of architecture; to use explicit criteria on design and planning; to have doubts about established things.

You were once an assistant to architect Shin Egashira. When and how did you find yourself interested in patterns?

Since September 11th, 2001. There were no specific reasons, it kind of happened automatically.

Has your architectural background affected the design you are doing now? How?

Rather than saying 'affected,' I'd say it's the 'core' of my design.

What inspires you to create?

Daily life. Sometimes my thoughts get off the track when I work, but I can manage to take care of those detailed thoughts.

Tell us about your latest pattern design for Issey Miyake's 'Pleats Please.' What led to this collaboration?

I met Hikaru Matsumura, a designer of Pleats Please at Musashino Art University, as he was also a teacher of the class next door. Naturally, he invited me to the project. I was happy to join as I like Bilbao Bag by Issey Miyake.

Your graphics have adorned shirts, wallpapers, interiors, car seats, stationery, etc. What is your future plan?

To make a book of my work; to run exhibitions outside Japan; to design jewellery, and lots...

What project/work of yours you find the most memorable? Why?

A board game called 'colo.' That is the first work I created after I made up my mind to be a designer. No one knows about it except my friends at that time. I'd like to show it to the public some day.

Who on the creative scene in Asia catches your attention the most recently? Why?

Xu Bing. I think his works have a presence, and it's already become a part of the art history. I'm totally blown away.

What is the most exciting/impressive work of others you find lately? Why?

Hechima, the works by Ryuji Nakamura. The structure is really beautiful.

How do you feel about the design industry in Asia and what are your expectations towards it?

I feel sad every time I hear the news related to copyrights. Hopefully they'll be something of the past as soon as possible.

How do you feel about your motherland, Japan? And how does it influence your design sense?

Lately I'm interested in the Japanese culture that consists of different cultures. I think I've been inspired by the traditional culture such as the family emblem and arabesque design.

What would you like to do most if not designing, other than architectural and pattern design?

Travelling.

You are now teaching at Musashino Art University, Tokyo, what is it about?

To make wearable things; to search for the basis of 'making;' and to think how to think.

Now there are many youths who want to become a designer, what advice would you give them?

Let us have fun!

Profile:

Artist Asao Tokolo is the director of TOKOLO.com. Born in 1969 in Tokyo, he graduated from Tokyo Zokei University in 1992 and AA School, London in 1993. Tokolo then worked in M. TOKORO architect and associates. He assisted renowned architect Shin Egashira in the following years between 1995 and 1999. Tokolo has been teaching display and fashion design at Musashino Art University, Tokyo, since 2003.

ISSARIYA VIRAJSILP & NUTTAWAT SUTHAPONG
INSPIRED BY INNER COMPLEXITY

What made you pursue design as your profession?

I (Also called Riya): I wanted to compose human figures as an art medium.

N (Also called Tae): I wanted to express my inner creativity and make it real.

What are your inspirations?

R: Initially, all came from the Holy Bible, and God led me to relate it with something else.

T: People and emotions.

What's your biggest challenge to date? Why and how did you overcome it?

R: To survive as a conceptual designer by focusing on what I have passion for and have faith in.

T: At the moment, the biggest challenge for our brand is to make Thai people understand our design concepts and fit them into their lifestyle. Most of the Thai people don't understand fashion in terms of conceptual design. They don't see clothes as art piece and pay attention to the stories behind before they turn into garments and being hung on the racks at stores. However, we are trying to educate our customers by accessing all the media channels, and make it easier for them to understand without losing our identity.

What project/work of yours you find the most memorable? Why?

R: 'Requiem Mass.' It taught me the process of what is so-called 'experimental art' in the realm of fashion design.

T: I like all the work that we have done. But the show of young designers for ELLE fashion week is the most memorable for me because it's my first show as a professional. It might not be the best one but it gave me a power to work in this business.

Thanks to the reality show 'Project Runway,' Parsons is even more desirable for aspiring designers. How did you find the school? Were the reins on your creative freedom tight or...?

R: I found it challenging when I read the criterias of how to get in. Fortunately, the school let me explore my conceptual art horizon.

T: It helped me in terms of my thinking process along with the ability to face the reality.

Riya, you said that New York changed you. How so?

I would give all the credits to my professors who let me do what I really wanted no matter how hard it could get into the final design. I was also able to absorb the beauty of art during my studies in New York!

Tae, how do you find the experience studying and living in New York then?

I could say New York changed me a lot. For 4 years that I lived there, I've done things that I've never done in Thailand before. It makes me stronger and opens my eyes to the real world. Parsons is not the only school where I gained knowledge, and NYC means even more than a school to learn the way of living.

Why the name Inspired by Inner Complexity?

R: I want a name which can speak for itself. I also believe that whoever you are or whatever you do, you are all inspired by inner complexity!

Who are your collections designed for?

The main audience that we are designing for is everyone who loves himself/herself; who has a strong character and attitude; and who thinks outside the box.

You are drawn to great themes such as religion and classical music especially songs from Mozart. Is there a special reason why?

R: God leads me to analyse the mystery of the Bible. Such interpretation also leads me to make related things. For example, Mozart's collection 'Requiem mass,' where the message behind was linked with how sinful acts can ruin one's life.

If you can change one thing about the Thai fashion scene, what would it be and why?

R: To widen the perspective of the meaning of making clothing.

T: I would change those who see fashion as circus shows.

What are your views of the Asia's design scene? What are your expectations for it?

R: It becomes bigger and bigger, I hope one day Bangkok would be one of the hot spots in the world's fashion industry.

Profile:

Inspired by Inner Complexity is founded by Nuttawat Suthapong and Issariya Virajsilp who both graduated from Parsons School of Design. Citing Mozart and the Bible as her inspirations, Virajsilp was featured in ELLE Thailand as one of its 'Young Designers' in 2004. Their collections are famed for its edginess and thought-provoking titles such as 'The Day of God's Wrath' and 'Requiem Mass.'

WABISABI

RYOHEI WABI KUDO & KAZUSHI SABI NAKANISHI

T: The new generation of young designers are more importantly influenced by the Asian fashion scene nowadays. Therefore, it's more fun to see Asian fashion move forward.

How do you feel about your motherland? And how does it influence your design sense/style?

R: I love my King! To be born in Thailand, I'm not sure what have influenced me but deep down I know there are something hidden in my instinct.

Which creative catches your attention the most recently? Why?

R: I'm exploring the interpretation of 'vanity' in life according to a chapter in the Bible. I also get into the Hebrew sound and try to transform it into clothing patterns.

What is the most exciting/impressive work of others you find lately? Why?

R: Undercover.

T: Undercover and Preen, I think both of them are totally different in terms of style and direction, but they always create something new for the fashion world.

What are your future plans?

R: Go with the flow, I might expand my line somewhere in Europe or Japan.

T: To make the name of 'Inspired by Inner Complexity' known as the front line in the world fashion business.

If you weren't a designer, what would you be? Why?

R: I would be nothing!! Because I believe that God made me to be a designer! I have my task to tell the story of how amazing the miracles in the Bible are. It motivates me to create my work as a conceptual designer. I devote myself to study it as my passion. Money is not my priority. I hope my audience would get something out of my work when they see my show. I accept that my collection is somehow hard to understand, but if you see it deeply, you'll get my message behind my designs.

T: If I weren't a designer, I would be a merchandiser because it's something that I studied and wanted to try.

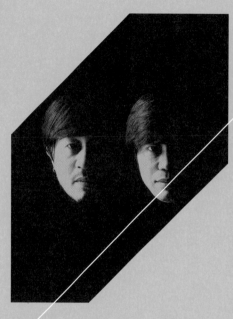

Profile:

...

The design studio named itself after 'Wabisabi,' a Japanese aesthetic about finding beauty in imperfection. Wabisabi comprises creative director Wabi and art director Sabi, who established the studio to create what they really want. The awards they have won over the years include New York The Art Directors' Club awards and International Poster Triennial in Toyama.

...

Why the name 'Wabisabi?'

We're impressed by the word 'Wabi-sabi,' a comprehensive Japanese aesthetic, so we named ourselves after that. Also, we don't think 'Wabi-sabi' can be found only in Japan. It's about finding beauty within something imperfect or incomplete, so we think 'Wabi-sabi' is everywhere in the world.

What made you pursue design as your profession?

After graduating from different design schools, we were employed by the same design company. We've known each other since then.

Please tell us about your educational background.

Ryohey 'wabi' Kudow studied design at Hokkaido College of Art and Design, and Kazushi 'sabi' Nakanishi at Hokkaido Designer Institute.

Where do you get your inspirations?

Everything in our daily life.

How did the Wabisabi story begin?

After leaving the same design company, we got an opportunity to work together on an apparel building advertisement. At that time, Wabi was an art director at an agency, and Sabi was a production designer. Wabisabi started after that project. We want to create what we really want, regardless of the client requests.

What's the scale of your company now? What scale do you target to have?

Wabi is a creative director/art director/director, and Sabi is an art director/director. We also have 6 designers and a copy writer. We think the current scale is an ideal working condition.

Your work is down to earth. Is it deliberate or...?

This is our favourite style. We don't complete design consciously, and try to leave some afterglow. Maybe that's what gives people a down-to-earth impression.

Your portraits ooze warmth. Have they always been like that?

Thank you very much. Yes, it hasn't changed since we started.

You are relatively new on the environmental design scene. Would you like to explore it further?

As a lifework, yes. Keeping our way of working, and of course we like constant challenge of something new.

What was/is the biggest challenge to date? Why and how did you overcome it?

To turn our personal works into money. We don't start to design after receiving requests from clients, but firstly to complete our works and then visit a company to sell them. Therefore, we need to consider how to present our works to the clients and to find a solution to establish them as advertisements.

Which project/work of yours do you find the most unforgettable? Why?

A print work called Flesh and Blood. It's a typography work using our original font Hormon. We think we have achieved the integration of characters and visuals in this piece.

How do you describe your design style?

'Wabi-sabi.' Based on the aesthetic concept established in the Japanese tea culture, our aim is to create something that is profound and accomplished when viewers see it with their own imagination.

What other design scenes would you like to explore in the future?

We would like to challenge different fields. Actually we're working on a clothing project and a website project. We're also interested in product design.

Who on the design front in Asia catches your attention the most recently?

Japanese designer Masayoshi Nakajo.

What is the most exciting/impressive work of others you find lately? Why?

The print of Hiroshima Appeals designed by Shin Matsunaga. It's thought-provoking, and filled with energy.

How do you feel about your motherland, Japan? And how does it influence your design sense?

At first, we were inspired by European designs. However, we read The Book of Tea written by Tenshin Okakura, and realised the original aesthetic we've had traditionally. We're also surprised that the concept had huge effect on Europe around that time. We think we could learn from both European and Japanese design aesthetics because we're born and brought up in Japan.

How do you feel about the design industry in Asia and what do you expect from it?

New designs from Asian countries include China's have got a lot of attention recently. Each design from each country reflects their lives, and nobody can copy it. We believe designs in Asia will keep growing.

If you were not a designer, what would you like to be?

A musician.

YUWEI WANG
XXXL REMIXED CREATIVE FACTORY

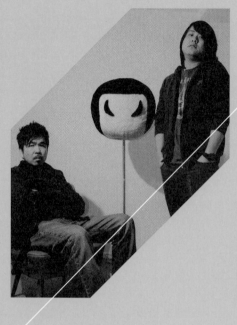

Profile:

XXXL REMIXED CREATIVE FACTORY was founded in 2007 by Lin Wenxuan, a famous Taiwanese musician, director and artist, and a well-known designer, Wang Yuwei. The company creates toys, clothing, record sleeves, etc. They insist that 'Design comes out from life; technology comes back to humanity, and the culture comes into the nature.' Their goal is to explore China's design through its traditions and to make the oriental civilisation known all over the world.

Please tell us about your educational background.

I had been learning art for more than 10 years before I studied art and design at Beijing Technology and Business University.

What made you pursue design as your profession?

I pursued design as a profession because of my uncle, who is a well-known designer specialising in wine packaging. At that time, design was hot on China's art scene.

Where do you get your inspirations?

I get inspirations from movies, books and friends.

'UPNUB' is a group you formed in 2006. What does the name stand for?

'UPNUB' means 'Unprosperous and Unbroken.' It's an idea my friends and I came up in the winter of 2006. We are planning to make a documentary and write a book about young Chinese designers. I think that 'UPNUB' fits contemporary Chinese designers like a glove. We have shot most part of China. And if everything goes according to the plan, the film will be out in June. We also plan to participate in film festivals.

What mission does 'UPNUB' have?

With the nation's fast development within the last 20 years, the population naturally began to experience all kinds of superficial prosperity. People have started to contemplate the chaos and disintegration belying our rapid development. But for the burgeoning creative industry, only top designers and studios are featured in newspapers and magazines although these designers only form part of our industry. Their power is dependent on people from other disciplines, labours working in small towns, and countless fresh graduates who are willing to devote themselves to the industry.

China's contemporary design industry has more contradictions than other fields. It is caught between the commercial and artistic planes, wanting to please both sides, which is tough. In the midst of temptation, it becomes increasingly hard for designers to differentiate between stunts and the nature of design. Practitioners' identity becomes fuzzier and fuzz-

ier, the word 'designer' has taken on a much broader meaning than before, and the lines between disciplines grow increasingly blurry.

We hope that all the designers participating in 'UPNUB' will share their experiences with us. We named it 'Unprosperous and Unbroken' because we see the excellent aspects of Chinese design, but we haven't achieved catholicity yet. Chinese design is in a state of helplessness. Despite that, idealism and creativity are still alive and kicking. We don't expect 'UPNUB' to solve this problem, but we really hope it can lead us to the heart of the problem.

Have you always been conscious of your own cultural roots and historical context? Why?

Yes, since I was born in the 80s. To be honest with you, our generation isn't really aware of China's traditions. Instead, we are chasing after new stuff and don't ponder the past.

Do you see yourself as a mover and a shaker in the Chinese design industry? How so?

I don't see myself as a mover nor a shaker since there are a lot of people out there who are similiar to me. What I'm doing is bringing together friends from all walks of life and do things we want to do. Somebody would always initiates it and I only initiated a few times. Chinese people have a weird mentality, they mind their own business and don't communicate. Also, they have an inferiority complex. What we want to do is to bring out the team player in our peers.

How did 'XXXL' start in 2007?

EMI has been my loyal client. I design record sleeves and come up with ideas for their artists' image. Tiger Lin, who helmed EMI at that time, came to me with the idea of setting up a workshop. He is a renowned musician who can paint well and has held exhibitions for that. Even though there's a 20-year age gap between us, we have a lot of common grounds, thus the birth of 'XXXL.'

Why the name 'XXXL?' Does it stand for anything?

Lin's nickname is 'Massive Tiger' while mine is 'King.' Two big shots added up as 'XXXL.'

The team is a combination of musician, director, artist and graphic designer, how are the advantages from this unique combination?

This is a crossover where we hope to bring together people from all walks of life. This combination gives us more opportunities and rooms for development, so that we can use a more comprehensive approach in our projects.

Your work is ornamental. Why did you choose this design style to express yourself in the first place?

My work has been ornamental since college. My animation and other works are all ornamental. I always believe that I need to come up with new ways to present my works, thus I'm always faithful to the ornamental style.

You insist that 'Design comes out from life; technology comes back to humanity; and the culture comes into nature.' Can you illustrate this using one of your submitted works?

Take my World Cup 2006 piece for Nike, which featured black, white and grey as the main colours. The piece is oriental with a modern twist. I think that the oriental style is all the rage, be it music or art.

We understand you are trying to develop a platform for Chinese toy designers, please tell us about your new toy 'I.'

I did 'I' in 2005, it was my MSN typeface back then. In 2006 it branched out into toys, mobile games, music, and MV. We even plan to collaborate with record companies to produce a simulating artist based on my character design. My character has a lot of MSN expressions and we have taken lots of photos of it, which is fun.

Thanks to our platform, some people got interested in design and art. Many visitors share their works with others through our platform.

What is/was your biggest challenge to date? Why and how did you overcome it?

Our challenge is running 'XXXL.' We face many problems which aren't about design and style most of the time. Our ultimate challenge is communications. I think that we'll overcome the obstacles by getting to know each other better. I think that whenever there's a will, there's a way.

What project/work of yours you find the most memorable? Why?

I find many of my works memorable. I spent one month on an installation project for AF1. At that time, we lived in the Beijing sub-urb. It was refreshing as it is different from working at our computers.

What's the scale of your company now? What scale do you target to have?

We have five full-time staff. Our animation and interactive media staff work at home. Our goal is to realise all our plans.

Your work ranges from video to toys, fashion to packaging to exhibition, what are your future plans?

We would like to morphe into a design agency and act as the bridge between corporations and creatives. Chinese designers tend to focus on their work rather than communications. I have learnt to pay more attention to interpersonal relationships from my record company days.

What other artist/designer in the same field as yours in Asia that catches your attention the most recently?

Ikko Tanaka, my uncle's ex-teacher. He's the only designer I've heard of when I was a kid and I've been influenced by him ever since.

What is the most exciting/impressive work of others you find lately? Why?

Macbook air. Its design is simple, convenient and delicate. Apple's design always catches people off guard.

How do you feel about Asia's design industry and what are your expectations towards it?

Asia's design industry is great, Japan and Singapore in particular. I want it to get better and better.

How do you feel about your motherland, China? And how does it influence your design sense?

The Chinese style can be described as multinational, it consists of numerous styles. The Chinese style hasn't emerged yet. Designers, including myself, need to study oriental elements. China has a great influence on my design sense since we are catering for the Chinese market. When we collaborate with international brands, we need to localise our designs, thus we need to be influenced by our motherland.

Any words for the aspiring designers/artists?

I hope they can persist in pursuing their dreams.

If you were not a designer, what would you like to be?

If I weren't a designer, I would like to open a restaurant or a bookstore since they provide nutrients for our bodies and souls.

KAY WONG & JING WONG

DAYDREAM NATION

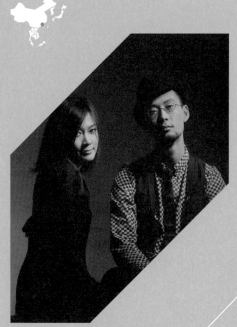

Profile:

Daydream Nation is a fashion label that loves storytelling. Theatre is the platform where the garments transcend from the everyday into the otherworldly. The brother-sister design duo are degree graduates from the Central Saint Martins College of Art, UK. While sister Kay Wong is master in Constructed Textiles at Royal College of Art, UK, brother Jing Wong is master in Theatre Directing at Central School of Speech and Drama, UK. Daydream Nation is an attitude. It is a way of life in which people sees boats in buckets and hears sea waves in radio glitches.

Please tell us about your educational background.

K: Central Saint Martins College of Art and Design, BA Printed Textiles, Royal College of Art, MA Constructed Textiles.

J: Central Saint Martins College of Art and Design, BA Theatre Design, Central School of Speech and Drama, MA Theatre Directing.

What made you two pursue design as your profession?

Design is the only profession we can turn silliness into gold, to work as an alchemist who transforms the ordinary into fantasy.

Kay, when and how did you and your brother, Jing Wong, get the idea of forming Daydream Nation?

I was doing my own label, Kay, two years ago when Jing was finishing his MA in Directing. I have always wanted to collaborate with Jing and we both thought crossing theatre into fashion is a rare but surprisingly compatible marriage. The idea of Daydream Nation however, came from our mutual feeling, that the society has a certain 'racism' against daydreamers, so we think it's our mission to protect and encourage daydreamers to carry on dreaming.

Why the name 'Daydream Nation?'

We were inspired by the album name of Sonic Youth, 'Daydream Nation.' Jing thought it is appropriate because we are in a metaphorical sense, creating our own Nation, drawing our own map on an uncharted territory.

How does Daydream Nation benefit from the different educational backgrounds of both of you?

Neither of us studied fashion. This freed us from all usual existing methods of garment making. We don't know, so we find out our own ways. Kay's background makes her interested in creating textures with folds, while Jing tends to come up with stories and make dramatic/playable costume-like pieces.

Where do you get your inspirations?

Anywhere but the familiar. We might go for an aimless tram ride in an alien city (when we have time) hoping something would happen. And something always happens at the end. We always exchange our latest favourite book too.

In your manifesto, you wrote, 'Daydreamers are the lost children in the society.' What do you mean by that?

The society of where we live, Hong Kong, has this priority set for doctors and lawyers, who always have a superior status than to creatives. It is even worse for daydreamers who are either branded as slackers or useless people. It's almost shameful to be a creative unless you become famous. The society neglects you and dismisses you as second rate, which is so not true. The child-like mentality is so precious because the society tramples on it, when it's the only thing that keeps us sane and human.

You also wrote that 'Daydream Nation is the missing link to the poetics of life that our society is slowly neglecting,' have you always been aware of your own cultural roots and historical context?

Hong Kong is a lost city just as all other big cities, but it is even more complicated because of our colonial past. We seem to have been cut-off from our rich Chinese cultural tradition, and introduced to western culture that never grows roots. We can never be pure Chinese or British, and our only way to salvation is by creating an identity of our own. Identity is eternally linked to culture, and culture doesn't come from finance or medicine. Hong Kong urgently needs a new generation that embraces music, theatre, films, books, etc. with a passion or else, or we'll get drown in the sea of shopping malls and celebrity gossips.

What new myths have you created with your latest collection 'Good Morning, I'm Sleeping?'

To consciously live in the state of dreaming. It's about a girl struggling to stay dreaming in bed while reality forces her to wake up.

You explored the fairytale 'Alice in Wonderland' in your AW07 collection. What other fairytales/myths would you like to explore?

We are constantly inspired by fairytales, but we like to alter them into urban legends instead of telling them straight. We also like to play around with classics such as 'Three Little Pigs,' 'Bremen Town Musicians' and 'Puss and Boots.'

What is/was your biggest challenge to date? Why and how did you overcome it?

Delivery to clients who are in Europe is one of the biggest challenges to us, we are still working on it.

Second is to find the right person to work with. We've never imagined hiring a right person to do the right job is such a difficult thing in a small company like ours. We'd like to work as a team, establishing a long-term work relationship. We are learning to define a clearer line between work and friendship, which is so important in a proper work environment. I guess trust and patience are the other two keys to it as well.

What project/work of yours you find the most memorable/recognisable? Why?

'Good Morning I'm Sleeping.' Our show performed in ICA in London for the first time. ICA has always been our dream venue and being sponsored by them to perform there is our biggest dream ever. And we did it!

What are your future plans?

We need a metaphysical manifestation of Daydream Nation, in other words, a shop or an venue. We need a place to work, play, organise events and exhibitions, and sell our designs.

Who do you admire the most in the same field as yours in Asia?

Rei Kawakubo, Comme des Garcons.

What is the most exciting/impressive work of others you find lately? Why?

'Paso Doble,' a show Jing saw in London Barbican Theatre as part of the London Mime Festival. He was conceived by two Paris-based artists, Miquel Barcelo and Josef Nadj. Nadj once told Barcelo that he wanted to immerse himself into one of his pictures, not just intellectually, but physically. Their shared desire to achieve this led to 'Paso Doble,' a production which defies all categorisation or definition. The show eventually resulted in a stage and a wall of red clay being manipulated like live sculptures, and interacting in and out of it physically till the end, when nothing is left apart from images and memories, nothing remains.

How do you feel about the design industry in Asia and what are your expectations towards it?

There are a lot of potential talents in the Asian design industry. Particularly in South Korea, the creative industry is booming. Their government is pouring money into it. There are so many designers and artists. The theatre and film sector is also growing fast and rising in the international status!

We feel strongly that the Hong Kong government needs to invest more money in art, or else we will soon become a city that knows nothing other than shopping. And it's such a joke that we claim ourselves to be an Asia's World City when our society only cares about money.

How do you feel about Hong Kong? And how does it influence your design sense?

Hong Kong is a great place to fill your life with good food and materialistic goods. Hong Kong is also a great place to fill your time with entertainment that requires no effort from the participants. It is as perfect to find and spend money too. What Hong Kong lacks is time and space where people won't just sit down and do nothing, absolutely nothing. The culture of sitting down reading a book or looking at birds flying by in a park is almost absent. Hong Kong people has too much of everything, and when you have so much to lose, there is so much you don't dare to do. This is our limitation. Our desire to break from this limitation becomes our urge to create, as long as they can take us to a place where people still dream and share stories.

If you were not a designer, what would you like to be?

J: A song writer or a theatre designer.

K: To work in film or to be a teacher.

STANLEY WONG
ANOTHERMOUNTAINMAN

Profile:

Stanley Wong aka anothermountainman wears many caps such as TVC director, graphic designer, photographer, and artist. He has won more than 400 awards in graphic design and advertising at home and abroad throughout his career. His works have been exhibited in Hong Kong, England, Germany, Korea, Japan, Singapore and China. In 2005, his 'Redwhiteblue' series travelled to Venice, Italy as one of the two artworks from Hong Kong presented at the 51st Venice Biennale.

Please tell us about your educational background. What made you pursue design as your profession?

I was born in 1960. It was hard to get into college back then. When I was in Form 4, I realised I had an issue: poor memory. So I knew I couldn't get into university because I failed in chemistry and I had this feeling of 'where am I going?' Then I decided to go to Polytechnic's fashion school but my Dad objected although he was a tailor. So I enrolled into The Hong Kong Teachers' College instead and learnt to be a teacher for design and technology there. In my second academic year, I enrolled into Polytechnic's graphics night school. That's how I met Tommy Li, who later became my flatmate. However, when the school found out that I was also studying at HKIEd, they kicked me out because I failed to meet their requirement as being a full-time designer in daytime. One of my schoolmates got me my first job in graphics where I started doing boutiques' window display, graphics, etc.

In 1985, I got into an advertising agency, Modern Advertising, as their art director. I was actually not particularly keen on advertising due to its materialistic nature and office politics. But I didn't want to leave the field until I felt like I had done my best. Advertising taught me the audio-visual side that was absent in graphic design. At the beginning, I thought I would only stay there for 2 years but then it actually took me more than 15 years, working at Modern, Grey, JWT, BBH, and lastly TBWA until the year of 2000. I've always been more drawn to filming, graphics and photography than advertising. In my early days, I had worked on TV commercials throughout the years and collaborated with Tony Leung on his CD covers and Wong Kar-wai on his film posters. Thanks to the 'Redwhiteblue' series, I am also known as an artist these days. But I'm still uncomfortable to be called like that.

What are your inspirations?

There are 4 stages of drawing inspirations.

1/ Immerse yourself in your life. Hong Kongers move too fast and are too goal-oriented when it comes to money and power. I think we need to pay attention to details in the process and everything surrounding us including rubbish. I've been collecting rubbish for many years.

2/ Observe others' lives. Everyone seems to have a similar pace of life and lifestyle. It's much easier to look at things in different angles and from various perspectives. Thanks to my advertising background, I got a lot of chances to travel and got to feel the foreigners' cultures, values, lifestyles, etc.

3/ Go beyond your own profession, don't limit your vision. I felt sorry for the way that people in the advertising industry only read advertising books and graphic designers only read graphic design books. In the past 20 years I exposed myself to various creative disciplines, from film to architecture, music to fashion, and things outside the field.

4/ Try to understand the mentality/works of other unique creatives through direct contacts, exhibitions or books, with the 'Why not?' attitude of Rei Kawakubo, Comme des Garcons for example.

Why are you dubbed anothermountainman?

At the age of 33, I was already at the top of the creative pool in the Hong Kong advertising field. I worked really hard, but I wanted to do something more meaningful for life besides that and make more contribution to the society. World in peace and harmony between people and the society are always my concern. I believe in Buddhism and hence I don't avocate unhealthy conflicts. I wanted to do something about it and so I decided to continue working on visual communication, which is what I am familiar with. However, this should be done under another identity, so that it won't lead to the commercial image that I had established in the ad field.

I use the name for my non-commercial works since I really like the Chinese artist Ba Da Shanren (八大山人) from the Ming and Ching Dynasties. He loved the nature, and his creative paintings were testimonial to that. As for 'Another,' I never like to be No. 1 but No. 2 since I can have the silver lining and goals that I haven't achieved yet. The signoff was firstly used in the poster of ChungKing Express 1994.

My second identity has helped me a lot to find the true one in myself. Throughout the process, I have found my eternity too. I feel like I am being two different persons and living for two different lives. That's why I always suggest people around me to do the same as an option to achieve in both commercial and personal sense!

You were later invited to join Bartle Bogle Hegarty (BBH) Asia-Pacific as the first Chinese to take on the position of Regional Creative Director in Singapore, how do you find the experience?

Great... Somehow common language is an issue. When you work at a regional office, all adverts have to be adapted into different local languages; it's rather hard to find a common one that is suitable and comfortable for all, where communication works would eventually become visual advertisements instead.

You set up 321 Film Production Limited in 2002 and have produced over 200 TV commercials. Which one are the most proud of and why?

The Hong Kong Broadband Network commercial starring Liu Xiang. At that time the company stepped up a notch by providing the fastest internet connection service, from 10 Mbit/s to 100 Mbit/s. So they compared themselves to the world's No.1 Liu Xiang whose biggest challenge would be transcending his own limits. I think it's incredible that a profit-oriented TVC could could hold the same belief as mine, which is, 'our only competitor is ourselves.' It is meaningless to compare yourself to others on every matter especially for creatives; it's like putting yourself in a dead-end, whether losing to others or winning over the losers.

Another extreme example is the TVC for San Miguel. The concept was about man living in the hell is not a real bad thing if he can still have parties and surrounded by beautiful women. The slogan for that was 'life shouldn't taste bitter' (人生，本來就唔應該係苦。) and the client was happy with it. However, I laughed at myself with the slogan two days after we successfully gained the client's approval of the concept. The reason is that this is not what I personally believe in, yet life should be suffering instead, according to buddhism. But due to the objective of the commercial, we developed this idea to convince others to 'believe' what I actually don't believe in.

The advertising campaign you made for the MTRC between 1990-95 was one that really captured the public's attention. How did you get the brilliant idea?

In the late 80s during my work trip to London, I came across a local shop that sold Hong Kong's very own red-white-blue bag. I found it very provoking and it was the transition point in my creative life where I started to think seriously beyond our original perception about local creativity and relevance. MTRC is a large scale ad campaign since everyone rides the tube, so I thought I should bring the local daily life elements to the table to strike a chord with the public.

What design elements epitomise Hong Kong besides the colours red, white and blue?

Hong Kong creatives like the ones for Sunday and G.O.D., or even the old days when I worked for MTR during the 90s, have been unearthing local elements so it is hard to discover the unused ones. It's not necessary to be unused but I think what matters is what content you want to say and sincerely express with the local element you employ. For example, I am not the first one to use red, white and blue in design. It was Yuri Ng, the choreographer of Hong Kong drama 'A Brave New World of Susie Wong.' He designed the redwhiteblue dress for the local and colonial character. However I am the first one to present the attitude of Hong Kong people, which is positive and hard working, with red, white and blue.

I am also interested in abandoned buildings, which inspired me of the work 'Lanwei,' and a architectural measurement technique called 'setting out' (striking lines), also 'Tan Sin' in Chinese that I used on paper for traditional Chinese paintings I have done and exhibited in 2006.

What would you like to accomplish through your work?

Creative works can be very commercial; creative works can also be brought to the social front to reflect the state of our society. Politicians and social activists shouldn't be the only people get involved in social issues as creatives can also join in. I hope to get more involved with the society through my works.

What's your biggest challenge to date? Why and how did you overcome it?

The pressure I faced in the advertising industry was a challenge, but I was able to free myself from it for the past few years. I will continue to join competitions and hope to scoop an award or two. I don't worry about making money these days and now my challenge is how I can contribute to my industry besides the commercial aspect. I would like to convey my idea of harmony and positive attitude to people and the society at large.

What project/work of yours you find the most memorable? Why?

I think the most memorable work of mine is the 'Redwhiteblue' series. What I find the most memorable isn't the one that I have garnered awards for, even though 'Redwhiteblue' is my most long-last series, I won't see it as the most unforgettable just because of that. What matters to me is the opportunity to communicate with the audience each time. Even though 'Lanwei' (refers to abandoned buildings) and other projects are much lesser popular than 'Redwhiteblue,' what matters is if I work from the bottom of my heart.

You are well-established in Hong Kong, what's your plan for the future?

In short-term, I am planning to extend my 'Lanwei' series, which now include Taiwan, Singapore, Shenzhen and Bangkok. I hope to exhibit the series which will have photos of buildings in 10 cities altogether. But I think 'Lan wei liu' (refers to abandoned buildings in Chinese) will disappear soon since the Asian economy is booming. I would like to make a movie about about the society, a non-commercial one. It has been my dream for a long time and I won't give it up. My heroes are Abbas Kiarostami and Chinese director Jia Zhang-ke who I respect a lot.

Who do you admire in the same field as yours in Asia? And why?

Fashion designer Rei Kawakubo of Comme des Garcons, Japanese architect Tadao Ando, Iranian director Abbas Kiarostami, and Chinese fashion designer Ma Ke, who is famed for her Wu Yong collection. I see Ma as China's Rei Kawakubo and have done lots of graphics for her brand, Exception. I also like the works of Chinese artist Liu Xiao-dong and Chinese director Jia Zhang-ke. The directors are similar in a way that they are both social-conscious. Ando's faithfulness to his minimal creations changes our values too. I also like Kawakubo's 'Why not?' attitude and Ma Ke's exploration of life and human nature through clothes.

TED, HOK TAK YEUNG

What is the most exciting/impressive work of others you find lately? Why?

'Still Life' by Jia Zhang-ke, Liu Xiao-dong's works and Ma Ke's Wu Yong collection.

How do you feel about the Asian design industry and what are your expectations for it?

From the visual arts' point of view, it's good that Asian creatives also put the social and political aspects in their works in addition to the commercial elements. There are too few creatives in Asia who have a futuristic vision and the heart and passion to make a difference. I think this is an unhealthy phenomenon. I don't feel particularly happy when I scoop an international award as I feel a bit sad that my industry isn't really progressing. It's not the ability of creation and expression among China or the whole Asia that concerns me and I believe this is very good-in-shape still. It's the absence of the passion to go beyond the original perception that troubles me. It's important for us to do works that are strong in terms of content which make the younger generation think about the future directions of themselves and our creative scene.

How do you feel about Hong Kong? And how does it influence your design sense?

In the past 10 years, Hong Kong has been through social segregation, economic turmoil, fluctuating property prices, etc. These uncertainties gave me the drive to do works conveying positive messages and made me think about my social responsibilities. I hope more creatives ponder their social responsibilities through their works too.

There are many aspiring designers, before we wrap it up for the interview, do you have any word of advice for them?

Be sincere, passionate and hardworking at the same time. If you're sincere and passionate but not hardworking, you're not going to make it.

If you weren't a designer, what would you be? Why?

Social worker. I think God sends me here to help myself and to help others at the same time.

Profile:

Ted Yeung started publishing comics in Cockroach Quarterly in 1999, and had his first graphic novel 'How Blue was My Valley' published in 2002. His comics appeared in several local magazines and newspapers: East Touch, City Magazine, Mingpao Weekly, New Holidays and Sun Daily. His comic book 'Pyschic's Fairy Tales' was one of the best-selling comic books in 2006 and 2007.

Please tell us about your educational background.

I studied at a technical institute majoring in illustration.

What are your inspirations?

TV, newspapers, movies, everyday life... the funny thing is the news coverage on newspapers and TV are over dramatic these days. This is bad but it inspires me a lot. I usually like to read trivial news that happens everyday. For instance, reports saying a guy in women's outfit sneaked into a ladies changing room in a public swimming pool. He was caught in the end and I developed the story by giving him a reason for being a transvestite. Of course the reason has to be as silly and ridiculous as possible to create a comic effect.

We heard you sometimes get inspired by your wife, any interesting stories to share with our readers?

I once made jokes about her and she said 'You're such a jerk.' I misheard the 'such a' as '7 feets' in Cantonese. So I created a character known as '7 feet tall jerk' in my comics.

You are getting more and more well-known now. How does fame influence your work?

Fame doesn't really influence me. Maybe I am not young anymore, so being famous or popular is not my primary concern.

My physical condition declined rapidly in my late 30s and I have become less productive and energetic. I hope to start exercising and become an early bird, but I find it hard to change my routine.

I feel so proud to be one of the 5 members of the Hong Kong comic group 'Spring Roll.' I have the chance to work closely with renowned artists Craig Au Yeung, Eric So, Siuhak and Chi-hoi. We had lots of good times and shared many memorable moments together.

How do you feel about Hong Kong? And how does it influence your design sense?

Hong Kong is a fine place, except the congestion and pollution. It is so lively and energetic. As a comic artist, I don't find it hard to find topics to talk about.

Before the release of the 1000-edition 'How Blue was My Valley' in 2002, you quitted your job and worked as part-time delivering organic vegetables. How did you find the experience?

I was running out of cash. But my time would be fully occupied again if I work as a full-time. So part-time delivery job seemed to be a 'care-free' position to me. I thought I could keep the good spirit for drawing comics. But I was totally exhausted at the end of each working day. So I quitted after only a month. I was nearly bankrupt when 'How Blue was My Valley' was finally published.

We heard you are compiling your illustration 'Perfect Ugliness,' have you encountered any difficulties in doing so? If so, what are they?

I like drawings by the self-taught. The forms and shapes in the drawings seem to be 'out of control,' which is so funny and unexpected. They are innocent like children's drawings. I find it hard to practise 'perfect ugliness,' maybe because I'm no longer a 'virgin.'

We know your idea of 'Perfect Ugliness' came from the Thai stores in Kowloon City, how did you get inspired by the place?

Those stores usually sell Thai film VCDs. I have many of them with interesting covers. Of course I don't know Thai but I just love the VCDs' 'pulp' taste, it's another example of 'perfect ugliness.'

Would you say that your characters are uglily-beautiful?

My characters aren't 'perfect' yet. People still think I draw ugly things. My goal is to make people think that I've drawn something beautiful when it's ugly. There is still a long distance to achieving this goal.

You seem to intentionally make a style of the working class, is that the case? Why?

I don't intend to keep my focus on certain sectors of the society. In fact, I would like to talk about the burgeoise class, but I have to get rich first.

What do you want to express through your work's eccentricity?

I may think that my works are normal, conventional...no? Oh my gosh, I finally understand why the OLs (office ladies) hate my works. Jezz!!!

You are drawn to the negative aspects of life, e.g. revenge. Why does the dark side appeal to you?

The story is not that 'dark' after all, those characters are just silly bums. My school life might not be a happy one, but it didn't impose any 'dark side' on me.

You have created many characters over the course of your career. Which one is your favourite and why?

I recently created a character called 'Big Girl.' She wears a tight satin suit and looks like a ballooned Wonderwoman. OK, I like fat girls, don't treat me like a freak!!!

From Hong Kong local magazines like 'East Touch' to personal publications like 'Monthly whistle,' the press always mentions Siu Hak when they talk about you. Please tell us about your relationship with Siu Hak.

I don't think I have to explain how good he is as an artist. He's the one I have been waiting for in my whole life. But he is a guy and I'm straight, what a pity!

Which Asian illustrator do you admire the most and why?

Those anonymous comic artists whose works are published in Thai and Filipino pulp magazines. They are really good at producing 'perfect ugliness.'

What is the most exciting/impressive work of others you find lately? Why?

The comics by Japan's Yuichi Yokoyama. Siu Hak discovered his works and showed them to me. I'd never seen such things in comics.

How do you feel about the design industry in Asia and what are your expectations for it?

I'd been talking about creating long stories, especially on historical topics. But money, time and physical condition are still the obstacles.

Historical topics such as...?

I am interested in the early history of Hong Kong, how it started and how it came to an end.

If you weren't an artist, what would you like to be? Why?

I would like to be a farmer. I love pastoral life, growing plants, breeding livestock, breathing fresh air...but it is getting more and more impossible in Hong Kong or any near-by area. So maybe I'll be a chef or something, working in a 'cha chen ten' (restaurants in local Cantonese style).

DOUGLAS YOUNG

G.O.D. LIMITED

Profile:

Born in Hong Kong 1965, Douglas Young was trained as an architect in Sheffield University and the Architectural Association in the UK. In 1996, Young co-founded G.O.D. Limited with Benjamin Lau. The shop retails contemporary furniture, home ware and lifestyle accessories with a contemporary Chinese twist. The long-term vision is to build a Hong Kong brand that is both forward-looking and proud to display its cultural origins. To date, G.O.D. has stores over Hong Kong and other major Chinese cities and wholesales to many countries around the globe.

What's your design motto/vision?

Don't reinvent the wheel. It's important that designers do not repeat what other designers have already done. We should try to be as original as possible and say something unique.

Where do you get your inspirations?

I get inspired by the chaos and energy of Asian cities, especially Hong Kong. But most of the time, the place where my inspiration comes from is my bed. I often wake up in the middle of the night with an idea and I would just have to work on it there and then.

You were trained as an architect in Sheffield University and the Architectural Association (AA) in UK, what made you go for furniture/product design instead?

When I returned to Hong Kong, I thought the architectural business was very boring and dominated by big firms. Young upstarts stood no chance, so I wanted to do something related to, but not architecture itself.

You used to do architectural design from residential to retail interiors, which is in much bigger in scale than furniture and products. How do you feel about the change?

Before retail, I was into interiors, which was related to my architectural training, but a bit more creative. I am an impatient person so the shorter time scale of realising projects also suited me fine. In terms of size, furniture may be smaller, but in terms of investment, both psychological and financial, it's about equal. In fact, architecture, interiors and furniture all share the basic principles of aesthetics, function and economy.

Does the fact that you were trained as an architect influence your furniture/product design? Does it show in any aspect?

My architectural training has taught me to respect the nature of materials. They are not just graphics with shapes and colours, they possess physical properties. Anything I create should also have a meaning beyond its function, so it's more than just fashion.

Beyond function, I hope that my products could say something in a metaphorical or symbolic sense. The choice of materials in construction can be a form of expression. Ultimately, I hope my products are endowed with cultural meanings and could inspire future generations.

How do you develop your products and find the niche market?

I simply follow my own instincts and pretend to be a customer at the same time. I would never sell anything in G.O.D. that I would not use myself. In many ways I think I am quite a typical G.O.D. customer who would have a sense of humour and share my memories of growing up in Hong Kong. They are trend-savvy and style-conscious and are interested in getting value for money.

How did you come up with the idea of opening G.O.D. with Benjamin Lau?

We were both frustrated architects and wondered why there wasn't a shop like the one we shared in our dreams.

Why the name 'G.O.D.?'

It's actually a Cantonese name meaning 'to live better,' but it sounds like 'GOD' in its short-form. It's in a Hong Kong dialect because we wanted to create a local brand. 'To live better' is something people of all classes desire, so it's classless. I abhor elitism. It's the abbreviation of 'Goods Of Desire,' something you want rather than in need. We never associate it with the religious aspect, although some say that brands are today's world religion.

What can G.O.D. give customers that other furniture shops can't, besides products that tip their hats to the past?

A sense of cultural identity, it helps modern Chinese people to find out who they are, and non-Chinese to discover the great culture. It's also humourous, so it's entertaining too.

Why the tagline 'Delay No More?'

There are a lot of urgent issues that cannot wait, e.g. environmental, heritage, universal suffrage, etc. I also realise it sounds similar to a Chinese swear word. That makes it very powerful.

G.O.D. is famed for its crossover projects. What crossover projects are in the pipeline?

We cannot reveal too much as we are still in discussion with some international brands. An interesting one would be a collaboration with a cigarette brand, which is about how to make smoking socially acceptable. It's an interesting challenge and I love challenges.

What is/was your biggest challenge to date? Why and how did you overcome it?

Everyday is a challenge. The Asian financial crisis was a big one. The current good economy also presents challenges through high rents and wages. The only way out is to produce good products and creative marketing.

Which project/work of yours you find the most memorable/recognisable? Why?

Some of our signature prints have become very recognisable. They have been licenced by foreign companies and that help us spread the brand around the world.

Many of your items are already commercialised. When you come up with some ideas for your new design, do you pretty much focus on the design aspect or you think of the market first?

Some with the market and some are initiated by my own instincts. With the latter, the market may not know what it has not seen before, a new product will always be a surprise - these are the best products. I'd say it's half half.

How would you describe your design style?

My style is a Hong Kong style with pride. Hong Kong style is a particular mix of the East and the West, the old and new. The definition is open for anybody to interpret since there is still little controversy over it. My ideas are very personal which are related to my upbringing and what I happened to come across back then. Compared with slick western design, my style is imperfect and chaotic, but full of energy.

Your work covers a wide range of categories. What other design items would you like to explore/further develop in the future?

I still want to erect a building and realise my architectural dream, so if there is a reader out there please let me know.

In your opinion, what design best symbolises Hong Kong's past?

The tenement buildings in Hong Kong which represent our amazing adaptability.

Have you always been conscious of your own cultural roots and historical context?

Only after having lived abroad did I become conscious of my roots. Before that, I saw everything around me as ordinary.

What is the most exciting/impressive work of others you find lately? Why?

The works of contemporary Chinese artists, which are powerful, daring and uniquely Chinese. My favourite artists are Cai Guo-qiang, Xu Bing and Zhu Ming. They are all original and quintessentially Chinese without being cliché. I love the way Cai expressed himself with an ancient Chinese invention. It is unlikely to do with traditional art. The results are beautiful and poetic.

How do you feel about the design industry in Asia and what are your expectations towards it?

There is not enough of an Asian point of view. Too many designers are trying to emulate western idols and models. We need to create our own game rules. We cannot beat the West at what they do best.

How do you feel about Hong Kong? And how does it influence your design sense?

Hong Kong is a place full of energy. Its imperfections somehow make it perfect. The people are pro-change, in comparison to many other developed cities. So the progress in design is fast.

In a fast-moving market, I feel the pressure to progress with speed. I think this is positive because it prevents procrastination. The market demands for something new at all time and as a retailer, I have to respond to this frequently, or to lag behind otherwise.

There are many aspiring designers, before we wrap it up for the interview, do you have any words for them?

Find a cause in life that is dear to your heart and fight for it. Make a unique point. Bury your idol.

If you were not a designer, what would you like to be?

I'd like to be the God. If I were the God, I would make a day lasts 30 hours; set 2 weekends per week; and introduce snow to Hong Kong so I could ski to work.

NOD YOUNG

Please tell us about your educational background.

I am a college dropout. I recently got accepted by University of the Arts London and am going to study design communications there.

We understand you worked in a factory seven years ago, what was it about?

I didn't do that intentionally. Also, I didn't know I would become a designer back then. But I only worked there for a year before I enrolled into art school.

What made you pursue design as your profession?

My father is an art lover. I loved to watch him draw when I was a kid and thus, I am drawn to art since then. It seemed very natural for me to become an artist after graduate.

Where do you get your inspirations?

From music, the stuff on my table and my memories.

How did you start the creative group 'Khaki Creative & Design?'

Khaki is my second studio, which I set up in the summer of 2005 with MCK. We didn't have an office so we did most of our works at my apartment. I set up my own studio since I like to be in control of my time and creativity and I already have my contacts.

How would you describe your design style?

There are various stages to the development of my design style. To sum it up, I like visually powerful, colourful, simply structured, happy and detail-oriented works.

What is the most exciting/impressive work of others you find lately? Why?

I got an invitation to a design event in March. Each designer was asked to create a work based on the characteristics of another designer's work. With inspirations from some clothing's details, I created an illustration which meant a lot to me because it was the first time my graphics got translated onto fabrics and I was quite pleased with the result.

What is/was your biggest challenge to date? Why and how did you overcome it?

I need new inspirations: this is why I've decided to further my studies in England. I want to be away from the commercial world for now and return to a pure design state, be adventurous and rethink my style.

Which project/work of yours you find the most memorable? Why?

'菩提' ('Bodhi,' means Buddhismus) is my first exhibited piece (the exhibition was held in the UK). I really like this set of work, which was brimming with style and meaning. Also, I rethink my style and I won't employ it again.

Your work 'Journey to the West' is inspired by the traditional Chinese tale 'Journey to the West.' Why is the story important to you?

I believe every child in China loves 'Journey to the West,' which boasts heroes, gods, monsters, etc. It's full of imagination and wisdom. We are more drawn to things which don't exist.

You said you have held onto the old... how do you do so in terms of design?

I say that? I believe my creativity and design sense will change as I grow older and wiser. I don't know what these changes mean to me but I can tell you that design is and will be the biggest influence in my life.

You enjoy collaborating with others. Who would you like to collaborate with that you haven't yet and what would you want to do with him/her?

Yes. I enjoy collaborating with people who are hardworking, creative, capable and have a mind of their own. They can be from any profession and are armed with a refreshing perspective so that we can bounce ideas off each other to give birth to a beautiful sound.

What's the scale of your company? What scale do you target to have?

Khaki is a small company with only 4 people now. Thanks to the small scale, we are a closy studio instead of a company. We would like to design more general, detailed and caring cor-

Profile:

Born and raised in Northeastern China, Young is the creative director and co-founder of the Beijing-based creative group, Khaki Creative & Design. His personal works show his interests in various types of design and have been displayed in exhibitions in the UK, Germany, Japan, Mainland China, and Taiwan. Nowadays, Young is collaborating with others on how to make designs into products that more people can own and enjoy.

porate identities. Our target clients are mostly medium and small corporations since we know that their demand for design is more urgent and direct.

What are your future plans?

I am doing preparation work for the UK and am solving more and more problems.

Branding was once the hottest topic in town among designers, however the boom was spoiled quickly in just a few years and much less people talk about it now. How do you find this phenomenon? How does it influence you?

Every client has different branding requirements and building a brand is not just about visual design. Instead, it is more about preserving the team's harmony. As a designer, I am more concerned about how visual design can be used to make a brand's image perfect in a clear manner.

As a creative consultant with a focus on branding, do you see any problems in the field of China? What is it and how could it be improved?

Our clients are mostly international companies and corporations that are gearing up for the Chinese market. As local design consultants, we are responsible for proposing our branding solutions. The Chinese market is competitive, and everyone knows that you have lots of competitors here, including those from China, the US, the UK, Germany, Japan and other countries. I won't say that if you have conquered the Chinese market, you have won the world, but at least you can tell the world that you have conquered it.

You are aware of the social responsibilities like education and environment, how do you translate it into your work/design?

Design can change people's lives; education can change people's lives; being responsible can change people's lives. I'm actually just doing my part.

We understand you are concerned about losing traditional culture in our modern life, do you think this is happening in China? Any suggestions on how to deal with it?

Yes. I've learnt a meaningful incident recently: China has started incorporating Chinese Opera in the curriculum of secondary and primary schools in some of its cities. From a cultural preservation perspective, I think that this is worth doing but on the other hand, if this induces pressure on students, it's likely that they will dislike the art. On a similar vein, if we don't make design history interesting, nobody will enjoy it! In these 2 years I think that Chinese traditional culture is slowly re-awakening, which I think is a good thing.

Have you always been conscious of your own cultural roots and historical context?

To people of various backgrounds, cultural roots and historical context form a way of protection. For instance, you are travelling with your friend in a foreign country where nobody speaks Chinese. Your dialogues in Chinese will protect your privacy and the locals will want to know what you are talking about. I'm very proud to live in China, if possible, I would like to preserve my feelings towards my country, including my way of thinking and art sense. This is because I know that I'm using a familiar feeling in creating my works and this feeling will bring me the creative freedom that I need.

Who do you admire in the same field as yours in Asia?

I like Yoshitomo Nara's sincerity and Takashi Murakami's wit.

How do you feel about Asia's design industry and what are your expectations of it?

We can see that Asian design forces are slowly blossoming. Asian elements as inspirations are more popular on the architectural, art and fashion fronts: they excite the senses and make people reminisce. We have been waiting for the birth of a brand new Asian style in a designscape dominated by the West.

How do you feel about your motherland, China? And how does it influence your design sense?

To me there are two Chinas: the familiar one and the unfamiliar one. The former is vast, old-fashioned and traditional. The latter is urbanised with skyscrapers, lots of people and a lack of space. We are flooded by information, technology and luxury. Like other countries, we are modern but dosed with a lost feeling when face our traditional art. I have inherited Chinese philosophy and I am reinterpreting it my way.

Any words for aspiring designers/artists?

Create free, natural and unique works.

If you were not a designer, what would you like to be?

A lead singer.

ZING

Profile:

Born in Singapore, Zing cut his teeth in the makeup industry in 1989 and has been working and living in Hong Kong since 1992. Zing elevates makeup to the artistic level. In the glare of the spotlight, he singlehandedly made his profession much more high-profile. He is the first makeup artist to have leapt from backstage to the sizzling celebrity zone. Faces adorned with Zing's makeup are not only stunning, they ooze creativity too. In the past 20 years, Zing never stops spreading the art of makeup in Asia with the impeccably painted faces of international celebrities and supermodels. It is not surprised that he is a role model for his profession and has set many milestones for the cosmetic scene.Thanks to his collaborations with renowned stars and models, Zing is a household name. In 1997, he held his first exhibition and published the book 'ZingMakeUp'. 2005 saw the release of his book 'zingbyzing,' he also held his second exhibition that year. In 2006, Zing won the 'Outstanding Artist' award from Singapore's Ministry of Culture. 'ZING the makeup school' was established in the same year.

Please tell us about your educational background.

I graduated from high school in Singapore. I am a self-taught makeup artist. I used to practise makeup on my girlfriends and then moved on to doing magazine and commercial jobs. The more I do it, the more it fascinates me. I love fashion, and I'm obsessed with makeup.

Why the name 'Zing?'

It's my name. Period.

Where do you get your inspirations?

For me, there is no particular source of inspiration. I draw inspirations from a myriad of things. From art and paintings to scenery and people's faces and characters... even just what's happening around us, all these inspire me. But no matter where you find your inspirations, you need to hone your skills as your foundation. Then you can explore, play with the rules, sometimes breaking them. I am lucky that sparks of inspirations come by me often, but we cannot depend on it. On days that we don't get them, we have to fall back on strong basic skills.

Between 1997 and 1999, you were the Image Creator of Max Factor and created seasonal looks and print ads that elevated the brand to a new level. How did you do so?

Max Factor is a professional, mature, and sophisticated brand. However, younger consumers sometimes mistake it as a brand that is old-fashioned and passe. I disagree. Together with my name and public image, I worked towards giving the brand a contemporary touch and a young and trendy feel. I wanted a new awareness for Max Factor. It was done mainly through the visual impact from the edgy makeup, the clinical photography, and also the careful but gutsy pick of models.

You are the first makeup artist in Asia who was interviewed by CNN in 1998. How do you find this experience?

I don't feel anything special about it. I'm just glad I did it.

In the early 90s, you made your mark in Hong Kong with the 'bare-faced' look that caused major changes in the makeup, fashion and entertainment scene. How did you come up with the idea that shot you to fame?

I get bored easily. It's not that I wanted to do something revolutionary, but we always look for changes. At that time, heavy and corrective makeup was all the rage. I wanted my girls to look beautiful in a 'natural' manner. This is how my 'bare-faced' look came about, which is clean, pretty and natural, like wearing makeup without appearing to. The industry soon followed suit. In fact, strong basic techniques and a keen understanding of your subjects' characters were required to accomplish such natural, nude looks.

In 2006, you established your makeup academy: ZING the makeup school. Do you have any advice for your students and the young in general, especially to the aspiring designers and artists?

Be hardworking, in every sense of the word. We have to prepare and practise before anything else can happen! Strike while the iron's hot, but be prepared beforehand. You never know when your opportunity will come by. Besides, the more we do, the better we get. That's why I never stop working. I eat with makeup; I sleep with makeup; I breathe with makeup....

The public now perceives the makeup profession as being extremely glamorous, and often it is only the glamour that they are interested in. I think I could be largely responsible for this trend, with my lifestyle being reported excessively and such. But the thing is, what I have now is something of an extra bonus. I never work towards it. I love makeup for its bare essentials. Kids forget that. They do things only for the outcome but avoid the process. A hair stylist has to love working with hair, a singer has to love singing. The same applies for makeup artists. In short, people should try to be the best at what they do and put other issues aside.

Your work 'Cara's eyes' is provocative. What inspired this piece?

I did the piece for SKII's eye cream launch. The theme and focus was naturally on 'Eyes.' I decided to take on an humorous approach and 'eyes' were made to appear on where they shouldn't be.

Understand from your previous interviews in other magazines, the collaboration between Faye Wong and you is a big career move for you. How did it start? And how do you find the experience with her?

For the first time, I did the worst makeup for her. She never wanted to work with me again. I learnt from that, big lesson. And then I was lucky to have worked with her again a year later, and it became one of the best collaborations ever. This is the best mixture of learning from your mistakes, hard work, and luck.

Which celebrity would you like to collaborate whom you haven't yet?

For now, no one in particular. When I first started out, I wanted very much to collaborate with Sandy Lam. It'd be a challenge but I knew I could rise to it.

We heard you wished to study theatre design in London, is that why your conceptual makeup designs has a taste of it, just like the ones you did for Carina Lau and Isabella Leung?

No, they are more from the art world. Carina's is Matisse, and Isabella's is surrealism.

Do you still have plans to move towards theatre design? Or anything related?

No.

What is/was your biggest challenge to date? Why and how did you overcome it?

I went through this period, sometime in the late 90s when I was acquiring a loadful of bad media. Rumours and gossips, 99% fabricated, suddenly began hitting the newspapers and paparazzi columns. Soon my notoriety preceded me. As it got worse I got more depressed. I wanted to quit, to leave Hong Kong. But there was nowhere else to go. There was nothing else I wanted to do, so I fought back. I had to. Fought a little, went with the flow a little, and with the help of my friends in the fashion and entertainment industries, singers, actresses, photographers, I quickly understood the art of marketing. Notoriety turned into fame. In 1999, SK-II and Max Factor started featuring me in their TV commercials. The bad press had become an abundance of good press.

What are your future plans?

I recently released my line of professional makeup brushes <ink>. <ink> brushes are available at LaneCrawford. These brushes are very functional, comfy and user-friendly, suitable for both professionals and everyday-use. I also plan to release my third book. It may not be purely about makeup, but it will have an interesting theme.

What is the most exciting/impressive work of others you find lately? Why?

Peter Philips, Creative Director of Chanel Cosmetics. He's good.

How do you feel about the design industry in Asia and what are your expectations towards it?

Too many people dub themselves makeup artists these days. It's a shame since many of them are not really into makeup, but really just want to be 'makeup artists.' As said, I got into the business because I love makeup. My job has been glamorised since I attained some sort of a celebrity stature. I am portrayed as someone who has a colourful life with good food and nice clothes, etc; and surrounded by singers, film stars, etc. But this was never my original aim. The focus should be on the work, not the network.

What made you come to work in Hong Kong in 1992? What drew you to the city?

I'd been here on holiday before and thought it was a fun place. When I decided to come again in 1992, it was intended to be a one-month stint and I didn't think I was going to stay. But now Hong Kong is my home.

Would you relocate back to Singapore?

No. Singapore is too hot and humid, and I've lost in touch. Even though the food back there is great.

Which aspects of Chinese culture/tradition do you find the most interesting and why?

There are many. Chinese Sichuan opera's 'Face-changing' is one of them.

Besides the pace of Hong Kong city life, which part of Hong Kong do you like the most? And still find it interesting?

Don't get me started. I could write a book about it.

Which part of Hong Kong do you dislike the most?

I could write a book about this too.

If you were not a designer, what would you like to be? Why?

I haven't really thought about it. Maybe I want to be a background vocalist. My favourite singers are those who are also great with background vocals, e.g. Faye Wong, George Lam and Yumi Matsutoya.

During my earlier years in Hong Kong realising the complexity of my industry, I wanted to be a taxi driver. I thought they work alone without the need of socialising and networking, and only had themselves to answer to. I soon figured out that contrary to my misconception, taxi drivers too have to interact with people. Their industry is just as complicated as any other.

INDEX

EXPLORE STUNNING TALENTS IN ASIA

First published and distributed by
viction:workshop ltd.

viction:ary™

Unit C, 7th Floor, Seabright Plaza, 9-23 Shell Street,
North Point, Hong Kong
URL: www.victionary.com
Email: we@victionary.com

Edited and produced by viction:workshop ltd.
Contributing editor: So+Ba

Concepts & art direction by Victor Cheung
Book design by Cherie Yip @ viction:workshop ltd.

©2008 viction:workshop ltd.
The copyright on the individual texts and design work is held
by the respective designers and contributors.

ISBN 978-988-17327-1-2

All rights reserved. No part of this publication may be
reproduced, stored in retrieval systems or transmitted in any
form or by any means, electronic or mechanical, including
photocopying, recording or any information storage and
retrieval systems, without permission in writing from the
copyright owner(s).

The captions and artwork in this book are based on material
supplied by the designers whose work is included. While
every effort has been made to ensure their accuracy, viction:
workshop does not under any circumstances accept any
responsibility for any errors or omissions.

EUR & US edition
Printed and bound in China

01086847 (MT)

ACKNOWLEDGEMENT

We would like to thank all the designers and companies who
made significant contribution to the compilation of this book.
Without them this project would not been able to accomplished.
We would also like to thank all the producers for their invaluable
assistance throughout this entire proposal. The successful
completion also owes a great deal to many professionals in
the creative industry who have given us precious insights and
comments. We are also very grateful to many other people whose
names did not appear on the credits but have made specific input
and continuous support the whole time.

FUTURE EDITIONS

If you would like to contribute to the next edition of Victionary,
please email us your details to submit@victionary.com

ISBN 9881732719

9 789881 732712